OXFORD ORIENTAL MONOGRAPHS

This new series of monographs from the Faculty of Oriental Studies, University of Oxford, will make available the results of recent research by scholars connected with the Faculty. Its range of subject-matter includes language, literature, thought, history and art; its geographical scope extends from the Mediterranean and Caucasus to East Asia. The emphasis will be more on specialist studies than on works of a general nature.

EDITORIAL BOARD

THE EARLY PORCELAIN KILNS OF JAPAN

*Arita in the First Half of the
Seventeenth Century*

OLIVER IMPEY

CLARENDON PRESS · OXFORD
1996

Oxford University Press, Walton Street, Oxford OX2 6DP
Oxford New York
Athens Auckland Bangkok Bombay
Calcutta Cape Town Dar es Salaam Delhi
Florence Hong Kong Istanbul Karachi
Kuala Lumpur Madras Madrid Melbourne
Mexico City Nairobi Paris Singapore
Taipei Tokyo Toronto
and associated companies in
Berlin Ibadan

Oxford is a trade mark of Oxford University Press

Published in the United States
by Oxford University Press Inc., New York

British Library Cataloguing in Publication Data
Data available

Library of Congress Cataloging in Publication Data
The early porcelain kilns of Japan : Arita in the first half of
the seventeenth century / Oliver Impey.
(Oxford oriental monographs)
Includes bibliographical references.
1. Porcelain, Japanese—Japan—Arita-machi. 2. Porcelain,
Japanese—Edo period, 1600–1868. I. Title. II. Series.
NK4568.A75I47 1995 738.2'0952'23—dc20 95-37747
ISBN 0-19-826370-8

1 3 5 7 9 10 8 6 4 2

Typeset by Graphicraft Typesetters Ltd., Hong Kong
Printed in Hong Kong
on acid-free paper

PREFACE

THE work of the early years of the porcelain industry of Japan is little known in the West, being overshadowed by the great quantities of export porcelain that still survives in Europe, in spite of the ravages of the years and the purchase power of the yen. This early porcelain, called in Japan *shoki*-Imari, was not exported and hence is not found in Europe; it was made for local consumption to local tastes. It is, in fact, therefore much more representative of Japanese taste in general than is the Europeanized Imari or even Kakiemon porcelain. We take this early period to last from the beginnings of the porcelain industry in Japan, around 1620, to the onset of the export trade to Holland and to the Near East in 1659. In fact, of course, the manufacture of porcelain in Arita for Japanese consumption continued in Arita parallel with the production of export wares. We shall only touch upon this.

The style was at first that of the simple brushwork of the *e*-Karatsu stoneware, much influenced by Korea, which developed into a definitely Japanese taste as it progressed into porcelain and as the porcelain itself developed into the taste of the teamasters; 'good' taste. This, again, changed subtly as the industry grew more sophisticated, and much mid-century Arita porcelain could be related to the work of the Rimpa painters in its search for decorative effect. So, too, the shapes grew more aberrant, frequently unrelated to the decoration placed upon them; this demanded inventive use of *mis-en-page*, as brilliant as that of the *tsuba* makers.

Many kilns worked in the area of Arita, and hence there were many styles and types of porcelain made, as well as many shapes and sizes; it was an industry catering to an increasingly wide demand. There is therefore an enormous amount of material worthy of examination and illustration, even in the short span of the forty-odd years covered in this book. To do justice to these fascinating and to my mind lovely porcelains would require whole sets of volumes, far beyond the scope possible here. My colleagues in Japan have started to do this; books by Imaizumi, Yamashita, Ogi, Nagatake, Ohashi, Suzuta, to name

but a few, illustrate numerous works of the *shoki*-Imari potters, and celebrate their achievements.

Part of the discussion will be devoted to the problems of the origins of the enamelled porcelain called *ko*-Kutani; these have been a puzzle for years. The excavation of the supposed Kutani kiln-site near Kaga demonstrated that the supposition was wrong; *ko*-Kutani was not made in Kutani, or at the very most, very little. On the other hand evidence has been growing that it was made at three or four kilns in Arita. This evidence is examined by the comparison of sherds and *densei* (handed-down) pieces, showing, I believe conclusively, that most *ko*-Kutani was made in Arita. I confess to some surprise that this is the result; I had not expected so much to be provably of Arita manufacture.

The sherds that form the basis of the structure of this book were collected by me at the various kiln-sites of Arita in the 1970s by kind permission of the Arita local authorities. Sherds collected since, either on the occasion of excavations or by surface collecting, and held in the Kyushu Ceramic Museum or the Arita Museum of History and Folklore, have been used for comparative purposes. During my frequent visits to Arita, I have been able to study all the methods and techniques used in the manufacture of porcelain in small workshops as well as in modern factories; this has provided the material for a substantial chapter. I have actually worked, if you can call it that, with two potters, Marota Masami and Eguchi Katsumi, and in the workshop or small factory of Kakiemon XIII. Useful comparisons can frequently be drawn between methods used in those workshops and those in use in the seventeenth century.

As far as I am aware, this is the first book in a European language devoted to *shoki*-Imari. There is not even a word for it in English. I have not tried to produce a book of masterpieces, though I am fortunate to have been allowed to illustrate a good number, but I have concentrated on the kilns that produced the work and on the town of Arita as a porcelain-manufacturing town. Many of my illustrations are of potsherds found at kiln-sites. I make no

apology for this; these are the solid evidence of history. These finds at kiln-sites were actually made at those kilns; this is not conjecture, but fact. It is from these facts that we can build the edifice of classification that we use to examine and to date the sequence that we seek to establish, the evolution of the early porcelain of Japan.

ACKNOWLEDGEMENTS

It is a pleasure to be able to acknowledge the generous help that I have received over the long period of this book's gestation, and without which the work could never have been attempted. So many friends and colleagues are there who have helped me in so many ways that it would be tedious to list more than their names; I hope I have included everyone. If you have helped me and you do not find your name listed, please forgive me.

Japan

Arakawa Masaaki, Eguchi Katsumi, Fukagawa Iwao, Fukagawa Tadashi, Habu Junko, Hayashiya Seizō, Igaki Haruo, Ikeda Chūichi, Iketani Masao, Iketani Tokuo, Imaizumi Imaemon XII, Imaizumi Imaemon XIII, Imaizumi Motosuke, Imaizumi Yoshihiro, Imaizumi Yoshio, Imaizumi Masato, Isaka Yoshiaki, Kawai Hidekazu, Kawai Hisako, Kodama Kōta, Kōhashi Ichirō, Kumazawa Masayuki, Kurita Hideo, Marota Masami, Mayuyama Junkichi, Mikami Tsugio, Morimura Etsuko, Morioka Yoshiko, Murakami Noboyuki, Nagafuchi Tomoko, Nagatake Takeshi, Nakajima Hiroshi, Nakamura Tadashi, Nakazato Taroemon, Nishida Hiroko, Ohashi Kōji, Oishi Shinsaburo, Ozaki Yōko, Saito Takashi, Sakaida Kakiemon XIII, Sakaida Kakiemon XIV, Sasaki Hanae, Sasaki Hidenori, Sasaki Tatsuo, Satō Masahiko, Shimazaki Susumu, Suzuta Yukio, Takiguchi Susumu, Tatebayashi Genemon, Tatebayashi Naohiro, Tatebayashi Shōji, Yamashita Sakurō.

Europe and America

John Ayers, Jan Baart, Richard Barker, Sister Johanna Becker, Anthony du Boulay, Donald Cook, Louise Cort, Jon Culverhouse, Herman Daendels, Malcolm Fairley, Rupert Faulkner, Menno Fitski, Barbara Ford, Roger Gerry, Victor Harris, Mark Hinton, Lawrence Impey, Greg Irvine, Soame Jenyns, Christiaan Jörg, Gordon Lang, Lady Victoria Leatham, Daan Lunsingh Scheurleer, Pauline Scheurleer, Bill Macdonald, Molly-Anne Macdonald, David Macfarlane, James McMullen, Richard de la Mare, Mark Pollard, John Pope, Friedrich Reichel, Gerald Reitlinger, Jeffery Story, Mary Tregear, Henry Trubner, Richard Weatherhead, Billy Winkworth, Nigel Wood.

For financial support I am grateful to a private collector in Japan, the British Academy, the Japan Foundation, the Weatherhead Foundation, the Jeffery Story Fund, and the University of Oxford. I am also grateful to the Institute of Oriental Culture, Gakushuin University, for my three-month Visiting Research Fellowship there.

The views expressed in this book are my own; I have tried to indicate where they are in conflict with those of others. All actual errors are, of course, my own.

CONTENTS

LIST OF COLOUR PLATES

LIST OF FIGURES

LIST OF TABLES

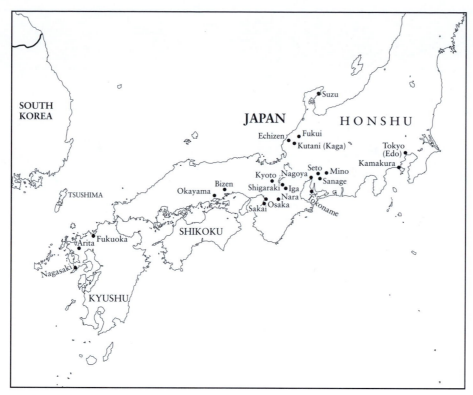

MAP 1. The Main Ceramic Centres of Japan

MAP 2. The Hizen and Adjacent Areas of Kyushu

1. Hyakken
2. Hyakken kita
3. Kama no tsuji
4. Danbagiri
5. Akiyama
6. Mizuo kama no tsuji
7. Kusunokidani
8. Gezuyabu
9. Toshikidani No.2
10. Toshikidani No.1
11. Toshikidani No.3
12. Kodaru No.1
13. Kodaru No.2
14. Yamagoya
15. Nakadaru

16. Maenobori
17. Nishinobori
18. Odaru
19. Maemaedani
20. Shirayaki
21. Tani
22. Shimoshirakawa
23. Nakashirakawa
24. Tengudani
25. Tenjinyama
26. Hiekoba
27. Lower Hiekoba
28. Tenjinmachi
29. Sarugawa shin
30. Sarugawa

31. Yamagoe
32. Chokichidani
33. Zenmondani
34. Ipponmatsu
35. Kakiemon
36. Mukurodani
37. Higuchi
38. Genzaemon
39. Nangawara kama
 no tsuji
40. Komononari
41. Tenjinmori
42. Upper Komizo
43. Middle Komizo
44. Lower Komizo

45. Yamabeta
46. Tatara no moto
47. Tatara No.2
48. Mukae no hara
 koraijin
49. Mukae no hara
50. Seiroku no tsuji
51. Seiroku no tsuji
 taishidoyoko
52. Seiroku no tsuji
 No.2
53. Noboritsuji
54. Haraake
55. Moemon
56. Kotake

57. Hirosemukae
58. Shishikawa
59. Benzaiten
60. Komori
61. Kuramoto

62. Toshaku mukae
 no hara
63. Hokaoyama
64. Hokaoyama byosodani
65. Maruo

66. Kake no tani
67. Yagenji
68. Kama no tani
69. Kuromuta shin
70. Hiratoko

⊏⊐⊏⊐ railway ——— road

0 500 1000 1500 metres

MAP 3. The Kiln-Sites of Arita (Note: not all the kilns shown are discussed in this book)

INTRODUCTION

THE Japanese porcelain exported to Europe in the second half of the seventeenth and the first half of the eighteenth centuries is one of the more familiar examples of Japanese art in Europe. Every great European house had its garnitures of vast Imari jars and a complement of smaller and usually more beautiful porcelain, often including the delicate Kakiemon enamelled wares and the vigorously painted blue and white. This was porcelain made specifically for export, in a variety of tastes largely dictated by European customers; it was not intended for use by Japanese nor within Japan.

This book is not about this export porcelain; it is about that porcelain made for domestic use in the first half of the seventeenth century, from the first beginnings of the industry to the commencement of the export trade.

This porcelain, for reasons that we shall discuss below, is called in Japan *shoki*-Imari, early Imari. Just as was the export porcelain, this was made in or near the town now called Arita in the Saga Prefecture (formerly Hizen) of the southernmost of Japan's four great islands, Kyushu (Maps 1 and 2). Kyushu lies closest to Korea of all of Japan, and the north-west 'corner' of the island is the closest point between the island and the Korean Peninsula; in between lies the island of Tsushima. Near this place, near to the town of Karatsu, stood Nagoya Castle (not to be confused with the Nagoya Castle on Honshu), which was the jumping-off base for the late sixteenth-century invasions of Korea under the command of Toyotomi Hideyoshi.

During the late sixteenth century the existing stoneware industry of Karatsu was revitalized by Korean immigrant potters, some of whom arrived with the returning invasion forces, importing new techniques, new technology, and new styles of ceramics. It was from the south-west part of the huge Karatsu stoneware-producing area that the porcelain industry was to develop, based on the discovery of porcelain stone in Arita.

The usual definition of porcelain states that porcelain is a high-fired ceramic, with a more or less translucent body that rings when struck. If this definition was to be applied strictly, then many oriental porcelains, including most of the Japanese wares, having a grey, opaque body, would have to be eliminated from the class; it is clear that we are talking not of a definition so much as of a guide-line. This does, however, serve to distinguish porcelain from stoneware; although stoneware and porcelain mature on firing at the same temperature, their bodies differ sharply, that of stoneware being a secondary clay, totally opaque, usually dark coloured and varying in colour with the conditions of firing, while porcelain stone is a decayed igneous rock which fires pale whether it is oxidized or reduced.

The 'new ceramics' of today are beyond the scope of this book.

The term '*shoki*-Imari' (early Imari) is used here to describe the porcelain made in or near Arita in the early period of the industry, which we shall take here as some forty years. This is to separate this early production from the export porcelain of the second half of the century and later, called in Japan '*ko*-Imari' (old Imari). The name Imari refers to the port through which this porcelain was shipped elsewhere. The export porcelain was shipped to Nagasaki for reshipment by the Dutch or by the Chinese, while the domestic wares went to Sakai, Osaka, Edo, and other ports in Japan.

In Europe it has become the custom to call the Arita blue and white 'Arita' and the overglazed enamelled porcelain from the same kilns 'Imari', while distinguishing one style as 'Kakiemon'. This is convenient, but is inaccurate and misleading, though that need not much concern us here as we shall overlap in time only with the very early stages of the export trade.[1] There is no European name for the *shoki*-Imari, for it is almost unknown in Europe.

This is a pity, for many of the *shoki*-Imari wares are of great beauty. In general, they can be characterized by their strong shapes decorated with fluid and bold brush-painting in cobalt oxide, underglaze blue, a character that runs throughout the period, regardless of style. Only towards the end of the *shoki*-Imari period does a more delicate touch of decoration appear; both these were to continue in parallel

into the export wares. Of course, other techniques were used, too; celadon and *temmoku* glazes, shaped profiles and moulded decoration, and even enamelled colouring. It now appears certain that many of the famous so-called '*ko*-Kutani' porcelains were in fact made in the Arita kilns in the *shoki*-Imari period and not at Kutani in Kaga on Honshu (see ch. 7), from whence their traditional name derives.[2]

We have become accustomed to talking of certain kilns, when in fact we mean certain kiln areas; in the forty years covered in this book, there were some forty-odd named kilns working at one time or another in the Arita area, and most of these had two or more (nine in the case of Tenjinmori) actual kilns working either concurrently or successively.

The working life of the somewhat crudely built *noborigama* kiln (the stepped, chambered kiln; see ch. 3) has been calculated by Nakazato Muan as some thirty years;[3] at the early period I think it may frequently have been much shorter. Excavation provides evidence of frequent repair and rebuilding of kilns. On the whole, there seems to have been a tendency for the kilns to get longer, that is, to have more chambers, and for the dimensions of the actual chambers to increase with time;[4] presumably this was due to increased skill on the part of the kiln builders as well as to increased demand for the product. Increase in the sizes measurable on excavation was soon accompanied by increase in the height of the roof of the kiln, more difficult to measure as so little survives. At the early period the greatest height was probably about one metre,[5] barely sufficient for the kiln-master to enter for the purposes of stacking and unpacking. The limit to this dimension was the unavailability of complex kiln furniture; seggars, already highly sophisticated in Song China, were little used, for whatever reason, in the early period of the Arita industry. The firing pots, then, stood only upon the floor or just above the floor on stands,[6] with consequent waste of the space above them and loss of heat. Rapid loss of heat on cooling is a cause of much damage. The introduction of seggars greatly increased the efficiency of the industry throughout the seventeenth century; by the standards of Jingdezhen, Arita was barely more than a provincial backwater.

We shall see that porcelain production in Japan began, slowly, in stoneware Karatsu kilns at some time around 1620. This is curious, as porcelain had been made in China for some eight hundred years, and was well known in Japan (see ch. 2). Some of the Karatsu kilns in the Arita area continued to make stoneware; new kilns were built especially to make porcelain. Demand increased, provoking competition from China (see ch. 6) and the range of product and the use of new techniques increased also. Japan began to export porcelain to South East Asia and then sell to the Dutch, first for Batavia and then for Europe and India. The internal disruptions in China caused by civil war consequent on the fall of the Ming dynasty affected Jingdezhen badly; The Dutch East India Company, by now aware of the increased quality of Arita porcelain, especially of the colours of the enamels, placed a huge order for porcelain for exportation in 1659, partly to replace lost orders from China. This I take as the end of the *shoki*-Imari period, for the effects of this and subsequent orders were very far-reaching.[7]

We shall be dividing this short period, some forty years, into notional phases or periods, according to differences in products detectable between those phases; usually such changes would be heralded by some new influence or innovation.

This has been done before; the first two phases, for instance, have usually been called the 'Korean' phase and the 'Tianqi' phase. I prefer the more neutral phase one, for the Korean influence was filtered through the Karatsu stoneware production, and phase two because I believe it to have been the *shoki*-Imari that influenced—indeed, provoked—the Tianqi porcelains and not the reverse as is usually assumed (see ch. 6). Phase three showed a marked increase in variety of product and of technology, including the beginnings of the use of enamel colours as overglazes by means of a second firing in a muffle kiln (see ch. 3). The third phase also saw the beginning of the export trade to South East Asia and to the Dutch in Asia. The fourth phase, which we shall only briefly consider, for it is well documented elsewhere, and beyond the scope of this book, begins in 1659 (see ch. 12). This is the start of the *ko*-Imari.

We shall not here be discussing exhaustively the various attempts to determine exactly who first began to make porcelain in Japan, whether or not it was a Korean named Ri Sampei. This argument is for the linguists—of whom I am not one—and for the archivists; we shall consider the documentation only when it seems strictly relevant. The major source of the evidence to be assessed in this book is the evidence on the ground; that is, the evidence of the sites of the kilns themselves and the rubbish dumps (*monohara*) where the wasters were thrown when

the kilns were unpacked after firing, and the sites where the final products were actually used, consumer sites. These will be examined in four ways.

First, by surface finds at the kiln-site, which may tell us what was made at the kiln and, by inference, what was not. This should give us an idea of when the kiln was working and for which market or markets. In practice it is usually easier to determine when a kiln began than when it ended production, for two reasons; one, because some types of porcelain continued to be made over a very long time, and the kiln might be very conservative; and, two, because wastage in the early period was a much higher percentage of the production than it was to be later.

Surface finds are a good guide, but a guide only; actual digging may reveal types that do not appear on the surface. In fact, this is unusual, for most kiln-sites have been extensively dug over either for agriculture or by sherd hunters. And, of course, many sites have been virtually lost or severely damaged by building works.

Secondly, we shall use, wherever possible, the results of archaeological excavation. Few sites had been properly excavated before 1970 when I first worked in Arita, but the pace has accelerated under the enthusiasm of the Arita Town Board of Education and the Kyushu Ceramic Museum. Now, new kilns seem to be discovered every year, and well-known sites excavated and re-excavated.[8] Inevitably this book will be out of date before it is written, and may well not include all the known porcelain sites of the period. Porcelain of this date, to add to the complications, has been found at kiln-sites outside Arita, too; not only in Hasami and near Ureshino, but further afield also.

In 1973 I was invited by Professor Mikami Tsugio to participate in the excavation of one of the Yamabeta kilns, to see at first hand the methods of excavation of kiln-sites.

Use of the evidence of the ground makes it perfectly clear that the making of porcelain was developed in Karatsu stoneware kilns as a progressive change within an industry, to adapt to new demands; we have no need to find a folk-hero to whom discovery and innovation can be ascribed.

Thirdly, we shall use selected records of excavations at consumer sites, which may tell us who bought and used shoki-Imari, and may even help us with the dating of it (see ch. 8).

Finally, we should look at the product itself. This should give us an idea of the immense range of production of the Arita kilns of the shoki-Imari period, and the quantities that survive suggest that certain phases were, indeed, as already suggested by finds of sherds at kiln-sites, more productive than others. This will give us information on supply and demand.

Some pieces are dated, others contained in boxes that bear an inscribed date; this latter group should be approached with caution, for contents of boxes can be changed, just as silver mounts on export wares can be changed (see Appendix 1). In some cases we shall be able to ascribe certain pieces to a single particular kiln; in most cases it will not be possible to determine the precise kiln of manufacture, but only a notional group of kilns, any member of which might have made that particular piece. Elsewhere I have proposed Impey's first law of kiln-sites—only partly facetiously—which states that almost everything is made almost everywhere. The exceptions are interesting. Nor should we forget the sheer pleasure of seeing and handling these fascinating and often beautiful pieces of porcelain.

We know next to nothing about the organization of these kilns. It seems most plausible to suggest that the kilns of the shoki-Imari period were more or less autonomous, working privately according to the skill or ambitions of the master. It is almost certain that in most cases several workshops shared the use of a kiln between them; this means that there must have been many more workshops than kilns—possibly hundreds. This may well explain the wide range of product, both in terms of style and in terms of skill to be found at some kiln-sites. It is unlikely that at this early period there was any control by the retainers of the Lord Nabeshima of anything but the widest issues; the only documentation that is relevant and reliable here is an order from Lord Nabeshima Katsushige of 1637 to a member of the Taku family, who are documented later as the 'agents' of the Nabeshima family, which mentions a 'mountain bailiff' by name (see ch. 11). In all probability this official was concerned with the assessment and collection of taxes. This document orders the expulsion from the area of 532 men and 294 women, in total 826 persons from eleven workshops in the ceramics industry, because of the rapid deforestation of the area due to the amount of wood cut for firing the kilns. The document does not tell us how many persons remained in the industry, nor how many of those expelled were allowed to remain after appeal.

It does give an indication, however, of the size of the industry; surely more would have been allowed to remain than were expelled, if only for purposes of taxation. Few of these persons would have been actual potters; most would have been the anciliary workers necessary to the workshops, from the clay diggers and preparers to the skilled painters and glazers.

As far as the actual processes involved in the making and firing of the porcelain goes, many methods of the early seventeenth century are still practised in some workshops in and near Arita today. Some early methods are used in conjunction with more modern technology; electric wheels and gas kilns, pug-mills and thermocouples can be found, as can the Kyushu kick-wheel and the wood-fired *noborigama*, while some firing-masters can still judge the temperature of the incandescent pots by eye. In 1970 I was privileged to stay at the houses of and work (*sic*) in the workshops of two stoneware potters, Marota Masami, who also made salt-glaze, and Eguchi Katsumi, who now also makes porcelain, and of Sakaida Kakiemon XIII, where I was able to study working methods that in many ways have not altered in three hundred and fifty years. Marota, for instance, used a kick-wheel; the Kakiemon kiln is a wood-fired *noborigama*. Since then, I have also been able to study at the workshop of Imaizumi Imaemon XIII and at the Tanigama kiln of Fukagawa Iwao, as well as having a detailed view of the Koransha and Fukagawa Seiji factories.

It remains somewhat of a question exactly why the Japanese did not make porcelain before the seventeenth century. When porcelain stone was exploited in Japan, first at Arita and then, briefly, in Kaga, and, much later, at Seto and elsewhere, it was at places that were already ceramic-producing. Why did they not make porcelain earlier? As we shall see, the technology of the actual making and firing of the porcelain body varies very little from that of stoneware. In the specific case of the blue and white, I shall be suggesting that this was for reasons of taste, for the lack of demand for blue and white in Japan until the beginning of the seventeenth century. But this to some extent begs the question; why did they not make celadon porcelain at Seto in the fourteenth century instead of the stoneware imitations of Chinese celadon? Or even at Arita in the sixteenth century, for that matter? After all, when porcelain was first made in Arita, it was not all blue and white; some was celadon and some iron-brown glazed. I find it difficult to believe that the Japanese could have been sitting for so long on mountains of porcelain stone without realizing it.

This last question, being almost rhetorical, may not be able to be answered. It is the other questions that I shall address in this book; what is *shoki*-Imari; who made it, when and where; how does it fit in with the pattern of production of other ceramics in Japan and with the importation of Chinese (or other) porcelain; how did it affect the export porcelain that followed it; how do we regard it now? These questions we may only partly answer, but it is worth the attempt in order to introduce these interesting porcelains to a Western language public.

Notes

1. For a recent discussion of this, see Oliver Impey, 'Japanese Export Porcelain', in John Ayers, Oliver Impey, and J. V. G. Mallet, *Porcelain for Palaces, the Fashion for Japan in Europe, 1650–1750* (London, 1990), 25–35.
2. See the exhibition catalogue *Polychrome Porcelain in Hizen: Its Early Type and Change of Style; Special Exhibition* (Arita, 1991).
3. This was kindly told me by Nakazato Taroemon.
4. Ohashi Kōji, personal communication, and Ohashi Kōji, 'Hizen koyō no hensen—shōsei shitsu kibo yori mita', *Saga Kenritsu Kyushu Tōji Bunkakan kenkyū kiyō*, 1 (Arita, 1986), 64.
5. One of the few measurable heights of chambers was that of chamber 5, kiln 2 at Yamabeta, where it was approx. 70 cm. tall inside.
6. See fig. 35; Fudōyama kiln at Ureshino, where the roof of the chamber has collapsed at the end of the firing cycle onto the pieces in the kiln, many of them still in their firing positions, either on *hama*, almost on the floor, or overlapping and (formerly) one stage higher, on *tochin*, dumbell-shaped stands.
7. For a recent discussion of the export trade, see Oliver Impey, 'The Trade in Japanese Porcelain', in Ayers, Impey, and Mallet, *Porcelain for Palaces*, 15–24.
8. Both these bodies publish useful excavation reports; however, as they do not form a series to which one can subscribe, they are difficult to obtain. I am deeply grateful to both bodies for supplying me with excavation reports and keeping me informed of new excavations.

ARITA: A PREAMBLE

THE town of Arita extends along a narrow valley down which runs as a spine the road that I shall call the high street; for most of its length, this street intertwines with a small river. Side-streets branch off this long street, each also winding up other small valleys, some to lead to other towns, others merely to the head of a valley; there is one along which the small river, the Shirakawa, flows from a modern dam. Closely packed into the main street and the side-streets are the small wooden houses typical of crowded urban small-town Japan, but here mixed with workshops, some open to the street, others with wide glass-filled *shōji*; behind, every now and then, can be glimpsed tall brick chimneys. These are the porcelain workshops and kilns of Arita, the cradle of the Japanese porcelain industry. The workshops are instantly recognizable, for outside will stand, on trestles, long planks on each of which is a neat row of pots, standing in the open air to dry. These have just been thrown or turned, and the planks have been carried out, one-handed, as a waiter carries a heavy tray, by an apprentice from the workshop within.

The workshops are mainly concentrated in the side-streets—the high street is for shops; innumerable shops display in crowded profusion the products of the town. Some of these shops specialize in reproductions of the former glory of the seventeenth- and eighteenth-century products of Arita, Old Imari, while others, often open-fronted and spilling out into the street, sell the multifarious everyday products that Japanese cuisine demands. This is the old-fashioned façade of the town, but it is very much part of the industry. The other part lies further embedded in the town, the factories varying in size from the small family concerns to the large old-established factories and the modern establishments of the large whole-sale dealers. In a separate category are the fine-quality workshops that trace their descent from the early Edo period, of which the most celebrated are the Kakiemon workshop in the Nangawara valley and the Imaemon workshop, half-way up the high street, on part of the site of the old Akae-machi, the enamellers' quarter.

Through the greater length of the town, down the valley runs the small river, carefully confined by stone or concrete walls, and crossed and recrossed by the high street on neat stone bridges. The name of the river, Shirakawa or White River, proclaims the use to which it was put in former times; in it and powered by it stood the balanced, water-driven rock-pounders that crushed the hard Izumiyama porcelain stone into powder before its levigation; doubtless the river ran white. Today there is no sign of this, for the little Izumiyama stone that is used today is ground in the factories in pug-mills. The bottom of the river is littered with potsherds and discarded kiln furniture—as are all footpaths, for that matter—but there are still enough fish or frogs and other small animal life to attract a few of the white Little Egrets, the *ko-sagi*, that so often appear as decoration on Arita porcelain.

Today the town of Arita has about 14,000 inhabitants, a good proportion of whom must be working in occupations related to the porcelain industry. In 1637, a document mentions '155 wheels' presumably 155 master potters; in 1880 there were said to be 5,430 inhabitants in 1,174 houses; 120 houses were occupied by porcelain makers, 30 by porcelain painters, to a total of 1,560 workers.

Porcelain is made of rock, not of clay, though one talks of porcelain clay once the rock has been powdered. In China the rock is dug ready powdered, washed down by great rivers; in Japan it is mined. The source of porcelain stone in Arita, in fact the first source for the porcelain industry in Japan is, or rather was, Izumiyama, which must in the early seventeenth century have been a reasonable-sized hill. Today it is somewhat like a working quarry, a moonscape generally below local ground level, with yellow-white stone that has here and there been left in small pinnacles and towers (fig. 1). This is a thermal area—the nearby Takeo and Ureshino are noted spa towns—and the weathering of the Izumiyama rock was both external and internal. Some pockets or areas were said to be of better-quality material for the required plasticity of the clay, and these pockets were

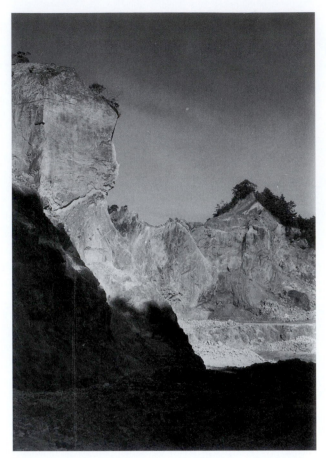

FIGURE 1. Izumiyama

competed for and early exhausted. The random-looking quarry of today was clearly not randomly worked.

Izumiyama clay is no longer considered of sufficiently good quality for its use in the porcelain industry; it is only used today for commercial drain-pipes or roof-tiles. Since the late nineteenth century and just possibly earlier than that, clay has been brought in from Amakusa island off the north-west coast of Kyushu. Now that the workshops and factories are so well established, it is easier to bring the clay to Arita than to move Arita to the clay. Arita had, of course, owed its existence as a ceramic centre to the presence of the porcelain stone.

The clay for the glaze, for glaze is made of a mixture of clay and wood-ash, is said to have come from another outcrop (if that is the word) of the decayed granite that constitutes Izumiyama. What the precise differences between the two materials were or are may not even be known, but empirically it was known that this outcrop, now called Shirakawa

Yamatsuji, was the source of the best material for glaze. It is difficult of access today; one of the main branch roads off the Arita high street, not much over a kilometre from Izumiyama, leads north at the corner where stands the Fukagawa Seiji factory, past the three kiln-sites, Shimoshirakawa, Nakashirakawa, and Kamishirakawa (Tengudani), up the river valley to the modern dam. Past the dam, the road is virtually impassable to motor vehicles, and the last part is a rough walk. It is said that even today some stone is extracted from this source; if so, it can only be in very small quantities. The place looks very different from Izumiyama; it is a quarry beside a cliff made by quarrying, and into this cliff run short tunnels. The whole place is overgrown and the rock looks grey rather than yellow-white, possibly because it has been exposed longer than the rock at the actively worked Izumiyama.

Izumiyama is at the north-east end of the long street that I have called the high street that runs through Arita. It stands in the fork, as it were, of the Fukuoka road; off the more northerly fork stand the kiln-sites of Kusunokidani and Gezuyabu, the more southerly is the road to Takeo. Almost parallel to the high street, on the southerly side until much further down, runs the railway, and, a more recent addition, the bypass road, with its many short tunnels as it passes brutally through the south side of the valley just as it begins to become steep-sided.

If we turn right, that is, north-east from Izumiyama, up the Fukuoka road, we would come to the *Rekishi Minzoku Shiryōkan*, the Arita Museum of History and Folklore, perhaps fifteen years old, and recently (1993) enlarged. Here are stored and exhibited the spoils of several of the excavations carried out at the kiln-sites of Arita and its environs. I have spent many happy hours in the storage studying these potsherds and am grateful to my colleagues there, and particularly to Murakami Noboyuki, for their enthusiastic help and collaboration.

Going back past Izumiyama, down the high street, in about eight hundred metres there is a turning to the left (south) which leads past two factories that belong to the Koransha (see below), to the Upper Arita (Kami Arita) railway station, under the railway to pass the old kiln-site of Yamagoya, perhaps the most innovative of the early kilns. This was the old road to Itanokawachi, over the hills, where were the old kilns of Hyakken, Danbagiri, and Kama no tsuji. This was a shorter distance, about eight

kilometres, than the modern route to Itanokawachi, which is off the Takeo road.

The subsidiary factories of the Koransha Company were making, I was informed, the lesser-quality products that are in demand for the Japanese custom of obligatory present-giving. The former President of the Koransha Company, the late Fukagawa Tadashi, once suggested to me, outrageously, that the boxes in which these porcelains were packed were never actually opened, but passed as one unwanted gift on as another unwanted gift. Perhaps an exaggeration.

Further down the high street from this turning, one finds on the right the Meiji period building that housed, when I first visited Arita in 1970, the Arita Ceramic Museum, the only public museum for the products of Arita in the town; there were then and are now several private museums that are open to the public. (Since then, of course, the Kyushu Ceramic Museum has been built, see below.) This was a charming run-down place with a good model of a *noborigama* kiln and with potsherds from the waste heaps of several different old kiln-sites. Quite close, on the other side of the street, is the modern Iwao Company factory, built on the sites of the Odaru and Nishinobori kilns; the railway passes close by and has disturbed the several other, later, kiln-sites in the area. The Iwao is one of the leading factories in Arita and makes both routine and special-order wares. The factory has a small museum, which, beside some *densei* pieces (literally 'handed-down', so that the word is usually used to mean a whole, unbroken piece suitable for display, as opposed to a piece found at a kiln-site), has a collection of sherds from the Odaru site. As the site is almost entirely either destroyed by the railway cutting or obliterated by factory buildings and tarmac, these sherds are invaluable for the study of the products of the area. I was able to study the collection through the courtesy of the late Ikeda Chuichi, then the chief designer of the factory and the man who discovered the record of the death of Ri Sampei, the supposed initiator of the Arita ceramic industry. As almost always, in spite of the buildings, I was able to find a few seventeenth-century sherds; but regrettably few.

Beyond the railway, up towards the Kami Arita railway station, lie the kiln-sites of Kodaru Shingama and of Kodaru. Both these sites have been badly disturbed. On the site of Kodaru stands the house of Mr Iwao Shinichi, the owner of the factory, who kindly gave me some sherds found at the time of the building of the house in the late 1960s. Much of this

area, open at the time of my first visits, is now built over.

Going back to the main street, we soon come to a fairly large road to the right. This is the road that follows the course of the Shirakawa river up to the modern dam. It is here that the river meets, as it were, the high street, and from here the road and river intertwine down the main valley. At the corner of this road is the Fukagawa Seiji factory, one of the two large factories founded in the Meiji period, a few years only after the Koransha; at first it was called the Seiji-sha ('House of pure ware'). This is a large concern, making a wide variety of qualities (and hence, price-brackets) of porcelain, and experimenting with other porcelain bodies such as bone china. The chief designer is Fukagawa Iwao, who in his private capacity owns and runs the three-chambered *noborigama* called Tanigama, almost on the site of the seventeenth-century Tanigama. Looking around this factory with Mr Fukagawa, I was able to see the mixture of machine-working and hand-finishing that varies from factory to factory, but that is the basis for most ceramic factories of today. Some techniques such as the spraying of glaze colours are clearly learned from Europe; others may well descend from the early Edo period. As we shall see at all the other factories we visit, and as was certainly so in almost all kilns in the seventeenth century, work is made to be sold in different price-ranges, made to different standards of quality for different markets.

If we follow this road we pass, on the left, the old school-house and, on the right, the successive kiln-sites of Shimoshirakawa, Nakashirakawa, and Kamishirakawa, Lower-, Middle-, and Upper Shirakawa. Kamishirakawa is also called Tengudani, and it is here that legend has it that the Korean, Ri Sampei, first made porcelain; a stele has been erected by the roadside to commemorate this. As we shall see, this is an over-simplification, a charming legend, though possibly based on truth.

In 1970, when I first arrived in Arita, the Tengudani kilns had just been excavated by the team led by Mikami Tsugio, perhaps the first Arita kiln to be scientifically excavated and recorded (fig. 2). When I first visited the site, the kiln structures were still clearly visible and not overgrown; sherds discarded by the excavators (as being from the *monohara*, the rubbish tip) were piled by a nearby shrine; some were still there in 1988. The sherds excavated from the site that were to be used for documentation were

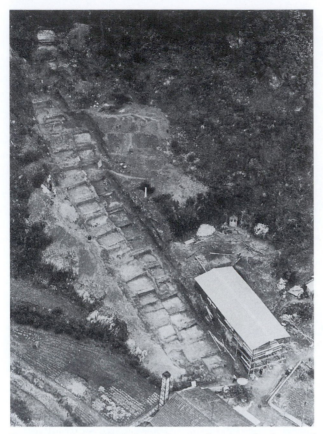

FIGURE 2. Tengudani from the air showing the bases of the chambers of two successive kilns. From Mikami *New Light on Early and Eighteenth-Century Imari Wares* (Tokyo, 1972)

laid out all over the floor of the old school-house, and I spent many happy hours there with Nagatake Takeshi arranging, classifying, and photographing these (fig. 3). The report, published in 1972, is still the fullest of any of the Arita kiln excavation reports. Unfortunately, the scientific evidence was marred by an admixture of late Meiji material, then unrecognized as such, which threw out the dating scheme then erected.

Almost opposite the lower end of this road, on the far side of the valley and approachable only from the bypass, stands the three-chambered *noborigama* of Fukagawa Iwao, almost on the site of the old Tanigama and the nearby Shirayaki kilns. I have helped to fire this kiln (see ch. 3) and I watched how Fukagawa-san used techniques that must have varied but little from those in use in the early seventeenth century, the period discussed in this book.

Back to the main road, we continue west-south-west, until we come to the Koransha factory, on the right. The Koransha ('House of the fragrant orchid', hence the rebus of an orchid flower as the factory mark) was the earliest modern-style factory to be founded in the Meiji period, opening in 1876. Its products were shown in Europe as early as 1878 at the Paris Exhibition and again in 1880 at the South Kensington Museum, later to become the Victoria and Albert Museum. At that time it was said to employ some 450 persons. In the 1980s the Koransha

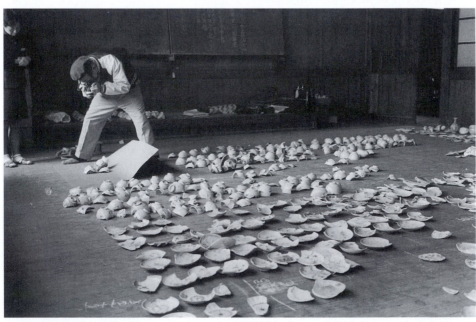

FIGURE 3. Nagatake Takeshi photographing sherds from Tengudani

began to make the 'new ceramics' or 'fine ceramics' which are so strong (being a spin-off of the rocketry industry) and hard that they can be used for knife-blades or as the impact area on golf-club heads.

A little further down the road and we are in the area that from the middle of the seventeenth century was called the Akae-machi, the enamellers' quarter. It is thought, but not yet proven, that here worked the muffle kilns in which the fired and glazed pots from most of the *noborigama* were refired with the brilliant polychrome enamel colours characteristic of the so-called *ko*-Imari, Old Imari, the enamelled porcelain of Arita.

On the left is the fine old wooden house of Imai-zumi Imaemon XIII, the inheritor of the Nabeshima tradition of porcelain decoration. Imaemon XII, still alive on my first few visits to Arita, began the innovatory approach to Nabeshima-style design that has been so successfully extended by his son, the present Imaemon. The house is worth describing. Behind a modest street entry is a form of hall, with a beaten earth floor, open up to the height of three storeys and criss-crossed by great blackened wooden beams. On the right is a comfortable modern showroom; not a shop, but a sitting-room in which a few visitors at a time can drink tea and eat *yōkan* while examining the few discreetly exhibited wares on offer. These vary from teacups and saucers to the magnificent exhibition pieces that have ensured Imaemon-san the title of *Ningen kokuhō*, living national treasure, perhaps the equivalent of the Order of Merit in Britain. In the open hall is one of those wood-fired stoves into which are inserted the skirted boiler-vats, such as can be seen in miniature in Tang tomb figures, and which no doubt originate much earlier. I do not think it is much used today. On the left, past an office, is the private side, where the family lives, with rooms divided by *fusuma*, sliding screens and therefore openable one into another. Some of these at the back look out onto a courtyard, which is part garden, with, at the far end, a working area, for the back of the house contains all sorts of facilities, such as a packing room. At a stone sink there, I have washed hundreds of sherds garnered from my visits to kiln-sites, some in the company of Imaemon-san, and then waited for them to dry before numbering and photographing them, and then packing them for shipment to Oxford. I hasten to add that I had special permission to do this, secured for me from the city fathers by the kindness of Nagatake Takeshi, then still very much the Grand Old Man of the history of Arita

porcelain. Nagatake-san understood and approved of my purpose to create a reference collection of kilnsite material, something that had not then been done.

About three houses down on the same side of the road is Imaemon's private museum, with both Arita wares in general and Nabeshima wares on view. Opposite the house is Imaemon's workshop. Built very much on traditional lines, of wood, with long walls of windows at which sit the skilled workers (fig. 4), from potters to decorators who make the high-quality products of the workshop. There is nothing made here that is not of high quality, even the plates and teacups, though of course the grander wares and the exhibition pieces are even finer. Imaemon's decorative style follows, at varying degrees of remoteness, the Nabeshima style of enamelling; one feature of this that distinguishes it from almost all the other products of Arita is the use of the defining outline in underglaze blue. This, the norm for the Nabeshima wares, is almost unknown in Arita in the Edo period. A concession to modern convenience is that the kiln is gas-fired. I once assisted at the unpacking of the kiln after firing; I felt very much in the way—as no doubt I was—for it was all as well choreographed as an energetic ballet performance.

Just beyond Imaemon's museum used to stand the old post office, a battered wooden affair much more attractive than the modern concrete barrack that replaced it. When the old post office was pulled down in 1988, standing as it did on part of the old Akae-machi, the ground was found to consist partly of an old rubbish dump composed of sherds of porcelain from the mid-seventeenth to the late nineteenth century in date, including some press-moulds for figure-models of the late seventeenth and early eighteenth centuries, and, curiously, some kiln furniture, seggars, and small *tochin* stands. As the land is flat there could have been no *noborigama* here, and the presence of kiln furniture is unexpected. It could be that, contrary to previous thinking, kiln furniture may have been used in muffle kilns, the kilns in which enamelled porcelain was refired. It has always been assumed, for no very good reason, that muffle kilns were small and tightly, even carelessly, packed. In fact no remains of any muffle kiln has been identified anywhere in Arita, and none was found on this site, though it seems probable that there were several in the general area. We therefore know neither the size nor the shape of muffle kilns in the Edo period, let alone how they were packed or used. Sherds of figure-models are virtually absent from the

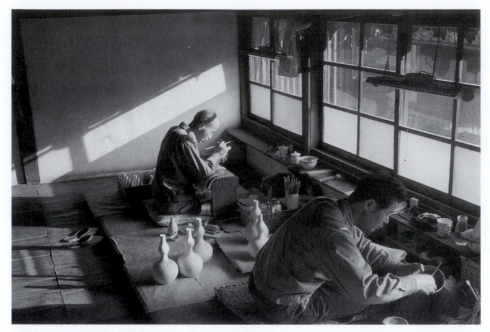

FIGURE 4. Painting in the Imaemon workshop

rubbish dumps of kiln-sites, perhaps unexpectedly, suggesting that they were not made at the workshops of the kilns themselves, but possibly here; here they would, being more precious and delicate than other porcelains, be biscuit-fired. They would then be sent to a *noborigama* to be fired and glazed, and returned to the Akae-machi to be enamelled and fired again in the muffle kiln. Almost no other Arita wares seem to have been biscuit-fired (though this has been argued). Be that as it may, not all of the vast quantity of sherds collected on this site, and now being studied in Arita, were enamelled; some were blue and white, with no need for enamel. So why should they appear here, on the site of an enamelling kiln? Perhaps the area was also a packing or distribution centre.

Almost opposite was an old-fashioned *ryokan*, an inn, where I stayed several times. Always I appeared to be the only guest; I think the owner did not want any guests at all and was only persuaded to take me by Imaemon-san. Now it is closed, as is the commercial Arita Kanko hotel (1993), so one has to go to Takeo or Ureshino or to the new hotel between the two, or to Imari.

On the foot of the valley-side, behind the erstwhile *ryokan*, are the sites of Hiekoba and Tenjinyama kilns. Hiekoba must have been one of the most important of all the Arita kilns; there seems to have been a kiln on the site from early times right on

through until the nineteenth century. It was a major contributor to the export trade and also made fine-quality porcelain for the domestic market; when I first went there, the site had just been bulldozed and was a car-park, shortly to be built over. This is a major loss. Tenjinyama was a kiln of no great significance, indeed it may well have been part of the Hiekoba complex. Soame Jenyns, in his *Japanese Porcelain*, comments on Upper and Lower Hiekoba, following Koyama Fujio, as if there had been two kilns; in fact it is likely that there were a dozen or so, successively, but none have been recorded or found.

On the other side of the road, the south side, is the shrine, the largest in Arita, and beyond that a side road leads off to the Iwayakawachi kiln-site, on top of a small hill. There are strange stories about the supposed connection between Iwayakawachi and the origins of Nabeshima porcelain. Nothing remotely resembling anything found at Okawachi (the Nabeshima site) has been found at Iwayakawachi. If there was a transfer of anything from Iwayakawachi to Okawachi it was more likely a transfer of patronage than of personnel. Further along this side road, passing under the railway bridge and the bypass, one comes to the site of the Sarugawa kiln. Along with Hiekoba, this was one of the earliest, most long-lasting and interesting of kilns; a rescue excavation at the time of the building of the bypass in June

1969 found some kiln structure, and a large rubbish dump. In all probablility more kilns lie under the railway embankment. Sarugawa was one of the first kilns to be excavated, and the excavation was to some extent an experiment. The kiln is most famous for the early finding of export-ware *kraak*-style sherds bearing the VOC insignia of the Dutch East India Company (Vereenigde Oostindische Compagnie) (fig. 5), which have since been found elsewhere, too.

A little further west, not approachable from the high street, on the south side of the bypass, a road leads off to the Junior High School, built in the late 1970s and early 1980s. When the site was first worked to be levelled, a new kiln-site, hitherto unknown to anyone in Arita, was discovered, Chōkichidani. I never had the opportunity to collect sherds from this site, which was clearly an important though not long-lived kiln. Working as it appears to have done from the 1640s to the 1670s, it was active at a very interesting period, spanning the end of the pre-export period and the beginnings of the export trade.

Vast quantities of sherds were collected by the excavators from the rubbish heaps; no kiln structure was found. It gives a saddening view of what must have been lost at, say, Hiekoba, which was in operation from the 1630s until the nineteenth century, and is likely to have been every bit as important as was Chōkichidani in the mid-seventeenth century.

Where the railway crosses the high street at a level crossing, now perhaps some three kilometres from Izumiyama, a road runs west, off the high street, towards the port of Imari, whence Arita porcelain was shipped to Nagasaki and elsewhere; hence the somewhat misleading name, *ko*-Imari, Old Imari. If we fork right again off this, we get into the area I would call north-west Arita; there is a complication here in that West Arita (Nishi Arita) is a different township. The road runs past the kiln-sites of Hokao, to the right, and of Maruo, over much of which is now built a vast porcelain wholesalers' complex. Part of the site is still accessible in a grove of *tsugi* trees and still belongs to the Genemon family whose extensive workshops lie beyond a beautiful garden on the other side of the road. The late Tatebayashi Genemon had a keen interest in early Arita porcelain, and formed an extensive collection. This interest is followed by his sons, who, in 1988 when my wife made her only visit to Arita, accompanied us to the site, where we introduced her to the thrill of

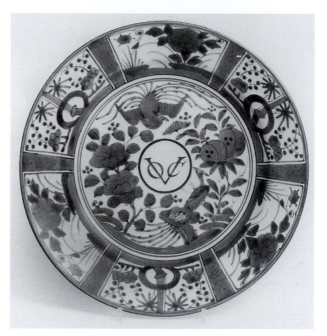

FIGURE 5. Arita dish in *kraak* style with the VOC insignia of the Dutch East India Company, dia. 39.9 cm. Ashmolean Museum, 1976.59, Christie-Miller gift

sherd-hunting at a kiln-site. Maruo was an important early kiln, and it owes its fame to two products in particular; the large celadon dishes made in emulation of the Chinese Zhejiang wares, and large dishes some of which were in the past called *ko*-Kutani (see ch. 7).

The road branches again, on the one hand towards the Hirose kiln complex and beyond that to the important Yamabeta sites, and on the north to Kake no tani and Yagenji. These latter were kilns of limited output, producing few shapes, all of poor quality. This is in marked contrast to Yamabeta, a highly interesting series of kilns, where not only the large early dishes unique to this kiln were made, but also much of the much-disputed *ko*-Kutani porcelain, different from that found at Maruo. In 1973, in May and again in November, excavations at Yamabeta were carried out under the direction of Mikami Tsugio (fig. 6). I was fortunate enough to be able to attend the second excavation at his kind invitation. At Hirose a series of kilns specialized in underglaze copper-red, making mostly the oil bottles called *aburatsubo*, over a period of perhaps less than twenty years, in the 1630s and 1640s (see Plate 9a). Beyond it, and beyond the scope of this book, was the late eighteenth- and early nineteenth-century kiln Hirosemaki which produced the cups for holding

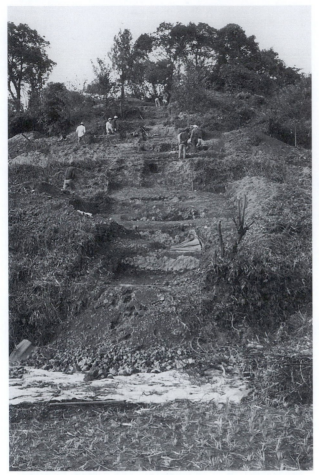

FIGURE 6. Excavation in progress, Yamabeta kiln four, 1973

the sauce for *soba* noodles, *sobachoko*, so much beloved of collectors (including me), and other 'folk' porcelains. In a stream-bed near this site, I was shown the (to me unrecognizable) foundations of an old water-powered balancing hammer for crushing porcelain stone.

If we had taken the first left fork, instead of the right, just before reaching Maruo, we would have taken the road towards Imari, running more or less parallel to the railway. After about a kilometre we would have come to the site of the Komizo kilns. The products of these kilns (there were three on the site) are related to those of the early kilns in the Nangawara valley; geographically we are opposite the end of the Nangawara valley, though we cannot reach it from here. We shall reach it from the high street, about two kilometres beyond the level crossing. If we continued on the Imari road for about a kilometre we would reach a group of kilns in West Arita, that includes one of the first kilns to make

porcelain, Mukae no hara, and, near the railway, the Seiroku no tsuji sites.

Back to the high street where we left it at the level crossing. The valley here widens out and the ground is much flatter. Near the garage on the right, a road leads off left towards Hasami, some twelve kilometres away. Hasami is another porcelain town, almost as big as Arita, where large quantities of perhaps lesser-quality wares are produced today. In the early seventeenth century Hasami had at least one kiln making porcelain (Hata no hara), and by the mid-century at least one more (Mitsunomata) making blue and white, and celadon rather similar to that made at Maruo. This road passes the new (1991) Arita Porcelain Park, a huge commercial and entertainment centre devoted to the promotion of Arita porcelain, which features a full-size replica of one wing of the Zwinger Palace of Dresden (see fig. 20) and a Baroque Garden. Temporary exhibitions, often of famous European collections of Arita porcelain, are sometimes held here.

In about four hundred metres we reach the largest crossroad in Arita; to the north lies the main railway station, West Arita, to the south the road joins the bypass just past the Arita Kanko hotel. Beyond the bypass, crossed at this point by an elaborate pedestrian flyover, up a steep hill stands the new Kyushu Ceramic Museum, which has not only a superb collection of the products of Arita, but also a vast collection of potsherds, the results of local kiln excavations. Through the courtesy of the Director and curators, especially Ohashi Kōji, I have had virtually unlimited access to this amazing reference collection. The museum puts on excellent educative exhibitions, publishes fine catalogues, and sponsors and undertakes excavations.

The immediate area around the crossroad is unlike the rest of Arita, seemingly not part of the porcelain town, but just another village. Some way beyond the crossroad, the ground becomes more open, and there are fewer houses and more small rice fields. After about a kilometre and a half we reach the end of the Nangawara valley, that runs south for about three kilometres. This is broad, mainly agricultural, though there are scattered houses in the fields and, in some places, ribbon development on the road, and it is flanked not by steep but by more rolling hills. The road leads along the left, the eastern side of the valley. Quite soon on the left lies the kiln-site of Kusunokidani, up on the hill, and on the right, across the valley, the site of the

Tenjinmori kilns. These were stoneware kilns that only later made porcelain; their porcelain products were related to those of Komizo (see above) and, curiously, to those of Hyakken in Itanokawachi (see above) and of the distant Kotoge in Uchida Kuromuta. Beyond Tenjinmori, rather in the wilds, is Haraake, a stoneware kiln that was one of the first to make porcelain. Curiously, again, the stoneware of this kiln resembles that of Komizo and Tenjinmori, but the porcelain is definitely earlier. No doubt the potters at Haraake believed that this new-fangled porcelain would be a sound commercial prospect before the potters at Tenjinmori and Komizo did.

On the left, where there are more houses, we pass the workshop of Inoue Manji, on the way to the Kakiemon workshops. Beyond, the road leads to the Higuchi kiln-site, and to the late seventeenth-century Mukurodani site. Inoue is a specialist in white wares, and in celadon, often beautifully incised, and in a lovely combination of the two. When I worked at the Kakiemon workshops, I used sometimes to go and visit Inoue-san; talking was made easier by the presence of an American potter, Charles Steele.

The Kakiemon workshops lie under the eastern hills of the valley, which here rise quite steeply and are wooded. Above the workshops, among the trees of a small *tsugi* plantation lies the old kiln-site, with its rubbish dump beside it in a small ravine. The public part of the present-day workshop has been much enlarged since I first worked there, to accommodate the tourist busloads that visit this famous kiln. There is a small pond with those shining metallic-coloured carp that are so highly prized in Japan; one can see why. The old house is on the left of the entrance, with a very old *kaki* (persimmon) tree beside it (fig. 7); a clear visual pun. Directly opposite was a museum, and on the right the showrooms; now some of the old collection is shown in the modern showroom. Behind on the right are the workshops and the kiln. I stayed there a month, living in a lovely room directly behind the late Kakiemon XIII's studio. He was very active then, and often I could see the sketches that he painted from nature that could be worked up for the designs on his exhibition pieces (fig. 8), on the fine white body that has been a specialization of the family since the seventeenth century. This milky-white (*nigoshide*) body was developed in the third quarter of the seventeenth century and used for the finest export wares, never in combination with underglaze blue, for about half

FIGURE 7. The Kakiemon workshop

a century. It was not made during the period covered in this book. At the Kakiemon kiln-site, sherds of *nigoshide* are found along with the much more plentiful blue and white; the enamelled *nigoshide* wares, the '*première qualité coloriée du Japon*' of the eighteenth-century French catalogues, were clearly very expensive even then. The kiln also made blue and white porcelain that was to bear enamel, but such pieces are never made of the *nigoshide* body. Similarly, today the kiln makes wares of different quality for different markets and price-ranges, just as we have seen with the Imaemon workshop.

The actual workshops are scattered around several courtyards, with the throwing, turning, and casting workrooms separate from the decorating shops. Outside stand racks of the long planks that bear the drying pots. Inside, the processes of manufacture are a logical mixture of the machine-made and hand-finishing. Most plates, for instance, are made by slapping a disc of clay face down onto a plaster mould and turning it, by hand, with the use of a jigger, a preformed cutting device. Plaster, being

FIGURE 8. Dish and sketch, Kakiemon XIII's private workshop

absorbent, dries the clay adhering to it; in the Edo period, such press-moulds would have been made of wood, for plaster was only introduced into Japan after the Worlds' Columbian Exposition in Chicago in 1893. Some press-moulds in the Kakiemon collection may be among the earliest to survive, though their age is uncertain. Today, piece-moulds are also used (they were not used in the Edo period), especially for complex shapes such as the spouts of ewers. In use, the parts of a piece-mould are assembled like a three-dimensional jigsaw puzzle, and held together by clips or straps; liquid clay is poured into the hollow interior and swirled around by the craftsman so that each part of the wall of the mould is in contact with the liquid clay. It is very much part of the skill of the craftsman to do this for exactly the right length of time, so that exactly the right thickness of the clay has been dried by contact with the absorbent plaster walls, before the excess is poured out. The still-assembled mould is then carried out of doors and left to dry until the thin wall of clay within is dry enough and therefore strong enough to support itself, when the mould will be disassembled. Clay treated like this has a total shrinkage of about 12 to 14 per cent, some of it at this stage, so it is important not to leave the pot in the mould too long. I have described piece-moulding here, and not in Chapter 3 where I discuss other technical aspects of the making of porcelain, as it was not a technique used in the early

seventeenth century and is therefore relevant only to this part of the book.

The decorating workrooms are in two parts. In the one, the biscuit-fired blanks (undecorated pots) are painted with cobalt oxide, which will fire, under the right conditions, to underglaze blue, making the classic blue and white (fig. 9). Some of these are to remain as blue and white, and will have had the entire decoration they will get, others will look only partly decorated as they have spaces left to receive the enamels that will complete the design that will be put on, after firing, in the next workroom. The biscuit body is very absorbent and it is thus difficult to apply the cobalt oxide, which is in the form of a powder suspended in water, and it allows of no mistakes. I used to sit beside one of the charming elderly ladies who did this work, trying to imitate her, usually unsuccessfully. One of them—the writer of the Kakiemon signature—used to rap me over the knuckles with a ruler or some such thing when I had been more than usually clumsy. Apropos the signature: I once asked Kakiemon XIII why he did not sign the exhibition pieces; he assured me there was no need.

Into the other workroom come the pots after their high-temperature firing in the *noborigama*. Here the overglaze colours are painted onto the glazed surface (fig. 10). The overglaze colours, which are actually lead glazes, before their low-temperature firing

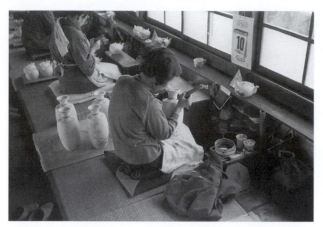

FIGURE 9. Painting in underglaze blue, Imaemon workshop

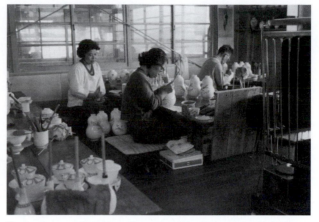

FIGURE 10. Painting in overglaze enamel, Kakiemon workshop

in the muffle kiln, do not always resemble the fired result, and thus the painted but unfired pots look strange to the uninitiated.

The Kakiemon kiln is a wood-fired three-chambered *noborigama* (see Plate 2*b*). Not far from it are piled the vast stacks of the bundles of wood that are consumed in each firing (fig. 32). I have described in Chapter 3 the process of the firing of a *noborigama*. Suffice it to say here that when the kiln has been packed (and each chamber holds many hundreds of pots) the kiln is fired sequentially from the bottom, chamber by chamber. The Kakiemon kiln-master judges the temperature of the incandescent pots by eye, looking through the bung-hole in the almost sealed door of each chamber, but there is also a thermocouple in each. When each chamber has reached the required temperature (1,280°C) and held it for the required time, the doors are sealed to prevent the entry of any oxygen, and the kiln left to cool for about four days. Unpacking a kiln is always thrilling; as the seggars are opened, the pots have to be examined. Great imperfections are immediately visible and the offending pot immediately smashed (fig. 11); smaller imperfections may only be detected at a second more careful inspection, when the feet are ground clear of any adhering sand. At the workshops which pride themselves on their quality, these, too, will be smashed. At other kilns some of these may be kept as seconds which may be sold off cheap at the great annual ceramic fair in the spring. Occasionally kiln accidents may be very beautiful, even if valueless commercially. Once, on unpacking the Kakiemon kiln, a broad flat seggar was opened in which had been carefully placed four teacups with handles and four sake cups. The floor of the seggar,

presumably somewhat overheated, had sagged slightly so that all eight pieces had dipped towards the centre, just touching, so that they were neatly and symmetrically fused together. I managed to grab this just in time to save it from being smashed on the floor.

My first visit to Arita was in 1970, in company with Igaki Haruo, who was then working for Mayuyama Junkichi in Tokyo, and who was to become a life-long friend. He took me to my first kiln-site; the excitement of visiting kiln-sites has never left me (fig. 12). We first went to see the recently excavated Tengudani, to see the remains of an actual kiln, and then went to Yamagoya; this was an inspired choice, for the kiln was not then well known as the innovative kiln that it undoubtedly was. Picking up sherds there of things such as I had never seen before was more than exciting (fig. 13).

My visit had been arranged through the kindness of Nagatake Takeshi, who was then Curator not only of the small Arita Ceramic Museum (see above), but also of the new ceramic museum in Saga, before the days of the Kyushu Ceramic Museum. I was to stay three months. Nagatake-san had organized it so that I should stay at the houses of three potters. He well understood that I would be trying not only to learn about the Arita sites, but also to study methods of production used today, hoping thereby to get some insight into methods in use in the seventeenth century. Visits to the actual kiln-sites, and some forty-odd were involved in the seventeenth century, would enable me to collect sherds as systematically as possible, in order to form a reference collection (rather than simply a collection of pretty sherds).

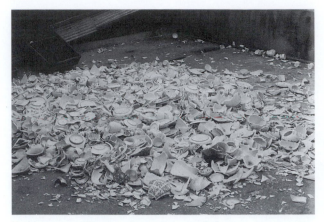

FIGURE 11. Wasters, Imaemon workshop

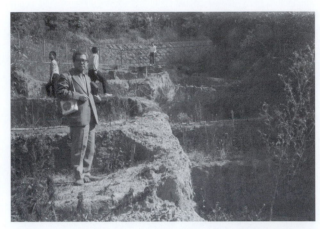

FIGURE 12. Igaki Haruo at the Tengudani kiln-site, 1970

My first stay was with Marota Masami, a stone-ware potter who had worked with Hamada Shoji, and who was, when I stayed with him, experimenting with salt-glaze. His workshop and house were fine old buildings at Kuromuta, north off the Takeo road, about twelve kilometres from Arita. He had formed a collection mostly of Takeo-Karatsu stoneware and of the peculiar type of primitive-looking grey porcelain found also at the stoneware kilns of Takeo and Ureshino. I was to find that almost all the potters I met took a keen interest in the local kilns and formed collections of sherds; but none made imitations, at least not until a few began to in the 1980s. Marota-san threw on a Kyushu kick-wheel, which he spun clockwise using his left foot (see ch. 3). Both he and his assistant could throw sixty-odd pieces an hour each. He had a three-chamber *noborigama*, wood-fired. I have worked at the firing of many kilns now, but never with a *noborigama* of more than three chambers; I think it is the minimum effective size, but also the maximum size for one workshop. If the kiln was too big, there would be a long time-lapse between firings, with consequent problems in cash flow. It was at Marota's house that I first got the smell of a proper working pottery; I had made pots myself at school, under the tuition of a good potter called Llewellyn Menzies-Jones, and though I was a very bad potter, it was then that my interest was aroused.

After about a month I moved further south, still outside Arita, to stay with Eguchi Katsumi, Nagatake-san's son-in-law, who lived on the old Karatsu kiln-site of Oyamaji, possibly the site furthest from Karatsu itself that specialized in *e*-Karatsu, painted Karatsu. This was off the road between Takeo and Ureshino. Eguchi was then also making stoneware,

FIGURE 13. The author at Yamagoya kiln-site, 1970

but as he had been trained as a porcelain maker, he threw the stoneware body as if it were porcelain; this was in strong contrast to Marota's tough and chunky throwing—quite a different style. Much of Marota's decorative effects had come through coloured glaze painting; Eguchi was making *e*-Karatsu (he could scarcely avoid it, living where he did) with good brush-painting, and was then experimenting with the sponge decoration that he was to use so effectively later. It was there that I learned how difficult it is to paint with a brush on the absorbent ceramic body. I have never tried sponge decoration.

Again, after about a month I moved. This time it was to the Kakiemon workshop in the Nangawara valley; from a workshop where the master had one apprentice or assistant, I was in a small factory, where everything was done by hand, but by a division of labour. I do not know how many persons were employed by Kakiemon in the making and decorating workshops, perhaps thirty or forty, but there

were also others for the innumerable other jobs, from the workers in the shop to the highly skilled kiln-master. It was a highly efficient self-contained enterprise; I imagine it was little different in the seventeenth century.

On subsequent visits I was usually dependent upon the hospitality of Imaemon-san, whom I had met through my friendship with Imaemon XII's brother, the scholar-collector Imaizumi Motosuke and his son Yoshihiro, who was later to work with me in Oxford. Imaemon XIII, who was then (1970) Imaizumi Yoshinori, used to come collecting with me occasionally, and allowed me the freedom of his workshops and of such vital extras as the use of his packing-room, from whence crates of sherds were sent back to Oxford. I owe a deep debt of gratitude to all the Imaizumi family, not only for their warm-hearted friendship.

There is something curiously satisfying about collecting sherds from kiln-sites. It is not that it is something for nothing, though that is a pleasure in itself, actually finding something interesting for oneself. There is much more to it; by analysis of the findings at a site, one learns what was made there. As one grows more experienced, one can determine the approximate date of these findings, and later still can fit them into an evolutionary pattern; that is mostly what this book is about. One also learns what was not made at the site, what is conspicuous by its absence. This, however, is dangerous, for a later collector may find what you failed to find. All this collecting is surface-finding; one does not dig. Actually generations of treasure-seekers have dug, randomly and unauthorizedly, and thereby severely damaged the possibility of scientific examination of most of the sites by proper archaeological excavation. But I was a good boy and did not dig. In truth, there is no need, for I was trying to collect an example of every type made at the site, rather than looking for pieces as undamaged as possible or for particularly attractively decorated pieces. I wanted to know what the production of the kiln was; of course, I tried to find the best examples, it would have been idiotic not to have done so, but it was more for the knowledge of the kiln itself than of the pots that I was working.

Most of the sites are well known, and it is simply a matter of getting there; this is specially true of the most famous ones. Some, particularly Hyakken and Tengudani, were so famous that there was a tendency to attribute to one or the other any sherd with no provenance that was at all unusual. As many collectors did not bother effectively to mark their sherds, this could cause the spread of misinformation. Other sites are more difficult to find, far from roads, on overgrown hillsides; I found that I could usually find them using the plants that grew on them as the first indication, for, of course, the soil was burned underneath. Sometimes sites have been lost (e.g. Hiekoba and Odaru, both built over) and sometimes they are farmed. At Sarugawa and Shimoshirakawa and some other sites I was either given sherds by the farmer, who was often surprised and sometimes pleased by the odd spectacle of a scruffy-looking foreigner rootling around in his fields, or I would find them on the banks of the field, cast aside as if they were in the way of the plough. The Kakiemon kiln-site was (then) in woodland, but the *monohara*, the rubbish dump, was in a sort of ravine, and it would be easy to have fallen down in an avalanche of old seggars and sherds. Some of the rubbish dumps were very large, for in the early periods the wastage rates must have been very high; the largest dump I found was at one of the stoneware kilns near Ureshino, where it must have covered the area of more than two tennis courts to the height of a bungalow. It has sometimes been thought, even by archaeologists, that the rubbish dumps were susceptible to stratigraphic excavation; I think this very dangerous, for by the very nature of the kiln-site, unavoidably on a slope of 10–15°, the kiln-damaged pots that were thrown away would have simply rolled down the hill until they stopped, randomly. Some sense of stratigraphy, only in the broadest outline, may be picked up from such evidence.

When sherds have been collected, they have to be washed and sorted. If I found that I had collected too many of one type at a site, and did not wish to send so many back to England, I would take them back to the find-site and dump them there. The washed sherds have to be marked, indelibly, so that there could be no confusion between sites. I found it best to give an arbitrary number to each kiln and to mark each sherd with this number in Indian ink on an unglazed surface. Later, in England, each sherd was laboriously given an individual museum number. Now it is not allowed to remove sherds from kiln-sites; I had had permission.

In November 1973 I was able to attend the excavation of one of the Yamabeta kilns, at the invitation of Mikami Tsugio and his team from Aoyama Gakuin. We were digging Yamabeta Four, a stone-

ware kiln, from my point of view the least exciting of this important kiln complex, but nevertheless a most interesting exercise. Since then many more kilns have been excavated and others not then known have been found, and some of them excavated too. The most interesting and important of these latter is probably Chōkichidani, south of central Arita (see above), discovered when work began on a new Junior High School; the site had been apparently unknown even to such knowledgeable local connoisseurs as Nagatake Takeshi and Ikeda Chuichi.

In fact, new kiln-sites are discovered, or at least examined, almost every year. At each visit to Arita I am shown new discoveries; recently these have been the sherds from Yamabeta and from Maruo that demonstrate so clearly the Arita ancestry of the ko-Kutani wares. Though I had been aware of some of these for years, the finds at these sites now confirm

this for almost all types of ko-Kutani (see ch. 7). Much investigated at the moment (1994) is the relationship between some types of shoki-Imari small dishes, often of irregular shape, the so-called Matsugatani wares and the origins of the Nabeshima style. Among the kilns investigated anew are Hokao and Kusunokidani. If I were to attempt to describe the complete production of the Arita kilns for only this, the first forty-odd years of the industry, I would never have finished this book, for the research continues.

The porcelain from Arita inevitably varies from the beautiful to the banal. This book is not a celebration of the great masterpieces of the age, though some are illustrated, but more an attempt to put those masterpieces into context by discussing the origins, the sites of production of this fascinating porcelain.

PART I

The Ceramic Background

1

HISTORY OF CERAMICS IN JAPAN

THE ceramics of the early Edo period (1600–1868) depend immediately upon tastes favoured in the Muromachi period and developed in the Momoyama period and upon a large injection of outside influences, mainly Chinese and Korean. But they also depend upon technological advances made in the Momoyama period and at the beginning of the Edo period. The technology is mostly that of improved design of the actual kilns, and the taste, of course, is that of the tea-masters. That the Edo period saw such a flowering of the ceramic industry, and such a wealth of innovation and skill on the part of potters and their patrons must be partly due to the very adaptability taught by the tea-masters who, by the Edo period, were as much dealers in tea utensils as teachers. These tea-masters were quick to see the possibilities of the new techniques, and quick to adopt new styles and designs from outside Japan. This continued even after the final closure of the country to all except a very limited trade with the outside world in 1639.

In the fifth century, high-fired Sue ware techniques were introduced into Japan from Korea. Although low-fired pottery has never ceased to be made in Japan, it was in high-fired stonewares, all ultimately depending upon Sue technology, that the craftsmen of the country were to excel. Sue wares were made until the twelfth century in the more provincial areas, but in central Japan, in particular near Sanage in the Tokai district, around modern Nagoya, the Sue wares were, by the ninth century, being edged out of production by better products. These, the Shiki wares, were of finer, whiter clay than were the very dark-bodied Sue wares, and were ash glazed. Originally made by the same techniques as the Sue, modifications of the simple *anagama* kiln enabled a closer control of the course of firing to be kept, and allowed better possibilities for raising the oxygen content of the kiln. The heavy reduction of the Sue wares was

changed into a partial oxidation, allowing a relatively pale iron-green ash glaze to be made. This was desirable as the intention was to compete with imported Chinese green-wares. This modification can be used to classify the two strains of high-fired wares made thereafter in Japan. The Sue-related wares retained the heavy reduction that gave the grey body characteristic of Suzu wares and of the early period of Bizen and possibly of Tokoname. The Shiki-related wares, which were partly oxidized, usually had a reddish surface on a pale body.

By the twelfth century ceramic production in Japan was becoming more industrialized; this is demonstrated by the fact that there is a gradual change (which actually begins in the eleventh century) from production of a wide range of vessels and utensils to a very restricted one, often of three shapes only. These were the *tsubo* or narrow-necked jar, the *kame* or wide-necked jar, and the *suribachi* or mortar. In the Tokai district some Shiki-related kilns made these three types, others made *yamachawan*, the simple unglazed food bowls that were in widespread production by the thirteenth century, while a few other kilns produced high-quality wares. The very restriction of range of product was caused by a vastly increased demand. During the twelfth and thirteenth centuries new levels of rice production caused an unprecedented rise in the farming population and a consequent high demand for utilitarian wares. Inevitably this brought with it a lowering of standards and this is now normally considered to mark the beginning of the medieval period of Japanese ceramics.

It used to be thought that medieval Japanese ceramics were made at six major sites of production, the famous 'six old kilns'. This has now, by the researches of Narasaki Shoichi and his followers, been shown to be a great over-simplification; now more than forty ceramic areas are recognized.

The decline of the true Shiki wares in the eleventh

century heralded the rise of the Shiki-related wares. (The main difference between these two was that the Shiki wares continued to be made in the simple *anagama* kiln, while the Shiki-related wares were made in a modified and more efficient *anagama* kiln which had a 'flame-dividing' pillar above the fire-box (fig. 14).) From the Kamakura period (1185–1392) all Tokai area kilns were Shiki-related, in other areas some kilns were Shiki and others Shiki-related. Of the Shiki-related areas, the most important for the long-term development of the history of ceramics in Japan was Seto. In the short term, Toko-name was to have a great influence on the medieval wares of Echizen and Shigaraki.

The earliest Seto pieces were ash glazed and were often made to imitate imported Chinese Song porcelains as far as their limited technology permitted. Unlike the Shiki wares, larger pieces were usually coil-built, not thrown on the wheel. In spite of this seemingly retrograde step, the Seto pieces were well made, and by the end of the thirteenth century were often decorated with stamped or incised designs. During the fourteenth and early fifteenth centuries Seto made the only glazed ware in Japan. In the fourteenth century the quality of the Seto wares again increased; the addition of feldspar to the ash glaze improved its colour, and the range of shapes was greatly expanded. As before, these shapes reflected imported Chinese porcelain, both celadon and white wares. *Temmoku* was successfully imitated by the end of the fourteenth century.

In contrast to the conditions in Seto, other nearby ceramic areas were not flourishing at this time and many had declined sharply. The most important areas of production at this time were Echizen, Tokoname, Shigaraki, Tamba, Bizen, and the Seto/Mino complex.

By the mid-fifteenth century Seto also went into a rapid decline, due to civil wars. The market moved to Mino which enjoyed the burst of prosperity that was to produce the great range of innovative ceramics of the late Momoyama and early Edo periods. The rise of Mino can be ascribed in part to the introduction of Seto technology. At the beginning of the sixteenth century, this included the *ōgama* kiln (fig. 15), whose introduction into Seto and Mino heralds the period usually known in Japan as the *kinsei* (pre-modern) period of ceramic production. Elsewhere in Japan this is only identifiable by the increase in shapes and in experimentation with glaze colours and glazes.

The *ōgama* was mainly above ground (in contrast to the *anagama*) and had various improvements, such as side doors for stacking the kiln, the step, and the barred wall above the fire-box that helped to produce a partial down-draught. This in turn produced a much more even distribution of heat within the kiln chamber, with consequent greater control over what actually happened during the firing process.

These early *ōgama* were not as efficient as they were to become in the second half of the sixteenth century, the Momoyama period (1573–1615) when they were to produce the famous tea ceremony wares that characterize Momoyama taste, the glazed wares of the Mino area. So highly praised have been the Momoyama tea wares of Mino, that it is salutary to remember that few Mino kilns actually made them. This tea ware represented only a small proportion of the production of some few Mino kilns; only a few Mino kilns, notably the Edo period *noborigama* Motoyashiki (see fig. 16), specialized in tea wares.

In the Ashikaga period (1392–1573) the tea ceremony arose as a withdrawal from the world into a simple ritual, the making and drinking of tea. Gradually this became more ritualized and codified. It became an occasion for the appreciation of aesthetic objects and a chance to handle and use prized possessions. At first only Chinese wares were used, but under the teaching of Murata Shuko (c.1421–1502) some Korean and Japanese objects were found to be of sufficient merit for their use for tea. Just as the taste for Chinese objects veered from the finest *kinuta* celadons towards the more lowly *temmoku* and to Korean *Korai-chawan*, so taste now demanded the simple, the simplified, and even the aggressively rustic. The very inclusion of Japanese ceramics into the tea ceremony increased the demand dramatically, for the taste for tea and its aesthetics was thus thrown open for the first time to those with no inherited Chinese treasures, but who were able to use their own judgement to choose Japanese wares. Very often this judgement was shaped, influenced, or taught by professional tea-masters, who became not just arbiters of taste, but dealers and entrepreneurs. It was an easy step from the finding of good Japanese wares to the ordering of tea utensils from a particular kiln.

By the 1580s the Ash Shino, the Yellow Seto, and the characteristic squat misshapenly cylindrical Black Seto tea bowls had appeared. In spite of some of their names, they are, of course, products of Mino. It is difficult to see how startling these must have been. The most dramatically different was the Black Seto. This introduced a new colour, a lustrous black,

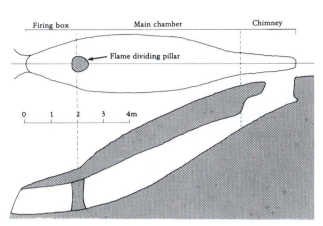

FIGURE 14. Diagram of *anagama*, from Faulkner and Impey, *Shino and Oribe Kiln-Sites* (London, 1981)

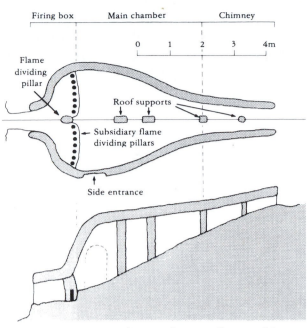

FIGURE 15. Diagram of *ōgama* from Faulkner and Impey, *Shino and Oribe Kiln-Sites* (London, 1981)

FIGURE 16. Diagram of *noborigama*; A, flues into adjacent uphill chamber; B, stacking floor; C, firing floor; D, door; E, stoke-hole. Drawing by Edward Impey

produced by their bodily removal from the kiln with iron tongs so that they would cool rapidly, a new shape, apparently without ancestry or prototype, and they were not even round; the tongs had seen to that. This heavy irregularity made them much prized, for they felt interesting when held in the cupped hands at the tea ceremony. The misshaping of tea bowls was exaggerated in the Momoyama period in the search for powerful simplicity. The black tea bowls became lower and wider, often in the so-called 'shoe' shape, and were sometimes decorated with simple irregular patterns on areas of white slip; this style is called Oribe-black.

The wares that had originally been 'recognized' as tea ceremony wares were the unglazed wares of Shigaraki, Iga, and Bizen. In these, it was the coarse, rough surface, partially or completely reddened by the chance effects of oxidization, and often showing coarse granules of quartz or other impurities of the clay body, that was admired. The simple shapes of these wares, not always unsophisticated, for Shigaraki jars had long been used for the storage of expensive leaf tea, were soon to be misshapen and twisted, cut with a knife or warped out of true in accordance with the new taste for irregularity.

These effects, so obvious in many high-fired wares and so exaggerated in the Iga wares, were also to generate a new type of low-fired ware, Raku. Raku wares, invented by the potter Chojiro (1516–c.1592) in Kyoto, and were so simple to make in the very low-firing kiln, that amateurs could easily achieve satisfying results. The relationship between Black Seto and early Raku is not clear, but they were remarkably similar, and in the hands of the successive generations of the Raku family after Chojiro, and in the hands of tea-masters and of creative men like Koetsu (1558–1637), Raku achieved its own distinction and identity.

Mino wares were to become increasingly striking during the late Momoyama and early Edo periods. The Ash Shino wares, at first possibly an attempt to imitate white porcelain (and even blue and white porcelain) had quickly been seen to be attractive in their own right; the most famous pieces that may belong somewhere in this story are the three white *temmoku* tea bowls that belonged to the tea-master Takeno Joo (d. 1555). Ash Shino gave rise to the true Shino wares, and later to the green-glazed Ofuke wares.

The Shino wares comprised not only wares for the tea ceremony, but also innumerable other shapes that reflect tea taste in their decoration. This extension of tea taste into ordinary ceramics was to become even more widespread and important in the Edo period. Shino wares are covered in a thick bubbly feldspathic glaze, greyish white in colour and frequently with patches of oxidized red. Under this almost, but not quite, opaque glaze iron-oxide pigments were used for underglaze decoration, the first successful underglaze metal-oxide painting of Japan. This was perhaps an attempt to emulate Chinese blue and white. Tea bowls in strong cylindrical shapes that parallel the Black Seto bowls were among the most beautiful of these Shino wares. Often the simple iron painting shows brilliantly where it burns through the glaze in a 'heaped and piled' effect. Other varieties include the Grey Shino, where a dark glaze may be scratched away to reveal the white body underneath, and white slip may be added on top.

The iron-glazed Yellow Seto possibly began before the Shino wares; at first rather simple, these soon became the most obviously sophisticated of the products of the *ōgama*. Carefully potted and finely finished, they did not suffer the same purposeful misshaping of the Black Seto and Shino wares. Almost all Yellow Seto wares were made for the tea ceremony; not for the tea ceremony proper, but for the *kaiseki* meal which accompanied a formal tea ceremony, or for minor appurtenances of tea. Yellow Seto seems rarely to have been used for tea bowls. The decoration of Yellow Seto may be simple and incised or moulded floral or geometric patterns heightened by a splash of underglaze iron-brown or copper-green. The use of copper-green was to become important in the Edo period Oribe wares, also from Mino.

The Oribe wares, with their contrasting areas of iron painting under a clear glaze and of dark green copper glaze, are often considered to be typical of the Momoyama period. In fact, they did not appear until perhaps 1610, and then were made possible by yet another advance in kiln technology. This time, it was a new type of kiln altogether, which was introduced to Japan from Korea.

In 1592 and again in 1597 Toyotomi Hideyoshi invaded Korea. After initial successes both invasions failed, and in both cases the Japanese withdrew, bringing with them, either as captives or as immigrants, many Koreans, some of whom were potters. Many of these potters settled in Kyushu, near to the port used for the invasions, and there at Karatsu they revived an existing stoneware tradition. With

them, the Koreans brought the skill to make the *noborigama*, the stepped chambered kiln (see fig. 16). The control of firing, the evenness of temperature gradients within the chambers, and the overall accuracy made possible by this semi-down-draught kiln was such that it is still widely used today.

The Karatsu wares are of coarse-bodied brown stoneware, usually in simple shapes for simple purposes; tea wares are relatively uncommon. The most beautiful variety is the painted Karatsu, *e*-Karatsu, where underglaze iron painting is used with spontaneity and fluency to produce simple flower or bird patterns, often of striking aspect. These were to have a strong effect upon the Oribe wares and the later Shino wares of Mino in the seventeenth century, when there was interchange not only of technical knowledge, but also of personnel between the two distant areas. Other types of Karatsu were the Korean Karatsu, where thick bubbly glazes overrun a plain black glaze, and the varieties of Takeo-Karatsu that we shall meet later.

At least three other pottery areas in Kyushu were founded (or revived) by immigrant Korean potters; these were Satsuma, later to be famed for its brocaded ware, Takatori, and Agano.

In Mino the new *noborigama* kilns continued to make some of the wares that had been made in the *ōgama* kilns; at Motoyashiki, the first and most famous of these kilns, both Black Seto and Black Oribe were made, and the new Oribe, as well as a range of more humble wares such as the caramel-glazed and *temmoku* pieces. It is uncertain whether or not Yellow Seto was made at Motoyashiki.

With the exception of the Oribe pieces, Edo wares, including the later Shino (called Shino-Oribe), the Karatsu, Satsuma, Agano (and its follower Yatsushiro), and the Takatori wares made little use of the violent misshaping of the Momoyama period. Indeed throughout the Edo period there seems to have been a search for perfection of shape; often this was a simple shape, but it was nevertheless an emphasis on controlled shaping as opposed to a partly chance effect.

Discussion of the Momoyama and early Edo wares has concentrated on the better-quality, more innovative, and consciously fine wares. Obviously these were for a market closely associated with the taste for tea. But throughout this time, as at all times, an undercurrent of cheaper and more ordinary wares were being made. At the bottom are the rustic—the genuinely rustic—earthenwares; a little higher up are the utilitarian stonewares of Shigaraki, Karatsu, Bizen, Tamba, Echizen, Tokoname, and Mino. It should be remembered that the greatest proportion of ceramics made in all these areas was of the cheaper and coarser types, more often than not undecorated.

After a burst of activity in the early years of the Edo, the two greatest ceramic areas of the time began to decline. Mino lost much of its market to Seto, which correspondingly enlarged again, while Karatsu turned its attention to an industry that it had itself begotten, the porcelain industry of Arita.

Notes

For general works, see the compilations: *Sekai tōji zenshū, Nihon tōji zenshū, Tōji taikei.* For individual areas, see: Johanna Becker, *Karatsu Ware: A Tradition of Diversity* (Tokyo, 1986); Louise Cort, *Shigaraki: Potters' Valley* (Tokyo, 1979); Rupert Faulkner, 'Seto and Mino: An Archaeological Survey of the Japanese Mediaeval Glaze Ware Tradition and its Early Modern Transformation', unpub. doctoral diss. (Oxford University, 1987); Rupert Faulkner and Oliver Impey, *Shino and Oribe Kiln-Sites* (London, 1981); Narasaki Shōichi (ed.), *Mino no koto* (Kyoto, 1976).

2

IMPORTS OF CHINESE PORCELAIN BEFORE THE SEVENTEENTH CENTURY

IT is well known that Tang three-colour wares were imported into Japan in the Nara period, and imitated in Japan.[1] There are examples in the Shōsōin treasure house in Tōdai-ji in Nara. Such lead-glazed earthenwares were to have some considerable effect on the ceramics of Japan in the Heian period. In the ninth century Chinese porcelain was imported, both green-ware and white-ware, and by the twelfth century there is evidence of the manufacture in China of porcelain specifically for Japanese use, and to Japanese order. These pieces are cylindrical sutra-cases, found either as celadon or as *yingqing*.[2] This is a shape unknown in Chinese archaeology, but well represented in Japanese burials and in the foundations of pagodas. Such ordered pieces are, of course, exceptional and by far the greater proportion of the considerable amount of Chinese porcelain imported into Japan at this time was run-of-the-mill export porcelain with no particular conformity to special Japanese taste.

The beginnings of the importation of Chinese porcelain into Japan lay in the hands of Japanese monks who visited China; they nearly all went to the area around Hangzhou, and thus they found the wares of Zhejiang, but not the more northern wares of Ding or Quan. Nor did they go as far south as Fujien, but collected the brown- and black-glazed stonewares from around the Tianmu monastic complex—hence the Japanese name, *temmoku*. The more exotic of these wares, those with 'hare's fur', 'oil-spot', or *yōhen* (irridescent) glazes, were to become much prized as the taste for the best examples of simple wares developed in the Muromachi period. On the whole, the porcelains imported into Japan were not of the best quality, for when the real commercial-quantity trade commenced, cheaper versions of well-known types were made for the Japanese market.

This was to be the pattern for some centuries to come. Among handed-down (*densei*) pieces, few are of the highest standard. The Sinan wreck, now securely datable to about 1320,[3] contained many porcelains of *kinuta* type certainly for the Japanese market. They are of lesser quality and of later date than the most famous pieces. And they were of standard Chinese shapes. That the quantity of this trade was very considerable has been shown by the excavations at the Daizai-fu site near Fukuoka[4] and by findings at Kamakura.

Imported porcelain was, presumably, expensive, and Japanese potters imitated it to the best of their ability in the different medium of stoneware. The most famous example of this must be the Kamakura Seto imitations of *yingqing* and of celadon.

Whether the Sinan ship carried no blue and white because no blue and white had yet been made, or merely because the ship was on the way to countries where no market for blue and white had yet been established is a matter of controversy. This is likely to remain the case, for it is very unlikely that an exact date will ever be established for the origin of blue and white. But clearly the ship was on its way to Japan (for it carried goods typically for the Japanese market), though not necessarily directly, when it sank. It may thus be that no demand for blue and white had begun in Japan, rather than that it did not exist, though it must be admitted that this is very unlikely.

In fact, blue and white of both the Yuan and Ming dynasties seems never to have been in much demand in Japan; it had, after all, really been created for a westward-looking market. As far as I am aware, no *densei* piece of Yuan or early Ming blue and white that has a secure provenance in Japan has yet been described. At consumer sites, Yuan blue and white

sherds are more commonly found on Okinawa (then the separate Kingdom of Ryukyu) than upon the other islands. The list of individual sites where Yuan blue and white or underglaze red sherds have been found, given by Kamei in 1983[5], includes three castle sites on Okinawa, and six castle sites, two palace sites, two temple sites, and five other sites including the sea-shore at Kamakura, on Honshu. Even middle Ming period sherds are uncommon; of the comparatively few consumer sites where mid-Ming blue and white occurs the most important seems to be the Asakura site in Fukui. Some of the sherds found there are very remarkable, for they bear an inscription in Japanese, including a Japanese reign-date *Tenmon nen zō*, which means 'made in the Tenmon period'.[6] This period covers the years 1532–55, the equivalent of the years Jiajing 11–32. This is evidence that even if Chinese blue and white was not in wide demand, at least it was known, and its place of origin well enough known for it to be possible for it to be ordered as required.

Evidence of the lack of interest in Chinese blue and white of the Japanese is also provided by other negative evidence; the only attempt at its imitation in Japan before the end of the sixteenth century seems to have been that of the Shino wares of Mino, and that was a somewhat remote attempt, more a pastiche than a copy.[7] If it had been highly prized or even expensive, it would surely have been copied. Even at the end of the sixteenth century, sherds are reported from remarkably few consumer sites in Japan. Among the sites that have them are those in Yamanishi, Fukui, Shimane, and Wakayama prefectures.

By the beginning of the seventeenth century the situation had changed; we now have documentary evidence of the demand for blue and white porcelain in high places. This is in the form of an important document 'The Inventory of Objects and Utensils in the Possession [of Tokugawa Ieyasu] at Sumpu' taken on the seventeenth day of the fourth month on Genna 2, that is spring 1616. This is nothing less than the probate inventory of the first Tokugawa Shogun.[8]

In this inventory, section ten of which is reprinted in full in Chapter 11, as we shall see, there is listed a great quantity of *sometsuke*, blue and white porcelain. This is listed simply as that, *sometsuke*. What we do not know is whether, to the compiler, this was self-evidently Chinese or self-evidently Japanese. Nowhere does the compiler give us a clue; whereas Chinese silk is described as being Chinese, the *sometsuke* is not qualified. There are also numerous

celadons in the lists, some of which are unqualified, others of which are called *Kuan*, Chinese, or *Korai*, Korean. As we believe the origin of the porcelain industry of Arita to lie somewhere around 1620, we cannot be absolutely certain that these are not Japanese. It is, however, almost inconceivable that anything made in Arita in the early stages of production could be sophisticated enough for use by the Shogun, particularly when much of it is listed under the rubric 'utensils used when entertaining'. I think we are more than justified in eliminating the notion that any of this porcelain was Japanese, and in using the inventory chiefly as evidence for the demand for Chinese blue and white in Daimyō circles.

Whereas the celadons are listed in the inventory in groups of four, five, seven, nine, or thirteen similar, the *sometsuke* pieces are much more numerous. Listed under 'Inventory of utensils used when entertaining' are, for instance:

Blue and white tea bowls; 1,000 in ten boxes
Small blue and white tea bowls; 700 in seven boxes
Small blue and white dishes; 200 in two boxes
Small blue and white dishes; 100 in one box
Blue and white fish salad dishes with crab design; 100 in one box
Blue and white fish salad dishes with design of grasses; 500 in five boxes
Blue and white fish salad dishes with tortoise-shell design; 120 in one box

Other shapes are fewer in number:

Four blue and white jars with lids
Five blue and white *sashimi* dishes
Seven large flat blue and white dishes
Eighteen large blue and white tea bowls with *fuyō* design
Twenty small blue and white helmet-shaped dishes
Thirteen blue and white oil jars in one box
Four blue and white bottles

A second volume lists:

Blue and white food boxes, incense burners, incense boxes, sake cups and bowls for medicine, with lids.

If it is correct to assume that these were all Chinese, and the *fuyō* patterned tea bowls seem to bear this out, then this demand for blue and white imports, relatively new as it was, may well have been part of the stimulus to the founding of the Japanese porcelain industry.

What was this porcelain like? The sherds and the intact bottles, small bowls, and dishes that have been found at consumer sites in Japan are all of relatively

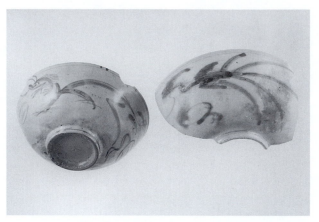

FIGURE 17. Bowls with dragon and phoenix pattern, Fudōyama and Tengudani kilns

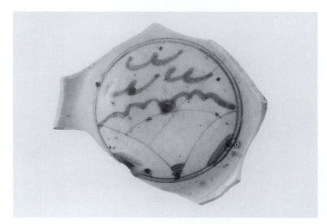

FIGURE 18. Centre of bowl, with 'rising fish' pattern, Tengudani

coarse porcelain. At an exhibition of these finds held in Tokyo National Museum in 1975, sherds from both Jingdezhen and the southern kilns were shown.[9] As the trade was still of small significance, porcelains would have been bought almost randomly, that is from any supply available, rather than being concentrated in the hands of any one area, though we have discussed already some special orders. When the trade did commence on a large scale, after the 1630s, then it was from one area, Jingdezhen, that the main supply was to come.

Apart from the provincial wares, much of China's production of blue and white at this time was that of Jingdezhen for the Western, South East Asian, and Near Eastern markets. This was still largely in the style known in Europe as *kraak porselein* and in Japan as *fuyō-de* (see fig. 5),[10] as we know not only from the vast quantities that still exist in the consumer countries, but also from dated shipwrecks such as that of the *Witte Leeuw*, sunk in 1613.[11] Checking with the shipping documents of the Dutch East India Company gives us some idea of the huge quantities shipped by this, the largest of the East India Companies.[12] But there is no record that the *Witte Leeuw* was carrying any porcelain, so its total cargo of porcelain must represent private trade, either concessionary or illicit. This cannot but make us aware of the great underestimates of trade quantities that have been inferred from trade documents; clearly the trade was vastly greater than has usually been suggested.[13] And much of this trade was in porcelain in *kraak* style.

This style was made for the Western trade, and was therefore little known in Japan until it was in-

troduced by the Dutch in the middle of the seventeenth century for very specific purposes. Almost the only evidence we have for the occurrence of the *kraak* style in Japan is the description of the 'large blue and white tea bowls with *fuyō* design' quoted above—which is uncertain to say the least—and the finding of a few sherds in the ruins of Ichijo-in in Nara, and from the Asakura clan site in Fukui. At this latter site was found a small dish decorated with a crab pattern,[14] and it is tempting to relate this to the one hundred 'fish salad dishes with crab design' listed in the Tokugawa inventory.

Did the Japanese, then, virtually ignore the *kraak* style of Chinese porcelain for reasons of taste, or was it more or less unavailable to them? This latter possibility seems unlikely, as when there was a demand for Chinese blue and white, in the second quarter of the seventeenth century, it was Jingdezhen which met the demand. It seems inevitable, then, to assume that both the *kraak* and the later Transitional styles were, for reasons of preference, not much used in Japan until they were both introduced in the 1650s by the Dutch East India Company as models for the Arita factories, and then it was merely to provide a substitute for the lost supply from Jingdezhen. The *kraak* style and the Transitional style, therefore, both reached Japan after the so-called Tianqi style.

A Ming pattern that was popular in Japan in the second and third quarters of the seventeenth century was the dragon and phoenix pattern which most commonly occurs around the outside of medium-sized bowls on the interior of which was painted the rising fish pattern (figs. 17 and 18). The pattern also

occurs in an abbreviated form around the rims of small dishes, which may have the *hi* (sun) character painted in the well. This style was made both at sophisticated Arita kilns, when it was well painted (an example dated 1666 was found at Chōkichidani kiln-site, see figs. 118–19), and at peripheral kilns where it may become so coarse as to be almost unrecognizable.

Many export designs for the Western market made in Arita were based on *kraak* and Transitional styles; on the whole, open shapes such as plates and bowls tended to be in *kraak* style, while closed shapes, bottles and ewers, tended to be in Transitional styles.

It was in the second quarter of the seventeenth century that China exported great quantities of porcelain to Japan; and then it was a direct market response to a new demand that was only partly being satisfied by the new porcelain industry of Japan itself. This Chinese export porcelain has been called in Japan *ko-sometsuke*, 'old blue and white' and in Europe Tianqi, or in the old transliteration, T'ien chi; we shall see that in fact it was mostly made in the Chongzhen (1628–43) period.

Notes

1. See e.g. Narasaki Shōichi, 'Three-Colour Glazed Ware and Green-Glazed Ware', *Nihon tōji zenshū*, 5 (Tokyo, 1977).
2. For examples, see Tokyo National Museum, *Nihon shutsudo no Chūgoku tōji* (Tokyo, 1975), figs. 27–30.
3. Bureau of Cultural Properties, Ministry of Culture and Information, *Relics Salvaged from the Seabed off Sinan* (Seoul, 1985).
4. See e.g. Yamamoto Nobuo, 'Dating of Northern Song Dynasty Trade Ceramics—Mainly Excavated from Daizaifu', *Trade Ceramics Studies*, 8 (1988), 49–87.
5. See Kamei Meitoku, 'Trade Ceramics of the 14th and 15th Centuries Particularly, about Chinese Ceramics Excavated in Japan', *Trade Ceramic Studies*, 1 (1981), 1–8.
6. See Tokyo National Museum, *Nihon shutsudo no Chūgoku tōji*, fig. 36.
7. See Rupert Faulkner and Oliver Impey, *Shino and Oribe Kiln-Sites* (London, 1981).
8. Tokyo Imperial University, Faculty of Literature, History Department (ed.), 'Inventory of Objects and Utensils in the Possession [of Tokugawa Ieyasu] at Sumpu taken 17th day, 4th month, Genna 2 [1616]' *Dainihon shiryō*, ser. 12, vol. 24 (Tokyo, 1923), trans. Rupert Faulkner.
9. Tokyo National Museum, *Nihon shutsudo no Chūgoku tōji*.
10. See Maura Rinaldi, *Kraak Porcelain: A Moment in the History of Trade* (London, 1989).
11. C. L. van der Pijl-Ketel (ed.), *The Ceramic Load of the 'Witte Leeuw' (1613)* (Amsterdam, 1982).
12. See T. Volker, 'Porcelain and the Dutch East India Company', *Mededelingen van het Rijksmusem voor Volkenkunde, Leiden*, 11 (Leiden, 1954).
13. For the existing Japanese records of what was shipped from Deshima (1709–11 only), see *Toban kamotsu chō* (Tokyo, 1971), summarized by Oliver Impey, 'The Trade in Japanese Porcelain', in John Ayers, Oliver Impey, and J. V. G. Mallet, *Porcelain for Palaces: The Fashion for Japan in Europe, 1650–1750* (London, 1990), 21, 22.
14. See Tokyo National Museum, *Nihon shutsudo no Chūgoku tōji*, fig. 36.

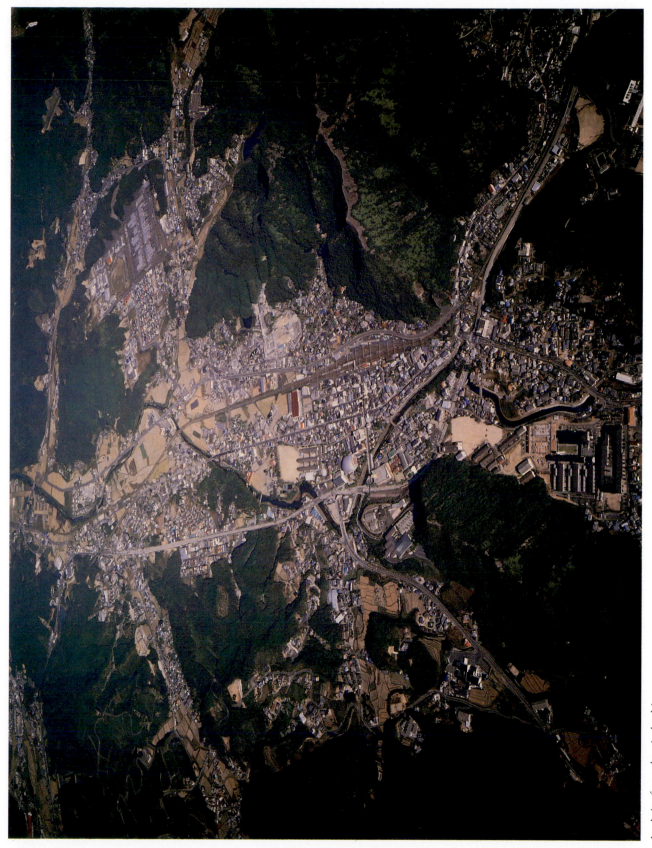

1. Arita from the air, looking west.

2. *a* Tanigama

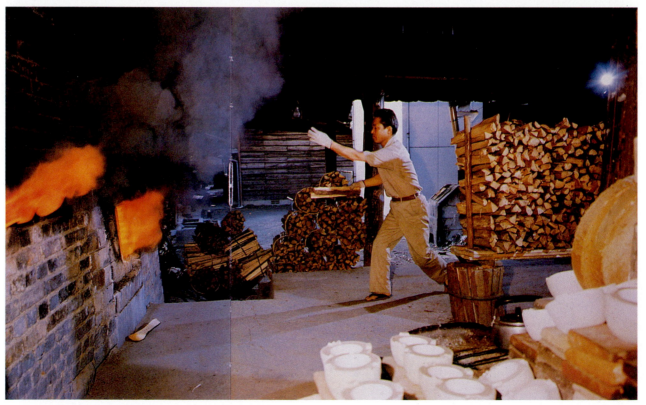

b Firing the Kakiemon kiln

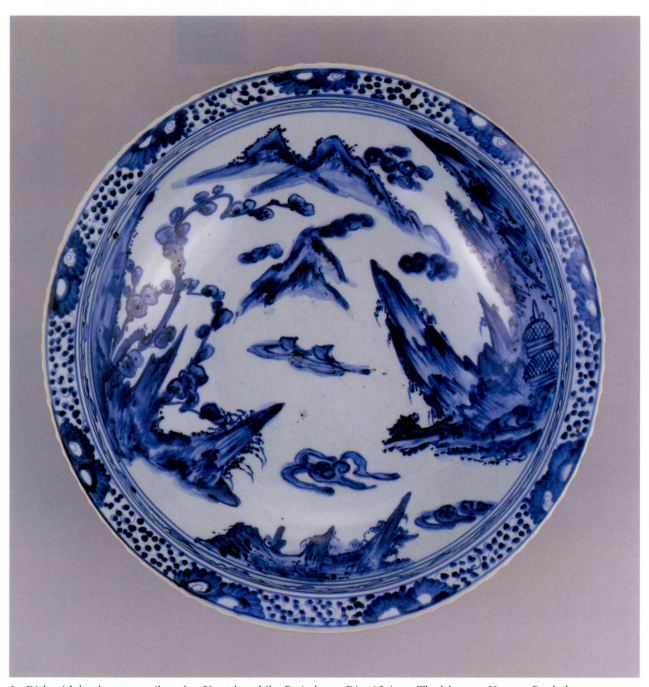

3. Dish with landscape, attributed to Yamabeta kiln. Period two, Dia. 45.4 cm. The Museum Yamato Bunkakan

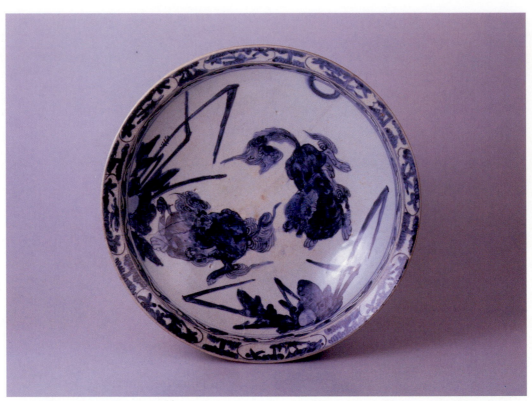

4. *a* Dish with shishi, attributed to Yamabeta kiln. Period two. Dia. 45.7 cm. Kyushu Ceramic Museum

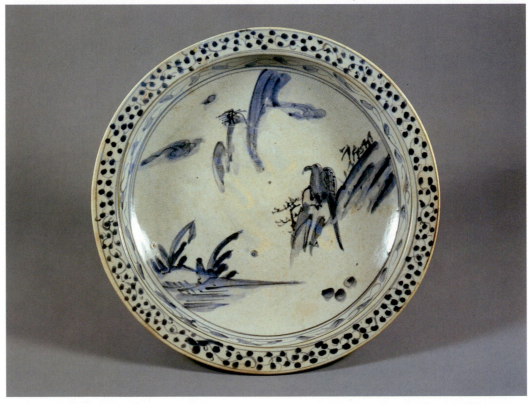

b Dish with bird and landscape, attributed to Yamabeta kiln. Period two, Dia. 40.5 cm. M. Kumazawa

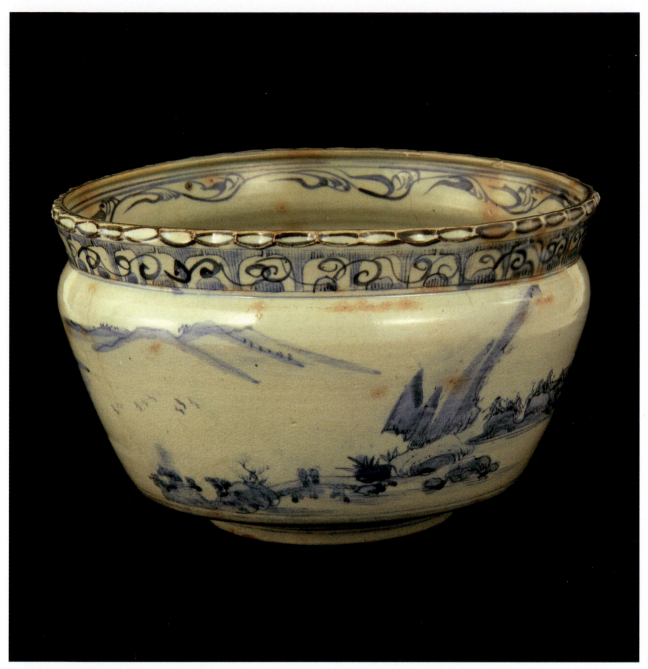

5. Large bowl with landscape, possibly from Maruo kiln, period two, Dia. 30.0 – 34.0 cm. Suntory Art Museum

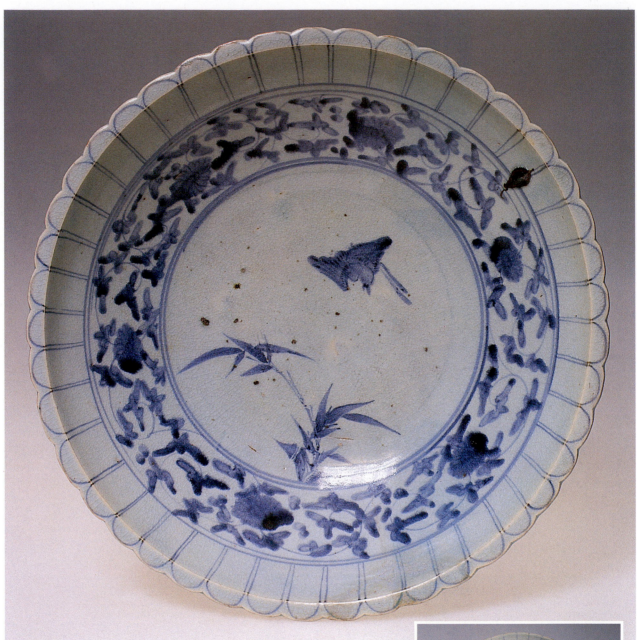

6. *a* Large bowl with radial panels, attributed to Hyakken or Sarugawa kiln. Period two, Dia. 39.0 cm. Museum Het Princessehof, Leeuwarden

b Underside, showing relatively small footring

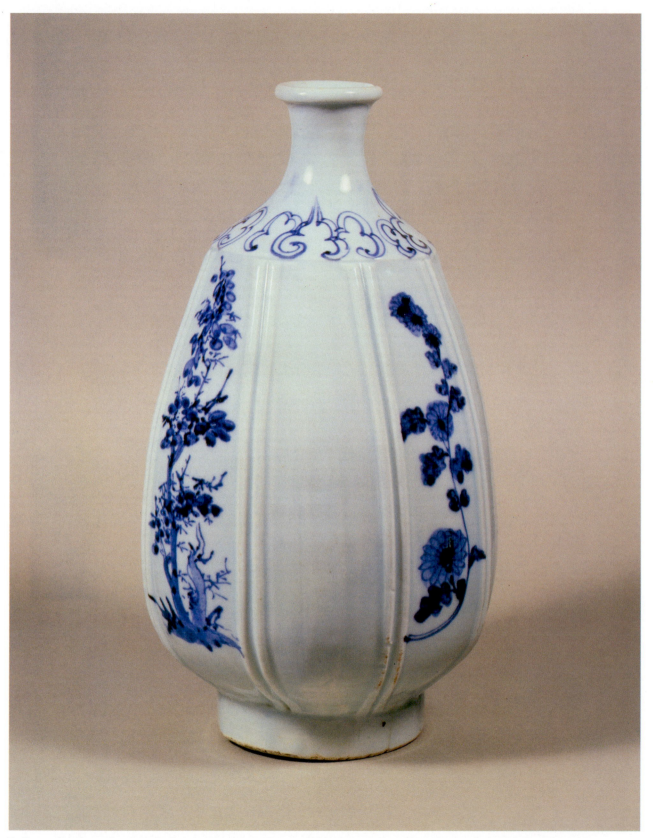

7. Large bottle with vertical ribs, attributed to Komizo kiln. Period two. H. 32.0 cm. M.D.A. Museum of Art

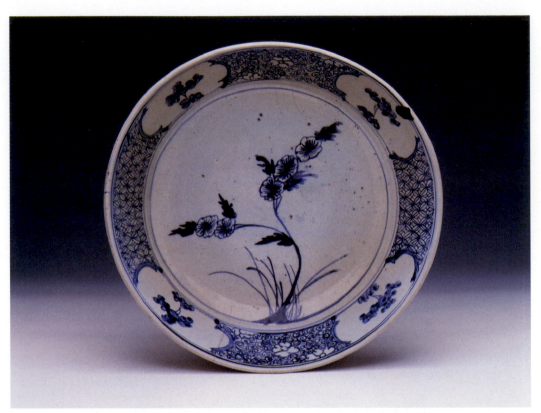

8. *a* Large dish with plant design and panelled border, attributed to the 'Hyakken group' of kilns, period two, Dia. 36.6 cm.

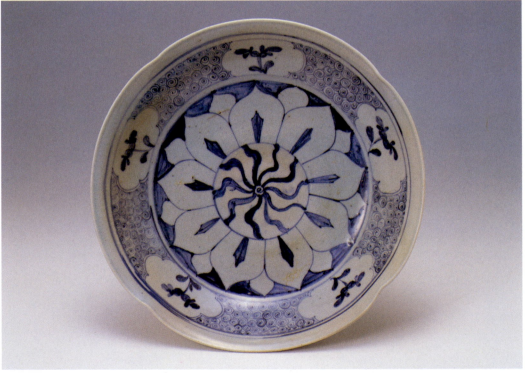

b Large dish with radial design, attributed to the 'Hyakken group' of kilns. Period two. Dia. 37.0 cm. Kyushu Ceramic Museum

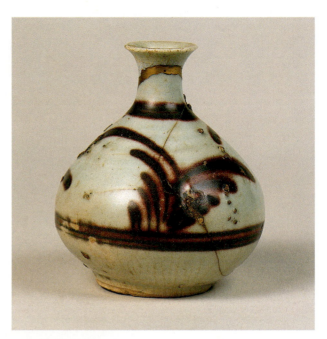

9. *a* Small bottle decorated in copper-red with grasses, attributed to Hirose kiln. Period two. h. 13.0 cm.

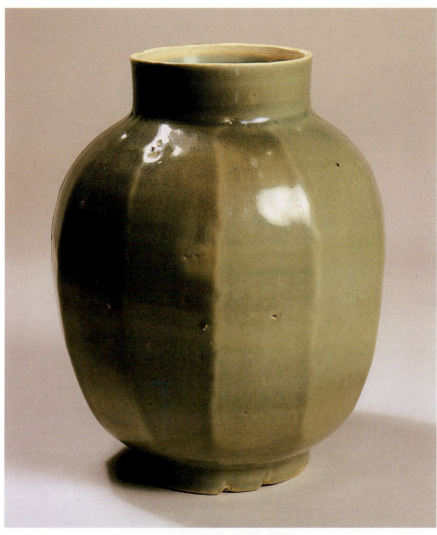

b Faceted celadon jar. Period two. h. 15.0 cm. Ashmolean Museum, 1987.34, Story Fund

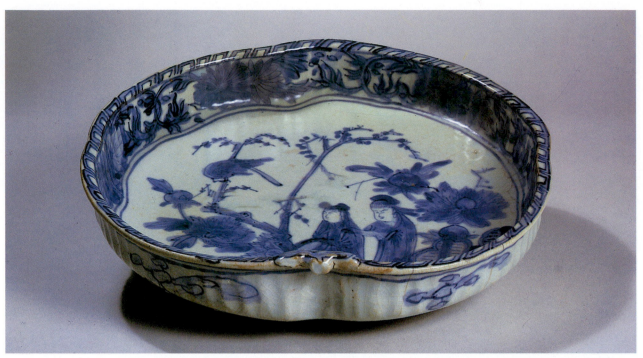

10. *a* Peach-shaped dish with Chinese figures. Period two. w. 30.0 cm. Ashmolean Museum, 1987.10, gift of Mr Imaizumi Motosuke

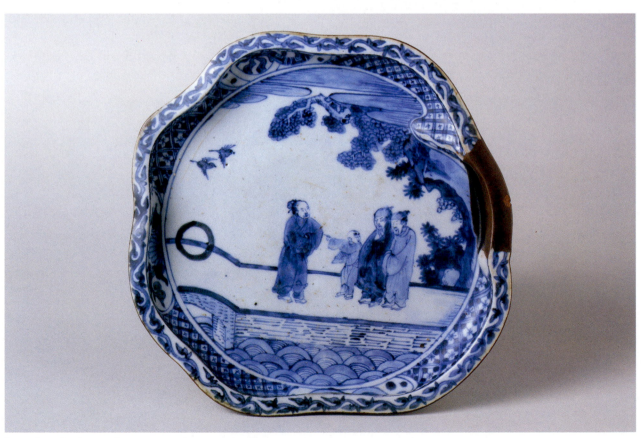

b Dish with Chinese figures. Period two. w. 24.0 cm.

11. *a* Leaf-shaped dish, blue on *ruri*. Period two, w. 22.7 cm.

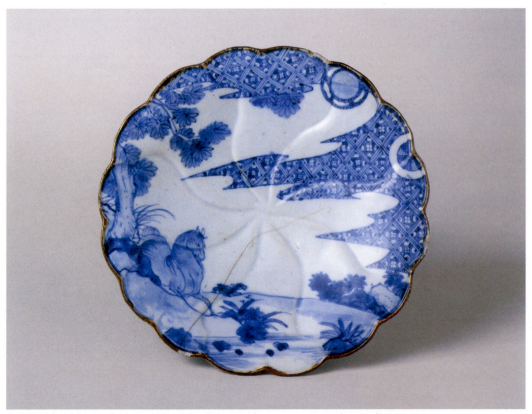

b Moulded blue and white dish with a horse and pine-tree. Period two, dia. 22.6 cm.

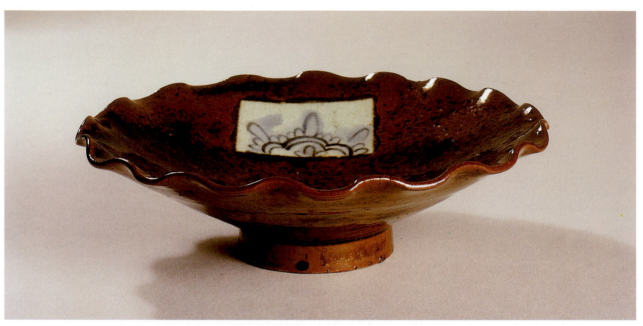

12. *a* Dish with waved edge, *temmoku* with blue and white reserve, attributed to Yamagoya kiln, Period two. dia. 15 cm. Ashmolean Museum, 1986.7, Story Fund

b Celadon and blue and white dish with rolled rim, attributed to Yamagoya kiln, Period two, dia. approx. 20 cm.

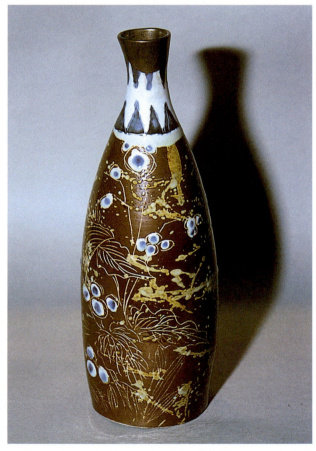

c Temmoku and blue and white bottle with splashed decoration, attributed to Yamagoya kiln. Period two, h. 26.0 cm.

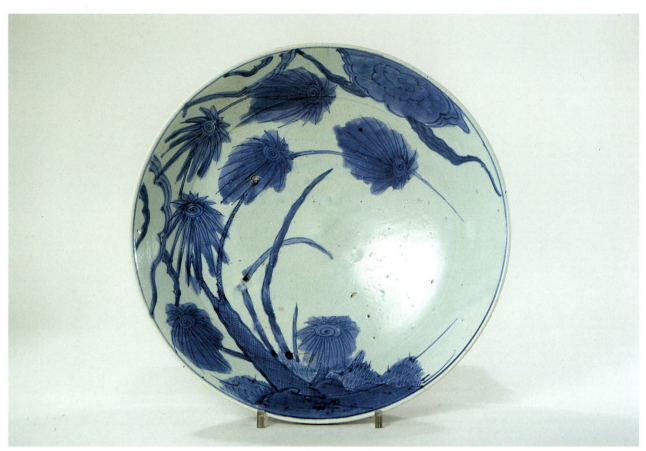

13. *a* Large dish with rushes and cloud, attributed to Maruo kiln. Period two, dia. 35.0 cm. Ashmolean Museum, 1985.33, Story Fund

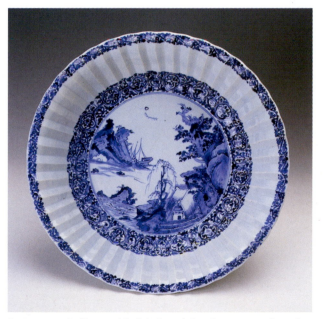

b Large radially moulded dish with landscape, attributed to Yamabeta kiln. Period three, dia. 39.4 cm. Kyushu Ceramic Museum

c Underside of (*b*)

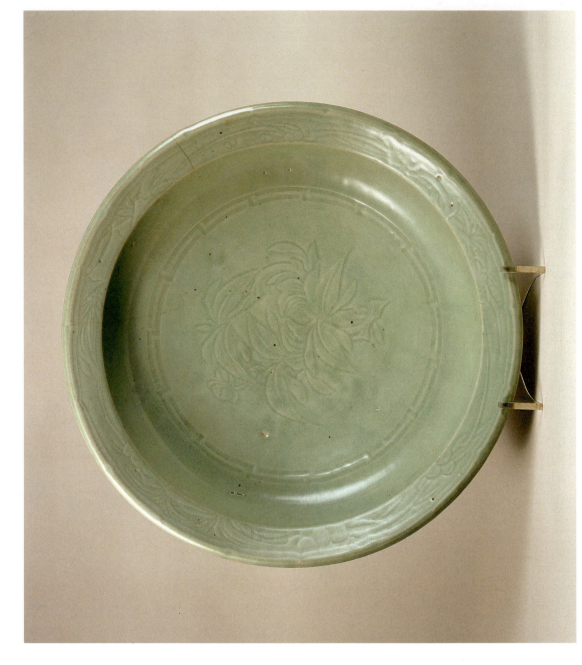

15. (opposite page) Large petalled celadon bowl, with underglaze blue roundels, attributed to Komizo kiln. Period three, dia. 31.7 cm. Metropolitan Museum of Art, Harry G. C. Packard Collection of Asian Art, gift of Harry G. C. Packard and Purchase, Fletcher, Rogers, Harris Brisbane Dick, and Louis V. Bell Funds, Joseph Pulitzer Bequest and Annenberg Fund Inc., 1975 (1975,268.508)

14. Large celadon dish with incised peony decoration, attributed to Maruo or Fudōyama kiln. Period three, dia. 47.0 cm.

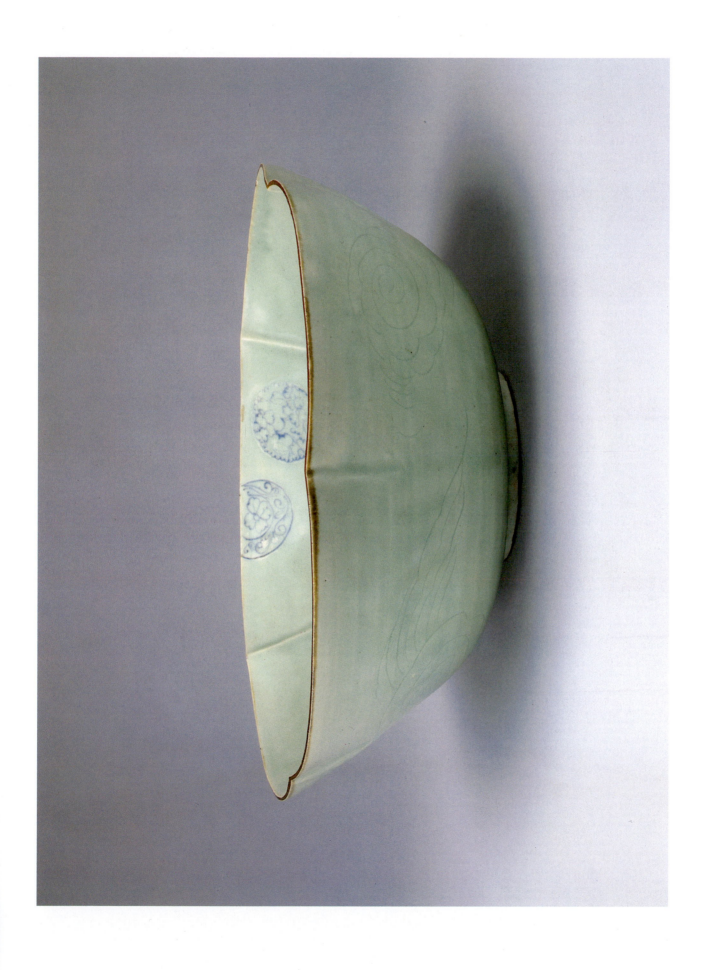

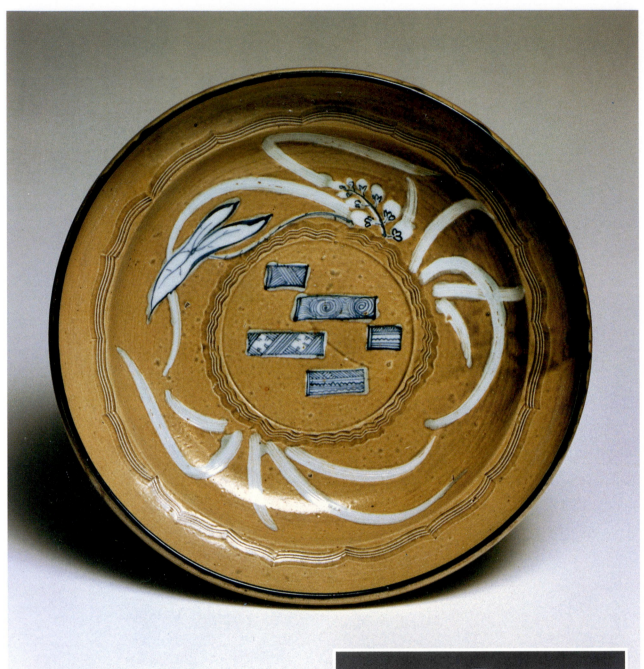

16. *a* Large bowl, yellow-brown glazed with combed deco-
ration and blue and white reserves of arrow-leaf around
geometric patterns, attributed to Yamabeta kiln. Period
two/three, dia. 33.8 cm. Baur Collection, E22

b Underside of (*a*)

17. Small dishes from period one; bowls from period two.

a Small dish with bowl of flowers, attributed to Kodaru kiln. dia. 15.0 cm. Metropolitan Museum of Art, Harry G. C. Packard Collection of Asian Art, gift of Harry G. C. Packard and Purchase, Fletcher, Rogers, Harris Brisbane Dick, and Louis V. Bell Funds, Joseph Pulitzer Bequest and Annenberg Fund Inc., 1975 (1975.268.456)

b Small dish with the 'net-window' pattern, dia. 15.5 cm.

c Small dish with willow tree and boat, dia. 14.0 cm.

d Sherd of dish from Kusunokidani kiln, willow tree, dia. 13.2 cm. Ashmolean Museum

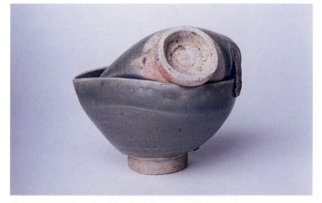

e Sherd of small dish from Nakashirakawa kiln, flower and moon, dia. 14.0 cm. Ashmolean Museum

f Two celadon bowls fused in a kiln accident, Sarugawa kiln, dia. approx. 11 cm. Ashmolean Museum

18. Shaped dishes with thrown, round foot, period one/two

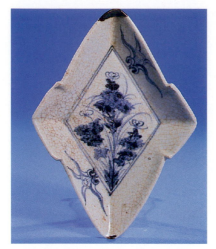

a Lozenge-shaped dish with flowers, L. 14.3 cm.

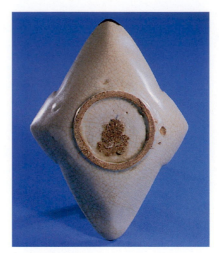

b Reverse of (*a*)

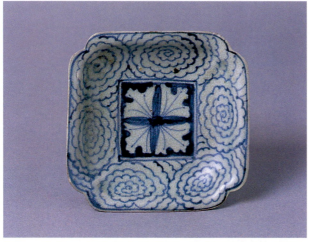

c Squared dish with quadripartite gingko pattern and cloud pattern border, w. 13.6 cm.

d Squared dish with geometric pattern, w. 13.5 cm.

e Squared petalled dish with Hotei, w. 16.0 cm.

f Hexagonal dish with egret, max. w. 16.0 cm.

19. Small dishes, period two

a Landscape dish with moulded border, attributed to Tengudani kiln, dia. 14.5 cm.

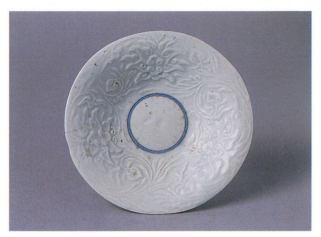

b Deep dish with moulded decoration, attributed to Tengudani kiln, dia. 16.1 cm.

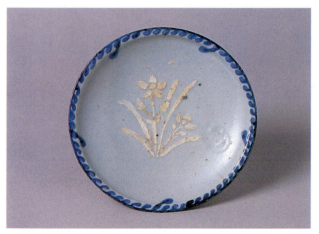

c Dish with moulded white slip decoration of narcissus, attributed to Tengudani kiln, dia. 16.0cm.

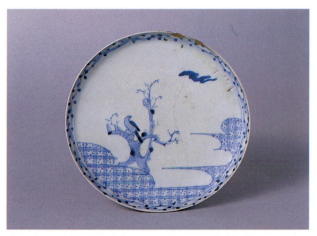

d Dish with bird and diaper pattern, probably from Maruo kiln, dia. 19.5 cm.

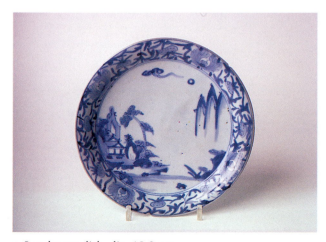

e Landscape dish, dia. 19.2 cm.

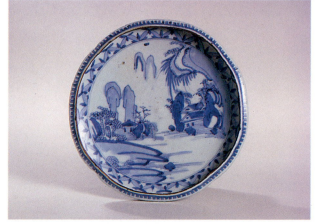

f Landscape dish with rolled-over rim, dia. 22.2 cm. Ashmolean Museum, 1987.9, Gift of Mr Imaizumi Motosuke

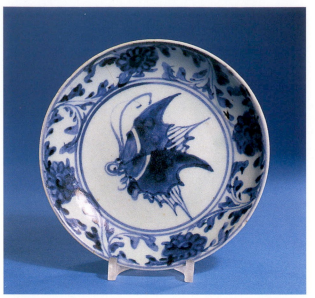

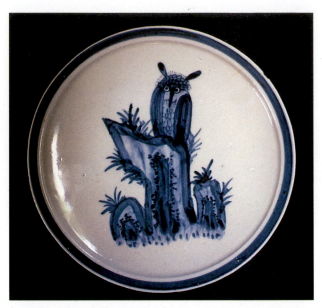

a Dish with butterfly, attributed to the 'Hyakken group' of kilns, dia. 15.0 cm.

b Dish with owl, dia. 20.5 cm.

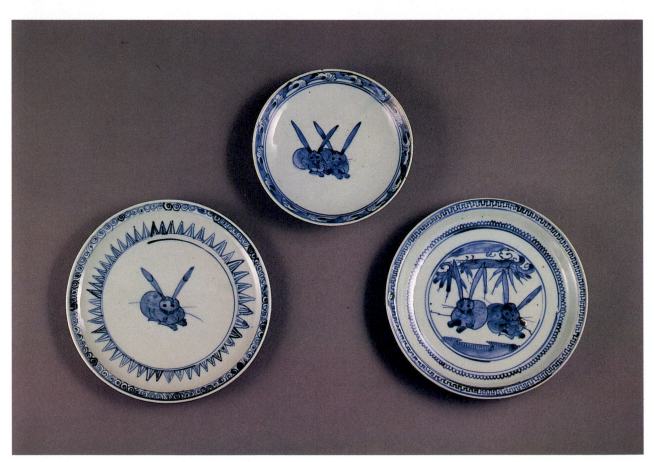

c Dish with two rabbits, dia. 14.5 cm.
d Dish with rabbit, dia. 18.2 cm.
e Dish with two rabbits and bamboo, dia. 18.5 cm.

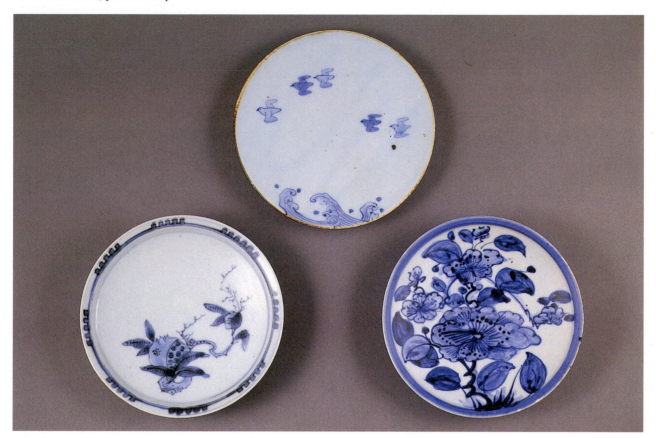

a Dish with *chidori* and waves, dia. 19.5 cm.
b Dish with pomegranate, dia. 19.8 cm.
c Dish with camellia, dia. 19.7 cm.

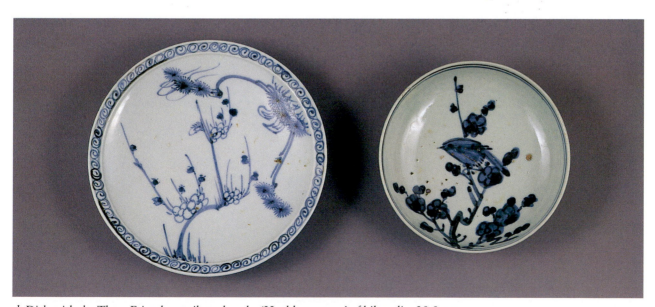

d Dish with the Three Friends, attributed to the 'Hyakken group' of kilns, dia. 20.0 cm.
e Dish with a bird in a branch, attributed to Komizo kiln, dia. 16.5 cm.

22. Small dishes, period two

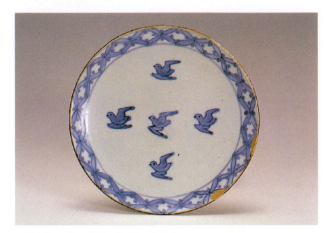

a Dish with *chidori*. dia. 19.6 cm.

Small dishes with *fukizumi* decoration, period two

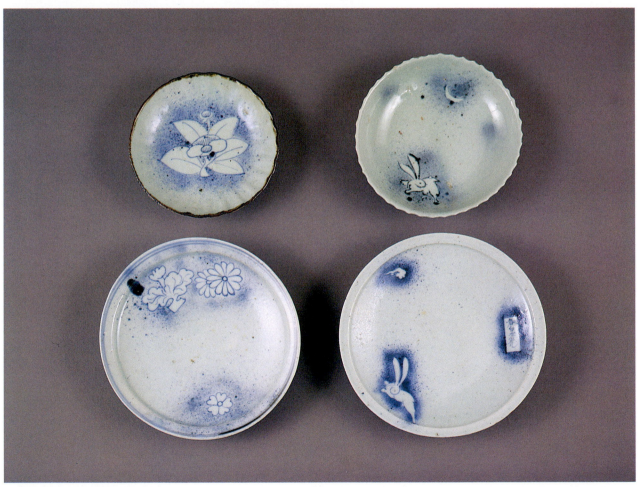

b Dish with camellia, dia. 14.0 cm.
c Dish with hare under the moon, dia. 15.5 cm.
d Dish with flowers, dia. 18.5 cm.
e Dish with 'the Jade Rabbit', attributed to Hiekoba kiln. dia. 19.0 cm.

23. Shaped dishes, attached small foot, period two to four

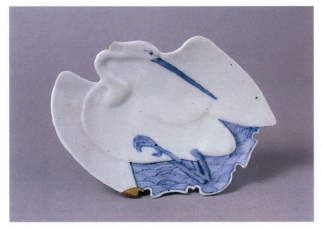

a Dish shaped as an egret, w. 18.5 cm.

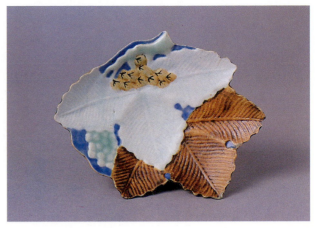

b Dish shaped as leaves and berries, with *temmoku* and celadon, w. 16.0 cm.

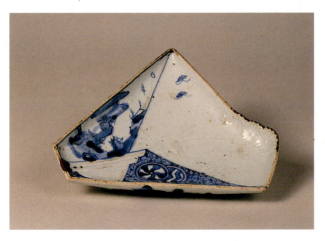

c Dish shaped as folded letter-paper, moulded with chrysanthemums and with landscape and geometric patterns, w. 16.5 cm.

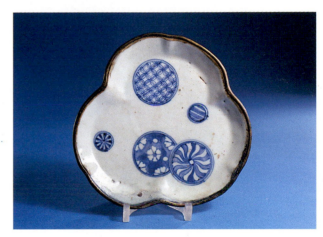

d Trefoil dish with geometric roundels, w. 14.3 cm.

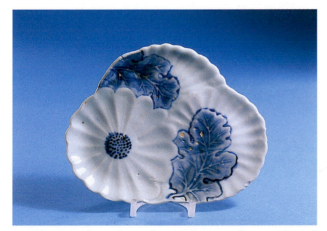

e Dish shaped as three chrysanthemum flowers. Period three, w. 17.2 cm. Ashmolean Museum, 1994.133, Story Fund

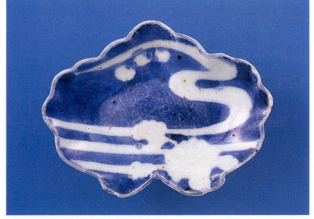

f Leaf-shaped dish stencilled with waves, attributed to Chōkichidani kiln. Period four, w. 10.7 cm.

24. Shaped dishes, attached tall foot, period three

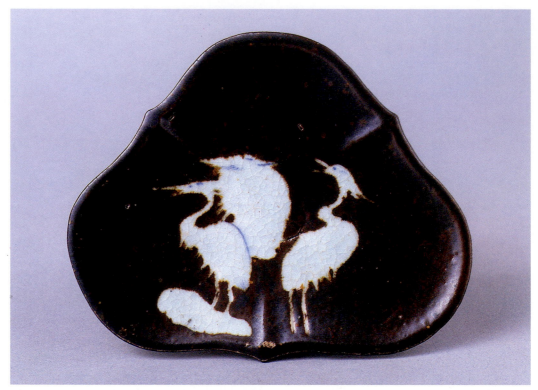

a Temmoku dish with egrets in reserve, w. 15.3 cm.

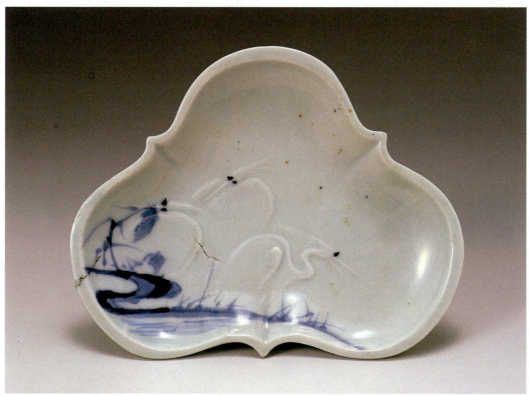

b Dish moulded with three egrets. w. 16.7 cm. Kyushu Ceramic Museum

25. Shaped dishes, attached tall foot, colour variations on.same shape, period three

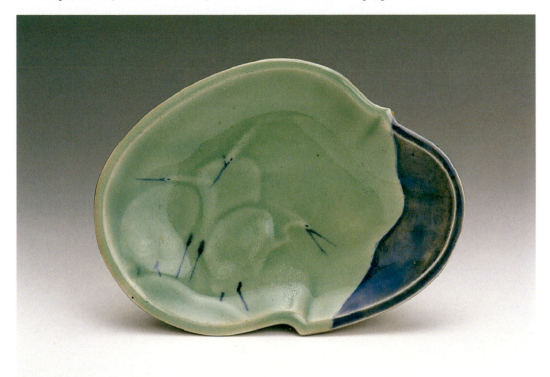

a Dish moulded with egrets, in celadon, *ruri*, and underglaze blue, w. 16.8 cm. Kyushu Ceramic Museum

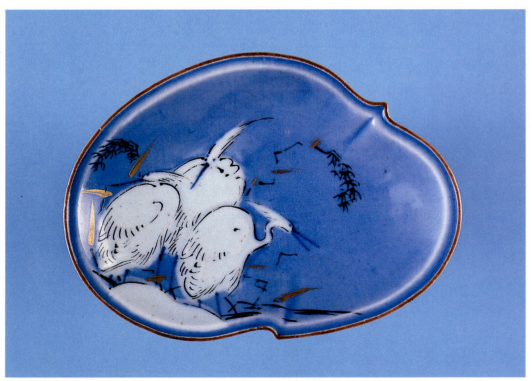

b Dish moulded with egrets in *ruri* and underglaze blue, with gold and silver enamelling, w. 16.8 cm. Ashmolean Museum, 1991.55, Story Fund

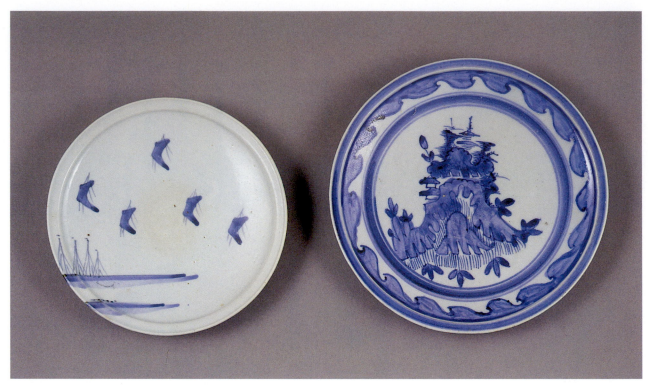

a Dish with distant sailing ships, dia. 20.0 cm.
b Dish with a temple on a rock, dia. 23.2 cm.

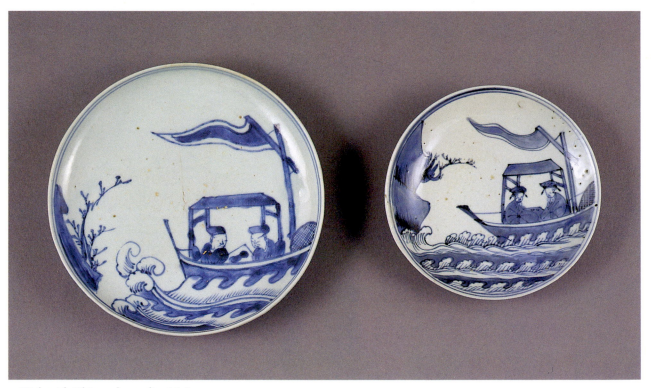

c Dish with Chinese boat. dia, 19.5 cm.
d Small dish with Chinese boat, dia. 15.4 cm.

27. Small dishes with radial designs, Period two.

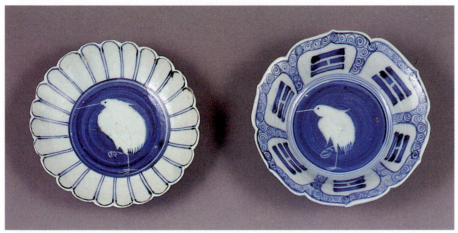

a Dish with petalled shape and egret, dia. 14.2 cm.

b Dish with six-lobed rim and egret, dia. 15.0 cm.

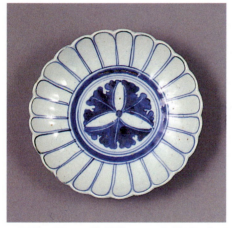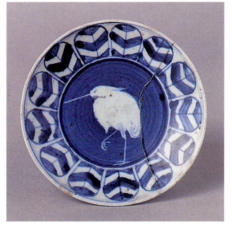

c Dish with petalled shape and gingko-leaf pattern, dia. 14.1 cm.

d Dish with feather border and egret, attributed to Kusunokidani kiln, dia. 14.7 cm.

Dishes with flattened rims, period two

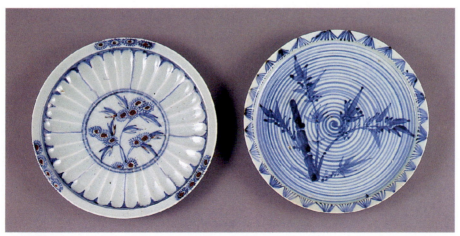

e Petal-moulded dish with copper-red decorated with daisies, dia. 21.5 cm.

f Dish with bamboo and blue spiral, dia. 21.6 cm.

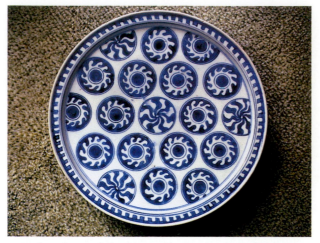

a Dish with roundels. dia. 21.5 cm.

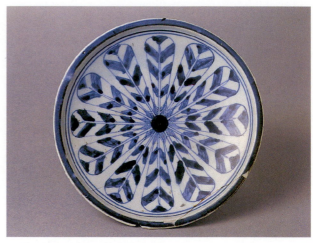

b Dish with radial feathers. dia. 21 cm.

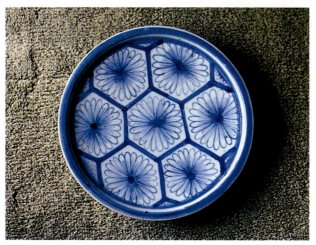

c Dish with chrysanthemums in a hexagon. dia. 21.2 cm.

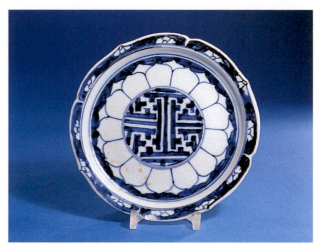

d Small dish with petalling and geometric patterns. dia. 15 cm.

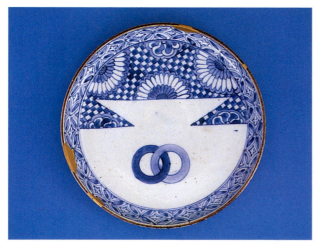

e Dish with flowerheads, diaper, and interlocked rings, dia. 20.5 cm.

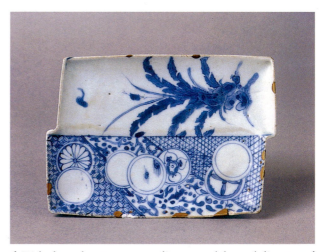

f Dish shaped as two poem-slips, roundels, and diaper and plant patterns, L. 15.9 cm.

29. Moulded dishes, colour variations on same shape, period three

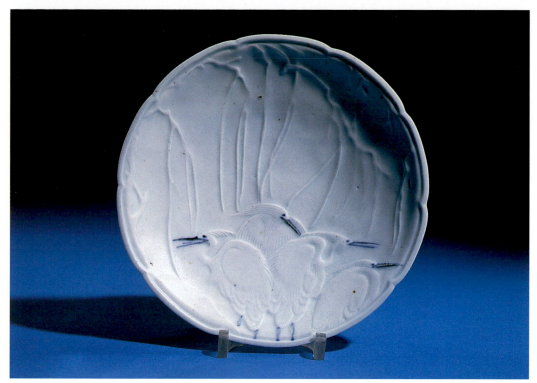

a Dish with underglaze blue moulded with egrets under willow, dia. 16.1 cm. Ashmolean Museum, 1985.47, bequest of Jeffery Story and Walter Cook

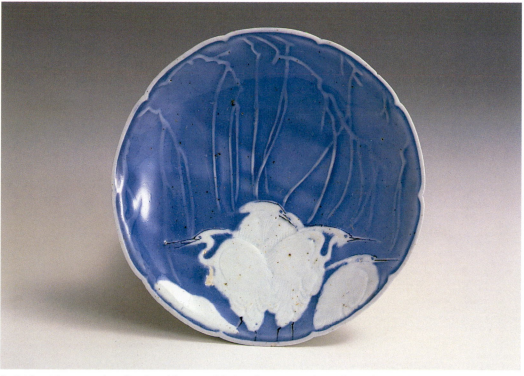

b Dish with *ruri* and underglaze blue moulded with egrets under willow, dia. 15.9 cm. Kyushu Ceramic Museum

30. Bottles, periods two and three.

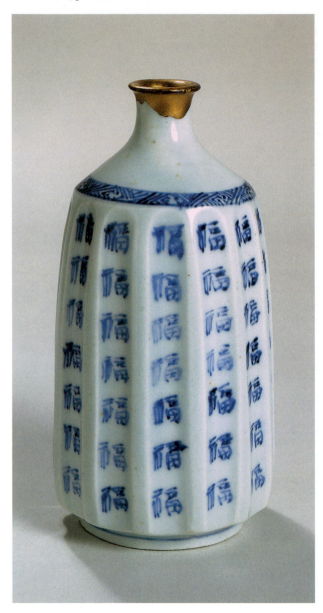

a Bottle with vertical ribs and *fuku* characters, attributed to Hyakken or Tenjinmori kiln, h. 15.0 cm. Ashmolean Museum, 1989.11, Story Fund

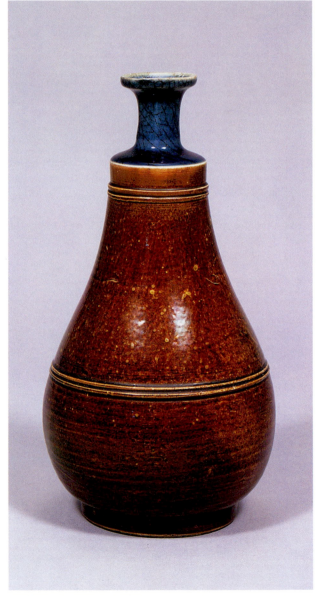

b Tea-whisk-shaped bottle in *temmoku* and *ruri*, attributed to Higuchi kiln, h. 26.7 cm. Idemitsu Museum of Arts

31. Bottles, periods two/three.

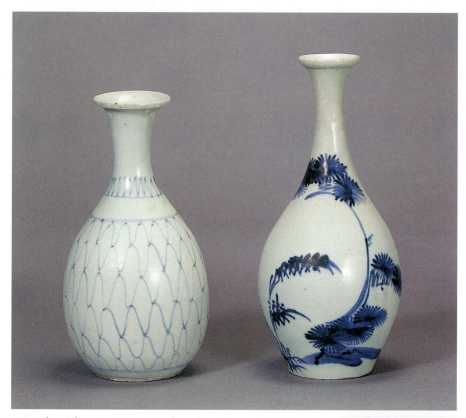

a Bottle with net pattern, attributed to Tengudani kiln, h. 22.0 cm.
b Bottle with The Three Friends, attributed to Tengudani kiln, h. 25.0 cm.

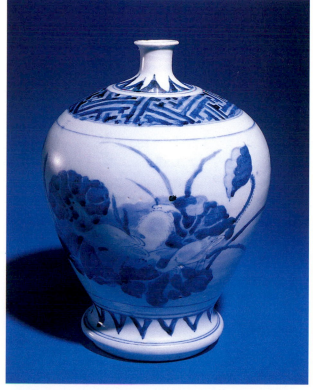

c Baluster-shaped bottle with egrets and lotus, h. 25.7 cm. Ashmolean Museum, 1976. Reitlinger gift

32. Celadon and blue and white, period three.

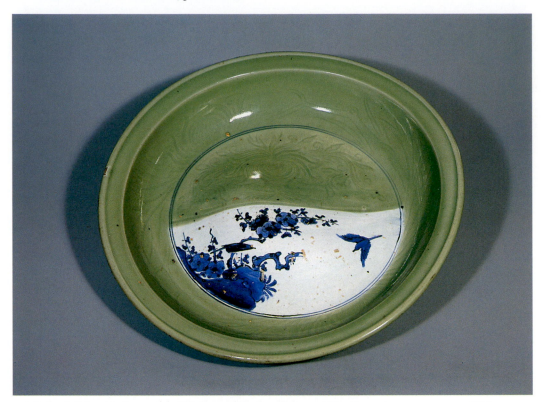

a Misfired dish with flowers and bird, possibly from Maruo kiln, dia. unknown, approx. 35.0cm.

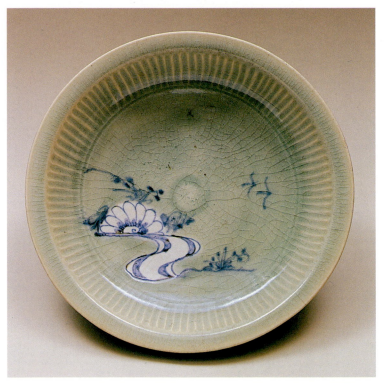

b Dish with flower in stream, dia. 30.4 cm. Jackson and Mary Burke Collection

c Reverse of (*b*)

33. Mukozuke, period three

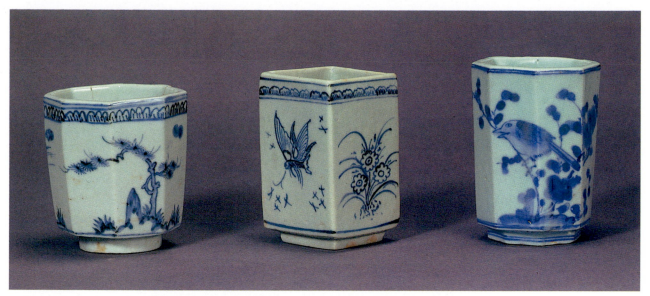

a Cup with the three Friends, h. 7.2 cm.
b Cup with butterfly and flowers, h. 8.7 cm.
c Cup with bird on a branch, h. 9.0 cm.

Tea Ceremony wares, period three

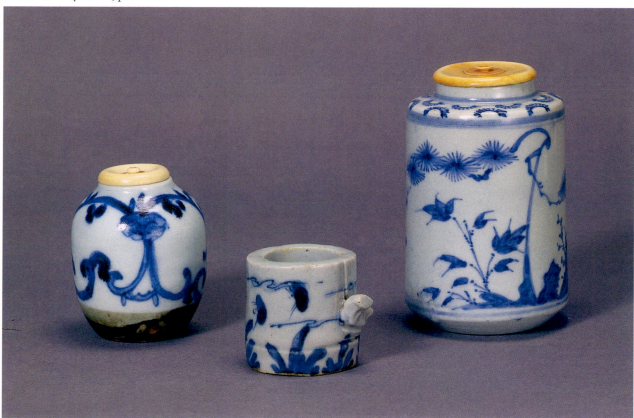

d *Cha-ire* with scrolling pattern, h. 7.8 cm.
e *Futaoki* shaped as a node of bamboo, h. 4.0 cm.
f *Cha-ire* with the Three Friends, h. 9.6 cm.

34. Mizusashi, period three

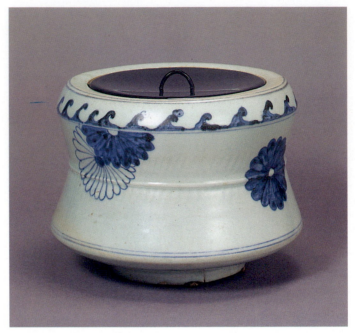

a Waisted shape with chrysanthemum flowers, h. 16.0 cm.

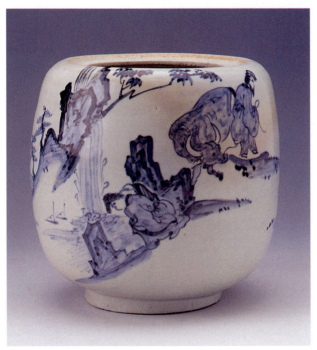

b Rounded shape with buffalo and landscape, h. 16.9 cm.
Kyushu Ceramic Museum

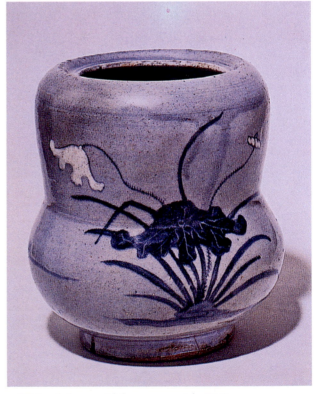

c Waisted shape with lotus on *ruri*, h. 20.2 cm.

35. 'Suisaka' style, period three

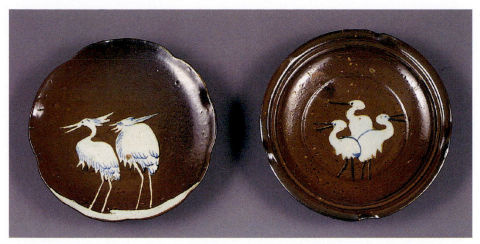

a Temmoku with blue and white reserve, egrets, dia. 14.6 cm.

b Temmoku with blue and white reserve, egrets, dia. 14.6 cm.

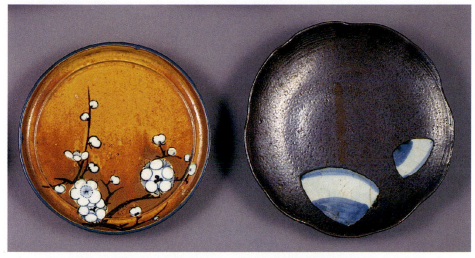

c Temmoku with blue and white reserve, plum tree, dia. 14.4 cm.

d Temmoku with blue and white reserve, clamshells, dia. 15.8 cm.

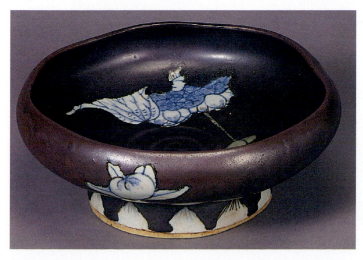

e Tall footed *temmoku* bowl with blue and white reserves, lotus, dia. 20.0 cm.

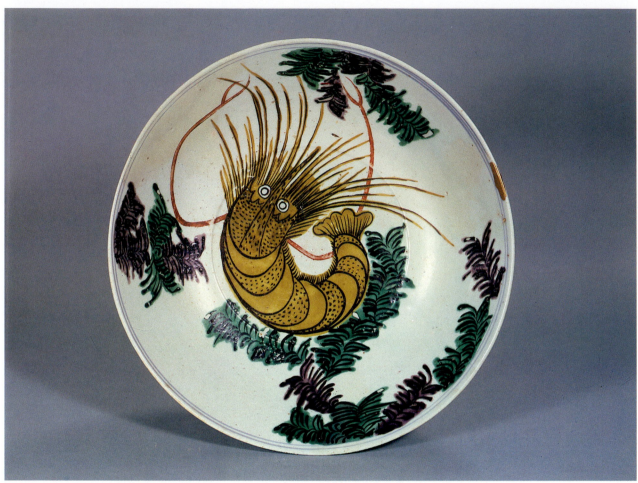

a Dish with lobster, overglaze enamel, dia. 34.0 cm. Ishikawa Prefectural Museum

b White sherd from Yamabeta kiln, w. 19 cm. Ashmolean Museum

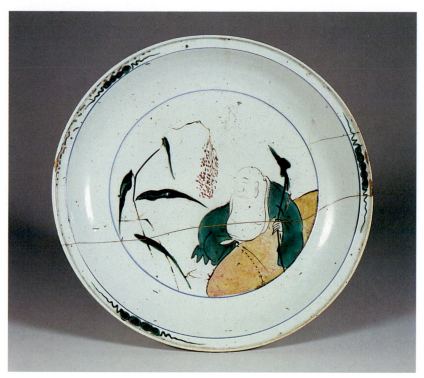

a Dish with Hotei, overglaze enamel, dia. 32.4 cm. Ishikawa Prefectural Museum

b Reverse of (*a*), underglaze blue and overglaze red

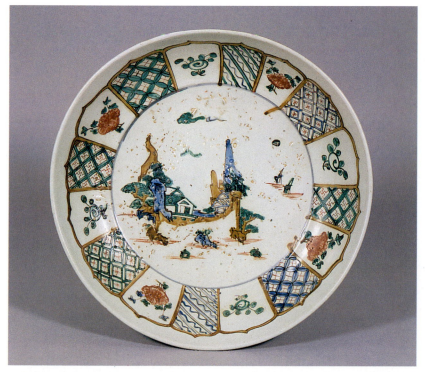

c Dish with landscape in overglaze enamel; the back with plum tree in blue and white and enamel, dia. 32.6 cm. Idemitsu Museum of Arts

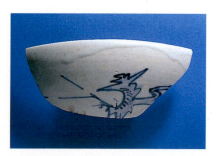

d Sherd from Yamabeta kiln, w. 13.0 cm. Ashmolean Museum

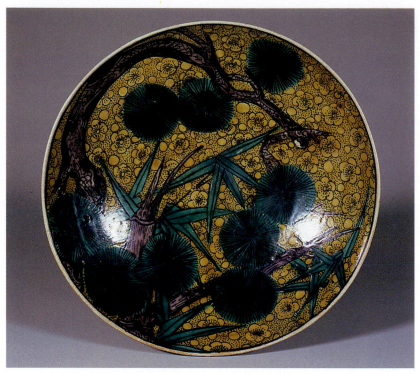

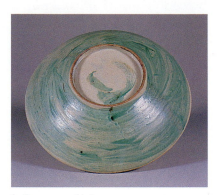

a Dish with pine tree and bamboo in overglaze enamels, the back washed in green enamel, dia. 35.6 cm. Ishikawa Prefectural Museum

b Reverse of (*a*)

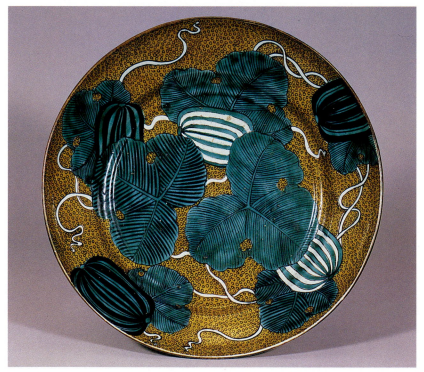

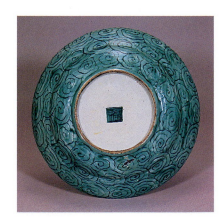

c Dish with melons in overglaze enamel; the back with black spirals on a green ground, dia. 32.6 cm. Idemitsu Museum of Arts

d Reverse of (*c*)

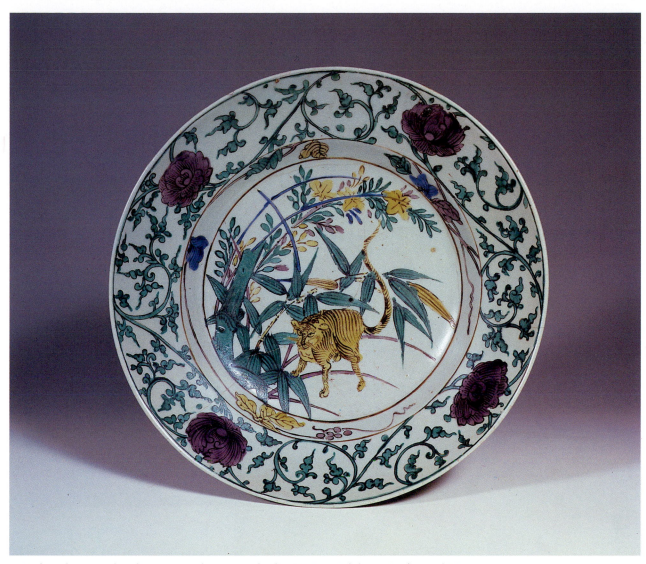

a Dish with tiger in bamboo in overglaze enamels, dia. 36.1 cm. Ishikawa Prefectural Museum

b Sherd from Yamabeta enamelled with tiger. Arita

c Sherd from Yamabeta enamelled with bamboo. Arita

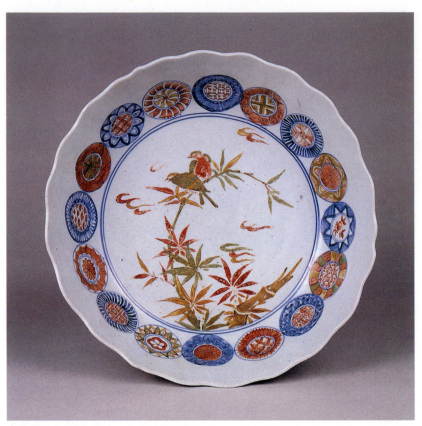

a Dish with landscape within border of roundels in underglaze blue and overglaze enamels, dia. 31.0 cm. Matsuoka Museum

b Sherd from Yamabeta kiln. Arita

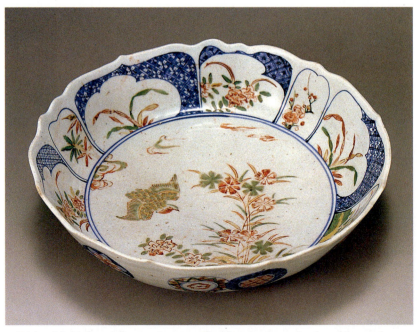

c Dish with bird and flowers in a panelled border in underglaze blue and overglaze enamels, dia. 30.5 cm. Kyushu Ceramic Museum

d Sherd from Yamabeta kiln. Arita

41. '*Ko*-Kutani' with Arita comparisons, period three

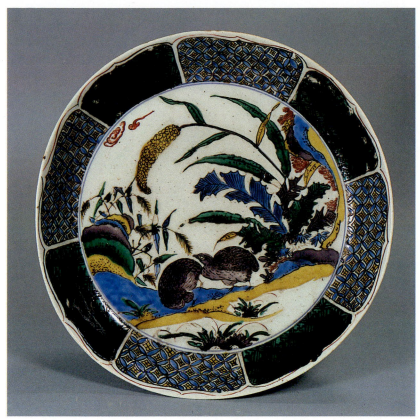

a Dish with quails and millet in overglaze enamels; the back with scrollwork in underglaze blue, dia. 30.6 cm. Ishikawa Prefectural Museum

b Sherds from Yamabeta. Ashmolean Museum

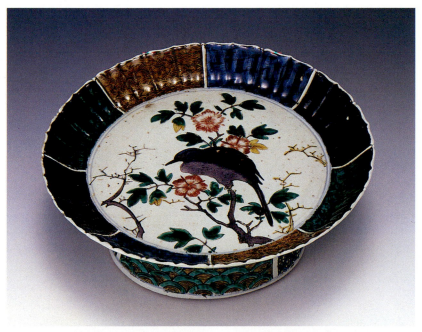

c Tall-footed dish with petal-shaped rim, decoration of a bird on a branch in overglaze enamels, dia. 29.4 cm. Ishikawa Prefectural Museum

d Sherd from Yamabeta kiln. Arita

42. 'Ko-Kutani'; quality of glaze on reverse, period three

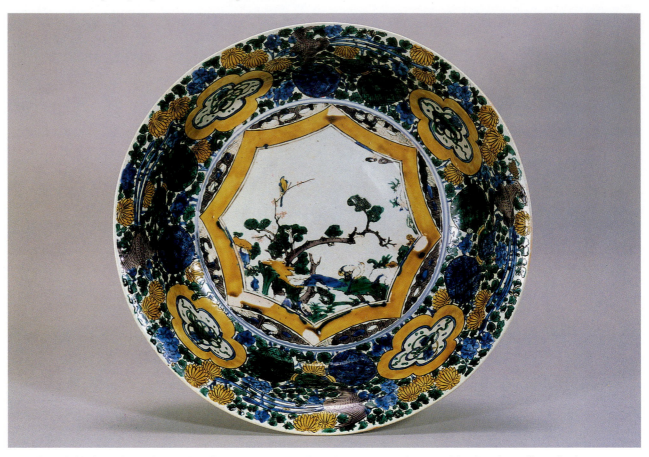

a Dish with birds on branches within flower-pattern border; the reverse with enamel bird and scroll-work, dia. 42.5 cm. Idemitsu Museum of Arts

b Reverse of (a)

c Sherd from Maruo kiln, w. 19.0 cm. Ashmolean Museum

d Sherd from Yamabeta kiln, w. 14.5 cm. Ashmolean Museum

43. 'Ko-Kutani' with formal patterns, period three

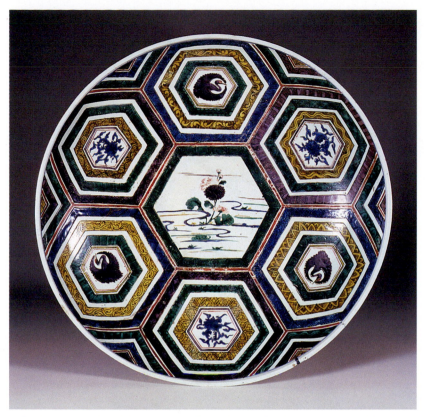

a Dish with pond within hexagons, dia. 45.5 cm. Ishikawa Prefectural Museum

b Sherd from Yamabeta kiln with formal pattern, Arita

'Ko-Kutani' with brown petalled edge, period three

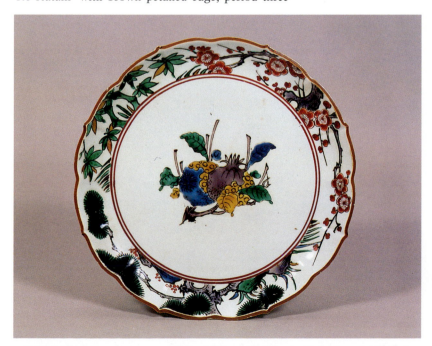

c Dish with pomegranates and Three Friends border, with brown petalled rim. Dated 1653, dia. 22.0 cm. Idemitsu Museum of Arts

d Reverse of (*c*)

e Sherd from Kusunokidani kiln. Arita

44. Enamelled dishes with flattened edge, period two

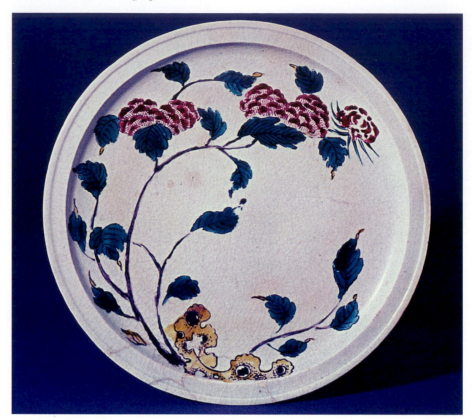

a Dish with flowers in overglaze enamel, dia. approx. 24 cm.

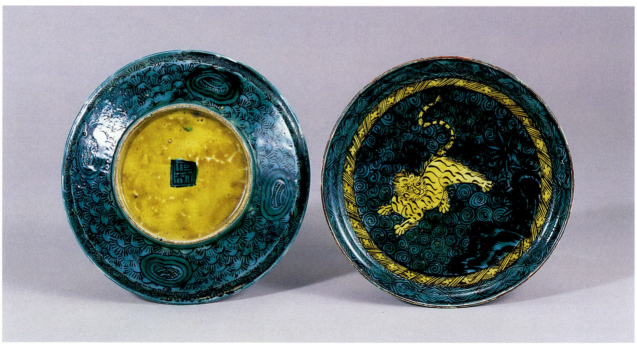

b Two dishes enamelled in ao-Kutani style with tigers, dia. 21.3 cm. Idemitsu Museum of Arts

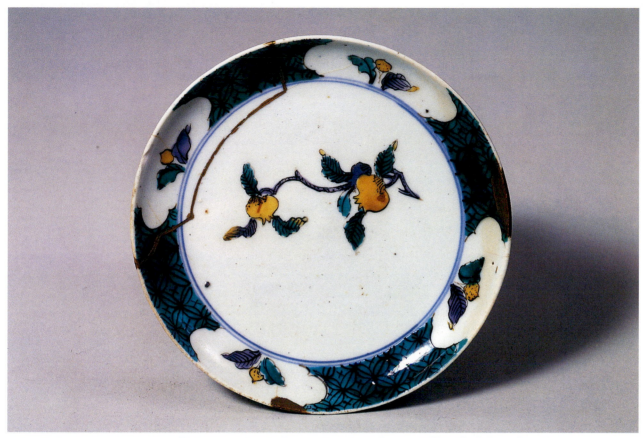

a Small dish with pomegranates. Period two, dia. 14.1 cm. Ashmolean Museum, 1990. 1240. Story Fund

Dated dish with enamel decoration

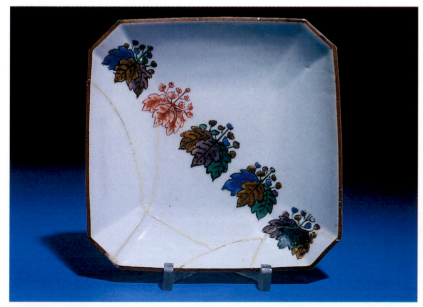

b Squared dish with line of *kiri-mon* in overglaze enamel, w. 13.3 cm. Ashmolean Museum, 1992.70

c Reverse of (*b*) with four character mark *Kyōhō ni nen* [1653]

46. Small enamelled dishes, periods two/three; *temmoku* and *ruri*, period three

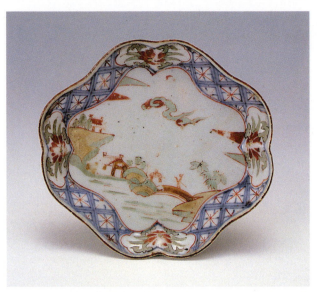

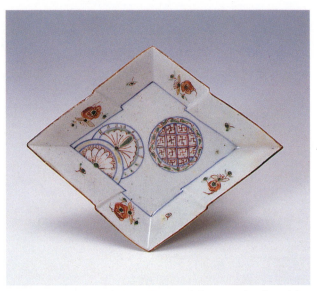

a Shaped dish in blue and white and overglaze enamels with landscape, probably from Kusunokidani kiln, w. 14.0 cm. Kyushu Ceramic Museum

b Lozenge-shaped dish with roundels in underglaze blue and overglaze enamels, attributed to Kusunokidani kiln, w. 17.5 cm. Kyushu Ceramic Museum

Glaze and underglaze pattern, period three

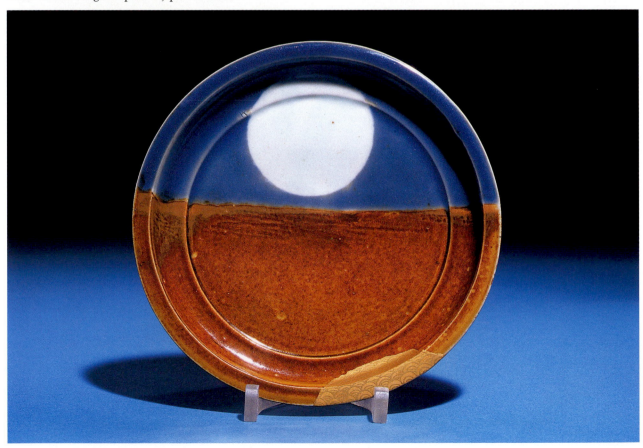

c Dish with *temmoku* and *ruri* with white reserve, decoration of Musashino, attributed to Shimoshirakawa kiln, dia. 14.3 cm. Ashmolean Museum, 1988. 11, Story Fund

a Dish with river scene and boat with broad landscape border, attributed to Chōkichidani kiln, dia. 46.5 cm.

b Dish with riverside hut, bamboo border, attributed to Chōkichidani kiln, dia. 41.0 cm.

48. Shaped, or 'Matsugatani' style, period three/four

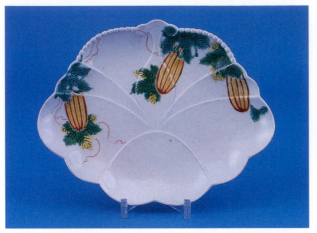

a Orchid-flower-shaped dish, overglaze decoration of gourds, w. 17.9 cm. Ashmolean Museum, 1986.56, Story Fund

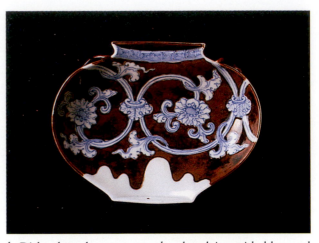

b Dish, shaped as a *temmoku*-glazed jar with blue and white scroll pattern and 'unglazed' base, w. 15.0 cm.

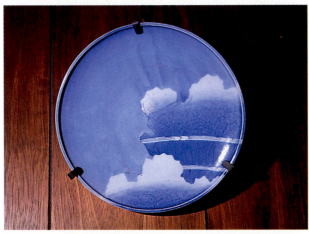

c Dish with banded hedges in snow on *ruri*, attributed to Shimoshirakawa kiln, dia. 15.5 cm.

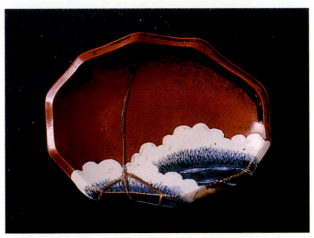

d Dish with *temmoku* and blue and white, snow on banded hedges, w. 15.4 cm.

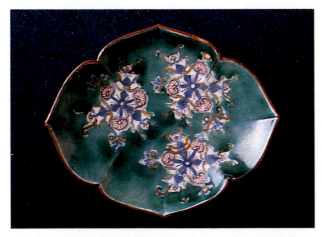

e Lobed dish with trefoil patterns in overglaze enamel, w. 16.4 cm.

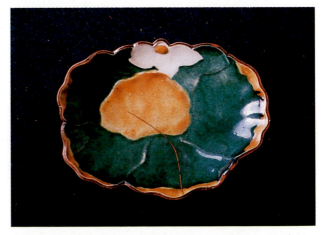

f Flower and leaf-shaped dish with overglaze enamels, w. 15.8 cm.

49. Sherds from Chōkichidani kiln, periods three/four

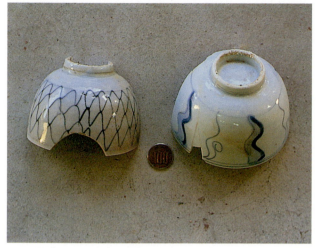

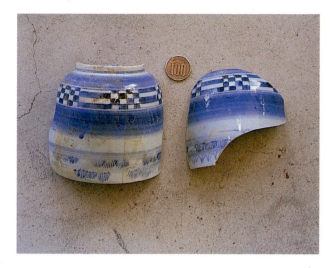

a–b Cups

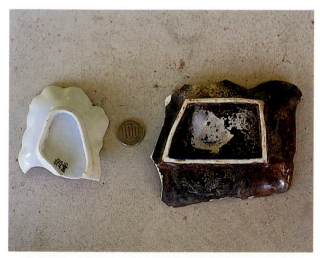

c Large dish with tiger and bamboo

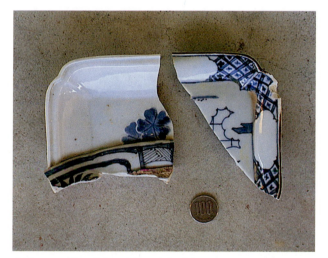

d Rectangular dishes, blue and white

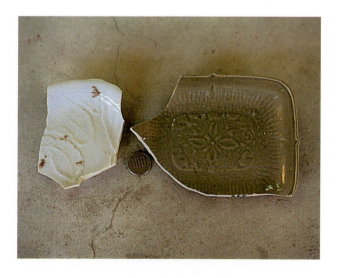

e–f Moulded dishes, white, *temmoku*, celadon

50. Sherds from Chōkichidani kiln, periods three to four

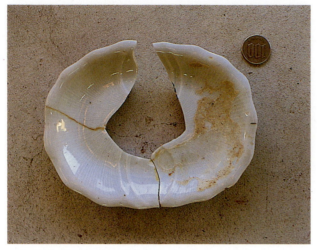

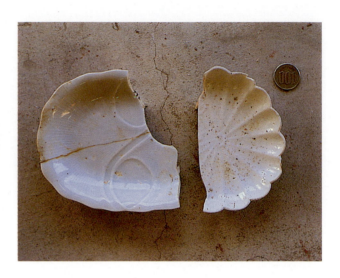

a–b Shaped and moulded dishes, white

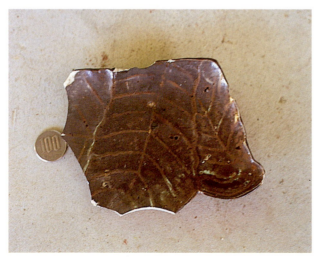

c Moulded blue and white dish

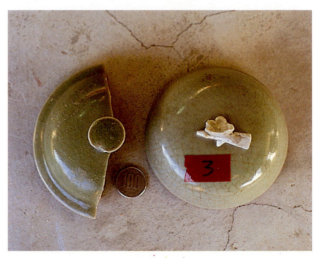

d Lids, one with white prunus spray knop

e Dish moulded as leaves, celadon

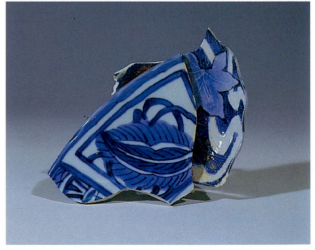

f Small leaf-shaped dish as Plate 23*f*, fused to export dish

51. Sherds from Hiekoba and Kama no tsuji kilns, period two

a–c Hiekoba. Landscape, b and c with flattened rim

d Hiekoba. 'Jade rabbit' *fukizumi* dish, *see* Plate 22*e*

e Kama no tsuji. Dish with moulded rim

f Kama no tsuji. Dish with flowers on water

52. Sherds from Kodaru kiln, period one

a Dish with vase of flowers, *see* Plate 17*a*

b Dish with random *fukizumi*

c Dish with bird and bamboo

d White dish with moulded rim

e Celadon leaf-shaped dish with thrown round foot, *see* Plate 18

f Kodaru Shingama. Dish with reversible arrow-leaf pattern

53. Sherds from Tengudani kiln, period one

a Bowl with simple Karatsu-style willow-tree

b Bowl with foliate scroll

c Bowl with 'net-window' pattern

d Bottle with all-over decoration

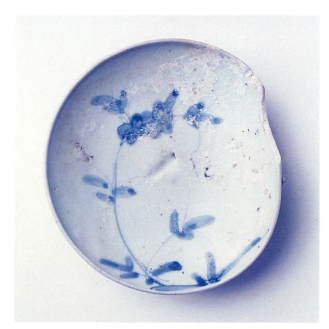

e Dish with border, flowers

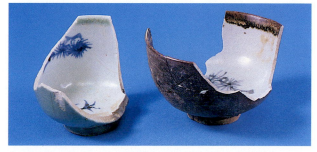

f Celadon and *temmoku* bowls with blue and white

54. Sherds from Tengudani kiln, periods one/two

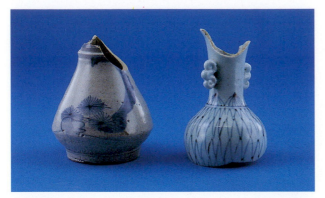

a 'Temple vases'

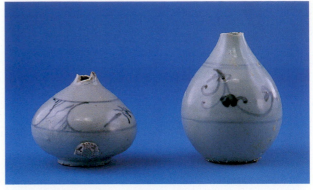

b Small bottles with zoned decoration

c Moulded bowls

d Small *guinome* cups

e Double gourd bottle

f Jar with floral decoration above a scroll-pattern border

55. Sherds from Kake no tani, Higuchi, and Gezuyabu kilns

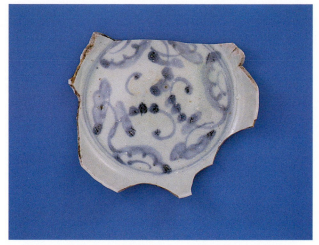

a Kake no tani. Reversible plant pattern, period one

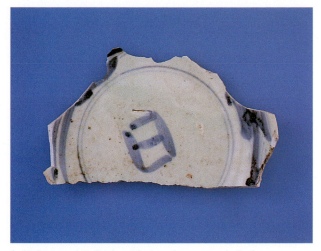

b Kake no tani. Dish with sun character, period one

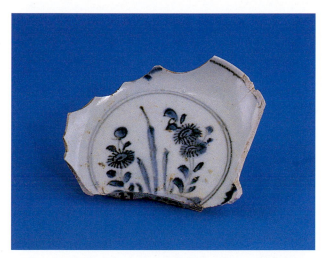

c Higuchi. Dish with plants within a border, period one

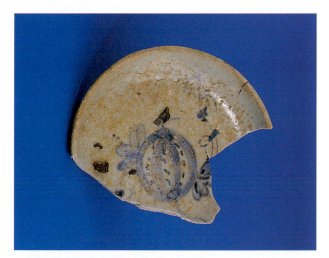

d Higuchi. Dish with melons, period one.

e Higuchi, Tea-whisk-shaped bottle, *temmoku* and ruri, period three/four, *see* Plate 30*b*

f Gezuyabu. Fisherman, period one

56. Sherds form Yamagoya kiln, period two

a Temmoku with blue and white reserve, waved rim, *see* Plate 12*a*

b Celadon with underglaze blue and rolled rim, *see* Plate 12*b*

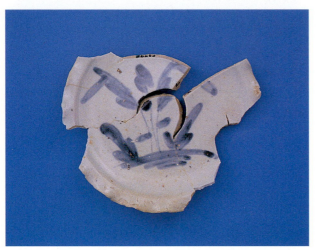

c Blue and white

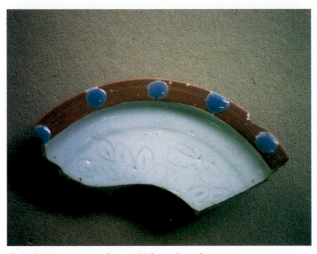

d Celadon, *temmoku* and blue-glazed spots

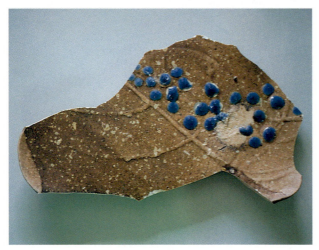

e Temmoku dish with blue-glazed grapes

f Reverse of (*e*) with splashed decoration, *see* Plate 12*c*

57. Sherds of small dishes from Tenjinmori kiln, period two

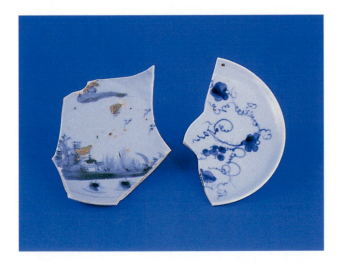

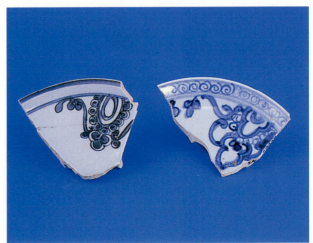

58. Sherds from Nakashirakawa and Komizo kilns, Period two.

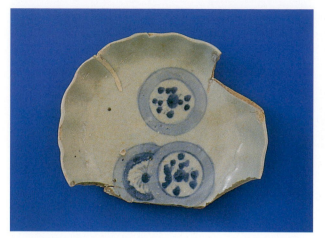

a Nakashirakawa. Roundels.

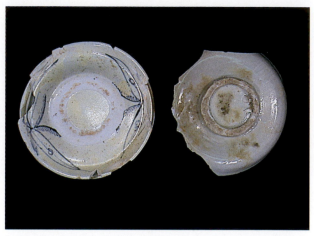

b Upper Komizo. Dishes with unglazed ring for stacking

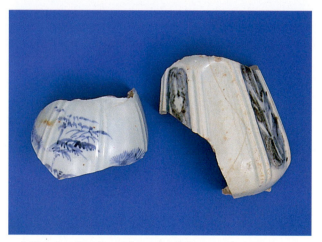

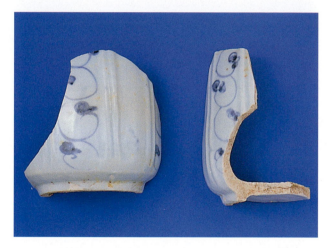

c-d Komizo. Bottles with vertical ribs, *see* Plate 7

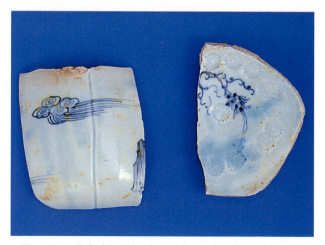

e Komizo. Celadon bowls with underglaze blue, *see* Plate 15

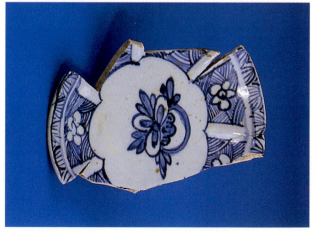

f Komizo. Small dish with underglaze blue

59. Sherds from Maruo kiln, periods Two/three

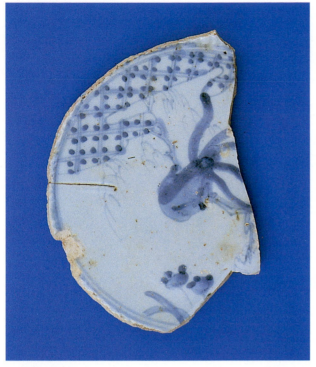

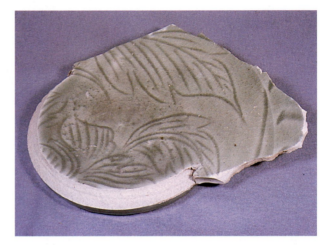

a Bird and diaper, *see* Plate 19*d*

b Celadon large dish, moulded decoration, *see* Plate 14

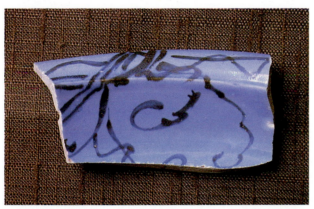

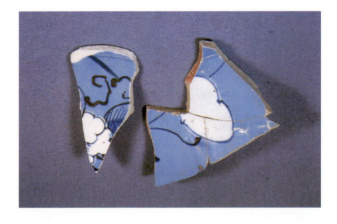

c–d *Ruri* with blue and white

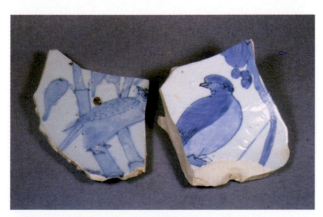

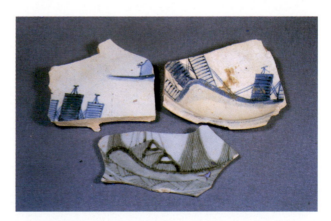

e–f Large dishes with strong designs, *see* Plate 13*a*

60. Sherds from Yamabeta kiln, periods one/two. Large dishes with small footring

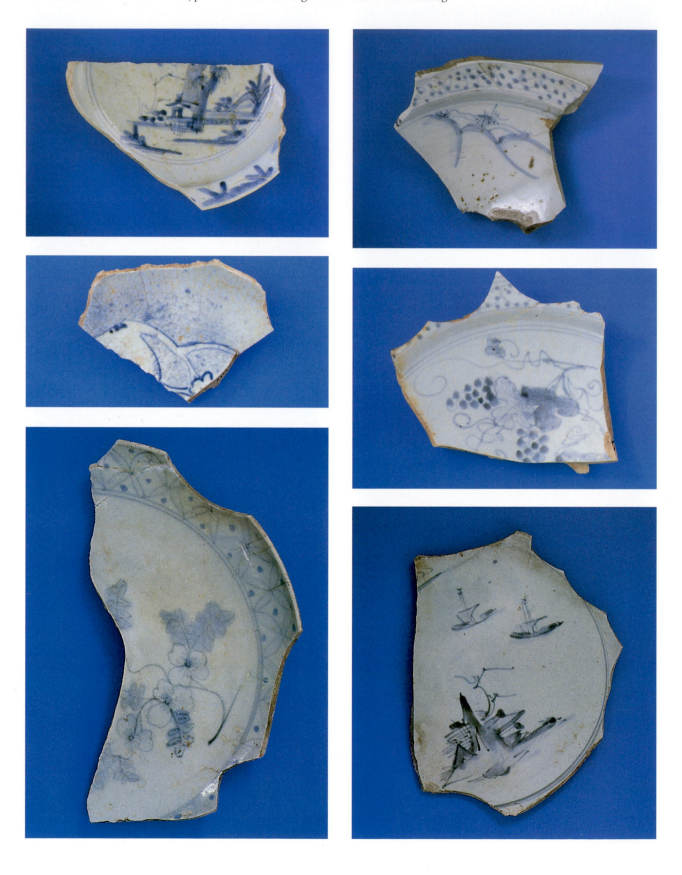

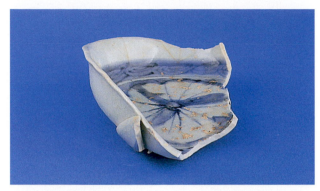

a Kusunokidani. Dish with gingko pattern

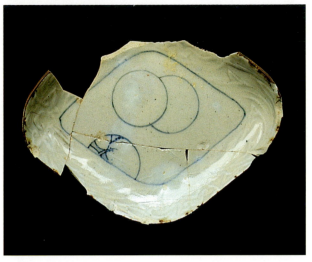

b Kusunokidani. Lozenge-shaped dish with roundels, *see* Plate 46*b*

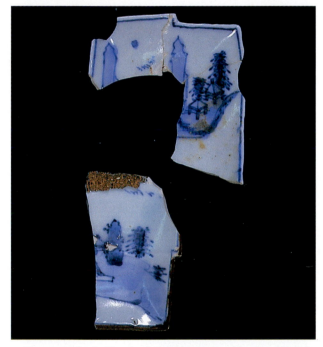

c Kusunokidani. Sherd of double poem-slip-shaped dish, *see* Plate 28*f*

d Fudōyama. Sherd of large celadon dish, *see* Plate 14

e Kotoge. Sherds of bowl with underglaze blue and copper-red and of bowl with iron-brown hatching

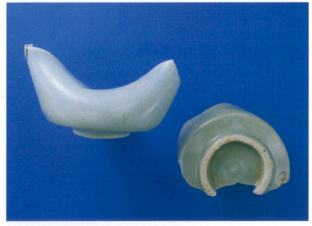

f Kotoge. Sherds of celadon bowls

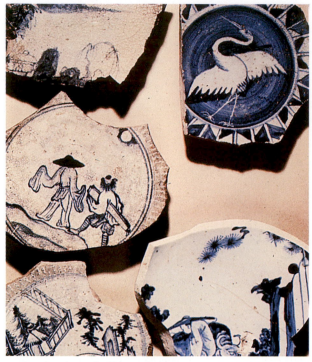

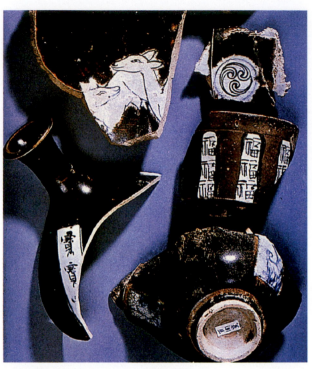

a Sherds of small dishes, from Nagatake (1975)

b Sherds of bottle, cups and plates with blue and white reserves on *temmoku* ground, from Nagatake (1975)

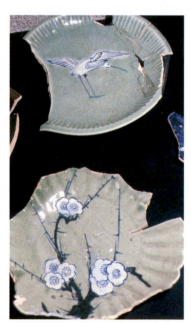

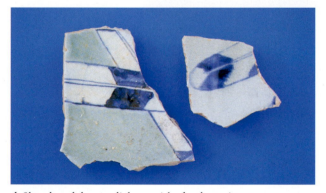

d Sherds of large dishes with feathers in reserve on a celadon ground

c Sherds of dishes with white reserves on a celadon ground

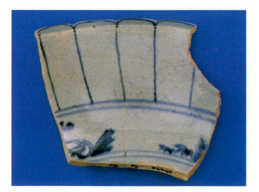

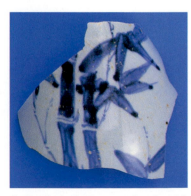

e Sherd of large bowl, *see* Plate 6

f Sherd of a large jar or bottle with bamboo decoration

63. Sherds from Hyakken kiln, period two

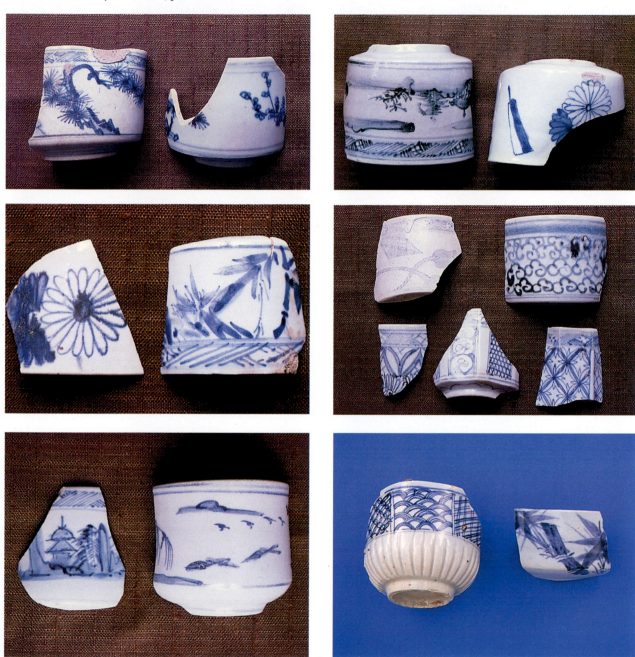

a–e Sherds of straight-sided cups *f* Sherds of cups

64. *a* Nakashirakawa. Sherd of large dish, Chōkichidani type, period three, *see* Plate 47

b Hyakken. Small dishes, chrysanthemum and landscape in formal border

c Hyakken. Two similar small dishes, landscape

PART II

The Production of Arita Porcelain in the First Half of the Seventeenth Century

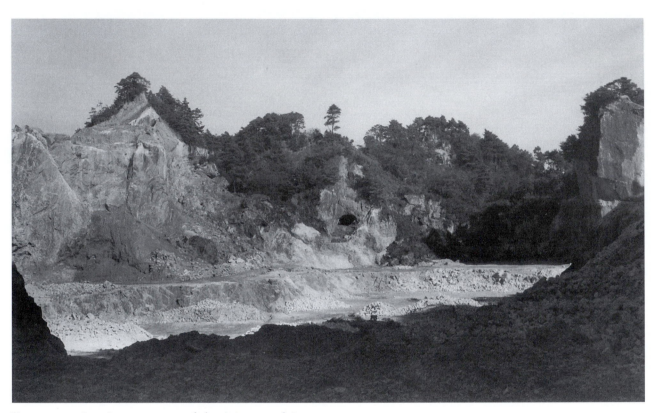

FIGURE 19. Izumiyama, source of the Arita porcelain stone

3

MATERIALS AND TECHNIQUES

Clay

THE clay used at the Arita kilns came from a deposit called Izumiyama, the mountain of clay supposedly found by Ri Sampei, in the form of porcelain stone (fig. 19). This is a metamorphosed acid rock of volcanic origin, consisting largely of sericite and quartz.[1] It is relatively low in alumina, but may naturally contain small quantities of the mineral kaolinite. Izumiyama was subject both to external weathering and to hydrothermic weathering from within, causing great variation within the considerable area of the deposit. It is weathering (by either method) that causes the breakdown of feldspar into sericite and kaolinite with accompanying loss of quartz. The more sericite and kaolinite is present, the higher is the alumina content which increases the plasticity of the clay and so these variations within the area of Izumiyama were very important. In the seventeenth century there was considerable competition for the better sites, or pits, from which to extract the clay.

Chemically Izumiyama porcelain stone is somewhat similar to that of the *yingqing* wares of China and to the mixture of clays used at Jingdezhen during the Ming period. In the form of which minerals the clay was used is not completely clear, however, nor is this possible to test by analysis of the fired body. The clay was clearly a very strong one, as the

observation that large jars could be thrown in one piece and not joined from two separate pieces as in China demonstrates. It is possible therefore that the clay contained some of the mineral montmorillonite, presence of which very greatly increases plasticity of a clay. The somewhat grey colour of the body of early Arita pieces was probably caused by a relatively high presence of titanium dioxide which tends to give a grey or green tinge.

Izumiyama stone was used unmixed and therefore was not the complex body such as that that was used in Jingdezhen. Simple bodies have the disadvantages of low plasticity and a high shrinkage, and it may be that mixtures of porcelain stone from different pits in Izumiyama were made in order to obviate these problems. Certainly the very thick body-wall used for some of the big dishes of Yamabeta kiln suggests that shrinkage was relatively low. All the better pits of Izumiyama clay are worked out and the clay is now only used for drain-pipes and suchlike so that it is impossible to make comparisons. It is fortunate that we have some comparative analyses from 1876 made by Wurtz,[2] who found that one area was almost entirely kaolinite; this suggests very strongly that the clay from different pits would have been mixed to form a comparatively complex body even though all of it was from Izumiyama. It is perhaps worth commenting that the Chinese Tianqi

TABLE 1. Two Typical Analyses of Unfired Izumiyama Porcelain Stone as given (i) by Yoshida and Fukunaga[a] and (ii) by Naitō[b]

	SiO$_2$	TiO$_2$	Al$_2$O$_3$	Fe$_2$O$_3$	P$_2$O$_5$	MnO	CaO	MgO	K$_2$O	Na$_2$O	H$_2$O	TOTAL
(i)	77.5	0.06	14.8	0.24	0.02	tr.	0.19	0.02	4.1	0.27	2.03	99.2
(ii)	77.9	0.05	14.2	1.02			0.54	0.20	5.1	0.40		99.7

a Yoshida Naojirō and Fukunaga Jirō, 'Mineralogical Studies of Izumiyama Pottery Stone', *Journal of the Ceramic Association of Japan*, 70/2 (1962), 36–41.
b Naitō, M. in the excavation report of the Haraake Kiln (no. 5), 38.

TABLE 2. The Means and Standard Deviations of the Chemical Composition of Fired Arita Porcelain given by Pollard[a]

	SiO_2	TiO_2	Al_2O_3	Fe_2O_3	MnO	CaO	MgO	K_2O	Na_2O	
mean	74.7	0.07	18.73	1.01	0.015	0.22	0.15	4.16	0.95	
standard deviation	2.6	0.04	2.04	0.30	0.007	0.06	0.08	0.45	0.33	(85 samples)

a For a more detailed chart of chemical compositions, see Appendix 2.

porcelain made for the Japanese market during the *shoki*-Imari period had a much higher alumina content. The data in Table 1 corresponds well with the analysis of the fired body used at Tengudani kiln. The body used at the Nangawara kilns of Komononari and (later) Kakiemon, but not, curiously, of the neighbouring Tenjinmori, were low in titanium which may have made it easier to obtain the famous milky-white *nigoshide* body of the Kakiemon kiln in the late seventeenth century. It has been suggested that some of the outer Arita kilns of the first half of the seventeenth century—in other words, in this context, those north-west of Arita—may have used a local source of porcelain stone. Thus the excavators of the Haraake kilns suggested that the source of the clay used there was Ryumon. Ryumon clay had a high level of arsenic in it and the excavators further suggested that this may have been a major factor in the short duration of porcelain production at Haraake. However, the mixtures of clay from various pits of Izumiyama may have been different enough for the bodies of the various kilns to appear as different as they sometimes do, and if the Outer kilns were treated by the Han administration with less esteem, then they may have had to do with the poorer mixtures. Analyses of the fired body of Izumiyama clay as used at different kilns have been made by Pollard,[3] and the differences between the kilns does not seem to justify postulation of a different source of porcelain stone (Appendix 2).

Arita porcelain was made from a mixture of porcelain stone from various places within Izumiyama. Amakusa stone was not mixed into this until the nineteenth century.

Preparation of the Clay

Porcelain stone is very hard and so it has to be crushed before it can be levigated in water. Today crushing is done by machinery; in the seventeenth century it was done by water-driven pounders. Partly for this reason many Arita kilns were near to running water. No such pounders exist today, though I have been shown places in a stream-bed near to Hirose kiln where cutting of some of the boulders in the stream-bed was said to mark the place of a former pounder. I have also been informed that there were until recently several such in the Shirakawa. The very name Shirakawa (White River) suggests that this was so. A contemporary description of the pounders of the mid to late nineteenth century, which were presumably very similar or identical to those of the seventeenth century, is given in the catalogue of the International Exhibition held in Philadelphia in 1876.[4]

The porcelain stone of Arita . . . is always powdered by means of balancing pounders of a peculiar construction. These are composed of long horizontal beams, with a perpendicular cross-piece at one end. This instrument is put up wherever a small stream of water can be utilised; the water running into a small trough raises the pounder by over-weight, and running out at the end in consequence of the incline, allows it to fall down again, with the iron-shod cross-piece dropping into a stone mortar, in which the materials are thus reduced to powder; the latter is then sifted, mixed with water, and decanted.

No other machinery, such as the quartz- or glaze-mills of foreign porcelain manufactories, is used, and the consequence is that all the material which cannot be sufficiently powdered by the above described pounders (amounting often from 40 to 50 per cent) is thrown away in waste. The fine powders produced by decanting are carefully mixed, and removed into flat boxes, where the water is partly drained off through a sand bedding, covered with matting, and partly tapped off from above the deposited clay; the latter is finally brought to more consistency by placing it on the warm furnaces. Long experience, combined with the good quality of the raw material, enables the manufacturers to prepare a clay fit even for the production of very large pieces, such as vases from six to seven feet in height.

A reproduction of these pounders has been built at the Arita Porcelain Park (fig. 20). In gardens in Japan today one may often see 'wild boar scarers', now purely ornamental, that work on this principle. An unbalanced bamboo stem stands horizontally on a pivot with the shorter end under a small waterfall.

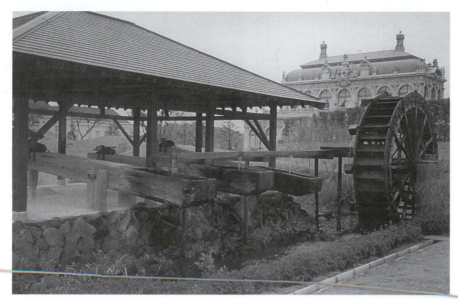

FIGURE 20. Replica of clay pounder; replica of the Zwinger Palace, Dresden, in the background. Arita Porcelain Park

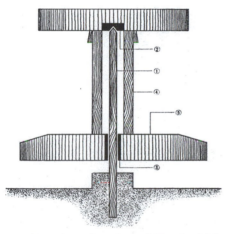

FIGURE 21. Drawing of section of Kyushu kick-wheel

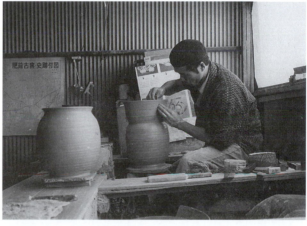

FIGURE 22. Eguchi Katsumi throwing

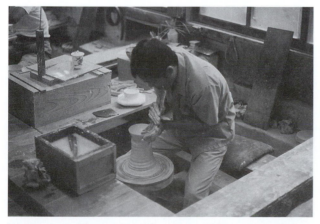

FIGURE 23. Throwing with a *hera*, Kakiemon workshop

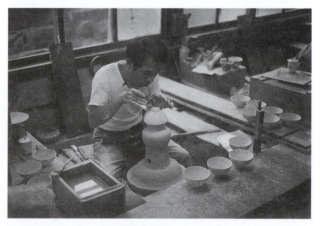

FIGURE 24. Turning, Kakiemon workshop

As water from the fall fills up the hollow segment, this end dips downwards; the water then runs out and the other end, now the heavier, falls sharply, hitting against a carefully placed stone and making an agreeable booming sound. One cannot seriously imagine it frightening away a wild boar, but no doubt the method might originally have done so.

Levigation in water is important as it helps to remove quartz, and both sericite and kaolinite have a smaller particle size than quartz. If more kaolinite were present, then less levigation would be necessary. After levigation the clay is partially dried by evaporation and then kneaded by hand.

Kakiemon XIII told me that the *nigoshide* clay body for which his ancestors were so famous was made not only of a special mixture of clays, but that also it was washed in water for a very long time.

Making

Almost all *shoki*-Imari pots were thrown on the wheel. This wheel, now called the Kyushu kick-wheel, was probably introduced from Korea at the end of the sixteenth century, and is still in use in many workshops in Karatsu and Arita. It works on the principle of a fly-wheel, with the table as an upper fly-wheel, and with a lower ring which the potter can kick with his foot (fig. 21). The spindle fits into the under surface of the upper wheel. As the potter sits to the wheel, the throwing surface is about level with the seat on which he sits, so that he can bend over the wheel (fig. 22). The lower ring is about two feet below the upper, at a convenient level for the foot to push it. All the potters that I have observed working used the left foot to push the wheel, as the Kyushu wheel is turned in the clockwise direction.

To throw, the potter usually places a large lump of kneaded clay onto the wheel, shapes it roughly conical and more or less centres it; he then centres and throws off the top of the lump, detaches the thrown pot, centres another small part of the top of the lump and throws another pot. For the simpler shapes, a good potter can throw fifty or sixty an hour. Every now and then the size must be checked against a model to ensure that there is no progressive change in size. Sometimes the potter will use a *hera*, a wooden spatula of a special shape for the inside wall of the pot (fig. 23). This *hera* seems only to be used in Hizen. The thrown pot is removed from the top of the lump with a wire while the wheel is still rotating. After a half-cut, one end of

the wire is released from the hand, and the still-turning pot is cut off. This gives a characteristic loop pattern to the base of the pot (this is called *Karamono itokiri*, or Chinese cutting). In Karatsu and some other stonewares this pattern was often retained, but in porcelain it is usually removed when the pot is turned at the leather-hard stage.

Turning is not usually done on a disc of clay, but on a lump of clay on top of a stick or a specially made ceramic pillar; the pot is inverted onto this, and centred while it rotates by slight flicks of the turner's finger (fig. 24). The earliest pieces had a small, neat foot that was glazed; in the 'mass-production' stage the unglazed foot was strongly cut with a few turns of a metal or sharpened wood knife, and the feet of early *shoki*-Imari bowls and small dishes are highly reminiscent of those of Karatsu. Chatter-marks are almost never found. Later in period two, the finer foot so characteristic of Arita wares was made, but these were by no means standard; at the Tenjinmori kiln-site, I found two small dishes of the same pattern of decoration, on one of which the foot was at least three times as tall as it was on the other. This foot is carefully made, relatively thin, and will be trimmed after glazing to eliminate glaze from the standing surface. At the early period, bottles tended to have no foot, but to be turned within the shape of the foot only (see Plate 31*a*).

Much of the porcelain made in the Arita kilns was not round. In period one this would be achieved by reshaping after throwing; in periods two, three, and four (and later) press-moulds of non-round shapes were used. Cast moulds were not used at all in the seventeenth century.

Small dishes were often incised with a modelling tool to produce a series of radiating lines on the wall of the piece, a petalled effect. Often the rim was trimmed to match; this trimming was to become extremely sophisticated in period three. Otherwise the dish could actually have cuts made to the rim until it was, say, lozenge shaped. In period one, the foot in such cases had been turned and remained round, and this is a good indication of an early date. Later, the modelled foot of period two was replaced by the attached ribbon foot of period three.

Bowls and bottles could be faceted or otherwise reshaped after throwing, before they were turned. Even the complex ribbed sides of the characteristic bottles of Komizo, Hyakken, and Tenjinmori were modelled at the 'green' stage. At Tengudani E kiln, the

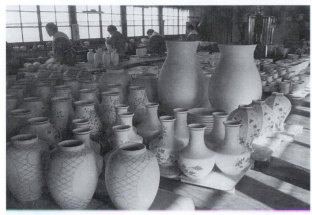

FIGURE 25. Underglaze-blue-painted pots waiting for glazing, and later enamelling, Imaemon workshop

Decoration

Shoki-Imari porcelain could be either decorated in glaze colours, or be left in the white, under a transparent glaze. The glaze colours from the earliest period were celadon and iron-brown. These often occurred over the whole piece, but also often in conjunction with the ordinary transparent glaze, when, for example, the exterior of a food bowl would be in celadon, and the interior plain. Sometimes the interior of such bowls had underglaze blue painted decoration within. Only from period two were celadon and iron-brown used together on the same piece.

Much of the Arita production was, of course, decorated in underglaze blue. Underglaze blue is made from a suspension of cobalt oxide in water; the mineral from which it derives is erythrite. It is not certain from whence the Arita cobalt came; possibly, though by no means certainly, it came from China. When raw, cobalt oxide is black; it only turns blue when covered with a glaze which is then fired to maturity in a reducing atmosphere. Late oxidation in the process of firing turns it grey. Underglaze red was used rarely; at least one kiln (Hirose) specialized in its use (see Plate 9a), some other kilns used underglaze blue and underglaze red on the same piece (see e.g. Plate 27e and Plate 61e).

The use of underglaze blue, under a transparent glaze, on a piece that also bore celadon or *temmoku* glaze was a commonplace from period one. At one kiln (Yamagoya) of the early period, underglaze blue and underglaze red were used together with celadon. A few kilns (especially Komizo and Hyakken) used

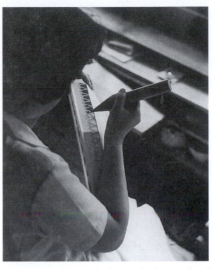

FIGURE 26. Painting in cobalt oxide for underglaze blue, Imaemon workshop

cobalt-blue decoration under a celadon glaze instead of under a transparent glaze. This was also done in the export period, at Hiekoba kiln and in the Nabeshima kiln.

Painting in underglaze blue leaving spaces for the later application of enamel pigments (see below) was common in periods three and four, but the space left was not specifically for a particular pattern. It was usually in the form of a cartouche that could be filled with any image in enamel (see, e.g. Plate 61b). Only very rarely indeed in period three—and, indeed, into the early export period—was space left that demanded a particular pattern. This required close collaboration between the painter in underglaze cobalt and the enameller working on the fired pot. This, in turn, implies a workshop where all the different processes could be undertaken, or co-operation between the workshop making the porcelain and an enamelling workshop (fig. 25). A rare example of such a collaboration in late period three is to be found on the backs of the dishes in *ko*-Kutani style depicting Hotei (see Plate 37a) and a landscape (see Plate 37c) where space has been left in the perfunctory cherry-tree branches for the red cherry blossom.

There was no biscuit firing of *shoki*-Imari. Pots to be decorated were dried in the sun, painted, and raw-glazed. The paint was applied with a special brush; this has a large cone of bristles tapering to a fine point, inserted into the end of a short piece of bamboo, perhaps 7 cm. long, and only a little longer than the length of the bristles. The bristles can be loaded with a very considerable amount of the cobalt oxide suspension (fig. 26). The painter holds the

bristles, not the handle. When the hand of the painter closes around the bristles the suspension can flow easily through the bristles and a blob of the coloured water is formed at the tip of the brush, on the surface of the pot to be decorated. This blob of liquid, whose size is controlled by the pressure of the hand of the potter on the bristles, is pushed around the surface of the pot. The blob can be lifted from the surface by relaxation of the painter's hand. The size of the blob of liquid determines how fine the line or wash area will be. As the unfired body is highly absorbent, this is not an easy technique; no revision is possible, and an area covered twice will be darker than an area covered but once. There will also be a hard dividing line where these areas meet. This phenomenon may well have been exploited by the Chinese to produce the 'cracked ice' pattern of the Kangxi. In Arita the colour of the blue varies very greatly; in the early years it was often of a distinctly greyish tinge, suggesting underfiring and imperfect reduction in the kiln.

Patterns for decoration were probably sketched or pounced onto the body in charcoal before the application of paint. This would leave no trace as the charcoal would be fired off.

Apart from glaze colours, all-over effects could be obtained by dipping the pot in cobalt oxide to make it blue (*ruri*) and partial coloration could be done with a spray, when often an area would be reserved with a paper cut-out pattern. This area could later be painted or line-decorated (see Plate 11*a* and Plate 59). This could be done in two ways; in periods two and three the blue would be scratched away to reveal a line of the white body; in period four (probably) the design would be painted in ink onto the unfired body before the application of the blue pigment. On firing, the ink would burn off (even under the glaze), leaving an almost white line as if it had been wax resist.

Partial effects could also be obtained either by flicking paint from a brush onto a pot randomly, or by blowing it through a bamboo tube with a cotton gauze over the end (see e.g. Plate 22 *b–e*). This produced an unevenly sprayed area and was called *fukizumi*; here also areas could be reserved for later painting. One of the most famous of Arita patterns, the 'jade hare under the moon', is made in this technique (see Plate 22*e*).

Yamagoya and Hyakken seem to have specialized in reserves of underglaze blue decoration on an iron-brown ground (see Plate 12*a*) (this is often called

Suisaka ware, after an unknown kiln-site in Kaga which is supposed to have made pieces in this style). Some kilns of the third period (e.g. Nakashirakawa) sometimes used complex reserved patterns; some others (e.g. Shimoshirakawa) sometimes used two different glazes, perhaps *temmoku* and *ruri*, together with reserves in the white (see e.g. Plate 46*b*).

Underglaze copper-red was little used in Arita. Hirose kiln seems to have been the only kiln to specialize in its use, and that only for a relatively short time, at the end of the early period and the beginning of the second period (see Plate 9*a*). A few other kilns used copper-red sparingly in conjunction with blue and white, and occasionally also with iron-brown. The colour was never very good, being rather dark; this is because the red is muddied by contact with the body. In China the successful red colour was achieved by painting the oxide between layers of glaze, needing of course a second firing; this seems not to have been done in Arita.

Press-moulds were used for the application of a moulded pattern to the upper surface of open shapes; sometimes (e.g. at Tengudani) these could be quite complex even in the early period. Almost certainly, such shapes were thrown before being pressed to the mould. The moulds were made of an absorbent material, possibly biscuit-fired clay; the use of plaster of Paris was not introduced until the late nineteenth century. Some early moulds are preserved by the Kakiemon family. Small figures were also made in press-moulds, in two or more pieces which were luted together when still green. Large figures were probably not made until the export period.[5]

Glaze

Korean stoneware is often glazed with a glaze made of porcelain stone and wood-ash. Many of the Karatsu stonewares may well also have had a porcellanous glaze. No doubt this use of the two materials together was part of the impetus towards the making of porcelain in some of the Karatsu kilns.

The source of the porcelain stone used for the glaze in Arita, and possibly also in some Karatsu, was an outcrop of decayed granite, closely related to that of Izumiyama, but about two kilometres up the Shirakawa river. It is today called Shirakawa Yamatsuji. Looking like a large quarry, one cliff wall has deep tunnels dug into it; clearly it was as variable as was Izumiyama. Stone from here is sometimes still used today, but the site is difficult of access

and I do not believe that it can ever be used in quantity.

The basic glaze used for Arita porcelain was a mixture of porcelain stone and wood-ash in the proportions of from 9 : 1 to about 6 : 4. Increase in the amount of wood-ash, which acts as a flux, lowers the melting temperature of the glaze and increases its transparency. For white wares a lower proportion of wood-ash would be used than would appear in blue and white decorated wares. Celadon glazes require the addition of iron to the glaze, and if the body selected for celadons was rich in titanium the greenish quality would be enhanced. Addition of much more iron made *temmoku*, black or brown glazes. As with blue and white wares, these would have been fired in a reduction atmosphere.

Liquid glaze has the consistency of cream. It can, therefore, be applied to the raw body in a variety of ways. In Arita the glaze was usually either poured over the piece or the piece was dipped into the liquid glaze. Bowls and small dishes could be held by the foot-ring, resulting in an unglazed foot-ring and the frequent occurrence of the glazers' fingerprints. A small bowl that was to be plain inside and either celadon or *temmoku* on the outside, common enough in Arita, would have the transparent glaze poured into it, swirled around, and then emptied out again. Quite quickly after that it would be dipped, inverted, into the coloured glaze; the airlock would allow the coloured glaze to reach just inside the rim of the mouth, and this would give a thick rim of coloured glaze in this area. Korean bowls were not glazed in this way, nearly all have a fully glazed foot. Nor were all Arita wares dipped; many of the *shoki*-Imari wares have a glazed foot-ring that has to be cleared of glaze before firing. This was usually done with some sort of knife, and the resultant cut of the foot is sometimes used to differentiate types from each other.

Glazed pots were left to dry and then fired (fig. 27). There is some disagreement as to whether or not Arita porcelain was all raw glazed, or whether after a certain period (usually held to be at the end of the seventeenth century) there was a biscuit firing. The second firing is said to cause the oxidation visible as a brown ring around the foot of so many Arita porcelains. It is, however, extremely unlikely that there was normally a biscuit firing at any Arita kiln until the nineteenth century. At the biscuit stage ceramics are relatively soft and are greatly susceptible to damage. Damaged biscuit sherds would have been discarded, for clay that has passed a tempera-

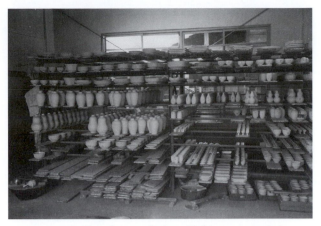

FIGURE 27. Glazed pots drying, Kakiemon workshop

ture of 500°C is irreversibly changed and cannot be reconstituted into clay, and a normal biscuit firing would have been to about 950°C. No grog was used in Arita, so discarded sherds would have been waste. Kilns that had used a biscuit firing would therefore have produced large quantities of sherds. Yet biscuit sherds are almost never found at Arita kiln-sites. Compare this finding with the results of the excavation of a nineteenth century site in Kaga, where the excavators had to remove several tons of biscuit sherd waste.

No biscuit kiln has ever been found in Arita; this may not mean much, for neither has any muffle kiln been found and they were certainly used. The only evidence we have for the purposeful biscuit firing of porcelain in Arita is from the Akae-machi site, where, as we have suggested, figures may have been biscuit fired in muffle kilns prior to high-firing in a *noborigama*. Today the upper chamber(s) of a *noborigama* may be used for biscuit firing.

Most Arita porcelain of the early period was rather underfired. The body was opaque and grey, and the glaze often a little matt. Sometimes there was slight pitting of the glaze; where this happened the unprotected body reoxidized and a pink area shows on the surface.

The Kiln

The choice of the site for the building of a kiln, if we ignore, in our ignorance, questions of landownership, were dependent first of all on the right degree of slope; usually 10–15°. In all probability access to running water would also have been important.

The kiln used in Arita in the seventeenth century was the *noborigama*, the stepped, chambered climbing

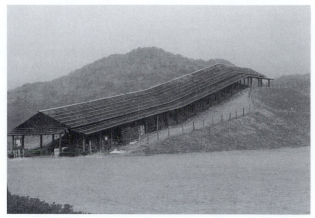

FIGURE 28. Reconstruction of the Tengudani kiln, Arita Porcelain Park

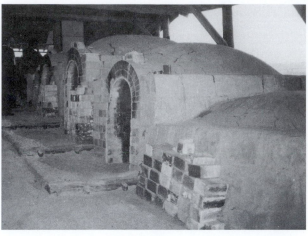

FIGURE 29. Three-chamber *noborigama*, Kurita workshop

kiln. This derives from the simple vaulted tunnel kiln of China, the dragon kiln, via the early Karatsu *waridake noborigama* ('split bamboo climbing kiln'), which had dividing walls pierced at the base at intervals, forming rudimentary chambers each with a door. These were used at the Kishidake group of kilns.

The earliest Arita kilns were built of a coarse clay, paddled into shape, apparently with no other support; later, the kilns were made of bricks, presumably of the same clay as used previously, and coated with clay outside and, possibly, inside too. It is likely that the interior of the kiln chambers were coated with glaze material to prevent falls of clay from the roof onto the firing pots.

The true *noborigama* seems to have been introduced to Karatsu by the Koreans who immigrated in the last decade of the sixteenth century. All Karatsu kilns after that period were *noborigama*, and hence so were those of Arita (figs. 28 and 29). The *noborigama* consists of an uphill series of linked vaulted chambers, with a firing chamber at the lower extremity and (today) a chimney at the top. It looks therefore like a series of domes ascending a hillside. Each chamber was linked to the chamber above by flue holes at the level of the floor of the upper chamber, and therefore a little off the floor on the uphill wall of the lower chamber (fig. 30). Sequential firing of these chambers, uphill, was economical on wood, and the partial down-draught produced allowed a much greater control over distribution of the heat within each chamber, and therefore around each pot, than had been possible before.

The structure of a kiln, if sufficiently well known,

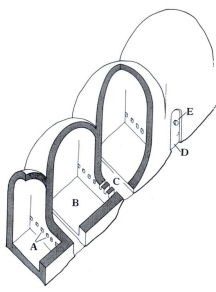

FIGURE 30. Diagram of *noborigama*; A, flues into adjacent uphill chamber; B, stacking floor; C, firing floor; D, door; E, stoke-hole. Drawing by Edward Impey

can provide an approximate guide to its date; Ohashi has drawn up a scheme of the relative progression of increase in size of the individual kiln chambers with time (see Table 4 in ch. 5).[6] Thus later kilns tend to have larger chambers than earlier ones. This should not be regarded as absolute. Nor can the decrease in the angle of the slope upon which a kiln stands be seen as an absolute indication of later date.

In period one each chamber was probably relatively low; with the unsophisticated kiln furniture available then, it is unlikely that they were higher than a metre. With the increase in the use of seggars, mainly during period two, the height of kiln chambers may have increased up to 2 m.

TABLE 3. Measurements of Four Representative Kilns of Early Seventeenth-Century Arita

Kiln	Angle of slope	Number of chambers	Length (metres)	Size of width (metres)	Chambers, depth (metres)
Tenjinmori 3	15°	?26	62	2.5–3	2–3
Tengudani A	14°	16	54	3.2–3.8	2–3.6
Sarugawa B	13.5°	9	c.24	2.9	2–2.2
Fudōyama	10°	17	60	3.3–5.1	2.8–4

Combustion began in the firing chamber at the lowest point; no pots were placed in this chamber. When a temperature of about 850°C was achieved in this firing chamber, then the first chamber proper was fired, and after this each chamber in sequence going up the hill. Today the draught is pulled by the chimney at the top, but there is no archaeological evidence for a chimney at any kiln of the seventeenth century. It may have been the angle of slope of the various kilns which controlled to a great extent the speed of firing of the kiln. A drawing of a kiln of the Ansei period (1854–60) shows that the chimney of the kiln depicted was about 4 m. tall. The chimney of the modern three-chamber *noborigama* Tanigama, the kiln of Fukugawa Iwao, has a height of about 4 m.

The draught in the kiln chamber is a partial down-draught produced by the shape of the chamber and its position relative to the one below and the one above. This draught is forced to pass around the pots stacked in the chamber, thus ensuring as even a temperature gradient as possible throughout the chamber. In practice, each chamber has and had its own idiosyncrasies, and it was part of the skill of the potter or firing-master so to stack the chamber as to take advantage of or to attempt to obviate these characteristics.

The floor of each chamber was on two levels; the lower level (only a few centimetres lower) was at the downhill end of the chamber. Level with this part of the floor were the flue holes from the chamber immediately below. At one side off this part of the floor was the door of the chamber. When the kiln chambers had all been packed, these doors were sealed with fire bricks and wet clay, save only for a stoke hole with a removable bung. It was through this hole that the wood was thrown during the individual firing of each chamber, onto the floor-space opposite. The lower section of the floor, therefore, was where the fire in each chamber burned. The higher section of the chamber was usually deeper, often twice as deep as the lower, and it was here

that the pots were placed on whatever kiln furniture was available (fig. 31).

On the uphill wall, adjacent to the next upper chamber, were the flue holes into that next chamber. In Tengudani A kiln, these were about 30–50 cm. from the floor. They were level with the lower, firing section of floor of the next chamber up. The main draught, therefore, heated and forced upwards by the fire as it came into the kiln chamber from the one below, travelled across the arched roof of the chamber and down the uphill wall to the flue holes near the base of that wall and out into the next chamber after that. The hot draught was thus forced to circulate around the stack of pots (see the diagram, fig. 30).

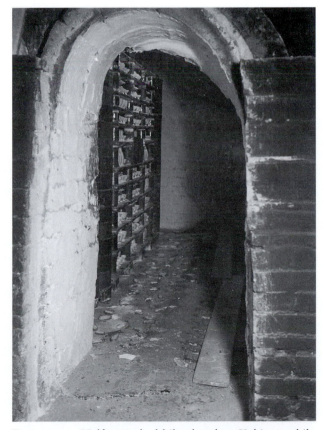

FIGURE 31. Half-unpacked kiln chamber, Kakiemon kiln

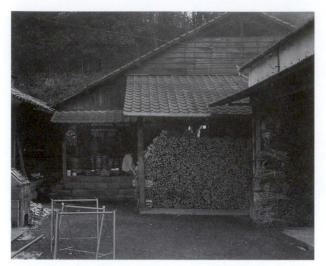

FIGURE 32. Firewood, Kakiemon workshop

The Firing of the Kiln

The amount of wood used to fire a chambered kiln is very considerable (fig. 32), and the more chambers, the more wood is used. In the seventeenth century there were edicts from the Nabeshima Daimyō attempting to control the amount of wood used, so as to prevent deforestation (see ch. 11).

The time taken to fire such a kiln is considerable. In a typical firing of the three-chamber Tanigama, it took twenty-three hours to fire the combustion chamber up to 850°C, when the first chamber was then fired. It took nine hours to bring this up to 1,280°C, the required temperature. At the sixth hour of this nine, the second chamber had reached 850°C and it was then fired. The third chamber reached the required 850°C just as the first was completed, and it was then fired. The whole firing process took thirty-nine hours. The kiln was sealed and left for two and a half days to cool down. The slow rate of firing is an essential part of the process; the correct maximum temperature must be reached as well as an input of the correct quantum of heat. Evenness of rise and fall of the temperature is essential for the best results of firing.

For the firing of pots decorated in underglaze blue or glazed in celadon, it is essential that the firing should take place in a reducing atmosphere, at least after the temperature of 1,000°C is reached, in order to obtain the desired colours. This is done by the removal of as much oxygen as possible from the chamber during and after firing. Wood freshly put into a fire requires oxygen to burn; it therefore

removes some of the available oxygen in its surrounding atmosphere. The potter uses this to reduce the amount of oxygen in the chamber by throwing in the wood at intervals timed to catch the fire just at the point where the wood stops needing oxygen to burn. This can be judged by eye. Wood freshly placed in the fire produces black smoke. After throwing some wood into the fire, the firer stands back to watch the smoke as it emerges from the chimney. When the smoke starts to turn white, then the fire is no longer reducing and more wood must be placed in the chamber. The amount of wood used and the timing of its use, which help to control the speed and the atmosphere of the firing, are thus essential ingredients of the skill of the firing-master. The final temperature of the firing, usually in Arita 1,280°C, can and could be judged by eye; today cones and thermocouples are used.

Kiln Furniture

The floor of each chamber of a *noborigama* is of beaten clay; every time each chamber is fired the surface of the floor, as well as the walls and the interior of the vault is also fired. Consequently, the floor is likely to become uneven as it accumulates the debris of small parts of roof and kiln wall that fall during firing, and are fused to the floor by the fall of natural ash glaze that is an inevitable by-product of the burning of wood within the chamber. It is therefore essential to the potter to raise pots for firing off the floor. The easiest way to do this is simply to use a scatter of sand, or to place small balls of clay under the foot of each pot. In practice this is insufficient to clear the pots from the accumulated glaze, and kiln furniture is used. It is onto the kiln furniture that the scatter of sand or the balls of clay may be placed. This kiln furniture must be made of a highly refractory clay so as to withstand the high temperatures of the kiln without warping, as this would misshape the pot placed upon it, and would render it unfit for reuse. Although kiln furniture is usually roughly and crudely made, it would be too extravagant to discard every piece after a single firing.

In Arita in the early phase of the industry, the kiln furniture used was very simple.[7] Only two shapes were used, and these could be used either separately or together. One is the *hama*, a flat disc or square of clay of varying thickness and diameter (fig. 33). At Tengudani A kiln, a representative kiln of the early period, these *hama* were 5–10 cm. wide and 2–3 cm.

FIGURE 33. *Hama* from period two, to take a shaped foot

FIGURE 34. (*right*) *Tochin* from periods one to three

thick, but occasionally they were much thicker. Sometimes, also, the *hama* were thick and tapered to form an inverted truncated cone. This latter was later to become the most common type. The other shape of kiln furniture was the *tochin*, a stand of dumbell shape with flattened ends (fig. 34). This stood upright on one end, bearing the pot to be fired upon

the surface of the other end. Sometimes, as we know from kiln accidents where pieces were fused together in firing, *hama* were placed on *tochin*, sometimes *tochin* upon *hama*. Clearly this would have been to gain height, for it was the height of the *tochin* that was exploited to fill the floor of the kiln as fully as possible. If *tochin* were interspersed with pots on

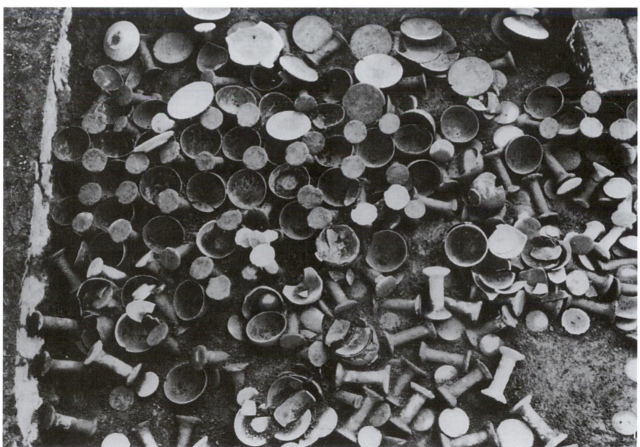

FIGURE 35. Excavated chamber of the Fudōyama kiln; the roof had collapsed and many of the pots are still *in situ*. From the kiln report (No. 4)

FIGURE 36. Kiln stacking; *suname* (sand) and *taidome* (balls of clay)

FIGURE 37. Seggar with collapsed pot, Kotoge kiln

hama on the floor of the kiln chamber, then the pots on these *tochin* would make, as it were, a second layer, almost doubling the capacity of the kiln with consequent saving of wood and of time. That this was standard practice is demonstrated by the finding at Fudōyama kiln, near Ureshino, a kiln that worked in the early period, of a kiln chamber with pots on stands *in situ*. This had not been disturbed and may have resulted from the collapse of the entire roof of the kiln chamber during firing (fig. 35).

By the standards of the contemporary kilns at Mino, this simplicity of kiln furniture, the scarcity of the seggars that we shall discuss later, is a little puzzling. After all, complex kiln furniture had been in use in China since the Song, and even at Mino since the mid-sixteenth century. But the Karatsu kilns did not use seggars, and presumably this affected the early stages of production in Arita. Even the lack of their use at Karatsu is a little strange, for there was considerable exchange of technical information between Karatsu and Mino, witness the *noborigama* itself. Nor can it have been due to lack of suitably refractory clay for the making of seggars, for these are of the same material as are *tochin* and *hama*.

In Karatsu stoneware and in the Takeo-Karatsu stonewares, small dishes were fired in stacks, sometimes of half a dozen or so pieces. Each piece was separated from its neighbour either by small balls of clay (*taidome*) or by the use of a scatter of a small quantity of sand (*suname*) (fig. 36). Both of these methods left unsightly scars on the using surface of each dish. In the former case there would be four or more small scars, in the latter a roughened incomplete circle the size of the foot-ring of the dish above. In the case of the Takeo-Karatsu stonewares, the *taidome* method of stacking continued, even for quite large dishes, for a long period; in the Karatsu stone-wares the *taidome* method was superseded by

the *suname* method at about the time of the introduction of the making of porcelain into some Karatsu kilns. Porcelain was sometimes stacked by the *suname* method (e.g. at Komizo kiln) but this was clearly too crude, and porcelain was thereafter rarely stacked. No case is known of Arita porcelain stacked by the *taidome* method. Later, porcelain, usually of inferior quality, was sometimes to be stacked by the technique of leaving unglazed a ring that conformed to the shape of the foot-ring of the piece that was to be placed on top. This left an unglazed but not too unsightly ring that could be covered in enamel in a second firing.

The use of seggars eliminates this and other problems. Seggars were used in Arita kilns in the second phase of production more commonly than they had been earlier; they do not, however, apparently coincide with any stylistic innovation and so cannot be used to mark a new period. They were made of the same material as the earlier kiln furniture, and are equally reusable. In essence a seggar is a pot into which another is placed to be fired (fig. 37). This confers four major advantages on the potter. First, pots can be fired without danger of them touching each other. Secondly, the seggar creates within its walls its own atmosphere, its own microclimate during firing, allowing much more regularity of this atmosphere. Thirdly, the seggar protects the pots from

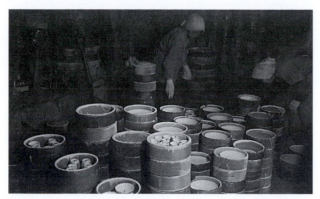

FIGURE 38. Modern modular seggars, Kakiemon workshop

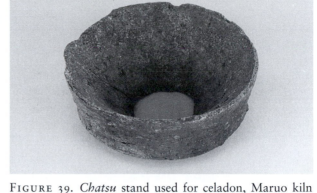

FIGURE 39. *Chatsu* stand used for celadon, Maruo kiln

falls of kiln roof material, a major source of waste in pre-seggar days, and fourthly, by the stacking up of the modular seggars the potter is able to fill the kiln up to the level of the roof (fig. 38). Not only does this fill the kiln more full than before, which helps to ensure a more even course of heating and cooling, but it allows the kiln-maker to build taller kilns. Early Arita kilns had had a roof about one metre from the firing floor, and even with chambers as low as this (and they could not have been packed if they were much smaller), much empty space was wasted. Today one can stand up in a kiln such as that of Kakiemon, and it is likely that the wide-spread introduction of the seggar into Arita kilns enabled them to increase in height until, possibly by the late seventeenth century, they were nearly as tall as they are today.

Seggars themselves are and were of different types and sizes. The most commonly used one in Arita was about 15 cm. tall and about 12 cm. in diameter. The base tapered slightly on the outside allowing it to fit snugly onto the top of the seggar upon which it was stacked. We do not know how many such seggars would then have been stacked, but this number would be limited by or determine the height of the roof of kiln chambers. On the uppermost of the stack there was a lid. Each such seggar would have held a single bowl, and this, with variations, is and was the basic method of the use of seggars. For the firing of tall closed shapes such as bottles, rings with vertical walls could be fitted onto the top of the seggar, making it taller.

Hama of complex shapes, suitable for the shaped (that is, not round) foot that could replace the thrown foot on shaped small dishes, occur from the second period (see e.g. fig. 33). Rudimentary kiln shelves

appeared in Arita towards the middle of the century, and later there were wide, flat discs that could be placed in the seggar. Kiln shelves on pillars seem to have arrived only in the nineteenth century.

Celadon, surprisingly widespread in Arita, required a specialist kiln stand, as the foot was glazed and therefore would have fused to a *hama*. To avoid this, an area of the inside of the foot was cleaned of glaze and painted with iron oxide. This resulted in a circular brown ring within the foot, resembling the similar ring on Chinese celadons from Zhezhiang. On this brown ring can be seen, in many Arita celadons and on many sherds from Arita kiln-sites, a thin scar where the ring has been touched by some support. Finds at Maruo and Mitsunomata kiln-sites demonstrate that this support was a tall ring, called a *chatsu*, the walls of which were narrower at the top than they were at the base (fig. 39). The ring itself stood on a *hama*. For the big celadon dishes at Maruo, these rings were about 12–15 cm. in diameter.

Approximate dating of a kiln by the type of kiln furniture present at the kiln-site is possible in Arita because of this delayed widespread acceptance of the seggar. If seggars are not frequent at a kiln-site, then that is good (though never conclusive) evidence that that kiln was active in the early period only.

Materials and methods available to the potter control to a great extent the range of possibilities open to him. Kiln furniture is no exception. In the early period of Arita production it was the kiln furniture at least as much as the skill of the potter in using the difficult medium of porcelain clay that controlled, in particular, the width or diameter of the pieces it was possible to make. This is of course most true of dishes and bowls. To a great extent the width of a dish or bowl depends on the size of the

FIGURE 40. Section of large dish from Yamabeta kiln, early period two, showing thickness of the base of the wall

foot-ring; if that ring is small, then it is very difficult to obtain great width. In the early period at Arita the foot of no pot could be wider than the diameter of the upper surface of the *hama* or the *tochin*. Thus the *shoki*-Imari wares tended to be relatively small. There was one kiln of the early period that specialized in wide bowls, Yamabeta. These bowls were relatively conical, and the walls near the base were very thick (fig. 40). Curiously enough, this limitation applies much less to stoneware, and several of the Karatsu and Takeo-Karatsu made wide dishes on narrow foot-rings. The limitation of size of the foot-ring has been used to help in the dating of pieces according to the relative size of the diameter of the foot to the diameter of the rim; the foot becomes wider in proportion to the rim throughout the seventeenth century (see ch. 9). This makes it possible to make bigger and relatively less heavy pieces, but it necessitates the use of spurs to support the well of larger dishes.

Unpacking the Kiln

When firing of the kiln is complete, that is, when a sufficiently high temperature has been maintained for a sufficient time, then the kiln doors and bung-holes are sealed with wet clay. This is to prevent late entry of oxygen into the kiln during the long cooling time; cooling must proceed slowly, and may take several days.

The kiln being cool enough, the doors are unbricked and the chambers completely unpacked. At this stage the seggars (when present) and fired pots may still be uncomfortably hot to the touch. As the seggars are opened and the pots revealed, the pots are inspected for imperfections; today at a kiln that prides itself on its high standards, imperfect pots are immediately smashed, though pieces that are only slightly imperfect may be kept for 'seconds'. In the seventeenth century imperfect pots were simply thrown away. As the kilns stood on hillsides, this

meant that the imperfect pieces rolled down the hill-side to form great heaps of sherds. These waste heaps (*monohara*) provide the basic information on what sort of thing was made at each kiln and, hence, at what date that kiln was working.

Perfect pots today have the foot cleaned of any slight adherence of sand with emery paper, either immediately (e.g. at the Kakiemon kiln) or later (e.g. at the Imaemon kiln) and have the spurs knocked off as cleanly as possible. Doubtless in the early period the bases were cleaned with a stone. During the export period, it seems that spurs were sometimes not removed until the pieces reached the transshipment port of Imari, for recent excavations in Imari have revealed great quantities of broken-off spurs.

The fact that a fired kiln would have been completely unpacked is sometimes forgotten by archaeologists; just because a pot is excavated in a kiln chamber, it does not necessarily mean that it was fired in that chamber unless it is still standing *in situ* on its kiln furniture. The working duration of a *noborigama* was probably usually considerably less than thirty years, and new kilns, as archaeological excavation shows, tended to be built close by old ones, possibly simply for reasons connected with land tenure. It is perfectly possible that a rejected pot could have been carelessly discarded into the partial ruins of an earlier parallel kiln; I have seen it happen.

Wastage has always been high; in the early seventeenth century it must have been a very significant proportion of pots fired that were damaged or blemished in the kiln. Today, at the highly sophisticated Imaemon kiln, an order is always doubled, as a 50 per cent wastage is expected between throwing and the showroom. This may be exceptional today, for not all kilns are so fastidious in the separation of perfect pieces and seconds.

Overglaze Enamel

Additional colours can be added to high-fired porcelain in a muffle kiln. These are overglaze enamels, painted onto the already glazed and fired body and refired to about 950°C (fig. 41). In the second half of the seventeenth century these were exploited by the Arita potters to produce the brightly coloured export porcelains so well known in Europe, the *nishiki-de ko*-Imari and the Kakiemon wares. Enamels were first used in Arita in period three.

Enamels are simply low-maturing coloured glazes, usually mixed with a siccative to prevent them falling

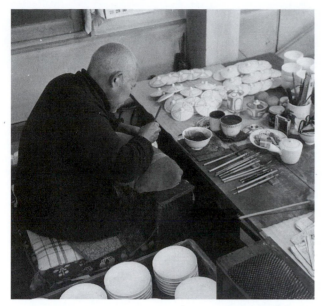

FIGURE 41. Painting in overglaze enamels, Kakiemon workshop

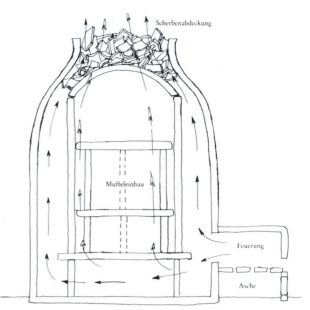

FIGURE 42. Diagram of a muffle kiln, from Jahn and Petersen-Brandhorst, *Erde and Feuer* (Munich, 1984)

off the high-fired glaze onto which they are painted. Pots that have survived temperatures of 1,280°C are rarely damaged in the lower temperatures of the muffle kiln, and even today these kilns are remarkably carelessly packed. At seventeenth-century kiln-sites enamelled sherds are very rarely found. When enamelling first began in Arita, it seems that each kiln (there were probably ten kilns active at the time) had its own enamelling workshop and muffle kiln. At some time in the mid- to late seventeenth century (according to the *Hizen tōji shikō* in 1672)[8] the muffle kilns and the enamellers' workshops seem to have been gathered together in central Arita in an area called the Akae-machi, the enamellers' district, in circumstances that are less than clear. Quite who worked in the Akae-machi and who did not, and what was enamelled there and what was not continues to be a controversial problem in spite of the excavations carried out in one small area of the site in 1988. This means that we do not know if, as is usually suggested, all enamellers were obliged to work in the Akae-machi, or whether kilns had their own enamelling workshops and muffle kilns.

The Muffle Kiln

A major problem is caused by the lack of information on muffle kilns themselves. The site of no muffle kiln has ever been found in Arita. The excavators

of the Kakiemon kiln in 1978 suggested that a flattened area close to the *noborigama* may have been the site of the muffle kiln, but no structure was found. We therefore do not know anything of the shape or size of any muffle kiln; nor how they were packed, whether or not kiln furniture was used. It is conjectured that packing was somewhat careless, as enamel decoration scarred by physical contact with another piece is not at all uncommon. In this context, the finding of kiln furniture at the Akae-machi site, where there could not have been a *noborigama* (for the site is flat) suggests that sometimes at least care was taken over packing the muffle kiln.

A muffle kiln is a double-walled structure with a space between the walls around which the heat from the fire circulates (fig. 42). The porcelain with the unfired enamel pigments are placed within the inner wall; there is a firing chamber outside, attached by a short tunnel to the space between the walls. Thus the fire is never in contact with the maturing enamels.

In the earliest account of one that I have found, Ernest Satow described a Satsuma kiln he saw at Kagoshima[9] in 1878.

The kilns in which *nishiki-de* . . . are baked, are one-celled and built of clay upon a foundation of brick, with walls about six Japanese inches thick. Fire is kindled in the mouth of a passage which projects from the front of the kiln, and the hot air passes up this to the chamber, where it can circulate freely round the muffle in which the biscuit is deposited.

(In Arita, of course, it would not be biscuit, but high-fired, glazed pots.) The size of the largest Satow saw was about 5.5 feet externally and 4.5 feet internally, the diameter 4.5 feet externally and 3.5 feet internally, though he adds that 'a space of four inches in width is left between the muffle and the inner wall of the kiln'. The firing time was about ten hours. He does not give the figure for the highest temperature, though this was judged 'through an aperture near the top, the test employed being a piece of pottery marked with various pigments, which gradually assume the desired tints as the heat increases'. Granted that there might be some differences with time and place, the actual pigments and the maturing temperatures were probably much the same in Arita and Kagoshima, and the kilns may well have been similar.

Gold and Silver

A third firing to a temperature of about 650–750°C was needed for the addition of gold and silver. These colours were first used at the end of period three; we have the word of Zacharias Wagenaer, Principal in Japan in 1657 and 1659, for it that the technology for the application of silver (and, by implication, gold) was available in 1659;[10] many extant pieces of this early date prove that this is correct. This is curious; Père d'Entrecolles in his second letter (25 Jan. 1722)[11] says that 'They say that it has only been about twenty years since they [the Chinese] have found the secret of . . . gilding porcelain'. (He was presumably ignorant of *kinrande*.)

Another problem is the fact that silver melts at a lower temperature than does gold, suggesting a fourth firing. Perhaps this, as much as the rapid tarnishing of silver, was the reason that remarkably little Imari porcelain was silvered after the first export orders; it simply was not worth while.

Notes

1. I am grateful to Nigel Wood for much help with this section.
2. Henry Wurtz, 'The Chemistry and Composition of the Porcelains and Porcelain-Rocks of Japan', quoted in J. Allen Howe, *A Handbook to the Collection of Kaolin, China-Clay and China-Stone in the Museum of Practical Geology, Jermyn Street, London SW* (London, 1914), 212.
3. Mark Pollard, '[Technical Studies of Tianqi Porcelain] Description of Methods and Discussion of Results', *Trade Ceramic Studies*, 3 (1983), 155, 156, 158.
4. *Official Catalogue of the Japanese Section and Descriptive Notes on the Industry and Agriculture of Japan* (Philadelphia, 1876), 63. This interesting account of the ceramics industry of the early Meiji period was almost certainly written by Gottfried Wagener; see Gunhild Avitabile, 'Gottfried Wagener (1831–1892)', in Oliver Impey and Malcolm Fairley (eds.), *Treasures of Imperial Japan. Catalogue of the Nasser D. Khalili Collection of Japanese Art, vol. i, Selected Essays* (London, 1995), 98–123.
5. For a discussion of the use of moulds in the early export period, see Oliver Impey, 'Japanese Export Porcelain Figures in the Light of Recent Excavations in Arita', *Oriental Art*, 36/2 (1990), 66–76.
6. Ohashi Kōji, 'Hizen koyō no hensen—shōsei shitsu kibo yori mita', *Saga kenritsu Kyushu tōji bunkakan Kenkyū Kiyō*, 1 (1986), 61–89.
7. Ohashi, 'Hizen Koyō no hensen'.
8. Nakajima K., *Hizen tōji shikō* (Arita, 1936).
9. Satow E., 'The Korean Potters in Satsuma', *Transactions of the Asiatic Society of Japan*, 6, pt. II (1879), 193–203.
10. Quoted in T. Volker, 'Porcelain and the Dutch East India Company as Recorded in the *Dagh-Registers* of Batavia Castle, those of Hirado and Deshima and other Contemporary Papers, 1602–1682', *Mededelingen van het Rijksmuseum voor Volkenkunde, Leiden*, 11 (Leiden, 1954), 136–7.
11. Père d'Entrecolles, 'Lettres édifiantes', 2 (1772), quoted in Robert Tichane, *Ching-te-Chen: Views of a Porcelain City* (New York, 1983).

4

CLASSIFICATION OF THE PORCELAIN KILNS OF ARITA

IN this book we consider the porcelain products of forty-odd named kiln-sites at which sherds of porcelain in *shoki*-Imari styles have been found. There were, later in the century, other kilns that made porcelain in and around Arita, but in different styles with which this book is not concerned. That we can distinguish such products from each other implies the existence of differences that can be used for purposes of taxonomy, and these differences both in the shapes and in the styles of decoration, as well as technological advance with time, can be used to chart a more or less linear progression. This enables us to produce a family tree with relative rather than absolute dates for the various types concerned; absolute dates can only be found by other methods. This linear view of progress is the one employed here, though there are arguments against it (see below). Thus the products of the early Arita kilns are here divided into four notional periods of manufacture, and classified accordingly; see Chapter 9.

But many of the kilns show affinities with other kilns in terms of the actual products, and are thus susceptible to division into various groups; different criteria can be used for the erection of such groups. One could, for instance, group together all the kilns that produced wares using underglaze copper-red, though this might not prove to mean very much. Such groups have to have some suggestion of some relationship that actually meant something at the time the kiln was working. Whether or not production of copper-red was a linking feature may or may not be important in those terms; much more to the point might be the production of a whole range of wares in common between a 'group' of kilns. Two such groups will be discussed below; the so-called 'Mukae no hara group' and the 'Hyakken group'. In the former case all the kilns concerned are geographically close

to each other, in the latter case they are not. Geography may or may not be an important factor.

As we know next to nothing of the organization of the kilns, of the potters themselves, of the distribution of orders, of the methods of sale, or of any other of the business practices of the early seventeenth century, we are obliged to discuss everything in terms either of the extant pots themselves, of *densei* material, or of what we can find in the ground at the kiln-sites.

Geographical distribution is one of the ways we shall use of categorizing the kilns; historically, this has been the standard method here. Whether or not it means very much is an open question; clearly in some cases it does and others it does not. It is, however, convenient for the listing of sites in alphabetical order, as it begs fewer questions that any other method of classification.

Recent excavations have shown that the geographical distribution of kilns that made porcelain related to the early Arita wares is wider than was previously realized; kilns have been found in Hasami, Ureshino, and even near Fukuoka. It must also be remembered that by the word 'kiln' we as often as not mean 'group of kilns successively occupying one site'; thus at Tengudani there were five successive kilns, at Yamabeta, seven, and at Tenjinmori, nine. For many of the larger sites we have little or no knowledge of the actual kilns; at Chōkichidani, which was working from approximately 1640 to 1670, the *monohara*, heretofore undisturbed, produced on excavation a vast amount of sherds, but no kilns were found. At Hiekoba, which was active over a far longer period, from before 1630 probably into the nineteenth century, much less has been found because of building work (when I visited the site in 1971, it was being levelled for a car-park); no kilns have been

found. Hiekoba must have made a far greater quantity of varieties of porcelain than did Chōkichidani, so that this disparity in actual finds could be very misleading. At Sarugawa, another long-lasting kiln, excavation revealed one kiln only; others simply must have existed, no doubt hidden under the railway.

Nor are we certain, unless it is archaeologically proven, that such groups were successive; it might be that some kilns in the same group ran concurrently. In some cases neighbouring kilns made wares so closely similar to each other, that we might do better to think of them as the same 'kiln' (Kusunokidani and Gezuyabu; Ippomatsu and Zenmondani).

In other cases, kilns far distant from each other made many styles that were closely related or nearly identical; thus, of the 'Hyakken group' (see above), Hyakken, in Itanokawachi, made many varieties that closely resemble some of those of Tenjinmori in Nangawara and of Kotoge in distant Uchida Kuromuta; Tenjinmori and Kotoge are about twenty kilometres apart.

These similarities and lack of similarity are the basis on which most taxonomy of the products of any kiln area is based. This is what is seen on the ground; sherds found at kiln-sites give us positive information. Sherds can also give us negative information; if we do not find sherds of a particular period or type at a site, then we can be reasonably sure that wares of that period or type were not made at that kiln, except where there has been gross disturbance such as building works or excavation. This is never certain, for the next dig at the site may find something new. In practice, this is uncommon, partly because wastage was very high in the early periods, and therefore things of any sort tend to be present in large numbers, and partly because most sites have been turned over to a considerable depth by sherd-hunters, by agriculture, or by building. There are, of course, the rarities; the point is they are rare.

It is not so much the rarities that cause the problems. Throughout this book there runs the theme of progression; progression of skill, of style, and of technology. This progression is seen as basically linear.

But is this so? Excavations at the Yamabeta site found that the products of the various kilns present in the kiln waste dumps were completely intermingled. Thus sherds of two of the most famous products of the Yamabeta kilns, the wide dishes with the very small foot-ring (see Plates 3, 4, and fig. 40) and the white-bodied dishes with the comparatively wide foot-ring, that were intended for enamelling (see Plates 36–43b and ch. 7) were found together. Thus either the sherds were of wares produced at the same time, or the waste heaps have been so disturbed as to provide no stratigraphical evidence of any reliability.

These two products of the Yamabeta kilns are as different as they could reasonably be; the former are nearly all decorated with bold, rather crudely drawn landscapes in underglaze blue, on a coarse thick body, the latter are thinly potted in a white clay with decoration that frequently demands the later addition of enamel overglaze colours (see Plate 40). Technologically they are equally far apart; the small foot-ring, necessitated (as we shall, I hope, show) by limitations of the size of the kiln furniture available, necessitated in turn a thick lower part to the wall of the dish and a deep conical shape to produce the strength to hold up the weight of the wall during firing; the wide foot-ring, made possible by the making of larger kiln furniture, necessitated the use of spurs to hold up the flat of the dish. And yet these types are found intermingled in the waste heaps.

Could it be, then, that there were two or more groups of potters using the same *noborigama* at the same time, and that their skills, styles, and available technology varied to this great degree? While it is, in fact, highly likely that different workshops would have shared the use of a *noborigama*, the likelihood of this disparity in technology, at least, is remote. Indeed, suggestion of their contemporaneity implies total rejection of all the systems of stylistic dating that have been used up until now, as well as Yamashita's rule of the progressive increase in the size of the foot-ring with time (see ch. 9), which I have suggested is closely linked to the improvement of kiln furniture with time.

Furthermore, it is known that the Yamabeta kilns were not all active at the same time; some overlaid others, showing that one had been built on the ruin of another. Is it more likely that everything was made all the time or that there was change and progression?

I do not believe for a moment that there is any possibility that the finding that the sherds in the rubbish heaps were mixed together means anything more than gross disturbance of the said heaps. I regard it as axiomatic that change in the industry to adapt to new demands and markets and to respond to new technological advances and to innovatory new styles, pigments, shapes, or anything else is not so much likely as inevitable. I therefore regard it as justifiable to adhere to the more or less linear progression that I follow here.

We can therefore classify by geography, by the time-span of a kiln's activity as judged here from sherd finds at the site, and by style. This latter, of course, depends on comparisons of the shapes and decoration, the quality of the body and the quality of the decoration, and the range of products found. In some cases we will also have enough information on the actual structure of the kilns themselves to be able to suggest a linear variation with time in increase of length of the kiln and in the size of the individual chambers; this can be used to cross-check other data (Table 7).

Scientific analysis is helpful to a limited degree, as the seventeenth century is too recent for thermoluminescence to be accurate enough to judge to within the ten years or so that we will attempt here. Other methods have in the past occasionally proved confusing; the excavators of Tengudani were seriously led astray by scientific analysis of much later interpolated material on the site giving an absurdly late date. Doubtless methods more appropriate will be found; at present, no dating technique usable for *shoki*-Imari kilns or sherds is as accurate as the practised observer's eye.

Documentary evidence is of two main types; first, written documents that are relevant to the kilns of the period. These are exceedingly rare and when found are difficult to reconcile with what one finds on the ground. In the classic case of the order of 1637 by Nabeshima Katsushige, that eleven workshops should be closed (see ch. 11), it is by no means clear which eleven were to be closed or even if they did close; we give Ohashi's list of those he believes to have closed below. Descriptions of individual wares or groups of wares can in no case of which I am aware be certainly ascribed to an existing porcelain. In the second category this is less difficult; this covers actual dated porcelains, which are just sufficiently common to be useful, and the dates inscribed on boxes of *densei* 'handed-down' porcelains. The former might be the goal for the forger, the latter for wishful thinking; inscribed boxes should be treated with the same circumspection that should be taken when examining porcelains mounted in silver in Europe—neither might belong to the correct porcelain.

All such dating to within the ten or so years that I will be attempting here is rash and possibly premature. There is still not enough evidence for us to be certain that we are right and, indeed, we may even not agree among ourselves. I am therefore left with the necessity to approach this problem not as a

scientist, but as a lawyer, or not at all. I will argue a case in which there are holes to be picked, attempting to tell what I believe to be the story of the first forty-odd years of the production of porcelain in Arita.

There is no need to discuss the various classifications that have been proposed; we shall adhere to the primary classification of this book in terms of time/stylistic change.

Phase one: previously called the Korean phase, approximately 1620–35.
Phase two: previously called the Tianqi or Chinese phase, approximately 1630–45.
Phase three: formerly within the Chinese phase, approximately 1640–65.
Phase four: the early export phase, approximately 1659–80.
[Phase five, not discussed here, might run from 1675–1740, possibly divided into two periods at the turn of the century.]

Even if we have chosen to deny the implementation of the closure order of the eleven workshops in 1637, we should consider which kilns might have closed then; Ohashi has suggested that the following kilns, all in the western part of Arita, closed: Tenjinmori; Komizo, Upper, Middle, and Lower; Komononari; Seiroku no tsuji; Genmei [?]; Mukae no hara; Benzaiten. Sherds suggest that neither Tenjinmori nor Komononari closed quite as early as that; nor is Komizo likely to have done so.

In Chapter 10 we shall discuss the *shoki*-Imari kilns of Arita kiln by kiln, considering their structure where known, their times of commencement and ending, where ascertainable, and their products. Naturally these kilns can be classified in many different ways, according to date, or structure, or products, or geographical position. I have chosen to do so in Chapter 10 by geographical position, and within each geographical group alphabetically; any other grouping, such as by date, would have been equally arbitrary and probably less easy to use.

The geographical classification that we shall use here is based on the traditional one, but with some adaptation to how I see the lie of the ground, rather than erstwhile political or ownership boundaries; this is purely topographical, and implies no other relationships.

Cutting across this classification are several groupings which may be useful; some of them may be

significant. For instance, it is impossible not to postulate some connection between the member kilns of the 'Hyakken group' or the 'Mukae no hara Group', the products within each group being so markedly similar. What that connection may have been cannot be more than conjecture, given our imperfect knowledge of the administration of the Arita kilns, but the connection must have been real.

TABLE 4. Classification by Typology

Kilns that were among the first to make porcelain 'The Mukae no hara group'	Kilns that had made stoneware before porcelain	Kilns that made stoneware of Takeo-Karatsu type, and porcelain	Early porcelain kilns that did not make stoneware
Haraake	The five 'Mukae no hara group' kilns	Kotoge	Iwayakawachi
Bezaeten		Taitani	Kōtake
Mukae no hara	Kodaru No.2	Umino	Sarugawa
Seiroku no tsuji	Komononari	Niwage	Tengudani
Hata no hara (Hasami)	Tenjinmori		Tenjinyama
	Komizo		Yamagoya
	Yamabeta		Hirose
			Kake no tani
			Yagenji

The Hyakken group	The ko-Kutani group
Komononari	Yamabeta
Tenjinmori	Maruo
Komizo	Chōkichidani
Danbagiri	
Hyakken	
Kama no tsuji	
Kotoge	

TABLE 5. Classification by Dates of Production

Kilns that began in phase two			Kilns that began in phase three
Long-lasting kilns	Phase two into phase four	Phase two into phase three	
Hiekoba	Maruo	Hokaoyama	Chōkichidani
Nakashirakawa	Danbagiri	Kodaru	Tsutsue
Odaru	Hyakken	Ippomatsu	Fudōyama
Shimoshirakawa	Kama no tsuji	Toshaku Mukae no hara	
Tanigama		Zenmondani	
Higuchi			

TABLE 6. Geographical Classification

Central Arita	Nangawara	South-West Arita	North-West Arita	West Arita
Chōkichidani	Higuchi	Haraake	Hirose	Benzaeten
Hiekoba	Komononari	Ipponmatsu	Kake no tani	Kōtake
Hokaoyama	Tenjinmori	Toshaku Mukae no hara	Komizo	Mukae no hara
Iwayakawachi		Zenmondani	Maruo	Seiroku no tsuji
Kodaru			Yagenji	
Kodaru No.2			Yamabeta	
Maemaedani				
Maenobori				
Nakadaru				
Nakashirakawa				
Nishinobori				
Odaru				
Sarugawa				
Shimoshirakawa				
Shirayaki				
Tanigama				
Tengudani				
Tenjinyama				
Yamagoya				

North-East Arita	Itanokawachi	Uchida Kuromuta	Ureshino	Hasami
Gezuyabu	Danbagiri	Kotoge	Fudōyama	Hata no hara
Kusunokidani	Hyakken	Taitani	Niwage	Mitsunomata
	Kama no tsuji		Umino	
	Tsutsue			

TABLE 7. Chart of the Progressive Size of Average Kiln Chambers

		Average dimensions of kiln chambers	
		Width (meters)	Length (meters)
Period 1	Mukae no hara	2.19	1.84
	Tenjinmori 7	2.19	2.07
	Yamabeta 4	2.24	2.39
	Haraake B	2.28	2.26
	Tenjinmori 4	2.4	2.65
	Hata no hara	2.4	2.2
	Sarugawa B	2.43	2.2
	Yamabeta 7	2.48	2.38
	Yamabeta 9	2.5	2.4
	Haraake A	2.59	2.51
	Seiroku no tsuji	2.76	2.02
Period 2	Yamabeta 2	2.9	2.85
	Yamabeta 1	3.18	2.85
	Tengudani E	3.44	2.88
	Tengudani A	3.53	3.17
	Hyakken	3.6	2.16
	Kake no tani	3.76	3.41
	Tengudani D	3.85	3.75
Periods 3 and 4	Tengudani B	4.0	3.41
	Fudōyama 3	4.73	3.82
	Kakiemon B	5.36	3.62

Note: Adapted from Ohashi, 'Hizen Koyō no hensen'.

TABLE 8. Chart showing the Origin and Duration of *shoki*-Imari Kilns

1620	1630	1640	1650	1660

Chōkichidani ————————————————→
Hiekoba ——————————————————→
Hokaoyama ————————————————
Iwayakawachi ——————————
Kodaru ——————————————
Kodaru No.2 ————————————————————→
Nakashirakawa ——————————————————→
Odaru ——————————————————→
Sarugawa ——————————————————————→
Shimoshirakawa ——————————————→
Tanigama ——————————————————→
Tengudani ——————————————————
Tenjinyama ——————————————————
Yamagoya ——————————————————
Higuchi ——————————————————————→
Komononari ——————————————
Tenjinmori ——————————————
Haraake ————————————————
Ipponmatsu ————————————————
Toshaku Mukae no hara ——————————————
Zenmondani ——————————————
Hirose ——————————————
Kake no tani ——————————
Komizo ——————————
Maruo ——————————————————
Yagenji ——————————
Yamabeta ——————————————————
Benzaeten ——————————————
Kōtake ——————————————
Mukae no hara ——————————————
Seiroku no tsuji ——————————————
Gezuyabu ——————————————
Kusunokidani ——————————————
Danbagiri ——————————————
Hyakken ——————————————————
Kama no tsuji ——————————————
Tsutsue ——————————————————→
Kotoge ——————————
Taitani ——————————
Fudōyama ——————————————————→
Umino ——————————
Niwage ——————————
Hata no hara ——————————

PART III

Shoki-*Imari*

KARATSU STONEWARE AND THE ORIGINS
OF PORCELAIN IN ARITA

WE have seen that the origins of the porcelain industry lie in the stoneware kilns of Karatsu in northwest Kyushu, so we must now see how this came about. Kyushu, lying as it does closest of the four great islands of Japan to Korea, has historically always been the first recipient of immigration, goods, and ideas from the continent. When the armies of Hideyoshi returned to Japan from the invasions of Korea of 1592 and 1597—and Nagoya Castle near to Karatsu City had been the departure point for the invasions—they brought with them, either as immigrants or captives, a considerable number of Koreans, some of whom were potters.

During the Momoyama period, when Korean food bowls, the so-called 'Ido' bowls, had been 'recognized' as suitable for use in the tea ceremony,[1] Korean ceramics had become extremely desirable, so that every Kyushu Daimyō seems to have wanted a Korean kiln-master. In fact, by the mid-sixteenth century Korean potters were already working in the Karatsu region, and at least four kilns are known to have been working in the area of Mt. Kishidake; the best known of these is perhaps Handogame.[2] These kilns made the early Karatsu wares that do to a great extent resemble the undecorated Yi dynasty wares of Korea, so much admired by connoisseurs. Korean potters now spread throughout Kyushu, and to Hagi on Honshu and, later, elsewhere, starting kilns that were often closely supervised by agents of the various Daimyō. So many potters are thought to have come from Korea with the returning Japanese forces in the last decade of the sixteenth century that the invasions have sometimes been called 'the potters' war'. In all probability the actual number of Korean potters who arrived then was not all that great; it was the influence exerted by the kilns that they started in Kyushu that was important.

To Kyushu the Koreans brought the new (to Japan) technology of the *noborigama*, the stepped, chambered climbing kiln. Allowing as it did a much greater control over the process of firing, this kiln revolutionized the ceramic industry of Japan, being rapidly imitated in Mino, then also an important ceramic centre. For a description of the *noborigama* and of the method of its use, see Chapter 3.

Most of the Korean potters had either made undecorated stoneware or the very simply decorated *punch'ong* stonewares.[3] Porcelain in Korea in the sixteenth century was usually white and seems to have been reserved for the aristocracy; blue and white was scarcely made at all. Few, then, if any, of the Korean potter immigrants to Japan are likely to have been specialists in porcelain. It has been pointed out that of all the Kyushu Daimyō most likely to have been able to find porcelain makers, it was the Lord Nabeshima who had the greatest opportunity, as he did not go north from Seoul; and, of course, it was in the Nabeshima fief that porcelain stone was to be found. In a document of 1637, we are told that Lord Nabeshima Naoshige had brought back from Korea six or seven potters.[4]

To Karatsu the Koreans also brought the technique of painting onto the unfired stoneware body in iron oxide, and then covering it with a transparent glaze. This is underglaze brown iron painting. Descending from the *punch'ong* wares, the styles of this painted Karatsu—*e*-Karatsu—was adapted to the Japanese taste for fluid brush-stroke decoration. Painted ceramics had been made in Japan before this time at Mino, where the Shino wares are often painted in iron oxide, so the technique was not completely new to Japan. Painted Karatsu wares are simply decorated with swiftly drawn brush-strokes, usually depicting grasses, bamboo, trees, or birds,

but some are more pictorial, and sometimes there are border patterns (figs. 43 and 44). Often there is a resemblance to the later Shino and to the Oribe pieces of contemporary Mino. Sometimes the iron oxide burns through the glaze giving an effect comparable to the 'heaped and piled' cobalt of early Chinese blue and white. It is in the e-Karatsu tradition that we shall find the origins of the Arita blue and white porcelain.

Most of the Karatsu clays fire to a buff colour, and are glazed with a transparent ash/clay glaze; by far the greatest proportion of Karatsu stonewares are undecorated, simple, cheap bowls and small dishes, swiftly and crudely, though skilfully made, with a strongly formed foot (fig. 45). In effect, all the Karatsu wares were made in a hybrid Korean-Japanese style and with the use of a hybrid Korean-Japanese technology. While the methods of decorating were similar to Korean methods, the decoration itself was more in Japanese taste and of Japanese subject-matter. The kiln was Korean, but the methods of glazing, using dipping or pouring, so that the foot and the lower part of the outer wall of the body was unglazed, was Japanese, for the Korean wares are glazed all over.

Several other styles of stoneware made in Karatsu have been recognized, as the use of Karatsu wares for the tea ceremony inevitably brings with it the detailed classification of connoisseurship. Following Sister Johanna Becker, we shall use only the simplest terminology. The so-called Korean Karatsu—Chosen-Karatsu—uses ash glaze often opacified with rice straw ash, and iron glaze. Frequently the pale straw-ash glaze is put above and over the iron glaze so that it drips down onto the dark glaze, forming blue streaks where the glazes meet. This may well have inspired or competed with the Agano, the Takatori, and the early Satsuma wares. The Takeo-Karatsu wares, mostly made north of Takeo and around Ureshino, in the south-east area of Karatsu production, used four main styles of decoration on stoneware, sometimes using more than one on one piece. *Hakeme*, or slip decoration, could be either painted or random *mishima*, stamped decoration, could be emphasized by an infill of slip; both these styles descend, with variations, from Korean origins (fig. 46). A third style, sometimes misleadingly called Oribe-Karatsu, bears broadly painted decoration of pine trees or bamboo in crude green and yellow pigments on a slip ground (fig. 47), while the fourth type of decoration relies on broad areas of dark but brilliant glazes in shades of green and blue.

It is a mark of the variation of the products of any individual kiln of the Takeo-Karatsu area, that, for instance, Sabitani kiln made e-Karatsu, though its main production was of undecorated wares, Yamasaki and Shokodani kilns specialized in 'accidental' trail decoration, while both also made e-Karatsu; Taitani made typical Takeo-Karatsu stoneware as well as one particular type of porcelain that was a somewhat free imitation of a Ming style (a type that was also made at the Niwaji kilns, see below), while Kotoge, mainly a porcelain kiln of the 'Hyakken group' (see chs. 4 and 10) also made stoneware including slip trail and undecorated wares. The Kotaji kilns made the three types of Takeo-Karatsu only, while the Niwaji kilns made Takeo-Karatsu and the distinctive type of porcelain found at Taitani. It should be noted that this Takeo-Karatsu porcelain, while looking crude and primitive, is not the earliest porcelain made in Japan, and is not relevant to the history of the origins of porcelain in Japan that we are discussing in this chapter.

It is at a few of the kilns in the south-western Karatsu area that we must look to find the first porcelain made in Japan. As we shall see, in this area, which is in effect western Arita, some kilns making Karatsu stoneware began to make porcelain. The technology of the firing of stoneware and porcelain is the same, so that these kilns were able to fire both materials in the same firing of the same chamber of the kiln; this can be proved by the finding at two kiln-sites of the two materials fused together (fig. 48). Some other kilns in the same area gave up the production of stoneware and went over to the making of porcelain, but this was later. In Arita itself, nearer to the source of porcelain stone, Izumiyama, new kilns were started, to make porcelain, that had had no previous history of the making of stoneware;[5] these were the first specialized porcelain kilns, but not the first kilns to make porcelain. Nevertheless, this was an important step in the birth of the porcelain industry, and one that demonstrates a demand for porcelain on the Japanese market.

The search for an exact date for the first making of porcelain in Japan has consumed much energy of the various writers on the subject. The same can be said for the search for the identity of the men who first found porcelain stone and first made porcelain. Soame Jenyns, in his indispensable but difficult book *Japanese porcelain*[6], gives a lengthy discussion of this wild-goose chase. There are, simply, no answers to these questions. There are several reasons for this; first, no contemporary documents that are directly

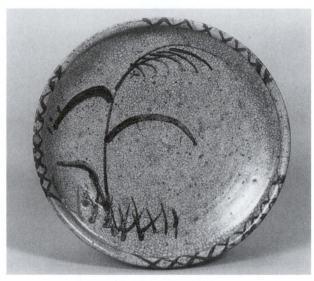

FIGURE 43. *E*-Karatsu dish with simple reed decoration, dia. 16.7 cm. Idemitsu Museum of Arts

FIGURE 44. *E*-Karatsu sherds from Oyamaji kiln. Ashmolean Museum

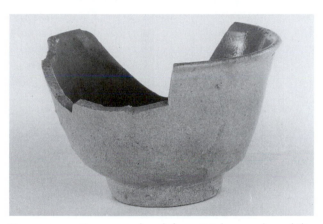

FIGURE 45. Stoneware bowl from Mukae no hara kiln. Ashmolean Museum

FIGURE 46. Takeo-Karatsu dish with *mishima* and *hakeme* decoration. Ashmolean Museum

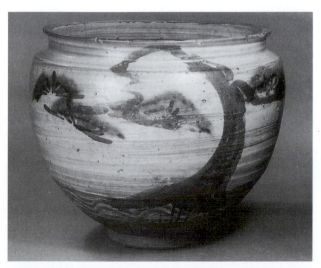

FIGURE 47. Takeo-Karatsu ('Oribe-Karatsu') bowl with painted decoration of pine tree. Ashmolean Museum

FIGURE 48. Stack of four stoneware dishes topped with a porcelain one, Mukae no hara kiln. Ashmolean Museum

concerned with these matters survive. Secondly, traditional accounts do not tally with either the findings of archaeological excavations, where these have been made, or with the consideration of surface finds from unexcavated kiln-sites. And, thirdly, the questions are vain ones anyway; we should not be looking for any individual nor for any single date. This was a process of change within an industry—in this case the Karatsu ceramic industry—on a broad front. It is quite evident that the finding of porcelain stone at Izumiyama did not overnight revolutionize the ceramics industry of Japan, but simply that some of the stoneware kilns of Karatsu began to experiment with and then to use a new material, hitherto unused for the manufacture of porcelain, but familiar from centuries of imports from China and possibly exploited for the making of glaze (see below). At first these porcelains were of typical Karatsu shapes and were fired actually with the stoneware. For this we have the evidence in the form of potsherds from the kilns Mukae no hara and Haraake, where in each case a stack of small stoneware dishes with a porcelain dish of the same shape and size as its upper piece has fused together in a kiln accident (see fig. 48). A few sherds may seem slight evidence on which to build a theory, but they are nevertheless the only hard evidence available.

It seems likely, then, that the first stage of porcelain manufacture in Kyushu was the venture of certain stoneware kilns in south-western Karatsu, which from now on can be called western Arita, into the making of porcelain. Some of these kilns ceased the manufacture of stoneware when they commenced making porcelain, others that made porcelain as well as stoneware seem to have stopped production relatively soon. Clearly these changes occurred at different times at different kilns. The only kilns known for certain to have produced both materials at once are the two mentioned earlier, Mukae no hara and Haraake. The implication that the neighbouring and very similar kiln Seiroku no tsuji was also producing both at once is inescapable, but evidence has not been found. These kilns produced plain white porcelain as well as blue and white of the earliest type, and stoneware; it should be remembered that the techniques necessary for the decoration with cobalt oxide onto a porcellanous body are very similar to those required for the use of iron oxide onto stoneware. It seems reasonable to suggest that even if these kilns were not actually the earliest producers of porcelain, they were certainly among the group of

the earliest, not all of which may have yet been identified. For the time being, for the purposes of classification, we will refer to this group of three kilns (so far) as the Mukae no hara group.

Of course other Arita kilns also made stoneware; Tenjinmori and Komononari kilns in the Nangawara valley, and Komizo kiln, just north of the valley, all have sherds of stoneware in styles markedly similar to those of the Mukae no hara group. But the porcelain found at these kiln-sites is not similar; it is definitely later and mostly it falls into variations of the sub-style that we will later be referring to as the phase two style. It must be concluded that the Tenjinmori group of kilns, as we shall call them, did not become involved in the making of porcelain until some time, possibly, as we shall see, as long as ten years after the Mukae no hara group. It is possible that the Tenjinmori group of kilns went out of business altogether, and had to be revived to make the later porcelain, but it seems more likely that the Tenjinmori group potters (or their patrons) made the (erroneous) assumption that the fashion for porcelain would fade and that they, as established stoneware manufacturers, would then be in a good commercial position.

We do not know to within ten years when the first porcelain was made at the Mukae no hara group of kilns. Logically we ought to presume that the finding of the porcelain stone would not have taken place too long after the arrival of Korean potters into the area. After all, it is scarcely likely that the potters would be practically sitting on a mountain of porcelain stone without noticing it. Nigel Wood has suggested to me that in all probability the Karatsu potters would have used porcelain stone mixed with ash for the glaze on the Karatsu stonewares.[7] Tradition has it that the date of the first making of porcelain was within the first twenty years of the seventeenth century. I have written elsewhere that I believed it to be within the first ten years of the century.[8] Current belief in Arita is that the date is close to 1620, which I accept.

Notes

1. For Ido bowls, see for instance Nishida Hiroko, *One Hundred Tea Bowls from the Nezu Collection* (Tokyo, 1985), nos. 20–30.
2. Much of the information in the early part of this chapter comes from *Karatsu Ware: A Tradition of Diversity* by Sister Johanna Becker (Tokyo, 1986), and from discussions with Sister Becker and with Nakazato Taroemon.

3. For these, see e.g. G. St G. M. Gompertz, *Korean Pottery and Porcelain of the Yi Period* (London, 1986).
4. See ch. 11.
5. In *New Light on Early and Eighteenth Century Imari Wares: A Report on the Excavations at the Tengudani Kiln-Site* (Tokyo, 1972), Mikami Tsugio did not question the traditional claims to priority of Tengudani. In fact, Tengudani was one among several Arita kilns set up to make porcelain in the years after about 1620.

6. Soame Jenyns, *Japanese Porcelain* (London, 1965).
7. I am deeply indebted to Nigel Wood for discussions on this suggestion of his, and on many other points, particularly those in ch. 3.
8. See e.g. Oliver Impey, 'A Tentative Classification of the Arita Kilns', *International Symposium on Japanese Ceramics* (Seattle, 1972), 85–90.

6

TIANQI PORCELAIN AND *SHOKI*-IMARI

THE first half of the seventeenth century saw a vastly increased volume of porcelain imported into Japan from China.[1] This was mainly of the type now referred to as Tianqi, from the reign name of the Emperor Hi Tsung (1621–7). This style of porcelain was specifically made for the Japanese market, and it was not, until recently, found outside Japan. Blue and white porcelain of this type is called in Japan *ko-sometsuke*, but this is a recent name, and in former times this ware was called *Nankin-sometsuke*. Such is the tradition of the influence of China upon Japan, that it has always been assumed that the middle and later period *shoki*-Imari wares were dependent upon and often copied from the Tianqi porcelains. In other words, the Japanese copied the Chinese, as usual. But this is not true. Being made for Japan, and for Japan only, these Chinese wares conformed to Japanese taste. They did not create that taste, they followed it.

Although these two wares are more or less contemporary, and remarkably similar, they have not often been looked at together.[2] Comparisons can easily be drawn not only between their styles and sub-styles, but also often between individual designs (figs. 49 and 50) and even techniques; a famous example is the 'jade hare under the moon' in the *fukizumi* ('blown blue') technique (figs. 51 and 52).

Reversal of the normal pattern of Chinese influence upon Japan is not all that uncommon; it can be readily recognized, for instance, in the early eighteenth-century attempt by Jingdezhen to win back from Japan the European market for cheaper wares by the production of the Chinese Imari imitations of Japanese porcelain. This particular instance has not, however, generally been recognized. In 1963 Jenyns wrote[3]

The earliest pieces of Kosometsuke to reach Japan were Chinese wares made for the home market which were adopted by the Japanese tea-masters to their own ends;

subsequently pieces were designed to meet Japanese taste.... It is interesting to note in passing that the designs on some of the dishes, like that of the 'jade hare under the moon' ... were closely copied in early Arita blue and white!

In fact, the reverse is true; the Arita model is earlier than the Chinese mimic.

Kawahara[4] has suggested that the Chinese style covered the Tianqi period (1621–7) and a little longer, he took it from 1620 to 1637. For reasons that we shall see in this chapter, I believe that the style continued longer than that; until about 1649 for the Chinese pieces, and even longer for the home-made *shoki*-Imari. Some Tianqi pieces may well have been made during the later years of the Tianqi period, but the majority must have been made during the Chongzhen (1628–43). The reasons they are called Tianqi must be due to the date of their origin and to the fact that many of them are so marked, with just the two characters; this of course is no indication of date. A few pieces are known that are actually dated within the Tianqi period (Jenyns illustrated four of these)[5] and none of them is in the style we are discussing here. This helps to confirm the later date of the style.

Every student of oriental ceramics knows the Tianqi wares by sight; usually they are small saucer dishes, often not round in shape, or small bowls or cups. They may be blue and white, or blue and white and enamelled, or just enamelled. The decoration is bold and vigorous, often sparse, and is in a variety of styles suitable for use in the *kaiseki* meal that accompanies a formal tea ceremony. They were, however, produced in such vast quantities that they must have been used much more widely than by devotees of the tea ceremony only. Clearly there was great demand in Japan for porcelain for everyday use that yet more or less conformed to tea taste. Tea taste was good taste, even for more humble utensils.

FIGURE 49. Japanese dish with demon in underglaze blue, period two, dia. 16.0 cm. Ashmolean Museum, 1978.2054, Reitlinger gift

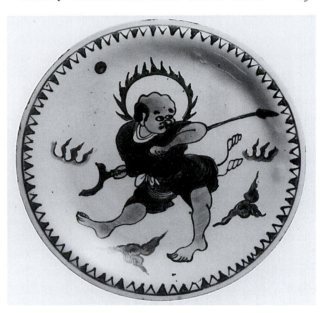

FIGURE 50. Chinese dish with demon in underglaze blue and overglaze enamels, Chongzhen period (1628–44). Ashmolean Museum, 1980.168

FIGURE 51. Japanese dish with 'jade rabbit' in underglaze blue, period two, dia. 19.0 cm, *See* Plate 22*e*

FIGURE 52. Chinese dish with version of 'jade rabbit' in underglaze blue. Chongzhen period, dia. 16.0 cm. Ashmolean Museum, 1978.840, Reitlinger gift

They appear to be quickly and crudely made, with no attempt at the high finish normally to be expected in Chinese porcelain of the seventeenth century, even of export quality. The bases are simple, often gritted, and display the chatter-marks of the turners' tool. The edges are, like so many contemporary Chinese porcelains, often distressed with the 'worm-eaten' edge (*mushikui*) where the glaze breaks away, unsupported, from the shrunk body.

Not all of the Tianqi wares were of this simple sort, though their decoration may be in similar vein. One variety was made specifically for use in the tea ceremony itself; usually these are water jars (*mizusashi*) or incense boxes (*kōgō*), and they were very much prized by tea-masters. It is quite likely that some of these special tea wares are earlier than their Arita counterparts, which seem not to have been made until the 1640s. The tea wares must first have been made to special order; almost certainly this trade would have been in the hands of Chinese merchants and therefore we shall not expect to find it documented when we come to consider the records of trade. The lesser pieces could equally well have been imported on Portuguese (until 1639), Chinese, or Dutch ships; they were trade goods, not made to order. As we shall see, they are described in the documents of the Dutch East India Company, the Vereenigde Oostindische Compagnie, as *grove porselein*, coarse porcelain. Of course it is not always possible to distinguish between pieces for tea and the others, but this was unimportant then and means little to us today. Perhaps the earlier orders for tea wares were followed by local imitations or pastiches of Japanese Arita or Oribe wares, and as many of the Chinese pieces were made in special shapes in great numbers, dishes shaped, say, like Mount Fuji might simply have been speculative. After the Chinese had got the measure of the style there would have been development of the style both in Arita and Jingdezhen, with consequent concurrences and divergencies one from the other within the style.

Related to the Tianqi tea ceremony style pieces were the 'Shonsui' wares of China, which have provoked a great deal of discussion. Some seventeenth-century Chinese porcelains in a particular style of decoration can be found that bear an inscription that can be read 'made by Gorodaiyu Shonsui'. Jenyns, in a lengthy discussion of these wares,[6] came to the conclusion that those of them that really were seventeenth century—for the style continues to be made today—were probably made in the Shunzhi period (1644–61). But there can be little doubt that the style was of Japanese origin. The point is that in all cases the Chinese perfectly understood Japanese demand, and catered for it.

Both the making of the Tianqi pieces, the apparently crude manufacturing process, and the styles of decoration found on these unfamiliar shapes are markedly different from anything else made in China. It has been demonstrated that in spite of the apparently careless method of production, the material is a fine-quality clay, typical of the body made at Jingdezhen.[7] As it has been assumed, in the absence of evidence, that these porcelains were made in the south of China, this confirmation of their origin in the Jingdezhen kilns is useful. Their style of manufacture conforms, just as do their shape and decoration, to the taste of their country of destination, Japan (figs. 53 and 54). Indeed these wares were, until very recently, unknown outside Japan. It is just possible that a few pieces filtered through to Europe by chance; it may be that some of the irregularly shaped dishes occasionally found in Delft faience may derive from Tianqi originals, or, with much less likelihood, from *shoki*-Imari originals. A well-known example of such a dish is the coloured piece from the Hoppesteyn factory in the Rijksmuseum.[8]

In Japan there are or were great quantities of Tianqi porcelain; there are not, however, large quantities of any other Chinese porcelain of the first half of the seventeenth century. This fact, and the low price charged for each piece as recorded in the Dutch shipping records, one tenth, approximately, of the average price of pieces exported to Europe, enable us to identify with some certainty the 'grove porselein' imported into Japan as these Tianqi wares. In the absence of any information available from Chinese sources, either of documentary or of kiln-site evidence, we must turn to the trade documents of, at first, the Portuguese and then of the Dutch East India Company to deduce the pattern of the importation into Japan of Chinese porcelain in the first half of the seventeenth century. From Japan there is little or no documentary information that is relevant to us here. On the other hand, there is the abundant kiln-site evidence that forms a major part of the scope of this book.

Documentation

The Japanese had imported Chinese porcelain since it was first available in the great quantities that we

FIGURE 53. Chinese dish in *shoki*-Imari style in underglaze blue, Chongzhen period, dia. 16.0 cm. Ashmolean Museum, 1978.801, Reitlinger gift

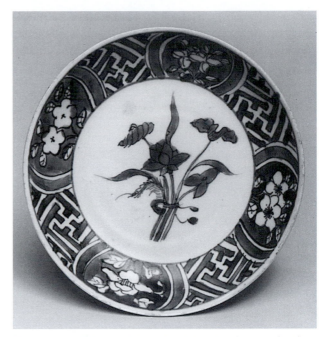

FIGURE 54. Chinese dish in *shoki*-Imari style in underglaze blue, Chongzhen period, dia. 14.4 cm. Ashmolean Museum, 1978.171, Reitlinger gift

now can deduce from the results of the excavations at Daizaifu[9] and from the recovery of the Sinan wreck off the coast of Korea.[10] In the sixteenth century Chinese porcelain had been one of the items of trade carried in the great Portuguese ships from Macao though the amounts seem never to have been very great.

In about 1600 the 'Memorandum of the merchandise which the Great Ships of the Portuguese usually take from China to Japan'[11] stated that 'It will also carry about 2000 ranquels of earthenware [a ranquel comprises 10 items], at the least. They are bought in China at many prices and are sold for two or three times as much in Japan.' In a 'Memorandum of the detailed selling prices at Canton', in other words, the prices at which the Portuguese bought, it records 'a ranquel of fine porcelain @ 1 tael 2 mace; and fine dishes @ 15 mace the ranquel—large fine dishes @ 5 mace each—medium quality earthenware is worth $1\frac{1}{2}$ mace per ranquel, both porcelain and dishes' and 'the ordinary earthenware is worth less than a rial a ranquel, either dishes or bowls'.

As I shall be quoting the figures in the Dutch documents in florins, I shall convert these figures into Dutch florins. The exchange rate before 1636 was remarkably constant at 1 tael = 3.125 florins. 1 rial was the equivalent of 8.5 mace, or 0.85 tael.

1 fine porcelain cost	0.375	fl.
1 fine dish	0.47	fl.
1 large fine dish	1.56	fl.
1 medium earthenware porcelain or dish	0.47	fl.
1 ordinary earthenware less than	0.26	fl.

It must be admitted that the terminology is obscure; quite what 'a porcelain' was, or what the earthenware was is far from clear. The fine dishes and large fine dishes must surely, however, have been Wanli-style porcelain. These pieces cannot be compared with the wares sold in Japan thirty years later; they can, however, be compared in price with the pieces sent by the Dutch to Europe thirty years later.

After 1600 the Portuguese documents do not help us much; fortunately, as we shall see, the information service of the newly arrived Dutch East India Company (VOC) was excellent, providing us with many details of Chinese and Portuguese cargoes, as well as of their own. At the turn of the century the Dutch were relative newcomers to Eastern waters. However, by policies of active aggression towards all competition they soon became the major competitors of the Portuguese and Chinese. No other nation was involved in the direct Japanese trade, save only England, which had a factory in Japan until 1623 only. Japanese control of the foreign factories

stiffened as time progressed. In the years leading up to the final edicts of closure of the country in 1639, progressive steps were taken to control all shipping. The Red Seal licensing system limited Japanese shipping, and finally, after massacres of Christian converts and of the Portuguese and Spanish missionaries, only the Dutch and the Chinese were allowed to trade in Japan. They were at first allowed to keep their factories at Hirado, in northern Kyushu; after 1641, however, they were forced to move to Nagasaki. The Dutch and the Chinese thereafter shared the monopoly of direct trading access to Japan.

The first Dutch ship, *de Liefde*, had only reached Japan in 1600, but even before the establishment of their factory in Hirado in 1609, the Dutch had sent a series of presents to the Shogun. This was to become a regular feature of the maintenance of the uneasy balance between the Dutch traders and the Japanese authorities. Among these presents, in 1608, were six large porcelain bowls, certainly of Chinese make.[12]

On 29 December 1614 the Dutch Chief Merchant at Hirado, Jacques Specx, reported to the Dutch Chief Merchant in the East, Jan Pietersz. Coen, at Bantam, the VOC headquarters in the East, that a cargo of Chinese porcelain that had arrived in 1613 had proved difficult to sell in Japan, because a Portuguese carrack had imported a large quantity of fine pieces. Specx's excuse is a strange one as there had been no Great Ship in 1613, nor did one arrive until August of the following year. However, in 1615, one of the free traders who were still allowed to operate at that time, Jon Joosten Lodensteyn, ordered from Specx '200 large dishes, 200 one size smaller, and 2000 butter dishes'. In August of the same year, Lodensteyn reported to Specx that a large quantity of porcelain had been brought to Japan by a Portuguese boat; this must have been the Great Ship *Nossa Senhora da Vida*. Almost no further details are available for Portuguese shipments.

But in 1620 the new Chief Merchant, Brouwer, wrote from Hirado to Coen in Bantam on 1 March, 'In this ship [the *Vliegende Bode*] go some remainders of porcelain of those which have been forwarded hither with the ship *Oud Hollandia* which, because they are not of the assortments wanted in Japan and have been bought very dear, I could not have sold here without a very great loss.' Brouwer later commented, 'they are very beautiful wares'.

On 6 May of the same year, Coen received a long order from the Directors in Holland not only specifying the exact numbers and shapes of the pieces wanted in Holland, but also demanding the best-quality pieces only. These were to be ordered from Jingdezhen. Volker, from whose compilations of extracts from the archives of the VOC most of this information is obtained, comments that this reflects on the changes in taste in Europe and on the length of time it took for letters to go back and forth between Europe and the Far East. I believe that in addition to this, these two letters make an altogether different and much more important point; that the Dutch had misjudged the taste of the Japanese market in porcelain, for that market was changing or had changed. It was the beginning of a new fashion in Japan.

Unfortunately there is then a gap in the Dutch records. In 1631 we hear that there were Chinese warehouses selling porcelain in Japan, but that this sold very slowly. It is not until 1634 that we hear of porcelain again in the Hirado register. Then both the Chinese and the Dutch imported porcelain into Japan; the Chinese in one junk from Nankin, and the VOC from Taiwan. These were listed, and the price given; this is an important point: 'Large coarse dishes, somewhat smaller dishes, plates, small bowls, somewhat larger bowls'. There was a total of 6,058 pieces costing 170 florins—a little less than 0.03 florins a piece at the Batavia price (very much higher in Japan).

In 1635 the January order for porcelain for Japan was enormous—coarse porcelain to the value of 20,000 florins. At least some of this order was fulfilled at an average price of 0.025 florins a piece. This implies that the order was for some 800,000 pieces. The part of the order that was fulfilled was carried on four ships, which arrived in Japan in August 1635. This list is detailed:

38,865	blue and white painted bowls	a little over	1,076	florins
1,400	blue and white painted dishes	a little over	218	florins
650	third sized dishes	a little over	67	florins
450	green and red painted dishes	a little over	93	florins
190	green and red painted dishes somewhat smaller	a little over	34	florins
94,350	rice and teacups		1,839	florins

This gives a total of 135,905 pieces costing just over 3,329 florins, which makes an average price for a single piece of 0.025 florins.

Now for two years we have had an average price per piece of 0.03 and 0.025 florins. Compare this with the average price in Batavia of the pieces shipped to Holland in the year 1636, 0.24 florins. Admittedly many of the pieces for Holland would have been larger, but the ten-fold price difference can probably be ascribed to the difference between the coarse wares for Japan and the fine wares for Holland. Notice also the similarity between the Dutch price for fine wares in Batavia and the Portuguese price for fine wares in Canton of thirty-six years earlier, quoted above.

Clearly in these years the Dutch had come to understand the Japanese market and could supply porcelain to fulfil that demand. Furthermore, some of this is specifically described as red and green, meaning overglaze enamelled ware with or without underglaze blue. In the long lists of items sent to Holland, whose shapes and sizes are carefully itemized, no mention is made at all of colour. The implication is clear; they were all blue and white. Brouwer's letter seems to imply that such beautiful ware had previously been saleable in Japan, but that by 1620 it was no longer so. This could well mean that the porcelain he mentions was in late Wanli style, but that by that date the Japanese had changed their taste to a new style; this must be the Tianqi style. Furthermore, it implies that that taste has only just started by 1620. Unfortunately no further documentation seems to be available in Holland until 1631.

That the Wanli-style wares were still being produced in quantity we can deduce from the huge orders of 1620 (about 63,500 pieces) and 1623 (about 74,776 pieces). And that much of this must have been in the Wanli style that the Japanese call *fuyō-de* is certified by the finding of the cargo of the *Witte Leeuw* which was sunk in St Helena in 1614; much of this was fine-quality Wanli. In parenthesis, however, it should be noted that just as the Tianqi conformed to Japanese taste, and in no way represented normal Chinese taste, so did the orders for Europe and for the Middle East conform to local demand; the Dutch orders were often very specific and new shapes were ordered each year, often based on models sent from Holland. These models were usually of wood and may well have been painted in Delft.

The Dutch documents continue to list Chinese porcelain shipped to Japan after 1636, commenting at the same time on the arrival of Chinese junks carrying porcelain.

In 1637 the Dutch carried 39,075 pieces of porcelain into Japan, costing 2,208 florins (average price 0.06 florins), the Chinese imported about 750,000 pieces, and the Portuguese 2 pieces.

In 1638 the Portuguese sent two galliots (the last Portuguese ships that were allowed to trade with Japan) which carried some expensive porcelain, and also about 3,200 coarse porcelain small cups, which sold for 163 florins (average about 0.05 florins each). The Dutch apparently sent none, but the Chinese sent several junks which carried porcelain, though the amount was unspecified by the Dutch.

In 1639 the Chinese imported into Japan 1,577 pieces of coarse porcelain, while the Dutch imported 180 fine porcelain dishes and plates costing over 42 florins, or about 0.23 florins each. This is a clear difference of about ten-fold between coarse and fine porcelain.

During these years, and over the next few years, some odd entries appeared in the lists. We must ignore here the fascinating orders for Dutch tin-glazed earthenwares and for German stonewares for various Daimyō, including the Maeda Daimyō of Kaga, of 1634, 1636, 1640, 1641, 1645, 1652, 1654, and 1656. There were also entries for such things as '260 old stoneware pots suitable to put Japanese tea into' of 1640, which sold for prices between 5 and 100 florins each, brought in by the Chinese along with other porcelains (type and amount unspecified). The Dutch sent no porcelain to Japan in 1640, nor is there any mention of imports into Japan of porcelain by the VOC thereafter. Indeed, in 1650 there is a record of the first export of porcelain from Japan by the Dutch. The Chinese, however, continued to import porcelain into Japan until 1653, according to the Dutch registers.

In 1641 the Chinese sent to Japan 2,698 teapots (probably tea jars), 1,400 cups, 5,000 teacups, 22,000 small brandy cups (possibly sake cups) and 1,000 other pieces, totalling 32,098 pieces.

In 1642 the Chinese imported to Japan 1,301 tea jars worth about 20 florins each, and other porcelain worth 14,250 florins. As this latter was not described, it is likely to have been coarse porcelain. If it averaged out at 0.025 florins each, then this would have totalled about 570,000 pieces.

In 1643 the total was only 2,200 pieces, but these were fine ware. In 1644 twenty-seven junks brought porcelain to Nagasaki, but details are lacking.

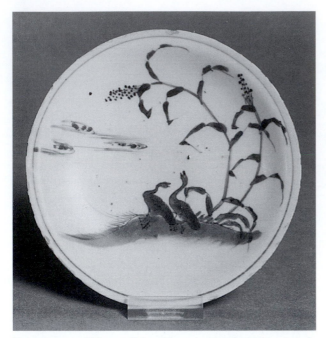

FIGURE 55. Chinese dish with geese in *shoki*-Imari style in underglaze blue, Chongzhen period, dia. 15.8 cm. Ashmolean Museum, 1978.2048, Reitlinger gift

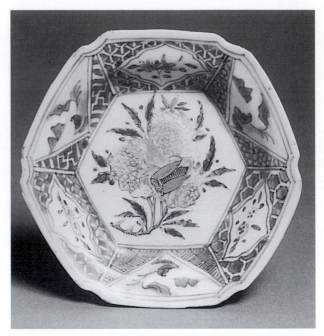

FIGURE 56. Chinese dish in *shoki*-Imari style in underglaze blue and overglaze enamels. Chongzhen period, dia. 15.0 cm. Ashmolean Museum, 1978.1151, Reitlinger gift. Compare with Plate 46*a*

In 1645, among a few expensive pieces, 229,000 bowls were imported, with an average value of 0.01 florins apiece—the cheapest recorded.

In 1646, 487 tea jars worth about 9 florins each, and 70,000 other pieces, average price 0.04 florins apiece were imported. In 1647 and 1648 no porcelain was mentioned. In 1649 the last of the large quantities was imported, 174 tea jars and 10,400 other pieces. The amounts for 1650, 1651, 1652, and 1653 were small.

Thus the Dutch stopped sending porcelain to Japan in 1639, presumably for good commercial reasons, yet the Chinese continued to send coarse porcelain in large quantities until 1646.

If I have interpreted Brouwer's letter, quoted above, correctly, then Japanese taste for porcelain was changing in 1620. This correlates with the date normally given as the beginning of the Tianqi style. And yet we are told specifically that in 1631 the Chinese could sell porcelain only very slowly. This contrasts very strongly with the amounts imported in 1634 and 1635 by the Dutch alone (the Chinese amounts being unavailable); 6,058 and 135,905 pieces respectively. Surely the implication here is that the trade only really picked up in the early 1630s. It cannot mean that there was another change of taste, for the

only early seventeenth-century Chinese porcelains found in quantity in Japan are these Tianqi wares; these have to be the wares imported from 1631, and they may even have begun to appear earlier, though it seems unlikely that they were available in 1620. No doubt it was at that date (1631) that the need for the new style first became obvious, following success by Arita. It therefore can be seen that the dates of the major production of the Tianqi porcelains lie in between the late 1620s and 1645: late Tianqi, Chongzhen, and the first year of Shunzhi. This fits in well with the dating scheme that I have proposed for *shoki*-Imari.

It seems clear that the Chinese style was made in imitation of the Japanese style (figs. 55 and 56); in other words, the commercial success of the domestic *shoki*-Imari prompted the Chinese to enter the market with a similar but cheaper product. Inevitably the competing national industries influenced each other, and imitated each other's shapes and designs. I do not for a moment suggest that all the influence was one way but that there was continual convergence and divergence. The result is that it is by no means always easy to tell the model from the mimic (see figs. 50 and 51).

It is, however, inescapable that the *shoki*-Imari

was first made in Arita before the first making of the so-called Tianqi in Jingdezhen. The Chinese, as usual, followed excellent commercial principles, exporting to undercut the relatively new and inexperienced Japanese porcelain industry.

Quite probably, if the providential fall of the Ming dynasty in China in the 1640s had not so affected Jingdezhen, Arita would have remained a relatively small, mainly domestic-market industry, never entering into competition with the vast and ancient industry of China. It was the cessation of production in Jingdezhen that gave Arita the chance to participate in the European market, making the wares for which it is so celebrated today, the export porcelains. This was to last until the 1730s or 1740s, when Chinese competition, again caused by imitation of a Japanese product, in the form of Chinese Imari, succeeded in forcing the Japanese out of the European market trade. Production of porcelain in Arita from the 1740s nearly until the end of the eighteenth century seems to have been relatively small.

Notes

1. Much of the material in this chapter has been taken from two earlier articles; O. Impey and M. Tregear, 'Provenance Studies of Tianqi Porcelain', *Trade Ceramics Studies*, 3 (1983), 102–18, and Oliver Impey, 'Shoki-Imari and Tianqi; Arita and Jingdezhen in Competition for the Japanese Market in Porcelain in the Second Quarter of the Seventeenth Century', *Mededelingenblad nederlandse vereniging van vrienden van de ceramiek*, 116 (1984), 15–29.

2. Though, see Yabe Yoshiaki, 'Shoki-Imari sometsuke-chukoku aobana taishōhyō' in Nagatake Takeshi and Hayashiya Seizo (eds.), *Sekai tōji zenshū*, 8 (Tokyo, 1978), 182, 183.
3. Soame Jenyns, 'The Chinese ko-sometsuke and shonsui Wares', *Transactions of the Oriental Ceramic Society*, 34 (1962/3), 13–50.
4. Kawahara Masahiko, *Ko-sometsuke* (Tokyo, 1978). See also Saitō Kikutarō, 'Ko-sometsuke, Shonzui', *Tōji taikei*, 44 (Tokyo, 1972).
5. Jenyns, 'The Chinese ko-sometsuke and shonsui Wares' illustrates four of these, plates 1a, b, c, 2a, c, d. A *mizusashi*, plate 2b, simply dated with the reign mark Tianqi, is more in the style discussed here, but is almost certainly later in date, probably Chongzeng.
6. Ibid.
7. Nigel Wood, 'Technical Studies of Tianqi Porcelain', *Trade Ceramic Studies*, 3 (1983), 119–44.
8. For an illustration see Impey, 'Shoki-Imari and Tianqi', pl. 5.
9. See e.g. Yamamoto Nobuo, 'Dating of Northern Song Dynasty Trade Ceramics—Mainly Excavated from Daizaifu', *Trade Ceramics Studies*, 8 (1988), 49–87.
10. Bureau of Cultural Properties, Ministry of Culture and Information, *Relics Salvaged from the Seabed off Sinan* (Seoul, 1985).
11. Quoted in C. R. Boxer, *The Great Ship from Amacon* (Lisbon, 1960).
12. Much of the information in this chapter is taken from T. Volker, 'Porcelain and the Dutch East India Company . . . 1602–1682', *Mededelingen van het Rijksmuseum voor Volkenkunde, Leiden*, 11 (1954). I am also grateful to the Algemeen Rijksarchief, den Haag, for giving me access to the VOC papers, and to Nishida Hiroko for letting me use her unpublished 'Japanese Export Porcelain', doctoral thesis for Oxford University, 1974.

SHOKI-IMARI, *KO*-KUTANI, AND THE ORIGIN OF ENAMELLING IN ARITA

IN the past, a wide variety of porcelains, mostly in the shapes of dishes, have been classified together as *ko*-Kutani, Old Kutani. To some extent this was a class into which enamelled porcelains with dark-coloured pigments were placed, even if there was little other resemblance between them. By extension, some blue and white was included as Blue Kutani on account of its supposed similarity in design to some of the other so-called *ko*-Kutani; and, of course, many things were included in the canon that were not old. To have suggested that all the types that were old came from one kiln working in isolation in Kaga on Honshu in the mid- to late seventeenth century has always seemed a trifle absurd and has been even more unlikely since the series of excavations at the Kutani kiln-site so signally failed to find anything comparable to any of the many types of so-called *ko*-Kutani.

It now seems clear that many of the porcelains usually called *ko*-Kutani, including many of the *ao*-Kutani (Green Kutani) types, must have been made in Arita. The argument is an old one but it needs rehearsing here for several early Arita kilns have provided sherds that closely resemble some of the porcelains that we are accustomed to classifying as Kutani.[1]

One can see a stylistic sequence in some of the products of the three Arita kilns, Yamabeta, Maruo, and Chōkichidani, each of which overlapped in time, though Yamabeta may have been out of production for a short time before the commencement of Chōkichidani, beginning production again at about that time. All three kilns made porcelain in styles related to some *ko*-Kutani wares. Other kilns, too, may have been involved; smaller *ko*-Kutani pieces may also have been made at Kusunokidani and some other kilns. The problem thus is not so much 'was *ko*-Kutani made in Arita or in Kaga?' as 'when did Arita make which types of so-called *ko*-Kutani?'

This is important in an Arita versus Kutani argument, but it is also for us here. What is important is the conclusion that enamels must have been used on Japanese porcelain before the middle of the seventeenth century, before the commencement of that part of the export trade that lay in the hands of the Dutch. If the Chinese were exporting Japanese celadon from Maruo and elsewhere, then could they not also have been exporting enamelled wares from Yamabeta and Maruo? That the Japanese themselves could not have been the only agents is clear from the various stages of the closure of the country evident in the edicts of the 1630s and concluding with the final edict of Sakoku of 1639. *Ao*-Kutani dishes, of a type that may possibly have been made at Yamabeta, are said to have been found in South East Asia, most commonly in Sulawesi. As Kutani has for some time been extremely valuable, the incentive to look for such pieces, and to remain silent about the details of their find-sites has been high. It is usually very difficult to find conclusive evidence that any *ao*-Kutani piece has recently been found in South East Asia. It is worth noting, however, that van Orsay de Flines in 1949 published an *ao*-Kutani dish[2] in the collection of what was then the Koninklijk Bataviaasch Genootschap van Kunsten en Wetenschappen, in Batavia, which came from Banjuwangi in East Java. If the stories are true, then the destination of the enamelled dishes is the same as that of the celadons; what we are seeing is a specialist market. As in so many cases, we ought to be looking at the demands of the customer rather that at the site of production.

However, the sites of production do help us. At Yamabeta site a very few sherds of porcelain dishes enamelled in the *ko*-Kutani style have been found; of

those which lack the blue rings, one piece was typical of *ao*-Kutani, with the remnants of green and yellow enamels and the characteristic wavy spirals in black, while another, showing a tiger on the face (Plate 39*b*), had an undecorated centre to the foot, and outside walls in yellow with the black wavy spirals. Sherds of *ao*-Kutani type dishes have also been found recently on the site that was part of the former Akae-machi, excavated in 1988. Murakami has recently drawn comparisons between enamelled sherds found at Yamabeta and some *densei* pieces, that are convincing.[3]

Enamelled sherds are, as we have seen, rarely found at kiln-sites; but it has never been suggested that the Akae-machi was earlier than mid-seventeenth century and therefore enamelling done before that time (as, indeed, sometimes after that time) was more than probably done in a muffle kiln near to a *noborigama*. Yamabeta may be an example of this. But if that is so, then why should sherds of *ao*-Kutani have been found in the Akae-machi? And particularly so as the date of the Akae-machi, from the evidence of the sherds so far recovered, seems indeed not to have existed in the period before the Dutch trade? From this we must conclude that even if enamelling in *ao*-Kutani style was done, probably at Yamabeta and Maruo at some time possibly as early as the 1640s, or even the late 1630s, it was also done later, during the Early Enamel period of the late 1650s and the 1660s. We must conclude that it is unlikely that Yamabeta can have ceased production as early as 1637, and we are therefore justified in our rejection of the effectiveness of the edict of 1637.

The finding of enamelled sherds, however few, at both the Yamabeta and the Akae-machi sites does seem to invalidate a frequently made suggestion that porcelains were sent in the white to be enamelled in Kaga; even if such white porcelain were thought to have been shipped as ballast, this has always seemed to me implausible for economic reasons. We are no nearer to the solution of the problem of why this type of porcelain should have carried the label Kutani for over a hundred years. Can it really be that there is no prototype from Kaga? We have not found one yet.

Nor, unfortunately, does the recent excavation of the Maeda house in the grounds of Tokyo University help us. Much has been made of the finding of dishes bearing decoration in enamels in Kutani style;[4] other finds from the same site are indubitably from Arita, but it cannot be assumed that these dishes are therefore also from Arita nor that they are from Kaga simply because they are found in a Maeda house. These findings therefore are of little help in this context.

The white-bodied porcelain sherds from the Yamabeta kiln-site, lacking underglaze blue (Plate 36*b*), cannot be directly associated with any one Yamabeta kiln, though they may relate to kiln four and possibly to kiln two. Kiln four is undoubtedly early, but this should not necessarily be taken into account in this context. Yet it does seem that these undecorated wares, with their very thin, underfired, smeared glaze must be early, early enough to be ancestral to the somewhat more robust but similar pieces from Maruo that do bear underglaze blue. Other blue and white wares from Maruo kiln confirm a date late in period two for the kiln, and this product at least of Yamabeta was probably earlier. This may mean that the white-wares of Yamabeta may have finished before 1637, the supposed date of the end of the West Arita kilns.[5] Whether or not this is important, it suggests that if the Yamabeta kilns were involved in an export trade such as we shall see from Maruo kiln, then this may have been based upon enamelled porcelain, and this in turn suggests an early date for the first enamelling on Japanese porcelain. In fact, we have chosen to reject the 1637 date for the cessation of the kilns of West Arita, so it is not so relevant. From the evidence of other finds at the Yamabeta sites, it seems likely that Yamabeta did not close before the middle of the century, possibly not until the late 1650s. The sherds suggest that there was discontinuity in production between the two major types of finds at Yamabeta, so that there may have been a later phase, a revival. This I believe to have happened, though it is contra-indicated by the findings of all the types of sherds in the rubbish dumps by the kilns totally intermingled. This I believe to be a later artefact due to disturbance, for I do not believe in the presence of good stratigraphical evidence for kiln-site rubbish dumps (see below).

Except for the *ao*-Kutani, few so-called *ko*-Kutani pieces lack underglaze blue, at least around the foot-ring; this is one of the arguments against the identification of the white dishes found at the *ko*-Kutani kiln-site with *densei ko*-Kutani.[6] The white dishes of Yamabeta are less coarse than those from the Kaga site, and the shapes are more akin to *densei ao*-Kutani, being shallower and with a more similar foot-ring. The sherds of white dishes—that is with

no underglaze blue at all—have a coarse glaze rarely free of dark spots due to iron impurities, that is thin and smeared; frequently the finger-marks of the glazer can be seen on the back, around the foot-ring, where it would have been held for glazing.

This white-bodied porcelain is probably that used for *ao*-Kutani, Green Kutani. In most Green Kutani the diameter of the foot-ring is perhaps half that of the dish (Plate 38*b* and *d*). This is smaller in proportion than that of most *ko*-Kutani pieces with blue and white and with enamel, but larger than that on the huge blue and white dishes for which Yamabeta is so famous (see Plates 3 and 4). This suggests, but no more than suggests, that while later than the blue and white, much *ao*-Kutani is earlier than most *ko*-Kutani.

Most Green Kutani has decoration covering the entire surface of the inside of the dish. Of that we can get no clue unless enamelled sherds are found at kiln-sites and this rarely occurs. However the finds that have been made at the Yamabeta sites (see above) do demonstrate the connection. Some Green Kutani has no decoration on the back at all, merely a thin coating of green enamel brushed on (Plate 38*b*), sometimes leaving the inside of the foot-ring clear. In most Green Kutani the back is covered with a slightly thicker (but still markedly thin) green or yellow enamel over which is painted in black enamel a cloud-pattern or something similar (Plate 38*d*). Sometimes the interior of the foot-ring is a different colour from that of the rest of the back. There is frequently a square seal-mark, usually written in black enamel on a green ground.

It is necessary to look at sherds of dishes with at least some underglaze blue to find the majority of those comparable to *densei ko*-Kutani pieces. These are to be found at Maruo and Yamabeta kiln-sites.

Maruo kiln is perhaps best known for its production of large celadon dishes (see Plate 14), very much in the manner of those of Zhejiang, that seem to have been made primarily for export to South East Asia. It is easy to date Maruo to period two into period three and later by its products; the early pieces include small blue and white dishes with the flattened edge so typical of the period, decorated with birds and with areas of geometric background as, for instance, 'cloud-bands' (see Plate 19*d*). These used to be called Blue Kutani in the distant past, and they were the first pieces of Kutani to be removed from the canon. Other products of Maruo include large dishes with a pale blue wash (*ruri*) under the glaze,

decorated either by scratching through to show the white body or by line painting in darker blue (see Plate 59*c* and *d*). Of interest to us in the context here are the large dishes that are plain on the interior or have boldly drawn, rather sparse decoration in underglaze blue on the upper side; both have perfunctory decoration on the back, around a foot-ring usually with a single blue concentric line within and with two or more without (Plate 42*c*). The glaze on the back of these pieces may be rather creamy and smeared, again, often showing the glazer's finger-marks; it strongly resembles that of many of the *densei* Kutani dishes. Presence of some very coarse, line-drawn *fuyō-de*-style plates, not of ordinary export type, suggests that Maruo may well have continued to work until almost the end of period three.

Other sherds are possible contenders for the title of *ko*-Kutani; these are sherds of dishes also with underglaze blue concentric rings around and within the foot, usually two in the latter place, loosely associated with Yamabeta kiln three (Plate 42*d*). Many of them have other blue and white decoration on the ouside wall of the dish. The foot-ring of these is much wider in proportion to the overall diameter than was that of the white pieces or that of most *ao*-Kutani and the flat well is supported by spurs; both these features suggest a date comparable with the early export trade.

Comparisons can be drawn between sherds such as those we have discussed and a number of *densei ko*-Kutani dishes; let us take some examples. Of the Kutani dishes that 'look' the earliest, the 'tiger' plate (see Nihon Toji Zenshu 26, Plates 3 and 4) and the 'shrimp' plate (Plate 36*a*) both have underglaze blue rings immediately without the foot-ring, but none within; I am not aware of any sherds with this configuration having been found at Arita, though I believe these dishes to have been made there. The 'Hotei' plate (Plate 37*a*), perhaps the most famous of the group, has rings within (two) and without the foot-ring and a sparse underglaze blue decoration of sprigs of prunus, in which spaces have been left for the addition of flowers in overglaze red (Plate 37*b*). Sherds of this pattern have been found at Yamabeta (Plate 37*d*). This is very similar to the back found on a dish in the Idemitsu Museum (Plate 37*c*), with a landscape in a panelled border. Typical of the smeared glazed backs of dishes, associated with sherds from Maruo and Yamabeta, is the great dish also in the Idemitsu Museum (Plate 42*a*) and the famous 'phoenix' dish (Ishikawa-ken Museum) (*Nihon tōji zenshū*

(NTZ), 26, pls. 48–50); in both cases the back is enamelled. The enamelled pattern on the back of the 'phoenix' dish is similar in design to the underglaze blue pattern found on several sherds from Yamabeta kiln-sites (Plate 41b) and on a dish in the Ishikawa Prefectural Museum (Plate 41a). Some sherds from Yamabeta have underglaze blue patterns on the inside that can be compared with certain *densei* pieces; there are sherds that correspond to the dish with a landscape within a border of circles (Plate 40a and b) and others that correspond to pieces with geometrically patterned edges (Plate 40c and d). A few sherds bearing the remains of enamel decoration in *ko*-Kutani (as opposed to *ao*-Kutani) style have been found at Yamabeta. One such has the Y-shaped edge decoration dividing areas of geometrical patterning from some other pattern (Plate 43b) that can be seen on many Kutani pieces, such as that illustrated on Plate 43a, and that are clearly related to many of the fine formally patterned dishes.

Some sherds that have shaped edges (as opposed to round or smooth edges) also correspond to known Kutani pieces. There are sherds from Yamabeta of the same complex bracketed shape (Plate 41d) found on tall-footed dishes such as that in Ishikawa (Plate 41c), and other sherds with more simple petalled edges have been found at Kusunikidani kiln-site, such as one (Plate 43d) which closely matches a dish in the Idemitsu Museum (Plate 43c). More examples could be cited; this may be sufficient to make the point. It is the inescapable conclusion that at the very least, a majority of types of *ko*-Kutani dishes were made in Arita.

If we can demonstrate the similarity between sherds of porcelain dishes from Yamabeta and elsewhere in Arita and complete *ko*-Kutani or *ao*-Kutani pieces, then should we not also expect to find other shapes or types, possibly even from other kilns? One such similarity can be drawn between known ring-shaped bottles, with cylindrical neck and rectangular foot, such as the one in Hamburg Museum, of a shape derived from the Korean, which bear Kutani-type enamels,[7] and with sherds found at the Chōkichidani kiln-site. At Yamabeta a sherd of a lid with a simple knop handle has been found that closely resembles those on the flattish sake-kettles such as that in the Eisei Bunko Foundation.

But we ought to look further than this; there are several examples known of the standard Arita middle-sized plates with the slightly raised but flattened edge and flat profile that are typified by examples from

Hiekoba kiln (see Plates 27e and f), that bear enamel decoration. There is an example in the Gerry Collection in New York[8] and a plate that may fall into this category was sold by Christies in London in November 1988.[9] There are two of these in *ao*-Kutani style in the Idemitsu Museum (Plate 44a). Opinion in the past has usually either classified such pieces as these as *ko*-Kutani or dismissed them as *shoki*-Imari with later decoration, in spite of the early, dark enamels they bear. As these shapes are found at Yamabeta and Maruo (but not, I think, at Chōkichidani), it would seem virtually inescapable that these pieces are in fact authentic examples of early enamelling in Arita.

Again, we do not know when this enamelling began. As we have rejected the 1637 date for an absolute terminus of the West Arita kilns, we must find some other suggestion. The earliest pieces to receive enamel may be even earlier than the white pieces from Yamabeta and the flattened plates we have just mentioned. Such a piece as that in the Ashmolean (illustrated here as Plate 45a) is simply an early *shoki*-Imari dish with enamels instead of underglaze blue.

Enamelling is likely to have started in Arita as a market response to imported Chinese 'Tianqi' wares. Sherds of white dishes are more commonly found than one would expect for ordinary demand; although lack of underglaze decoration does not necessarily imply the future application of overglaze enamels, such numbers suggest it. Nor does presence of underglaze blue preclude the later addition of enamels. At several kilns, notably Kusunokidani, sherds are found which not only are of the irregular or at least non-round shapes that were such a feature of the early imports (and of the Japanese equivalent of them) but that also bear underglaze patterns with spaces that are certainly intended for enamel decoration. Often such spaces are non-specific, in that any pattern or picture could be enamelled into them (Plates 46b and 61b).

From other stylistic grounds we would conclude that the flattened plates and their precursors could have been made in the 1630s and 1640s but probably not later, while the white dishes of Yamabeta must also be of the 1630s and early 1640s. The *ao*-Kutani may have preceded the *ko*-Kutani in the 1640s and into the 1650s. It may well be, judging from the finds in the Akae-machi, that *ko*-Kutani went on being made into period four and so was in its later phases concurrent with the early enamelled ware. The ring-shaped bottles are surely later.

In 1991 in a symposium in Arita, Ohashi[10] divided the period of production of the large dishes into three periods; 1640–50, 1650, and 1655–60. Within these periods he drew up groups of dishes perceived as similar enough to warrant such classification; this method of classification may be valid and useful, but perhaps not as universal as there suggested. In the same 1991 symposium, which was hailed by one rash scholar as finishing the debate for once and forever, Murakami drew attention to the apparent similarity between blue and white sherds found at Yamabeta and Maruo sites comparing their motifs with those found on certain *densei* pieces, confirming our earlier belief in the relevance of the blue and white of the Maruo site to this argument.[11] Other sherds from Kusunokidani resemble blue and white *densei* pieces. It should be noted that, as has been the case for a long time, we are still discussing the problem in terms of opinion and not much in terms of hard facts; perhaps the only facts are provided by these comparisons drawn between sherds and *densei* pieces. This we have attempted to do here; it has been done before, notably by Ogi in 1990.[12]

Clearly we are in a position to conclude that enamelling was a widespread practice in Arita well before the commencement of the export trade. The enamels of Arita may well be as early as those of Kyoto. Their colours were certainly not obtained from the Chinese, as they include a cobalt overglaze blue not in use in China until well into the Kangxi period. The enamels were dark and rather opaque, more closely resembling those known from wares previously described as *ko*-Kutani, than those on the Early Enamelled wares of the export period of Arita, or those of Wanli or Tianqi China. In all probability enamelling was started in Arita as a response to market forces imposed by the importation of Chinese porcelain in the late 1620s through the 1640s (see ch. 6).

Quite which pieces of *ko*-Kutani should now be classified as of Arita manufacture is still, in spite of the 1991 symposium, open to argument. Clearly, we can demonstrate that the majority of the multifarious different types of porcelain that have been called *ko*-Kutani are of Arita make; we should not yet claim that they all are. No sherds, as far as I am aware, have been found of the famous nine-sided dishes such as that in the British Museum or those illustrated in *NTZ* 74–6.

Notes

1. The literature on where *ko*-Kutani was actually made is more than extensive; its first attribution to Arita in English may have been that of Soame Jenyns in *Japan-ese Porcelain* (London, 1965), who wondered whether it might not be the work of the early members of the Kakiemon family. For illustrations of many pieces of *ko*-Kutani see Shimazaki Susumu, 'Kutani Ware', *Nihon tōji zenshū* (hereafter called *NTZ*), 26 (Tokyo, 1976). For representative, recent work see Ohashi Kōji and Shimazaki Susumu (eds.), *Exhibition of Imari and ko-Kutani Ware* (1987), held at the Ishikawa Prefectural Museum of Art and the Kyushu Ceramic Museum, the Special Exhibition catalogue *Polychrome Porcelain in Hizen: Its Early Type and Change of Style* (Arita, 1991), and Ogi Ichirō, *Shoki-Imari kara ko-Kutani yōshiki: Imari zenki no hensen o miru* (Tokyo, 1990).

2. E. W. van Orsay de Flines, *Gids voor de Keramische Verzameling* (Batavia, 1949), pl. 78. For a similar example see Plate 38a.

3. In a paper given at the October 1991 conference of the *Tōyō Tōji Gakkai* in Arita, Murakami Nobuyuki compared enamelled sherds found at the Yamabeta kiln-site with several well-known *ko*-Kutani dishes. He also drew attention to the similarity in design between a blue and white sherd depicting a tiger from Maruo kiln-site and the enamelled image of a tiger on the famous tiger dish illustrated here as Plate 39a.

4. Suzuki H. and Watanabe S., 'Sherds of the Early Edo Period Unearthed at the Site of the Memorial Hall of His Imperial Highness in the Hongo Campus of Tokyo University', *Tōsetsu*, 432 (1989), 15–25, fig. 8.

5. See ch. 11 for the order of Katsushige of 1637.

6. For illustrations of sherds from the Kutani kiln-site, see Ohashi and Shimazaki, *Exhibition of Imari and ko-Kutani Ware*, pls. 134 ff.

7. See Shimazaki, 'Kutani Ware', text figure on p. 58. There is a fine example of this shape in Eisei Bunko, illustrated by Nishida Hiroko in 'ko-Kutani', *Tōji Taikei*, 22 (Tokyo, 1990), pl. 76, and another in the Kunstgewerbe Museum, Hamburg.

8. See Barbara Ford and Oliver Impey, *Japanese Art from the Gerry Collection in the Metropolitan Museum of Art* (New York, 1989), pl. 77.

9. Christies, London, sale catalogue, 9–10 Nov. 1988, lot 430.

10. *Tōyō Tōji Gakkai*, Oct. 1991 (see note 3). This paper was amplified and published by Ohashi Kōji as 'Overglaze Enamel Porcelain Wares of Hizen during the First Half of the Edo Period', in *Tōyō tōji*, 20–1 (1990–3), 5–31.

11. *Tōyō Tōji Gakkai*, Oct. 1991 (see note 3); Murakami has apparently not published this paper.

12. Ogi, *Shoki-Imari Kara ko-kutani*.

8

EVIDENCE FROM CONSUMER SITES OF
THE MARKET FOR *SHOKI*-IMARI

IN recent years, excavations all over Japan have provided evidence of the distribution of *shoki*-Imari wares to a wide variety of sites. For a selection of such finds, we shall look at two exhibitions of potsherd material of recent years, that at the Kyushu Ceramic Museum of 1985,[1] and that at the Goto Museum of 1984,[2] as well as the Report of the Number Seven Science Building Area Excavation at the Hongō Campus of the University of Tokyo, 1989.[3]

Not many of the consumer sites can provide evidence of precise dating; in the few cases where it can, this can be useful. We are here simply demonstrating the fact that *shoki*-Imari porcelain was in demand in and was supplied to places throughout Japan.

In parenthesis, all three sources provide ample evidence that Arita porcelain of export type were available and in use in Japan in the late seventeenth and in the eighteenth centuries.

In many cases, tentative attributions to Arita kiln-sites or to a group of Arita kiln-sites can be made for these consumer finds. To demonstrate more than a few examples would be meaningless; I hope to make the point with a small selection.

Sites on Kyushu

SAGA-KEN

Miyako Site[4]

This is close to the town of Takeo, on the Rokkakugawa river; it is close to the Mode site; see below. The site has been occupied since Yayoi times, through the Middle Ages and into the sixteenth and seventeenth centuries. Finds are noticeably fewer after the 1620/30s, when the area may have been abandoned because of river-bank workings.

This piece (fig. 57) was found in a river-bed by Takeo Castle. The sherd is of a small dish, diameter approx. 15 cm. with chrysanthemum roundels against a speckled ground, a fairly typical pattern of phase two, from a kiln of the Tenjinmori group. The sherd is no. 605, found in pit 217.

The Mode Site[5]

The Mode site in Takeo City. Close to the town of Takeo and to the Miyako site (see above). A residential area since Yayoi times, a village in the Edo and Meiji periods; considered to have had members of the samurai class living in the centre of the village.

One sherd is of a straight-sided bowl typical of phase two, Hyakken kiln type, with a landscape pattern (fig. 58); another is of a flat plate with the raised flattened rim typical of Hiekoba and some other phase two kilns (fig. 59), with an unusual decoration of standing human figures, perhaps from Kama no tsuji.

NAGASAKI-KEN

The Kōzen-chō Site[6]

In Kōzen-chō in Nagasaki City. Established in the late sixteenth century after the opening of the port in 1571, and hence called 'Shin-machi' (New-town) until 1963. The residential site of the Yao family, a family of *otona* (local officials) who established a business, trading in armour, called 'Gusoku-ya'. Evidently, from the artefacts found, a wealthy family.

One sherd (see figs. 17 and 18) of a small (diameter 14.5 cm.) bowl was with the phoenix and dragon pattern, inside with a very rudimentary version of the leaping fish pattern. This probably came from one of the West Arita kilns that specialized in these simple, rather crude wares, difficult to date on account of their provinciality, but probably of late

FIGURE 57. Sherd found at the Miyako site

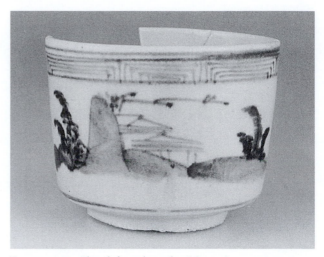

FIGURE 58. Sherd found at the Mote site

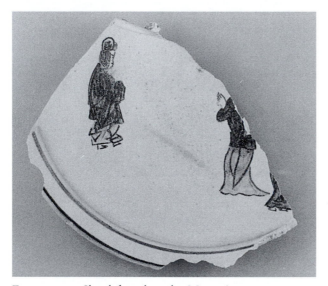

FIGURE 59. Sherd found at the Mote site

FIGURE 60. Sherd found at the Notame site

FIGURE 61. Sherd found at the Reisen site

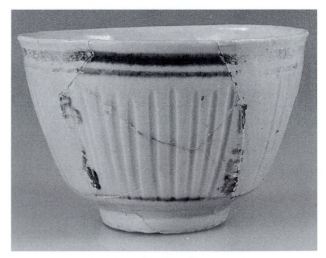

FIGURE 62. Sherd found at the Hata-e site

phase two. The site is thought to have burned down in the Kambun period (1661–73).

FUKUOKA-KEN

The Notame Site

The Notame residential site, in the Minami district of Fukuoka City. The excavation reports do not include information on the Edo period.

A small dish with the pattern of a fisherman typical of Kusunokidani, Gezuyabu, Yamagoya, and Kōtake kilns; late phase one/early phase two (fig. 60).

The Reisen Site[7]

In the Hakata district of Fukuoka. A place of residence of Hakata merchants; Chinese porcelains as well as Japanese were found at the site.

A small dish with the reversible plant pattern as found at Kake no tani and at Kodaru (fig. 61).

The Hatae Site[8]

In the town of Maebaru, in Fukuoka Prefecture. A house site built on the remains of one destroyed in the early seventeenth century; most of the sherds were found in ditches and wells.

Here (ditch SD002) there were two bowls, a ribbed late phase one bowl with four lines of *kanji*, a fairly common type found at Tengudani D, Tenjinmori, Sarugawa, and some other kilns (fig. 62), and a rounded bowl with the three friends, of typical phase two Hyakken, Tenjimori, Kotoge type (fig. 63).

Sites on Honshu

OSAKA-FU

Sakai City[9]

The site in Kushiya-machi is not named, but indentified by the excavators as SKT 3. An urban living area of evident prosperity. The excavators comment on the rising prosperity indicated by the amount of Chinese imported porcelain and the fact that as this became cheaper it was replaced by Karatsu ware which was in turn replaced by *shoki*-Imari.

A small bulbous jar of early type was found (fig. 64). Sherds of similar jars have been found at Tengudani.

NARA-KEN

Nara Women's College[10]

The site of the former Nara Bugyōsho, the magistrate's office, founded in 1603, located in Kitauoyanishi-imachi, Nara. Much *shoki*-Imari and Karatsu, the latter mostly *taidome* stacked must have been used between 1600 and 1640.

Many interesting examples of *shoki*-Imari; a *temmoku* bowl with a blue and white flower inside (fig. 65) and a bowl with the net and window pattern (fig. 66) are the same as sherds from Tengudani, a landscape plate (fig. 67) and a bowl (fig. 68) with an unusual pattern of flowers and pine tree might have come from Hiekoba or another central Arita kiln. Pieces of a ribbed bottle with the *fuku* character in lines (fig. 69) comes from Tenjinmori, Komizo, or Hyakken, a celadon plate with incised decoration and raised on three low feet (fig. 70) must come from Maruo or Yamabeta or from Fudōyama.

OKAYAMA-KEN

The Hyakkengawa Taima Site

Thought to have been a site where merchants would have lived.

A bowl with a flower-scroll between two borders may come from Hyakken (fig. 71); another bowl with curved sides and incised decoration (fig. 72) may come from Komizo.

The Futsuka-ichi Site[11]

A residential site in the centre of the city of Okayama, near the Asahigawa river. Apparently occupied (evidence of coin material) between 1637 and 1640.

Two straight-sided bowls are of phase two; one with landscape pattern may be from any of the Hyakken group of kilns (fig. 73), another with ribbed sides, decorated with *fuku* and cross-hatching (fig. 74) is identical to sherds from Komizo. The rounded bowl with 'scribbled flower' scroll (fig. 75) might also be from Komizo. Several other small dishes might be from Komizo or Tenjinmori (figs. 76–8).

TOKYO-TO

The Toritsu Hitotsubashi kōkō Site[12]

In the Chiyoda district of Tokyo. A Daimyō residence after 1684; before that, uncertain. The layer in which the dishes were found is thought to belong

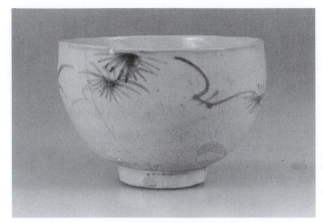

FIGURE 63. Sherd found at the Hata-e site

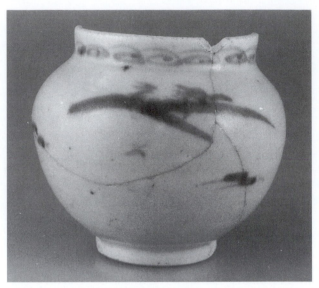

FIGURE 64. Sherd found at the Sakai site

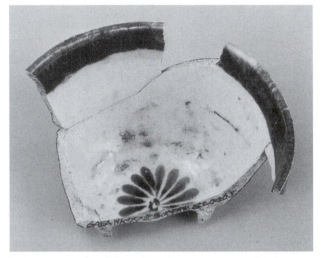

FIGURE 65. Sherd found at the Nara Bugyōsho site

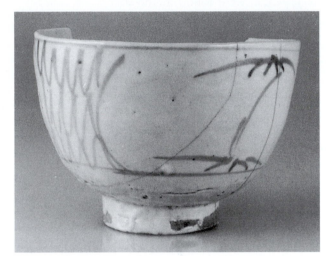

FIGURE 66. Sherd found at the Nara Bugyōsho site

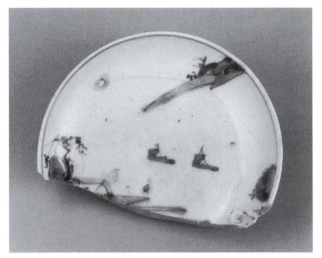

FIGURE 67. Sherd found at the Nara Bugyōsho site

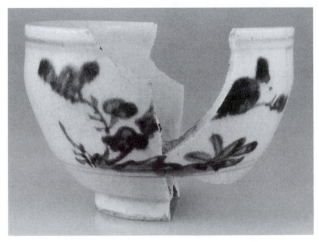

FIGURE 68. Sherd found at the Nara Bugyōsho site

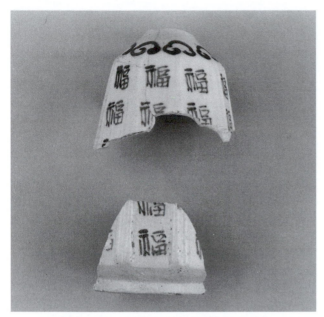

FIGURE 69. Sherds found at the Nara Bugyōsho site

FIGURE 70. Sherd found at the Nara Bugyōsho site

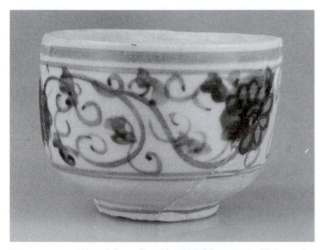

FIGURE 71. Sherd found at the Hyakkengawa Taima site

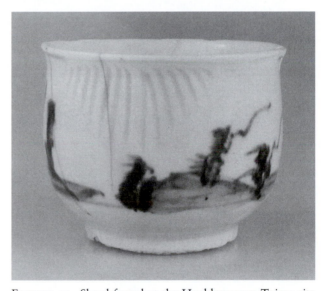

FIGURE 72. Sherd found at the Hyakkengawa Taima site

FIGURE 73. Sherd found at the Futsuka-ichi site

FIGURE 74. Sherd found at the Futsuka-ichi site

FIGURE 75. Sherd found at the Futsuka-ichi site

FIGURE 76. Sherd found at the Futsuka-ichi site

FIGURE 77. Sherd found at the Futsuka-ichi site

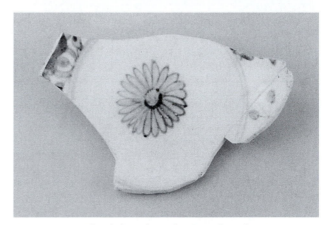

FIGURE 78. Sherd found at the Futsuka-ichi site

to a period from after the great fire of 1657 until 1684.

Among a quantity of the contemporary Takeo-Karatsu and Ofuke wares, the *shoki*-Imari was conspicuous by its rarity; only a Tengudani-type bottle and a *fukizumi* dish with leaf decoration, possibly from Hyakken and a few others were found.

The Shiba Rikyū Teien[13]

In the Minato district of Tokyo, this was a seaside villa built by Matsudaira Tsunashige after 1652.

Here, too, *shoki*-Imari is conspicuous by its scarcity. Two celadon *kōro* may be of the period, as may be a celadon dish with fluted side and outturned rim. Two large celadon dishes may come from Maruo, Fudōyama, or Mitsunomata in Hasami.

The Tokyo daigaku kōnai rigaku-bu 7-gōkan Site[14]

The Tokyo University Campus, formerly a Maeda family building.

A quantity of *shoki*-Imari sherds were found in Pit 2. These included two large dishes with the spotted borders typical of Yamabeta; some dishes of Yagenji/Kake no tani type, some bowls, and a bottle typical of Tengudani, with rudimentary plant, willow, or landscape patterns. There was some early celadon and a bowl with roundels that might be from Komizo. In the report there is a comment on the expense of these pieces, so that 'this indicates that these artifacts were used by fairly rich people'.

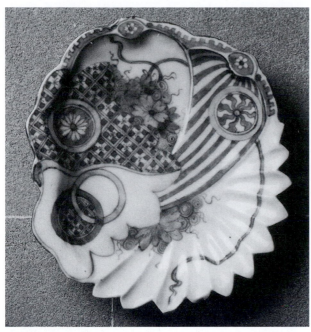

FIGURE 79. Shaped dish with geometric patterns from the collection at Burghley House. Date of acquisition unknown, w. 15.8 cm. Burghley House.

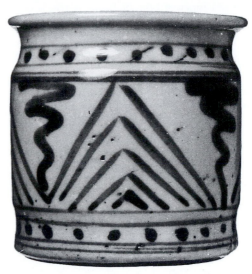

FIGURE 80. Albarello excavated in Amsterdam, Zwanenburgwaal, dia. 8.6 cm.

The excavation reports of the three Tokyo sites discussed all the sherds, or at least a representative sample of all the sherds found at the site; the other pieces were selected from an exhibition of sherds of the ceramics made in Hizen; the latter can be used to look at distribution, the former to see whether Arita pieces were as commonly found as other contemporary wares. While quantitative analysis is lacking, it is still quite clear that early Arita wares were either difficult to obtain, possibly because of price, though I find this unlikely, or because they were not much in demand yet. More work is needed on these problems.

Shoki-Imari is so rarely found in Europe that we can be clear that it must almost never have been shipped to Europe in quantity. The only example I know of in an early collection that looks as though it must date to before 1650, is one and one only of the small dishes at Burghley House[15] (fig. 79); it is not described in the 1688 inventory[16] and its acquisition appears to be unrecorded. It is likely to have come with the other blue and white dishes in the house, similarly unrecorded, that are mostly of non-export types that may have been acquired as curiosities towards the end of the seventeenth century. These vary in date from the middle of the century (a small dish from Chōkichidani similar to that illustrated in Plate 23*f*) to well into the export period.

A few examples exist of Dutch Delft earthenwares, either blue and white or coloured, that imitate either *ko-sometsuke* or *shoki*-Imari, being irregular in outline and of the style, but it cannot be determined which. No known piece of *ko*-Kutani style porcelain exists in Europe the history of which can be traced further back than the nineteenth century.

Nor am I aware of any *shoki*-Imari except the celadons of Maruo, Fudōyama, and Mitsunomata and some few *ko*-Kutani dishes being found at sites in South East Asia. The Maruo style celadons were clearly competition for or replacements for the Chinese celadons of Zhejiang, that were much prized in Sulawesi and elsewhere. One sherd has been found in the Maldive islands.[17]

Possibly the earliest piece of Japanese porcelain found in an excavation in Europe is an albarello found in Amsterdam in 1973[18] (fig. 80). The site was datable to the early 1650s. This is quite likely to have been from one of the shipments to the Surgeons' shop in Batavia.

There is also some documentation of the usage of *shoki*-Imari porcelain in Japan; the diary of the Kyoto priest Hōrin, the *Kakumei-ki*,[19] written between 1633 and 1668, contains many references to Imari porcelain. Hōrin Shōshō was second priest of Rokuon-ji Temple and a cousin of the retired Emperor, Goyōzei

(abdicated 1628), so he was accustomed to high circles.

In 1639 Hōrin refers to 'a blue and white Wistaria seed-shaped incense box of Imari ware' (in 1652 he refers to another one 'with paint', which may mean enamel). There is also mention of Imari bottles, plates, dishes, tea bowls, incense boxes, and incense burners. In 1645 Hōrin had tea in a white Imari bowl and in 1648 he was given two celadon chrysanthemum shaped bowls as gifts. In 1652, he was given an Imari *nishiki-de* bowl; this is the first unequivocal documentary evidence of enamelled Imari porcelain known. On the fifth of September 1652, Hōrin attended a party at the house of the retired Emperor; after dinner the retired Emperor brought out 210 Imari *sometsuke* jars as prizes for gambling. Hōrin won fifteen jars. In 1653 the retired Emperor gave Hōrin an Imari celadon incense burner with 'an extraordinarily beautiful celadon glaze, a marvellous piece. I have never seen such fine celadon.' Hōrin had a box, a sack, and a lid made especially for this piece. Later (in the 1660s) there is mention of black-glazed shallow bowls and a tea bowl in *mishima* style.

Hōrin gives us a hint of the price of Imari plates; ten Imari porcelain plates cost 108 *momme* the ten. Later in the same year (1664) he mentions sixty Zeze *temmoku* tea bowls at 3 *momme* 5 *bu* for ten. Thus an Imari plate was thirty times as expensive as a Zeze tea bowl.

Notes

1. Kyushu Ceramic Museum, *Kokunai shutsudo no Hizen tōji* (Arita, 1985).

2. Goto Museum, *Edo no yakimono* (Tokyo, 1984).

3. 'Tokyo daigaku hongō kōnai no iseki: Rigaku-bu 7-gōkan chiten', *Tokyo daigaku iseki chōsa-shitsu hakkutsu chōsa hōkokusho*, 1, Tokyo daigaku rigaku-bu iseki chōsa-shitsu (Tokyo, 1989).

4. 'Miyako iseki: Rokkakugawa kasen kaishū kōji ni tomonau maizō bunkazai hakkutsu chōsa hōkokusho', *Takeo-shi bunkazai chōsa hōkokusho*, 15, Takeo-shi kyōiku iinkai (Takeo, 1986) and 'Miyako iseki, II: Nōgyō kiban seibi jigyō ni tomonau hakkutsu chōsa hōkokusho', *Takeo-shi bunkazai chōsa hōkokusho*, 19, Takeo-shi kyōiku iinkai (Takeo, 1989).

5. 'Mode iseki: Rokkakugawa kasen kaishū kōji ni tomonau maizō bunkazai hakkutsu chōsa hōkokusho', *Takeo-shi bunkazai chōsa hōkokusho*, 15, Takeo-shi kyōiku iinkai (Takeo, 1986) and 'Mode iseki: Rokkakugawa kasen kaishū kōji ni tomonau maizō bunkazai hakkutsu chōsa hōkokusho 2', Takeo-shi kyōiku iinkai (Takeo, 1983).

6. Nagasaki-shi kōhōka, 'Yomigaeru', *Shimin gurafu Nagasaki*, 30, Nagasaki-shi kōhōka (Nagasaki, 1991).

7. 'Hakata I', *Fukuoka-shi maizō bunkazai chōsa hōkokusho*, 66, Fukuoka-shi kyōiku iinkai (Fukuoka, 1981).

8. 'Itoshima-gun Maebaru-chō shozai Hatae iseki no chōsa', *Imajuku baipasu kankei maizō bunkazai chōsa hōkokusho*, 6, Fukuoka-shi kyōiku iinkai (Fukuoka, 1982).

9. Sakai-shi kyōiku iinkai (ed.), *Sakai-shi bunkazai chōsa hōkokusho*, 15, Sakai-shi kyōiku iinkai (Sakai, 1983).

10. Nara joshi daigaku maizō bunkazai hakkutsu chōsa-kai (ed.), *Nara joshi daigaku kōnai iseki hakkutsu chōsa gaihō*, II, Nara joshi daigaku (Nara, 1984) and Nara joshi daigaku maizō bunkazai hakkutsu chōsa-kai (ed.), *Nara joshi daigaku kōnai iseki hakkutsu chōsa gaihō*, IV, Nara joshi daigaku (Nara, 1989).

11. Nihon kōkogaku kyōkai (ed.), *Nihon kōkogaku nenpō, 35: 1982 nendo-han*, Nihon kōkogaku kyōkai (Tokyo, 1985).

12. Toritsu hitotsubashi kōkōnai iseki chōsa-dan (ed.), *Edo: Toritsu hitotsubashi kōkō chiten hakkutsu chōsa hōkoku*, Toritsu hitotsubashi kōkōnai iseki chōsa-dan (Tokyo, 1985).

13. Shiba Rikyū teien chōsa-dan (ed.), *Shiba Rikyū teien: Hamamatsu-chō eki kōkashiki hokōsha-dō kasetsu kōji ni tomonau hakkutsu chōsa hōkoku*, Shiba Rikyū teien chōsa-dan (Tokyo, 1988).

14. 'Tokyo daigaku hongō kōnai no iseki: Rigaku-bu 7-gōkan chiten', *Tokyo daigaku iseki chōsa-shitsu hakkutsu chōsa hōkokusho*, 1, Tokyo daigaku rigaku-bu iseki chōsa-shitsu (Tokyo, 1989).

15. The Japan Society, *The Burghley Porcelains*, Catalogue of an Exhibition held in New York and elsewhere (New York, 1986), pl. 23, plausibly attributed to Dambagiri kiln in the 1650s.

16. Manuscript inventory taken by Culpepper Tanner, 'An Inventory of the Goods in Burghley House Belonging to the Right Honble John Earl of Exeter and Ann Countesse of Exeter taken August 21th 1688', Burghley House. I am grateful to Lady Victoria Leatham, Gordon Lang, and Jon Culverhouse for the opportunity to study the porcelain collection at Burghley House.

17. John Carswell, 'China and Islam in the Maldive Islands', *Transactions of the Oriental Ceramic Society*, 41 (1976–7), 121–97, plate 60*f*.

18. See Jan Baart *et al.*, *Opgraving in Amsterdam* (Amsterdam, 1977), 279, 282, No. 550. This is almost certainly from Shimoshirakawa kiln and is similar to another illustrated in *Japanese Porcelain in the Idemitsu Collection* (Tokyo, 1990), pl. 584 and in the Idemitsu Museum of Arts catalogue, *Inter-Influence of Ceramic Art in East and West* (Tokyo, 1984), pl. 157. Sherds of albarelli of the same pattern from Sarugawa kiln have a slightly different foot. A sherd of a white albarello of this pattern has been excavated in Nagasaki.

19. See Akamatsu T. (ed.), *Hōrin shōshō 'Kakumei-ki'* (Tokyo, 1958). I have drawn my examples here from Nishida Hiroko, 'Japanese Export Porcelain', unpublished doctoral thesis, Oxford University, 1974. I am grateful to Dr Nishida for allowing me to use her work and her translation.

9

HISTORY AND DATING OF *SHOKI*-IMARI

DIVISIONS of production into phases will be arbitrary unless some influx of new ideas, be they techniques, shapes, or styles of decoration, can mark a division. In these circumstances I can see three divisions in the early period of production in Arita, with the beginning of a fourth being defined by the great export order of 1659.

The first phase or period must run from the commencement of porcelain production in some few Karatsu stoneware kilns until the change to mass-production methods which clearly indicate an increased demand for porcelain. During this period new kilns are, for the first time, built especially for the production of porcelain alone and the stoneware kilns are gradually phased out of operation.

At the beginning of the next phase, phase two, there is a marked increase in the variety of shapes made and a fairly rapid development of styles of decoration. In some kilns there are signs of mass production and we now see the emergence of two distinct markets for Arita porcelain, as cheap and commonplace goods or as more expensive goods in 'better taste'. This phase has, in the literature, usually been referred to as the Tianqi (or, in the early transliteration, T'ien-ch'i) period. This, as I have made clear in Chapter 6, is misleading and I prefer the more neutral 'phase two'.

It is in this phase that the geometrical style, a very distinct feature, arises. I see this phase as beginning only towards the end of the 1620s; Ohashi sees this second phase both to begin and to end earlier than I do. I am unable further to subdivide phase two.

Phase three I see as covering the 1640s and 1650s; most Japanese authorities would see it as commencing in 1637. I see it later than that, possibly a few years into the 1640s, basing my dating on the few dated sherds that are known. Phase three sees the beginnings of the export trade to South East Asia in celadon and in enamelled porcelain (also made for

the first time in Japan in this period). Recorded purchases by the Dutch East India Company begin in 1650; orders commence in 1653. The first export to Europe (of samples) is in 1657 and the first major order, which ends this phase, in 1659.

It may well be that the Dutch bought Japanese porcelain before it appears in their records. If the Japanese were selling celadon and enamelled porcelain to South East Asia, then the Dutch must certainly have known about it. Knowledge of the trade, indeed, may well have provided the impetus for the Dutch orders of the early 1650s. I do not think that enamelled wares were likely to have been made before 1637, though this is controversial.

There is no evidence that the Chinese bought Japanese porcelain before 1659; after all, they had been exporting Japanese-style Jingdezhen wares to Japan until the late 1640s. After 1659 they probably bought as much as or more than did the Dutch, at least until the 1720s.

During this period we have the first known mention in the Japanese written sources of Arita enamelled porcelain (1652) in the *Kakumei-ki*,[1] the diary of the priest Hōrin, where it is described as *Imari nishiki-de*.

Phase three saw the improvement of kiln furniture that was to be vital to the success of the export orders of 1659 and later, for only then could large enough *hama* be made to take the wide foot-ring necessary for the very large (by Japanese standards of the day) dishes then ordered.[2] Seggars became almost universal, with consequent improvement of firing conditions within the kiln, cutting down wastage due to damage and wastage of wood due to loss of heat in the empty space in the kiln above the stacked pots.

Pieces actually for use in the tea ceremony, as opposed to simply being in tea taste, were probably first made in phase three. Some of these were in the

so-called Shonsui style, a variety of the geometrical style of phase two, which was copied by the Chinese in the Shunchi period. Whether the ultimate origin of the Shonsui style lay in China or Japan is often debated;[3] it is clear that in this context it is a variety of a Japanese style.

Phase four is the export period after 1659; that it, too, can be subdivided at least into two phases, say up to 1680, and 1680 to about 1740, is beyond the scope of this discussion.

Phase One

To go back to the beginning, we have seen that the making of porcelain began, slowly, in certain Karatsu kilns in western Arita. We do not know exactly when this started. Many studies have been made attempting to find a precise date for the first porcelain;[4] this attempt is a vain one, for there is insufficient evidence. The process was one of a slow evolution rather than a sudden event. A suggested date has often been 1616;[5] though this was arrived at by a most dubious series of leaps of the imagination, it cannot be too far from the truth. In the 1970s it was usually thought that the date might be earlier, and Mikami Tsugio once suggested to me that it might be before 1600. Today the accepted date for the commencement of these early excursions into the making of porcelain in Arita is somewhere shortly before 1620.

This is the date that I accept here. The earliest porcelains were in typical Karatsu stoneware shapes, and their decoration in cobalt oxide could at first be regarded as a refined version of straightforward *e*-Karatsu painting, in the different metal oxide (Plate 53*a*). The strong brush-strokes of the iron oxide gave way to a more delicate use of the cobalt; designs were smaller and more detailed, and patterns less overall in effect. This seems to have happened immediately, for there is no other intermediate phase between the decoration on painted Karatsu and on the earliest porcelain; this is the intermediate stage. There is, however, one marked difference in the stoneware and the porcelain vessels of the same period, a difference in the method of manufacture that seems at first sight to be somewhat surprising. The foot of the Karatsu stonewares is strongly built, sharply cut, and unglazed; the unglazed area may extend some way up the outside wall of a bowl, dividing the surface into a glazed and an unglazed part. The earliest porcelains, made in the same kilns at the same time, have, in contrast to this, a small somewhat feeble

foot-ring that is glazed all over (Plate 53 *a–c*). We shall see that at a later stage, the foot of some Arita porcelains was to be much closer to the Karatsu type and to bear no glaze (Plate 17*e*). The explanation for this seems to be that when porcelain was first made, it was regarded as something of a luxury; it must have been relatively expensive and it had therefore to be made with more care than would have been expended on the virtually mass-produced contemporary stonewares. The finish would then have been important, and the whole piece glazed. Once porcelain was more widely available, when more kilns had joined the industry, then competition would have lowered prices and standards of finish would have dropped as kilns sought a mass market. This would have been particularly true for the more mundane everyday shapes such as the small bowls, dishes, and bottles that were the staple of production; they were mass produced. One way of saving time and the cost of material would have been to glaze a bowl or dish simply by dipping it into the glaze when holding it by the foot, without totally submerging it; sharply raising it and quickly lowering it again into the glaze mixture ensured an even distribution of the glaze on the interior. This reversion to mass production, as we shall see, probably happened at the end of phase one and the commencement of phase two.

Products of the earliest phase are usually described as being in Korean style, the description presumably applying both to their shapes and the styles of their decoration. This is only partially true. Korean influence is undoubtedly present, but it has already been filtered through the fine Japanese sieve of the Karatsu painters' and potters' styles. It is worth remembering that little or no Korean blue and white porcelain was made in the latter half of the sixteenth century; there would therefore have been no models to copy and no skills to learn. One must presume that the Korean potters brought back to Japan by the returning invaders were not porcelain potters but makers of *punch'ong* stoneware. In the same way, later styles of decoration painted onto Arita porcelains are sometimes called Chinese styles; if they are so, then that does not necessarily imply a direct influence or ancestry (though there may indeed be one in some cases), but a more indirect one through, perhaps, Japanese painting, for virtually all Japanese styles of painting are ultimately to be derived from the Chinese. The term Korean style, therefore, should be regarded as taxonomic rather than descriptive.

The first porcelains made in the stoneware kilns

were simple enough; mostly they were small dishes with upcurved rims of a diameter of about 10–12 cm. or bowls of rounded profile of a height of about 8 cm. and a diameter of about 10 cm. (Plate 53). These were shapes for which there was a proven demand in Karatsu stoneware. At first, the decoration on these pieces was relatively slight, and there has been some speculation that this may have been due to the high price of cobalt. But the source of the cobalt used in Arita is still unknown, let alone the price. It would be perfectly permissible to suggest that it was simply a matter of taste.

Models for the decorative motifs were at first, obviously enough, to be found among the *e*-Karatsu wares; good examples of this can be seen in sherds found at the Haraake kiln, one of the very earliest if not the earliest stoneware kiln to make porcelain. There were almost no Korean or even Chinese models to copy. Usually the decoration was of plants, most commonly floral. As is so often the case, particularly in Japan, the new medium quickly achieved its own identity, and even the inventiveness of the *e*-Karatsu decorators was not enough for the decorators in cobalt. They rapidly established a decorative style that just enough resembles Korean work, as we have seen, for it to have been described in modern times as a Korean style. This phase of Arita ceramic production has usually then been referred to as the Korean phase; I prefer to refer to it as phase one.

The pictorial patterns of phase one tend to cover the surface of a bowl or dish in the sense that there are rarely zones of decoration, borders, or undecorated areas, and yet the decoration leaves plenty of the surface uncovered (Plates 53*a*, *b*, and *e*). At this stage there is little of the pattern-making that was to become so important later. Obvious exceptions to this last point are the net pattern and the ubiquitous scrolling pattern, the floral scroll, often used with great verve (Plate 53*b*). Borders appeared soon; usually these were simply circumferential lines confining a main area of decoration, and not yet an actually decorated border (Plate 17*d*). Sparsely drawn landscapes typical of the Chinese *sansui* tradition are also now present. All these types can be found at the Haraake site. Borders have appeared before the finish of Seiroku no tsuji No. 2, and are found at Tengudani E and D but not at Tengudani A.

The end of this phase is heralded by an increase in the variety of shapes made, in particular by the appearance of the *tokkuri* bottle with the slightly flared lip that is so characteristic of *shoki*-Imari,

though certainly derived from a Korean shape (Plate 31*a* and *b*). On its earliest appearance, this bottle has no visible foot and no zoning of decoration (Tengudani E and D) or no visible foot but with horizontal bands of decoration (Yamabeta). Later the foot is visible, e.g. at Tengudani B. Borders now appeared more frequently on bowls and dishes; sometimes the borders on dishes were moulded (Plate 17*e*) (by hand, not yet by a press-mould). Landscape motifs became more common and more complex. Celadon appeared (Plate 17*f*) (Tengudani E, Sarugawa). Use of the seggar, against all expectation, appeared, though very uncommonly (no seggars at Haraake or Tengudani D, few at Tengudani E, Yamabeta, or Seiroku no tsuji). Presumably seggars were used for the grandest pieces only, where they are present; many later kilns, especially those of western Arita, did not use seggars at all.

Stoneware production decreased during phase one, as several of the early kilns seem to have gone over entirely to the making of porcelain, though some few kilns (e.g. Tenjinmori and Komizo) may have continued to make stoneware almost until the end of phase one.

Phase Two

The second phase of production of the *shoki*-Imari kilns, often called the Tianqi phase, after the supposed Chinese influence attributed to that period (see ch. 6), or, as I prefer to call it phase two, is marked, as we have seen, by the commencement of mass production of porcelain. This is most easily seen in the unglazed foot of bowls and small dishes from, for example, Tengudani A and D kilns. This did not persist throughout the phase, for no unglazed feet to bowls or small dishes have been found at Kusunokidani.

Another change was the beginnings of pattern-making, and the increased zoning of decoration that were both to become noticeable features of this long-lasting phase. Characteristic of the end of phase one and the beginning of phase two is the break-up into discrete areas of a surface to be decorated. Most typical of this, perhaps, is the net and window pattern of Tengudani B (Plate 53*c*) (the net pattern, with or without a fish or leaf, is earlier (Plate 81)). This is found at many other kilns including Yamabeta and Sarugawa. Many similar patterns follow, breaking the wall of bowls into various zones of

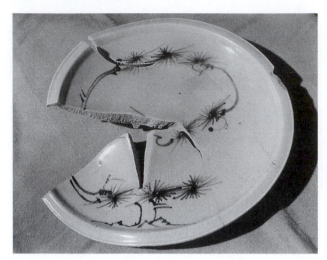

FIGURE 81. Dish with pine tree, Tenjinmori kiln, period two

decoration. Borders are often found, and become increasingly important, though there are still patterns that lack any form of painted border, even when one would seem to be called for by the shape.

Many of these new borders are divided into compartments, possibly influenced by Wanli *fuyō-de* (*kraak*) patterns, and as in the Wanli, may enclose complex or simple patterns, landscape or a single butterfly, 'three friends' or geese and reeds (Plate 57a–c). Some of this painting is of very high quality.

Some patterns occur on several shapes and at different kilns; typical of this is a particular way of painting the 'three friends' which is found on bottles from Tengudani (Plate 31b), plates from Tenjinmori (fig. 81) and vertical-sided bowls from Hyakken (Plate 63a). We shall be discussing a bowl dated 1642 of this pattern, probably from Hyakken, below (see figs. 109–11). This correspondence of motif and shapes does not follow exactly from kiln to kiln, but of course, similarities do tend to occur in kilns of the same group—hence, indeed, the grouping. Another example from other kilns is the ribbed, tea-whisk-shaped bottle apparently found only at Hyakken, Tenjinmori, Komizo, and possibly at Kodaru No. 2 (Plate 30a).

Perhaps the most characteristic shape of phase two is the vertical-sided bowl (Plate 63a–e), most commonly found at Hyakken and Kotoge, but also found at Komizo, Tenjinmori, and other kilns, though conspicuously absent from yet others including Tengudani, Yamagoya, Hiekoba, and Chōkichidani. The shape is surely a development of the steep-sided

conical bowls that are a feature of early phase two and are common at Hiekoba and Tengudani.

During the period, many new shapes appeared and larger sizes were made possible, presumably by the greater experience of both clay and firing techniques, though not so much by the use of better kiln furniture until later in the period. The use of press-moulds increased the variety of decorative possibilities.

It is convenient, and not too misleading, to divide the products of this period into two streams, the crude and the advancing. Few kilns fit only into one category, though enough do so to suggest that it was not only demand that controlled output, but also some limitation of expertise. Some kilns made one shape and size only (Kake no tani, Plate 55a and b), or very few (Yagenji). In the early period Yamabeta rarely competed in the fine-quality market but triumphed in the production of very wide dishes (Plates 3, 4, and 60); but, then, Yamabeta is an exception to most rules. Yamagoya was the most innovative, though it did not last into the export period (Plate 12); Chōkichidani was inventive in period three and adapted quickly to the export market (Plates 47 and 50f).

The old classification by location of the kilns into the groups Inner and Outer Arita does deserve consideration, for it is to some extent valid. The kilns of western and north-western Arita, including Kōtake, Seiroku no tsuji, Mukae no hara, Haraake, Kake no tani, and Yagenji, do form some sort of group, overlapping at the edges with Yamabeta, but not with the nearby Komizo, Tenjinmori, or Komononari, all in or close to the Nangawara valley, which definitely belong together (in the advancing group) and have strong affinities with distant Kotoge and with Hyakken and Kama no tsuji in Itanokawachi. Admittedly Komizo, Tenjinmori, and Komononari all finished production relatively early (as did Kotoge) whereas the Itanokawachi members of the Hyakken group, including Danbagiri and Tsutsue continued longer.

Some phase two kilns were content merely to develop the styles of phase one (Gezuyabu and probably Iwayakawachi) while others developed but little more (Tengudani, Kodaru, Kodaru Shingama, and Tenjinyama). Some kilns were founded that were to continue into the export stage, but were themselves not, at first, all that inventive (Nakashirakawa and Tanigama). Yet other kilns were more original and inventive (Hyakken, Yamabeta, Maruo, and Hiekoba) or were startlingly inventive (Yamagoya).

Towards the end of phase two an export trade in celadon had begun (Maruo, Fudōyama near Ureshino, and Mitsunomata in Hasami) (Plates 14 and 61*d*) and enamelled wares may also have been made, possibly for the same South East Asian markets as the celadons (Yamabeta, Maruo, and possibly some other kilns) (see ch. 7). Larger pieces were more easily made, and more skilfully, or at least more accurately painted (Maruo, Sarugawa, Hiekoba, Nakashirakawa, and Chōkichidani) (Plates 47 and 64*a*).

The order of 1637 by Katsushige, that eleven kilns should cease production,[6] may well not have been obeyed. It is normally assumed that it would have been the kilns of Outer Arita that would have been closed down, as they made lower-quality products, in general, than did the Inner Arita kilns. And there is some evidence that some kilns did cease work at about this time, but this cannot have been based entirely on geographical location, for Yamabeta most certainly did not close then.

Some kilns may have done so; in western Arita, Haraake, Mukae no hara, and Seiroku no tsuji may have gone out of business some time earlier, while Kake no tani and Yagenji, the most provincial of kilns, may well have ceased about then. Komizo, Tenjinmori, and Komononari probably ceased a little later, and so did Kotoge at Uchida. In Itanokawachi, Kama no tsuji closed, though Danbagiri and Hyakken continued unaffected. In central Arita, Kodaru, Kodaru Shingama, and Tenjinyama may have ceased about then, while Yamagoya and Iwayakawachi had probably closed a little earlier.

Whether or not any kiln closed as directed is not known, and therefore the certainty of the 1637 closure is in question. It should not be accepted as irrefutable evidence nor as a certain criterion for the dating of kilns, styles, or individual pots. From the point of view of findings at kiln-sites, it might well seem that some of the kilns supposed to have closed in 1637 could have continued for another ten years or so. In the lack of further evidence, I have chosen to reject the date of 1637 as too early for the major shut-down, or reorganization of the Arita kilns. And this rejection is based partly on securely datable material. In the style that I have referred to as the advancing style there are several dated potsherds;[7] these vary in date from 1624 (Tenjinmori, see fig. 104) through 1639 (Tenjinmori, see figs. 105–6) and 1642 (Hiekoba or Hyakken, see figs. 109–11). The second Tenjinmori piece looks earlier, closely resem-

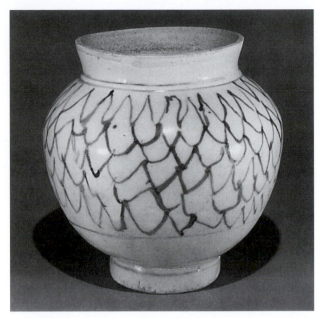

FIGURE 82. Small rounded jar with net pattern, attributed to Tengudani kiln, period one, ht. 14.5 cm. Metropolitan Museum of Art, Harry G. C. Packard Collection of Asian Art, gift of Harry G. C. Packard and Purchase, Fletcher, Rogers, Harris Brisbane Dick, and Louis V. Bell Funds, Joseph Pulitzer Bequest and Annenburg Fund Inc., 1975 (1975.268.457)

bling pieces found at Tengudani E. The pattern ('three friends') on the piece dated 1642 is found on other shapes at Hyakken, on plates from Tenjinmori, and on bottles from Tengudani E. I am aware that this suggests a longevity of a style or pattern that may question the plausibility of the attempt I am making to date the styles. It may be that we are better able to estimate the date of commencement of a kiln's production than of its cessation. Nevertheless, the kiln-site evidence for exact obedience to Katsushige's dictat is insufficient for its acceptance, and, indeed, suggests that the order was flouted. This is particularly clear in the case of Tenjinmori. We have seen that the major phase of the import of *ko-sometsuke* wares was the late 1630s and the early 1640s; it scarcely seems likely that Tenjinmori, a major producer of the best quality phase two wares (Plate 57), should have closed down either from lack of competitiveness or by order if it was competitive, at just this time. It would have been a bad business decision.

During this period the repertoire of shapes increased dramatically. This was, in some sense, the formative period of the Japanese porcelain industry, taking place during a period of peace and relative

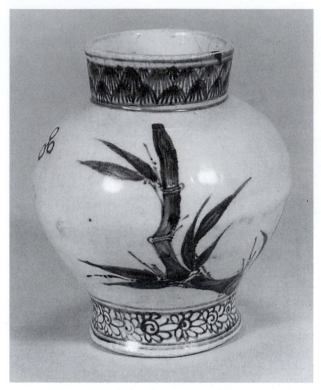

FIGURE 83. Jar with bamboo, period two, ht. 14.9 cm.

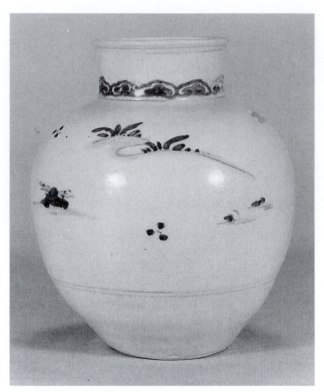

FIGURE 84. Jar with landscape, period two, ht. 22.2 cm.

prosperity, the early Edo period, after centuries of destructive civil wars. New customers were appearing, as the townsmen (the *chōnin*) grew rich in the new currency of money, as opposed to rice. Consumer site finds demonstrate the spread of phase two Arita porcelain throughout Japan in contexts that suggest that it cannot have been all that cheap (see ch. 8). The industry would have had to struggle to keep up with fashion, particularly in the face of competition from China, *ko-sometsuke*.

Among the new shapes were jars, at first rounded (fig. 82) and then more high-shouldered (figs. 83–6), some with rudimentary handles, and with or without lids, new shapes of bottles (ribbed tea-whisk (Plate 30a), double-gourd, narrow-necked), 'temple vases' (Plate 54a), flared bowls, wide and deep bowls, lotus-petalled bowls (Plate 15) and plates, *kōro*, tripod bowls, covered boxes, stem-cups, shaped (not rounded) plates (Plate 23), bowls with vertical sides, plates with flattened rims, bowls with waved edges, miniature dishes, and others.

One of the finest achievements of the various *shoki*-Imari styles is the geometric pattern-making style of phase two (Plate 28), continuing into phase three. At first this is seen in the use of small geometrical *mon*, or pattern-*mon* in association with another pattern,

and subsidiary to that pattern (Yamabeta, Sarugawa) or by an area of geometrical cross-hatching as background to part of another scene, much as cloud-bands were used in Kano painting (Maruo, Hiekoba, Sarugawa; Plate 19d). The disintegration of natural forms such as leaves and many-petalled flowers, especially composites, into central or all-over patterns becomes commonplace, and much the same thing happens to some artificial forms such as fans (fig. 87) or the feathers of arrows (Plate 62d). Somewhat Baroque-looking ribbon-knots may appear symmetrically disposed around the edge of dishes (Plate 57f). Later the geometric patterns become more truly abstract and need no further elements for their overall design.

An extension of this geometrical style is the so-called Shonsui style. This is a decorative style that looks Chinese, but is derived from Japanese adaptations of a Chinese style. Areas or zones of decoration are as arbitrarily placed and as asymmetrical as they were on the Oribe stonewares, on Kōdaiji lacquer, or on contemporary *kosode*. This is a somewhat fussy style, a logical development of the geometrical style into over-decoration; landscapes or birds and flowers may share a crowded surface with abstract geometric patterns (Plate 19d). In this style can be seen the

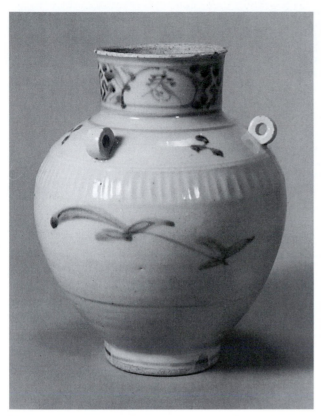

FIGURE 85. Jar with lug handles, period two, ht. 20.0 cm.

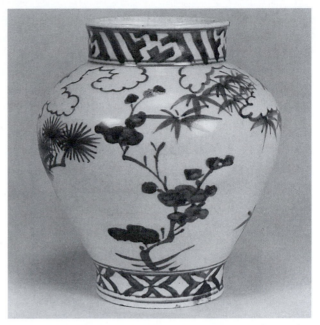

FIGURE 86. Jar with the Three Friends, period two, ht. 16.0 cm.

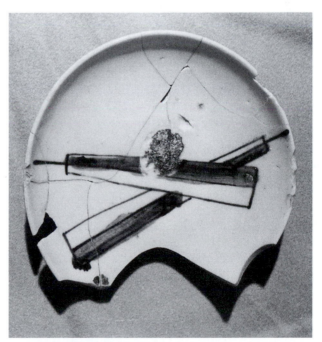

FIGURE 87. Dish with folded fans, Tenjinmori kiln, period two

origin of some of the early *ko*-Imari wares, particularly those of the Early Enamelled group, mostly jugs and bottles, that used to be called *ko*-Kutani. Presumably the Chinese essays in this style that are seventeenth century are contemporary to and in competition with the *shoki*-Imari examples. Some of the Chinese Shonsui wares were made in shapes used in the tea ceremony, specifically for Japan.

Much of the work of phase two is in a taste related to tea taste. It may not actually have been made for use in the tea ceremony, but was in tea taste, as tea taste was good taste. By the 1640s both the Chinese and the Japanese were making pieces actually for use in the tea ceremony, *mizusashi* (Plate 34), *kōgō* and even *cha-ire* (Plate 33d and f). This may be diagnostic of the beginning of phase three. Most of the Arita tea wares were for the *kaiseki* meal that accompanies a formal tea ceremony, but sherds of *mizusashi* may have been found at Hyakken, sherds of *kōgō* at several kilns and of tea bowls at Komizo. *Densei* pieces of all of these shapes, except *chawan* are not uncommon.

The diary of the Priest Hōrin, the *Kakumei-ki*,[8] mentions the use of an Arita tea bowl in 1663. As early as 1652 Hōrin had described an Imari *nishiki-*

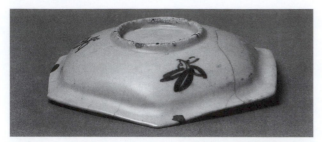

FIGURE 88. Thrown foot on shaped body. Reverse of Plate 18*f*

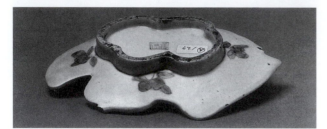

FIGURE 89. Shaped low foot on shaped dish. Reverse of Plate 23*a*

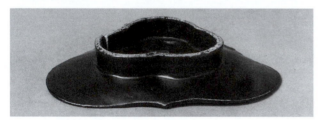

FIGURE 90. Tall attached ribbon foot. Reverse of Plate 24*a*

de bowl and in 1653 an Imari celadon *kōro*: 'it has an extraordinarily beautiful celadon glaze, a marvellous piece. I have never seen such fine celadon ware.' The 1663 entry is the first mention of an Imari *chawan*.

During phase two the kiln furniture used increased greatly in sophistication;[9] seggars, uncommon early in the period, become commonplace (see fig. 37), and *hama* (see fig. 33) are wide enough for the foot-ring to be increased in width, strengthening the vessel. From being usually about one third of the diameter of a dish, the increase in width of the foot-ring during phase two is to about one half the diameter.[10] Spurs are, apparently, unnecessary. For celadon, the ring-stand *chatsu* (see fig. 39) is invented (or copied from China). Late in the phase, and really part of the transition to phase three, is the arrival of the shaped *hama* for the foot of shaped pieces. For such pieces, the foot is not turned (as at Kama no tsuji) (fig. 88)

but is shaped to conform approximately to the outline of the dish (Hyakken) (fig. 89) or even later is a tall ribbon-shaped foot luted on (Danbagiri, Sarugawa) (fig. 90).

By the end of the phase, large celadon dishes were being made for export at Maruo, Fudōyama, and Mitsunomata (Plate 14), and large blue and white dishes at Maruo, Nakashirakawa, Sarugawa, Hiekoba, and Chōkichidani (e.g. Plate 47). It is possible that enamels were in use at Yamabeta and perhaps also at Maruo or even Hiekoba, though I see this as the beginning of phase three rather than the end of phase two.

Just when the phase two styles reached maturity is important to determine if we are to consider how the styles arose. Were they natural developments from phase one or were they affected by imports from China? We have seen earlier (ch. 6) that the styles were already formed before the Tianqi period in China began. Further, if Tenjinmori really did close down in 1639,[11] and Tenjinmori produced some of the finest wares in phase two styles, then it would have been out of business just as the major imports from China were beginning. In fact, we have suggested earlier that Tenjinmori did not close down so early.

It seems clear that much of the style is, indeed, native. On the other hand, so many motifs in Japanese art are ultimately derived from Chinese origins that it is impossible to ignore the Chinese influence. Once the Chinese had entered into competition for the Japanese domestic porcelain market, then certainly there would have been convergences and divergences in sub-styles, motifs, and shapes. Many Chinese wares would then appear to have no Japanese inspiration, as the Chinese wares developed the market in new directions.

Some few Japanese patterns were direct copies of known Chinese originals. The well-known Wanli bowls of about 15–17 cm. diameter, decorated on the outside with dragon and flying phoenix, and on the inside with a fish rising from waves, were copied by many kilns in and around Arita (see figs. 17 and 18), and begat a type that is also widespread; small dishes with two or three flying phoenix in the border and with the *hi* (sun) character in the centre (Plate 55*b*), which were made equally widely. The Japanese version of the bowls vary greatly in quality. At Tengudani B, for instance, they are of fine quality, while in West Arita and at the somewhat anomalous kilns of Uchida Taitani, Umino, and Niwage they

are coarse and grey bodied. Nor is their date easy to determine. Certainly they appear in phase two, but they continue into phase four—a bowl of this type dated 1660 has been found at Chōkichidani[12] (see figs. 118–19)—the time of the export wares, when the rising fish pattern was to appear in the well of some *kenjō*-Imari dishes. Some kilns made both the bowls and the small dishes (Sarugawa, Yagenji), some only the bowls (Tengudani, Chōkichidani) and some the dishes only (Yamabeta). Neither were apparently made at Tenjinmori, Yamagoya, Komononari, Hyakken, Kama no tsuji, or Kotoge.

Such immediate copies seem rare. Certainly Chinese motifs were frequently used, but comparison of individual matching motifs in search of priority is fraught with danger for it is rarely possible to be sure which is model, which mimic, when it is quite as likely as not that in fact they merely share a common source. Thus such a motif as the 'jade rabbit', the hare and moon pattern, usually found in reserve against a *fukizumi* (blown-blue) background,[13] is just as possibly derived from a Japanese as from a Chinese source in this manifestation, wherever the ultimate derivation may lie (figs. 51 and 52).

Phase Three

The third phase sees, most importantly, the introduction of enamelling. Some authorities believe this to have begun earlier, that is, at the end of phase two; I propose that it defines phase three.

Enamelling must have arisen not only for the export market to South East Asia, but also in response to the Chinese coloured Tianqi pieces that were reaching Japan in quantity. The enamel pigments themselves do not come from China, for the Arita enamellers had an overglaze cobalt-blue lacking from the Chinese and Swatow repertoire. As it was almost contemporary with the time in Kyoto when potters such as Ninsei were enamelling on a low-fired pottery body, the actual skills may have come from thence (or could it be vice versa?). The colours improved greatly during the period, for we can make a logical deduction from the Dutch documents (see ch. 12) that high-quality pigments were available by 1657. These colours must have been more translucent than the earlier *ko*-Kutani-style colours (see ch. 7), resembling closely some of the Early Enamelled wares that we shall discuss briefly below.

Another characteristic of the phase may be the introduction of the shaped *hama* to conform to a shaped small dish that had a foot that was itself not round (e.g. at Hyakken, fig. 33). Irregular or shaped dishes had been not uncommon in phase two (e.g. at Kama no tsuji) but these were usually made by being moulded or cut after throwing—or at least after trimming, for they are raised on a round, turned foot (see fig. 88). This desire for shaped pieces may have been due to competition with China. The early Chinese shaped *ko-sometsuke* pieces had three or more rounded modelled feet rather than a foot-ring; later a foot was made and shaped to conform to the shape of the dish, as were those of Arita, luting it on when the pot was still 'green'. This Arita foot is relatively thick and may have to be trimmed after fitting (fig. 89). This attached foot led, of course, to the taller ribbon-shaped foot-ring that is first found in phase three (Danbagiri, Sarugawa, Kusunokidani) (see fig. 90), but then occurs at many Arita kilns towards the fourth quarter of the seventeenth century, including the Kakiemon kiln. It has often been thought of as the characteristic foot of the so-called Matsugatani wares.[14] It eventually gave rise to the tall foot-ring of the Nabeshima wares of Okawachi.

Kilns must have been getting taller as the use of seggars became more widespread. Seggars seem to have been used mostly for smaller pieces and it is not likely that very wide seggars were available as early as phase three, for wide dishes. Nor are the pancake *hama* used until, during phase four, the export period, the foot becomes wider in proportion to the diameter of a dish, up to two-thirds. The foot, then, in phase three remained about half the size of the diameter. Spurs were not necessary until the very end of the period or into early phase four.

The making of porcelain for particular use in the tea ceremony is also, as we have seen, characteristic of phase three. Shapes included *mizusashi*, *kōgō*, *kōro*, and even occasionally *cha-ire* or *chawan*. *Mizusashi*[15] may be bucket-shaped, square-shaped, constricted in the middle, or squat; they may be celadon, *ruri*, or blue and white (Plate 34). *Kōgō* may be circular, shaped as some object, or in the form of a bird or animal. *Kōro* vary considerably in size, are often celadon, or occasionally *ruri* with moulded decoration. *Cha-ire* are usually blue and white (Plate 33*d* and *f*). Sherds of *chawan* have been found at Komizo only; I am unaware of sherds of *mizusashi* from any official excavation, nor did I ever find any. I have been informed that they have been found at Hyakken, and while this is plausible, and, indeed, likely, there was, at the time, a tendency to attribute all unusual

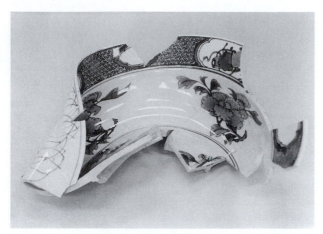

FIGURE 91. Large bowl, Chōkichidani kiln, periods three/four

sherds to Hyakken because of its reputation. While sherds of *kōgō* are common, occurring also in phase two, I am unaware of the finding of sherds of *cha-ire*.

This late phase three, before the flowering of the export trade and after phase two (the so-called 'Tianqi phase'), of *shoki*-Imari, that is, from about 1645–59, has been somewhat overlooked. The excavation, or rather discovery of the Chōkichidani site (no remains of the kiln were found) demonstrated that domestic market porcelain of considerable sophistication was clearly contemporary with the export porcelain of the 1660s. Among the pieces from Chōkichidani of this period were two main types; first, large dishes and, secondly, small dishes of irregular or representational outline. Both types were characteristically beautifully made and decorated. In the case of the large dishes, the blue and white decoration seems to have been individual, not repetitive, arguing an expensive product (Plate 47). The small, shaped dishes must have been made in considerable numbers but were usually very well decorated and finished (Plates 49*d* and *e*, 50*a* and *b*).

The shapes of these small dishes are very inventive, ranging through animal, plant, and other forms to abstract shapes of great elegance (Plate 23*a–c*). Often the decoration entirely ignores the shape so that a scene or picture may overlay a moulded decoration (Plate 48*a*). It is in these wares that the origin of the Nabeshima porcelain has been sought; certainly the tall foot of the later examples invites comparison and in many cases so does the careful decoration. The outlining in underglaze blue of a shape to be later filled with enamel, characteristic of Nabeshima, is, however, entirely lacking.

Large dishes with a fairly wide foot-ring (i.e. half the diameter of the mouth) had been made at Maruo at the end of phase two (Plate 13*a*). Like the phase three dishes from Chōkichidani they were of a continuous curve, lacking the flattened shelf-like edge of the export wares. The Chōkichidani-style pieces, also found at Nakashirakawa and Hiekoba (Plates 47 and 64*a*), were carefully made in a more sophisticated shape than those of the contemporary rounded dishes of Yamabeta. At Yamabeta, however, sherds of wide dishes of a complex shape, as if folded, have been found, apparently uniquely (Plate 13*b*). For a discussion of the *ko*-Kutani style see Chapter 7. The Chōkichidani pieces usually have a broad painted border with a central scene, either landscape or flower and bird on a very large scale and strongly painted. This style is carried over into some pieces of export type and shape such as the large basins the sherds of which have been found at Chōkichidani (fig. 91)[16] and also appears on some large bottles of typically early export blue and white type. It is, indeed, a major influence on the early export wares; it is the third component in the make-up of the export styles, after *kraak* and the 'transitional'.

Some of the small dishes of this type found their way to Europe; the classic examples are those found at Burghley House, Stamford. These do not appear in the celebrated 1688 inventory and it is uncertain when or how they were acquired. As they range in date very considerably, they were probably not all acquired in one purchase or gift. One of these dishes we have already discussed as *shoki*-Imari, probably from Danbagiri (see fig. 79); another is a very small leaf-shaped dish with an impressed 'swastika' pattern and with a plant and water pattern reserved on the blue ground, and is exactly the same as some sherds found at Chōkichidani kiln-site, one of which was fused in a kiln accident to a *fuyō-de* plate of early export type[17] (Plates 23*f* and 50*f*). It must date to the early 1660s. Yet another small dish, of finer quality, at Burghley House, is identical to sherds found at the Kakiemon kiln-site.[18] Such dishes are rare in Europe; others have been found in other early, but not inventoried, collections such as those of Lady Elizabeth Germain (Drayton House), and Margaret, second Duchess of Portland (Welbeck Abbey).[19]

It seems clear that even if these were not export-type wares, then they continued to be made into the export period, period four, presumably for the domestic market.

The range of shapes and sizes and of the patterns

of decoration in blue and white increased dramatically throughout period three; it was clearly a strong market. It is worth noticing that this was precisely the time when Jingdezhen was beginning to feel the effects of the civil wars in China that were totally to disrupt production in the 1640s. And this was also to lead to the export orders for Arita porcelain of the Dutch and of the Chinese.

Records of the Dutch East India Company show us that the Dutch began to purchase Japanese porcelain on an official basis in 1650[20] towards the middle of phase three (see ch. 12). In all probability these first purchases, of porcelain for Tonkin, 145 pieces in 1650 and 176 assorted plates, dishes, and bottles in 1651,[21] would have had little effect on the industry; they are likely to have been straightforward *shoki*-Imari, bought, as it were, off the shelf (though why Tonkin needed *shoki*-Imari is difficult to see). Presumably these were to supply a specific demand. The shipment of 1652[22] was of 1,265 pieces for Taiwan; these are of specified shapes, large and small medical pots. It is unlikely that these first two purchases were for porcelain made to order, for in a letter from the Opperhoofd in Deshima, of 1654,[23] Gabriel Happart says that he is able to make the 1654 order cheaper than that of 1653, because that had been the first order. The 1653 order,[24] for 1,200 small porcelain bottles and pots and for 1,000 pots for medical salve must have been made to order, for a letter from Batavia of 1652[25] mentions 'models... that were sent from here'. These models were probably of tin-glazed Delft earthenware, if they were not wooden, as had been models sent to China. In seventeenth-century Europe, the term 'pots for medical salve' would almost certainly have applied to the shape called an albarello. Sherds of albarello of undoubtedly European form and style of decoration have been found at Sarugawa and Shimoshirakawa kiln-sites[26] (see fig. 93). These were for the surgeon's shop and were presumably not for resale; at least one, however, reached Europe, for one of these albarelli, probably, judging by the shape of the foot, from Shimoshirakawa kiln, has been found in an excavation in Amsterdam datable to the late 1650s[27] (see fig. 80). The bottles may have been of shapes derived from European glass, but not necessarily of the so-called 'gallipot' shape.

The orders for 1654 (4,745 pieces), 1655 (3,209 pieces), 1656 (4,149 pieces), and 1657 (3,040 pieces)[28] were not materially different; all were for the surgeons' shops in Batavia. However, in 1657 there

was also one very important item; one chest of assorted porcelain samples was sent to Holland[29] (see fig. 101). No list of these samples appears to have survived, but some were undoubtedly enamelled; this we can tell from the order of 1659 which these samples provoked. In 1658, 4,800 medicine pots and bottles were supplied to Batavia and also 457 undescribed pieces to Bengal.[30]

The order for 1659 marks the end of phase three and of the *shoki*-Imari period, but we must pursue the story at least into the early part of the export period. The order of that year[31] was for a total of 64,866 pieces; 56,700 for Mocha (nearly all blue and white), 500 pieces for Surat, 1,048 pieces for Bengal, 870 pieces for Coromandel, and 5,748 pieces for Holland and Batavia. Volker quotes the full order for Mocha; all was to be made according to samples provided. The samples for the shapes were presumably wooden, and numbered 1–7, for paintings were also provided for the patterns, lettered A–G. The problems for Arita were acute; the small pieces were no problem, even if the shapes were novel and the style of decoration demanded unfamiliar (e.g. '15,000 fine [porcelain coffee-cups] fashioned according to sample No. 1, with flower-work inside and outside painted thereon as shown by the models marked A', '5,000 fine [coffee-cups] fashioned like sample No. 3, wholly snow-white with six Japanese letters on the foot below'). It was the large pieces that must have been difficult, given the inadequacy of the kiln furniture. Among these are some of which we can judge the size; '100 large porcelain flasks, contents about six litres each,[32] decorated with flower and leaf-work... to wit, 50 pieces with blue painting like the model and 50 pieces with red and green painting...' (these last are the only enamelled pieces for Mocha); also '200 fine dishes as large as the accompanying models... 200 fine ditto one size larger... and 200 fine ditto one size larger still...' though we do not know what size these were. The order could not be filled that year, but took two years; after that, Arita was presumably able to adapt.

A report[33] by the retiring Opperhoofd, Zacharias Wagenaer, is revealing on the speed of adaptation of the Japanese potters and on the methods of ordering

now that these people see that this fine ware is not only looked for and transported annually by us, but also by the Chinese [evidence that the Chinese bought Japanese porcelain at least as early as 1659]... from year to year they begin to improve and to obtain more skill... each one

tries to outvie the other in skill and quickness ... for we have seen with astonishment, with regard to the afore-said porcelains for Mocha, and indeed a month before the same could be delivered to us a multitude of similar pieces were brought to the island of Deshima for sale to everyone, and this not by the master who had been contracted by us for the baking of the same, but by some other and odd brethren who ... had ... got ... several of the models and had in a hurry imitated a good lot. But because it was too sparsely flowered and therefore unwanted they were left with most of it on their hands.

Wagenaer also tells us how some patterns were transmitted, even describing a pattern of his own invention that we can recognize in existing specimens.

long before the arrival of our ships I had contracted with a certain person for about 200 pieces after my own invention, to be made curiously, on a blue ground with small silver tendrilwork [in Dutch, *curieus op blauwen grond met kleyn silver ranckagiewerck*] ... But seeing later on that all corners and shops were filled with them ... I have taken less ...

These were silver overglazed on *ruri*.

From this we can assume that Wagenaer had direct access if not to a potter, then at least to an agent who was capable of transmitting an order to a single workshop or kiln. There were also, by 1659, shops on Deshima (or near?) selling from stock rather than filling specific orders. And many, if not all, of the potters' workshops were in competition with each other rather than under the direct control of some official of the Daimyō.

The descriptions in the order for Mocha do not tell us much; nor are those of the orders for Holland and Batavia much better. We will quote here a selection from the shipping list of the pieces actually loaded on the *Vogelsangh*, for Batavia (and thence to Holland).[34]

400	[White-sided teacups], red and green
200	Teacups with silver flowers
100	Large cups with silver and red borders
42	Large blue cups gilded outside, white within
5	*Jubako* with red painting
60	Red and green bowls
100	Tea dishes, red with silver flowers
50	Red and green bottles

Any suggestion as to what these pieces actually looked like would be pure conjecture.

Presumably, however, these were in the relatively dark enamels (relatively dark in comparison with the mature enamels of the 1680s) of the Early Enamelled wares of the 1659–late 1660s period.[35] They were surely a marked change from the *ko*-Kutani-style colours. In all probability the Dutch had waited until the colours had improved to the point where they could be considered commercially desirable in Holland. This point was clearly reached in 1657. But these 'improving' colours must have been developed during the 1650s at the same time that the *ko*-Kutani-style wares were being made. We should therefore expect to find *shoki*-Imari wares in these 'improving' colours. Perhaps some of the enamelled bowls with the phoenix and dragon pattern found at Fukiage no hama, washed ashore from an ancient wreck, represent this stage.[36]

From this time, Arita porcelain made for the export trade developed into styles beyond the scope of this book. It is worth remembering, however, that these styles had a tripartite origin: first the domestic *shoki*-Imari styles, and secondly and thirdly the two newly imported Chinese styles, the Wanli *kraak* or *fuyō-de* and the 'Transitional'.

Notes

1. See Akamatsu T. (ed.), *Hōrin shōshō 'Kakumei-ki'* (Tokyo, 1959).
2. For an analysis of the development of Arita kiln furniture, see Ohashi Kōji, 'Hizen kōyo no hensen—shōsei shitsu kibo yori mita', *Saga Kenritsu Kyūshū Tōji Bunkakan kenkyū kiyō*, 1 (1986), 61–89.
3. See the discussion by Soame Jenyns, 'The Chinese kosometsuke and shonsui Wares', *Transactions of the Oriental Ceramic Society*, 34 (1962/3), 13–50.
4. See Soame Jenyns, *Japanese Porcelain* (London, 1965), ch. 3.
5. This was worked out by a complicated use of dubious sources by Mizumachi Wasaburō, 'Ko-Imari', *Tōji taikei*, 22 (Tokyo, 1960).
6. See ch. 11.
7. See Appendix 1.
8. Akamatsu, *Hōrin Shōshō 'Kakumei-ki'*.
9. See Ohashi, 'Hizen kōyo no hensen'.
10. See Yamashita Sakurō, 'Imari no nazo o sagaru', *Nihon bijutsu kōgei*, 424 (1974), 38–49, and Oliver Impey, 'The Earliest Japanese Porcelain: Styles and Techniques', Percival David Foundation Colloquy on Art and Archaeology in Asia, 8, *Decorative Techniques and Styles in Asian Ceramics* (London, 1978), 126–148.
11. Tenjinmori is sometimes quoted as one of the kilns that should have closed down in 1637, following Katsushige's edict; we have, however, already argued that this is unlikely to have happened. This argument was partly based on common sense and partly on the evidence of the sherd found at the Tenjinmori site, dated 1639 (Appendix 1, see figs. 105–6). The kiln cannot have closed until 1639; I believe it may have continued into the 1640s.

12. See Appendix 1.

13. For illustrations comparing the two see Oliver Impey, 'Shoki-Imari and Tianqi; Arita and Jingdezhen in Competition for the Japanese Market in Porcelain in the Second Quarter of the Seventeenth Century', *Mededelingenblad nederlandse vereniging van vrienden van de ceramiek*, 116 (1984), 15–29, pls. 1, 2.

14. This name of a characteristic group of late phase three and phase four wares is puzzling; some years ago I visited the site of the Matsugatani kiln, near Saga, with Imaizumi Imaemon XIII. We found no sherds that had any resemblance to anything called Matsugatani.

15. See Yamashita Sakurō, 'Shoki-Imari no mizusashi', *Tōsetsu*, 217 (1971), 42–7.

16. See John Ayers, Oliver Impey, and J. V. G. Mallet, *Porcelain for Palaces* (London, 1990), pl. 44.

17. Illustrated in Oliver Impey, 'The Beginnings of the Export Trade in Japanese Porcelain', *Hyakunenan tōji ronshū*, 3 (1989), figs. 5, 6.

18. Illustrated in Mark Hinton and Oliver Impey, *Kakiemon Porcelain from the English Country House* (Oxford, 1989), pl. 17.

19. See ibid.

20. Manuscript in the Algemeen Rijksarchief in the Hague, Factorij Japan, 774. For a transcript and translation of these early orders, see ch. 12.

21. NFJ 775.

22. NFJ 776.

23. NFJ 286. Much of the information used here from the Dutch archives was used by T. Volker, 'Porcelain and the Dutch East India Company . . . 1602–1682', *Mede-delingen van het Rijksmuseum voor Volkenkunde, Leiden*, 11 (Leiden, 1954). This letter is quoted on p. 125. This book is an indispensable source. Volker, however, did not see or utilize all the sources used here, particularly the bills of lading, such as NFJ 774–83. It was Nishida Hiroko who first drew my attention to these, and I have worked on them with Menno Fitski.

24. NFJ 286.

25. NFJ 285.

26. See Impey, 'Beginning of the Export Trade', pls. 1, 2.

27. Jan Baart *et. al.*, *Opgravingen in Amsterdam* (Amsterdam, 1977), 282.

28. NFJ 286, 287, 288.

29. NFJ 781. No details are given; *1. cas met diverse monsters van porceleijn voort vaderland waer van uijt zoorteringe zijn verbleven gemt No 2. costende als pr specificatie 29:5;3:* [29 guilders, 5 maas, 3 conderijn].

30. NFJ 782.

31. NFJ 290. The order is quoted almost in full by Volker, 'Porcelain', 129–31.

32. This is important as it is the only absolute measure of size that is given; the other sizes would have been taken from the models, which are, of course, lost.

33. NFJ 290, quoted by Volker, 'Porcelain', 136, 137.

34. NFJ 783. See Ch. 12.

35. See John Ayers, Oliver Impey, and J. V. G. Mallet, *Porcelain for Palaces* (London, 1990), ch. 4.

36. See Ohashi Kōji, 'Kagoshima-ken Fukiage no hama saishū no tōji-hen', *Mikami Tsugio hakushi kiju kinen ronbunshū* (Tokyo, 1985), 275–91.

PART IV

The Kilns

10

THE PORCELAIN KILNS OF ARITA

Central Arita

CHŌKICHIDANI

The kiln-site lay just south of the bypass at the south-western extremity of Kami Arita. It is now covered by the Junior High School. The site was discovered only in 1978 when work on the school began; as it was not known in 1970 or 1973, no sherds are in the Ashmolean collection. No kiln structure was found during the rescue excavation, and the excavation was thus of the *monohara* only; this *monohara*, heretofore unknown, had not been disturbed by casual digging and was exceedingly productive. Part of this was cleared *in toto*, and the vast quantity of sherds collected is now in the Kyushu Ceramic Museum. The massive quantity of material, the range of shapes and styles of decoration, and the high quality of much of the porcelain makes Chōkichidani a most important site, particularly as its period of production covers the end of the *shoki*-Imari period and the beginning of the export period. During its time of production, however, Chōkichidani, while important, was probably no more important than Hiekoba or Sarugawa, nor was the quality of the best work necessarily higher. And these two kilns both began earlier than and finished long after Chōkichidani.

No stoneware was found at the site. The earliest porcelains were typical small food bowls of rounded profile of late period two (Plate 49a); decorations on these included the net pattern and the net with fish pattern, landscapes, flowers, trees, compartmented flower patterns, and an unusual horizontally striped pattern. Most bowls had circumferential lines at the foot and the mouth. Some bowls were flatter in profile; among patterns of these was the phoenix and rising fish pattern. One such was dated 1660. Some taller bowls had a chequer pattern (Plate 49b), also found on the rounded bowls and on bottles,

that does not seem to have been found elsewhere. Other apparently early shapes include *aburatsubo* and stem-cups.

Possibly contemporary with the early export wares found at the kiln were a series of large dishes, finely and very boldly painted with large-scale patterns of landscape, bamboo, birds, or animals (Plate 49c) within a wide and strongly painted border (Plate 47). The lack of repetitive designs on these suggests a sophisticated domestic market for high-priced blue and white. All examples of the dishes now in the West seem to have been recent arrivals, not part of the early export trade. Many of these do, however, have close affinities with export ware bottles (but not, apparently, dishes) of large size. There is also an overlap with the styles to be found on wide, deep bowls with flaring rims, a shape that has only been found here, of which several examples are known in the West.

Small, shaped dishes also occur commonly as sherds, many of them moulded with a low relief pattern. Some of these are blue and white (Plate 49d), either painted or stencilled, others are white (Plate 50a and b), or celadon (Plate 49f), or *temmoku* (Plate 49e). These are in a variety of shapes, as leaves either folded or in a formal pattern (i.e. as double gingko leaves) (Plate 50a), or rectangular with indented corners (Plate 49d). These all have a shaped attached foot, but not the tall ribbon foot. At least two of these types have been found fused in kiln accidents to ordinary *kraak* wares, thus demonstrating their contemporaneity (Plate 50f); as a matter of further interest, one of these latter is to be found in the collection of Burghley House, though not identifiable in the 1688 inventory (Plate 23c).

Other non-export types include dishes of medium size with no border with a single motif finely painted in underglaze blue; some of these are on a high foot, like a tazza. Celadon *kōro* are not uncommon and

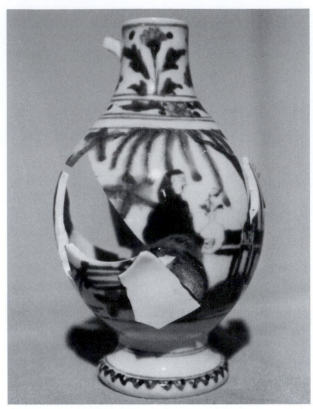

FIGURE 92. 'Transitional' style mug, Chōkichidani kiln, period four

celadon lids for jars, with the handle as a spray of prunus in the white, have been found (Plate 50d). Also in celadon are waisted temple vases; this shape is also found in blue and white.

Small figures of men and of birds have been found, in the white; these might be early examples of export figures such as those mentioned in the Dutch archives in 1662 (poppegoet).

For the study of the export period Chōkichidani is extremely useful. Vast quantities of kraak-style pieces have been found, mostly large dishes, none of which bear the VOC monogram. Some of these dishes had fused in kiln accidents to other pieces, hence helping with the determination of dates. 'Transitional'-style pieces were also found, mostly closed shapes such as the narrow-necked mugs copied from European stoneware shapes (fig. 92), and kendi. Closed shapes in styles more advanced than the copying styles include large bottles, kendi, small jars, mugs of German stoneware shape, and tea-whisk-shaped bottles. Very large basins with bold individual designs somewhat like those on pieces at Maruo suggest a continuity from Maruo to Chōkichidani (see fig. 91). Other smaller plates have well-painted decorations within borders

that may or may not conform to moulded decoration; several of this type are of patterns not found elsewhere; others seem to anticipate to so-called Kakie-mon style.

The possibility of some production of Kutani-style wares is suggested not only by some of the styles of painting in underglaze blue, but also by the presence of sherds of bottles of ring shape, hitherto only known in Japanese porcelain from examples decorated in ko-Kutani-style enamels (ch. 7).

Two dated pieces have been found at the site; the earlier of the two was a white lid, of flattened profile, which is dated under the overhanging lip, Meireki 2 (1656). The later piece is a dragon and phoenix bowl with the rising fish pattern inside (see figs. 17 and 18), which is dated Manji 3 (1660, see figs. 118–19). This latter pattern is derived from Wanli prototypes and seems to have been made in the Arita kilns almost throughout the seventeenth century.

Kiln reports 3 and 11.

HIEKOBA

The site of Hiekoba kiln is in central Arita, north of the main road and of the Akae-machi. Almost totally destroyed by building, the site was on the western slope of the same hill as was the site of Tenjinyama, below a shrine. In 1958 there was a somewhat perfunctory excavation of the site, and nomenclature of the time used the terms Upper and Lower Hiekoba. In fact, this is a great over-simplification and the vast waste heaps formerly on the site (some was still there in 1970) testify to the huge production over a very long period of this highly important site.

It has sometimes been suggested that Hiekoba was the site of the earliest Arita kiln; while this is manifestly incorrect (and, indeed, we have seen how such an attribution is meaningless), there must have been kilns on this site from an early period. These kilns, and there must have been many, seem to have been innovative and of large-scale production almost throughout the shoki-Imari period, the export period, and well into Meiji.

Confusion sometimes arises over findings of potsherds from Hiekoba kilns and from the neighbouring Tenjinyama site, which lies in close proximity to the east.

No very early sherds were found by me at the site (then mostly a car-park) in 1970. It seems likely that the kiln commenced during the latter part of period one; most sherds of shoki-Imari are from period two.

Small early dishes included landscape patterns, sometimes within elaborate borders, and the twisting radial pattern. Early bowls (uncommon) have the foot glazed.

Many of the dishes of period two have the flattened narrow rim so characteristic of many *densei* small dishes (Plates 27*e* and *f*, 51*b* and *c*). These often have floral or landscape patterns and many of the rims are decorated with waves, cross-hatching, or lines. Typical of the kiln in this shape is the famous 'jade rabbit and moon' in *fukizumi* (blown-blue) (Plates 22*e* and 51*d*) otherwise only reported from Kama no tsuji. Sherds of larger dishes, possibly up to 35 cm. in diameter are found. Celadon is common and often of exceptionally high quality; bowls, dishes, some with the iron-washed stacking ring (as at Maruo), bottles, temple vases, cylindrical or rounded *kōro*, and stem-cups. Some of these bear impressed designs, others cobalt-blue decoration under the celadon glaze; this latter technique may well be too late to be relevant here, though not certainly so. I found no *temmoku* at Hiekoba.

During the export period, Hiekoba was a major contributor to the trade; quite possibly it was, in the last quarter of the seventeenth century and the first quarter of the eighteenth, the largest and most important of the export *ko*-Imari kilns. Most export types were made there, from the very early *kraak* style and the pomegranate pattern, including pieces with the VOC monogram, to the standard export wares intended for enamelling, easily recognizable by the spaces left in the underglaze blue, and plain white-wares.

HOKAOYAMA

The kiln-site lies south-south-east of Maruo, on the east side of the road leading to Hirose, but can only be approached from the hill above the road. It has only recently been identified, and lies close to a Meiji-period site called Hokaoyama Byōsodani.

Trial excavations in 1991 revealed part of the *monohara*, where sherds make it clear that the products of the kiln were closely related to those of Tenjinmori. All the sherds revealed were of phase two, and included straight-sided bowls, small plates, and dishes. The area has been much worked over for agriculture. Further work has produced sherds of irregular outline, with a shaped low foot-ring to conform to the shape.

Kiln report 14.

IWAYAKAWACHI (Also called Iwayakochi, Tenjinmachi, or Koraisan)

The site lies on the western slope of a small steep hill north of the railway, and north-west of Sarugawa kiln-site. The site is mostly concealed under buildings and under the road up the hill.

The name of this site is famous for its supposed connection with the Nabeshima kiln; the story goes that the Nabeshima-style porcelains were first made at this kiln, and that the Nabeshima Daimyō ordered the removal of the production to Okawachi. While historically there may have been some movement of personnel, there is no archaeological evidence for this whatsoever. Jenyns in 1965 was misled by this legend into attributing some types of blue and white wares to this kiln, as possible ancestors to the Nabeshima wares.[1] In fact, those wares were late seventeenth-century export types, sherds of which have been found at the Kakiemon kiln-site.

Almost all the sherds I found at the site were of bowls, and most of these were of the type typical of Tengudani E and A kilns, with primitive landscape or flower patterns. One bowl had the net and window pattern (see Plate 53*c*), another was celadon both inside and out. The only sherd I found of a small dish was celadon.

Some period two wares were also present; faceted bowls with the *fuku* (luck) characters, as at Hyakken, and a rounded bowl with lines and flowerheads that may be of this date. The only other shapes were two bowls of unusual profile and a larger petalled bowl with an out-turned rim similar to those from neighbouring Sarugawa kiln, and possibly an intrusion from Sarugawa (see Plate 6).

KODARU NO. 2 (or Kodaru Shingama)

There have been at least two kilns at the site that is now called Kodaru 2, though none has been excavated. The sites stand about 100 m. south of the railway, south-south-east of Kami Arita station. This kiln has in the past been called Kodaru Shingama. In my 1972 paper I confused the site with that of Nakadaru.

There is documentary evidence that a new kiln was started on the site in 1810; it was to have fifteen chambers. It is presumed that it had ceased production by 1876 as the name is not mentioned in the lists of the potters' guild of Arita of that date. A survey of the site in 1986 produced sherds of both

stoneware and porcelain, and this may have been the only site in Inner Arita to make stoneware in the seventeenth century. Ignoring here the nineteenth-century finds, the early kiln on the site must have been an interesting one. Most of the sherds are of small dishes decorated in blue and white; there are also rounded bowls—at least one in *temmoku*—with unglazed feet, small bottles, stem-cups, and *kōro*. White moulded very small bowls (as at Kodaru and at Danbagiri) are found, and celadon small moulded dishes and *kōro*. In Kyushu Ceramic Museum there are sherds of *aburatsubo* (oil bottles) with horizontal ring decoration in underglaze copper-red and small dishes with landscape designs in underglaze blue surrounded by a ring in underglaze red.

The styles of painting are eclectic; many of the small dishes are akin to those of West Arita kilns such as Kake no tani. These are small early dishes with sketchy landscapes, or flowers and scroll-work, or arrow-leaf plants. Sometimes the latter are single, sometimes they are doubled and reversible (Plate 52*f*). Similar pieces can be found at Kake no tani. There are small dishes with phoenix flying around a border and with the *hi* character (sun) within (see Plate 55*b*); one similar dish has a phoenix in the centre.

Bowls have unglazed feet and are decorated with willow, pine, bamboo, or landscape; some seem later than the dishes, well into period two. I found no period two dishes and no vertical-sided bowls; the survey reports that both were found, many with patterns relating to Hyakken, Kodaru, and Tenjinmori.

Kiln report 12.

KODARU

The site of Kodaru has been destroyed by development, and nothing is known of the structure of the kiln. The site lies about 250 m. south-south-east of Kami Arita station, south of the railway and of the bypass, and about 150 m. south-east of Kodaru 2.

The owner of the site, Mr Iwao Shinichi, kindly gave me access to the site, and also some sherds from his own investigations of the site; these are clearly completely reliable, and have not been differentiated here from my own findings.

Jenyns, on Koyama's authority, considered this an early site, and this is borne out by the sherds found there. One of the pieces found by Mr Iwao is virtually identical to the piece illustrated by Jenyns in *Japanese Porcelain* as plate 1*d*, as from 'Lower Hiekoba' (Plate 17*a*). Apart from this specimen, now in the British Museum, no piece with this style of drawing has been found outside Kodaru, and one suspects that the Jenyns piece has been misattributed, though it is dangerous to use such negative evidence. Similar small dishes with a vigorous depiction of a tiger among bamboo also seem characteristic of this kiln, as do small dishes with a large *kanji* character, *kotobuki* in the well.

The range of types is extensive, covering jars with impressed flower decoration, bottles with underglaze copper-red and moulded celadon dishes; one of these shapes is a trefoil leaf (Plate 52*e*), as found at Yamagoya.

In some cases the kiln relates to the Hyakken group, though not enough to be included in that group; a curious *fukizumi* plate, with no pattern (Plate 52*b*) seems to be paralleled only at Hyakken. Other pieces of Hyakken type are small dishes with gingko leaves in a trefoil pattern, as at Kama no tsuji, and others with fan decoration much like those at Tenjinmori. Some celadon bowls of standard size have the unglazed foot washed with iron slip, thus resembling *temmoku*. Bowls have either glazed or unglazed feet. One of the specialities of the kiln was small cups; this is unusual, and is matched only at Danbagiri. One most unusual model was a series of tiny cups (or covered cups?) flattened in profile, with impressed radial lines on the outside and with a squared off edge, made of a very white body. Possibly these were for cosmetics.

I found only one piece of stoneware, a bowl, and could find no evidence for the use of seggars; *tochin* were plentiful.

MAEMAEDANI

Locally pronounced Myamyadan, the kiln is thought to have lasted from early Edo until Meiji, though no early sherds seem to have been found there. The site is in woods south of the railway, about 150 m. west of Yamagoya, not far from Kami Arita railway station.

MAENOBORI

North of the railway, east of Odaru and Nishinobori, Maenobori is another site of which the exact location is unknown. Fired earth demonstrates its approximate whereabouts, but there has been much alteration of the topography in this crowded area of south-east Arita, and no early sherds are now found there. In 1970 I found only late Edo and Meiji-period sherds.

NAKADARU

North of the railway, almost due north of Maemae-
dani. The site of the former kiln is now mostly oc-
cupied by one of the Koransha factories. Most of the
kiln was destroyed by building, though it is said that
the upper part of a *noborigama* is visible. I have
failed to find it. The *monohara* has been shifted with
earth-moving and is now muddled with debris from
modern works as well as with infill. The only sherds
I found of seventeenth-century date were of export
type, large dishes, one of them painted with a bird
in a tree.

In 1972 I used this name incorrectly, when I should
have been referring to Kodaru Shingama.

NAKASHIRAKAWA

The site is now mostly built over, but some is farm-
land and woodland. It lies to the east of the road
leading northwards to Tengudani, about midway
between Tengudani to the north and Shimoshirakawa
to the south. The site has held a series of kilns whose
exact localities are unknown.

Among early wares, bottles of Tengudani type (kiln
E) have no foot, and bowls have either glazed or
unglazed feet. Small dishes with sharply upturned
rims are usually simply decorated with landscape
(Plate 17e) or floral motifs, though some have a
more formal pattern of three circular *mon* (Plate
58a). There were a few ribbed bowls and some small
celadon dishes. Perhaps curiously, there seemed to
have been no pieces that were unequivocally of pe-
riod two.

Of later pieces there was one large dish with a
landscape decoration in the bold style of painting
(Plate 64a) associated with some of the products of
the Chōkichidani kiln. There were also *kraak*-style
large dishes and other export wares.

Trial trenches were dug in 1989 on the north slope
of the site, finding a kiln of at least nine chambers.
Many pieces of *kraak* were found, and a range of
wares of Kakiemon type; some of these were found
at a *monohara* to the west of the site, others in the
kiln area. Also found were sherds of phase two, which
I had not found. Food bowls, larger bowls (of about
12 cm. diameter), *kōro*, and bottles. A trumpet-
shaped vase and a water-dropper are probably of
later date.

Kiln report 8.

NISHINOBORI

The site is now that of the Iwao Porcelain Company,
off the main road, just north of the railway. It is
very improbable that surface finds (which rarely occur
as the site is much built over) could be distinguished
from those of the immediately neighbouring Odaru.
The exact location of the kiln or kilns is unknown,
but it is said to have lasted from early Edo until the
Taisho period, and is sometimes listed as having
produced export porcelain, as did Odaru.

ODARU

Odaru site is now part of the Iwao Porcelain Com-
pany premises; much of it was destroyed when the
railway was built in Meiji 30 (1898). Working from
an early period, it was a major producer of export
porcelain as sherds preserved in the Iwao Company
collection demonstrate; these include dishes with the
VOC monogram. White-bodied porcelain virtually
indistinguishable from *nigoshide* from the Kakiemon
kiln, and sherds with underglaze copper-red are to
be seen in the Iwao collection.

I found very small dishes with simple landscapes,
bowls with unglazed feet and with willow decora-
tion and *guinome* (see Plate 54d), large sake cups,
with the bunch of grass motif (as found at Kodaru
etc.). I also found a small cup and a small dish of the
nigoshide-style white porcelain; the dish had an
unusual foot of triangular section, so that the edge
is sharp. This may be related to one of the enamelled
wares that is often called Kutani.

SARUGAWA

The site lies to the south of the railway immediately
south of the bypass in the central area of Arita. It
was excavated in 1969 just before the building of
the bypass. The sherds are in Saga.

The kiln is famous as the site at which sherds
bearing the VOC monogram were first found (see
fig. 5). It was thought then that all such pieces must
come from Sarugawa, but similarly monogrammed
pieces have subsequently been found at Hiekoba and
Odaru kiln-sites, and it is likely that other export
kilns may also have made them. A suggestion that
Sarugawa may have been among the first kilns to
participate in the export trade with the Dutch is
given by the presence at the site of sherds of the

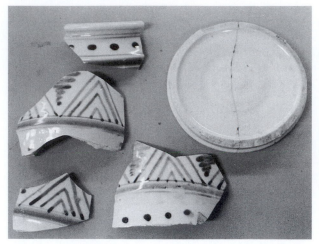

FIGURE 93. Albarelli, Sarugawa kiln, period three, *see* Figure 80

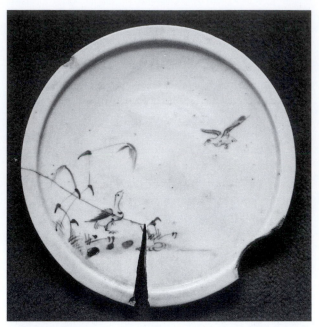

FIGURE 94. Dish with flattened edge, geese, Sarugawa kiln, period two

albarello shape (fig. 93) bearing geometric decoration of markedly European style, similar, save in the shape of the foot, to those found at Shimoshirakawa (see fig. 80).

There are thought to have been four kilns on the site, though only two were revealed in the 1969 excavation. Of the upper of these kilns (B) a firing chamber and nine chambers were found. The angle of the slope was 13.5° and the chamber sizes were width 2.9 m., length 2.1–2.2 m.

Early sherds found in 1969 included only bowls and dishes. Dishes were mostly small (7–9 cm. diameter) though some were up to 24 cm. diameter (fig. 94); some had moulded edges and the earlier types had borders. Bowls were rounded though there were a very few vertical-sided bowls. The manufacture was relatively crude and, as the decoration resembles that from Tengudani as well as from Tenjinmori kiln, it seems that the kiln was working in the late first and early second periods. Celadon and *temmoku* bowls (Plate 17*f*) were both made there, though underglaze blue was predominant, and some copper-red was also found.

Kiln furniture was mostly *tochin* and *hama*, though wheel-thrown and *tatara*-built seggars were also found.

I found some dragon and phoenix bowls and also blue and white bowls which had the lower exterior iron-washed to look like *temmoku*.

Among sherds in Saga are large dishes somewhat resembling the even larger ones from Yamabeta, and later bowls decorated with radial lines and with out-turned flat petalled rims (see Plate 62*e*). These are also found at Hyakken. The bowl of this type in the

Princessehof Museum in Leeuwarden may well be from Sarugawa or Hyakken (Plate 6).

Intermediate in date are shaped small dishes with the attached ribbon foot as found at Danbagiri and dishes with underglaze blue double circles under the foot (see Plate 42*d*), as at Yamabeta, possibly intended for enamelling.

Kiln reports 1 and 2.

SHIMOSHIRAKAWA

The site is up a path leading to a small shrine to the east of the road that leads to Tengudani, about 250 m. west-north-west of the point where this road meets the main road. Some remains of kiln wall are visible on the site, so large that they must be of a late kiln. The site is not built over, though it shows signs of having been so in the past, and the hillside has been terraced.

In 1988 trial trenches were dug on the site for a preliminary excavation. Not enough evidence was found for any accurate details to be given of its structure. The investigators found few sherds of the early period, though in 1970 I found more early pieces than later ones. Bottles and dishes from late period one were then the most common sherds; the bottles have either zonal or open decoration. Celadon and *temmoku* bowls with blue and white to the interior are found (see Plate 53*f*). The foot of bowls

may be glazed or unglazed. Some sherds of early period two include vertical-sided bowls (very few) and larger dishes (possibly of diameter up to 20 cm.) with glazed foot-rings of small diameter, with landscape or dragon patterns.

The later (periods three to four) pieces from this kiln are interesting; they include a type of 'Suisaka' ware that has hitherto been somewhat ambiguous, that has an iron-brown glaze and blue and white. An example is in the Ashmolean Museum (Plate 46c). Sherds of albarello-shaped jars, some like those of Sarugawa but lacking a foot (see fig. 80), and others in the white only suggest that this was one of the earliest export kilns. Other early export wares include the covered boxes that often bear early enamels, *kraak* wares, and reticulated celadon tripod bowls. There are many later export wares (including blue and white decorated in Kakiemon style), domestic wares, and even late stencilled wares which demonstrate the long duration of this interesting kiln.

Kiln report 23.

SHIRAYAKI

The site is now the Tōzan shrine, south of the railway, and south of the valley in which stood Tengudani, Nakashirakawa, and Shimoshirakawa kilns. Close by, to the west, is Tanigama.

Early sherds are said to have been found at the site, though I have never seen any. I found only export wares (including a blue and white piece with spaces left for enamelling) and later domestic wares.

TANIGAMA

South of the railway, about 100 m. south-west of the Tōzan shrine and of Shirayaki kiln-site, Tanigama is famous as an export kiln. It was excavated in 1976 by Mikami Tsugio and Yoshida Shōichirō. It was then said to be over 100 m. long; the number of chambers was estimated to have been twenty-five. The chambers were large; the six that were investigated were on average some 7 m. wide and 5 m. deep. Under the *monohara*, some sherds of *shoki*-Imari were found, but their kiln could not be excavated because of the presence of a cemetery.

Early sherds from this site in the Arita Ceramic Museum include celadon bowls, some ribbed, with white interiors, some with a perfunctory blue pattern in the centre (see Plate 53f), and *temmoku* bowls with white interiors, blue and white small dishes and

bowls, some with the net pattern, and larger bowls with the dragon and phoenix and rising fish pattern (see figs. 17 and 18). There is also a small *temmoku* jar, about 30 mm. tall, shaped as a section of bamboo and similar to pieces found at Chōkichidani.

I found no early pieces at the site. It has been suggested to me that the early kiln may have been between Tanigama and Shirayaki.

Kiln report 19.

TENGUDANI (Also called Kamishirakawa)

The site of Tengudani, perhaps the best known of the early Arita kiln-sites, lies to the east of the road leading from north-central Arita up the valley of the Shirakawa towards the modern dam.

Documentary suggestions that Tengudani might be the earliest of the Arita porcelain kilns, founded by Ri Sampei, provided the impetus for excavations in 1965 and 1970 by a team led by Mikami Tsugio. The report, edited by Professor Mikami and published in 1972 is still the fullest report on any Arita kiln-site (see fig. 2).

Five kiln-sites were found, in close proximity to or overlaying each other. The excavators deduced that the sequence of the kilns was, using their letter nomenclature, E, A, D, B, C with the possibility that there were some extra, anomalous chambers that they called X between D and B. There was some doubt as to whether A really was earlier than D, though it was considered likely.

E kiln was much damaged, and partly overlaid and hence destroyed by kiln A. It probably had had fifteen chambers, and stood on a slope of about 11°. Chamber sizes were approximately: width 3.10–3.65 m. by depth 2.55–3.80 m. Kiln A had sixteen chambers and stood on a slope of ±12°. Chamber sizes were: width 3.20–3.86 m. by depth 2–3.60 m., the lower chambers in general being less deep than the upper. Of kiln D, only four chambers were found; the slope quoted as just over 14° may be misleading as one chamber was exceptionally steep. Chamber sizes were: width 3.6–4.1 m. by depth 3.16–3.8 m. Kiln B had thirteen chambers with a discontinuity at chamber 11 which may imply the later addition of chambers 12 and 13. The slope was ±12°. Chamber width varied from 2.55–4 m., depth from 1.8–3.75 m. Kiln C was in a poor state of preservation; it may have had nine chambers. The angle of slope is not known, and the only chamber measurable was 3.66 m. wide and 3.44 m. deep.

On the basis of magnetic dating techniques, and discounting the sherds found, the excavators concluded that the kilns at Tengudani fell into two time groups; kilns E, A, and D being early seventeenth century, and kilns B and C being late eighteenth and early nineteenth century. Kiln A was given an extinct date of 1614 ±12; as kiln E was considered earlier than kiln A, it was suggested that kiln E might have been established in the first five years of the seventeenth century. Kiln C was given a magnetic dating (extinction time) of 1815 ±40. It is now recognized that this late date for B and C kilns is an error, accountable for by the presence of remains of a very late kiln that had nothing to do with the sherds of porcelain found on the sites of B and C kilns. When I worked at the site in 1970 (after the excavation) I found sherds of green-glazed ceramics that may have been made at the very late kiln.

Certainly Tengudani was a very early producer of porcelain; the excavators never seem to have questioned the assumption that its priority of date was secure. We have seen, however, that the origins of Arita porcelain lie in the Karatsu stoneware kilns of western Arita; Tengudani may have been the first kiln to be established especially to make porcelain, having no history of the making of stoneware. This is an important point in the history of the Arita porcelain industry. Interestingly, and sensibly, the kiln was built near to water, the Shirakawa river, and close to the source of porcelain stone, Izumiyama.

The excavators assumed that pieces found in the various kiln chambers of the various kilns had been fired in those chambers. As we have seen, this is not necessarily a valid assumption. Kiln E lies under kiln A and yet its supposed products seem considerably more sophisticated than those of kilns A and D. In kiln E, for instance, seggars of two advanced types were found, as well as *tochin* and *hama*, whereas no seggars were found in A or in D. As we have seen, lack of seggars is usually a diagnostic feature of an early site. The bottles found in kiln E of the standard Arita shape, though lacking the turned foot (as at Yamabeta) yet are decorated with a pine tree in the swift and fluid style (Plate 31b) characteristic of dishes and bowls of the second period of Arita production, as found at Hyakken, Tenjinmori, and Kotoge. Uniquely in kiln E were celadon bottles with long cylindrical necks rising from flower-moulded shoulders; these are much better made and of a better colour than other very early pieces.[2] Is it possible

that the products found in kiln E were not from that kiln but from a later one? As kiln A lies on top of much of kiln E this is difficult to understand, especially as it is considered that kiln A is the next in sequence. But it must be said that the pieces found in kilns A and D look earlier than those found in Kiln E. It is dangerous to question the findings of archaeological sequence, but this area has been much dug over, and it might be that disturbances of a major sort have occurred.

Characteristic of sherds found in kiln E were the long-necked celadon bottles mentioned above and the standard early Arita bottles. These latter have no dividing circumferential lines, a feature in common with those found at kiln A, but not with those of other kilns, where the decoration is zonal. Blue and white bowls were rather sketchily painted with landscapes or flowers; more uncommon was the net and window pattern (with bamboo leaves, not willow) (Plate 53c). There were celadon bowls and *temmoku* bowls each with white interiors and some small central underglaze blue pattern within (Plate 53f). There were also white-glazed bowls with unglazed feet. Dishes were relatively uncommon; one had a Chinese-style landscape within a lambrequin inner border, another a version of the jade rabbit and moon pattern in *fukizumi* (blown-blue) technique; both of these seem unexpectedly early.

Kiln A had many plain white bowls and many other bowls, though very few bottles, dishes, or wider bowls. Patterns common in both kilns A and D were willow (Plate 53a) or willow within a border. Kiln A had many bowls similar to those of kiln E with the landscape or plants. As well as the white bowls there were white *kōro* on three feet, high-footed white bowls, and small moulded white dishes. There seems to have been no *temmoku* at kiln A and little celadon. Most bowls at kilns E and A had the foot glazed, most bowls at kiln D had the base unglazed. Bottles at kilns E, A, and D had the concealed foot, bottles at kilns B and C had tall feet, and the body was more covered in decoration, divided into horizontal zones, than it had been in kilns E, A, and D. In general, the products of A and D were rather similar as were those of B and C. In this latter group, which must immediately follow the earlier group, and not have the hiatus postulated by the excavators, there were some larger pieces, including wider and flatter bowls, some with the dragon and phoenix and rising fish pattern (see figs. 17 and 18). Other shapes included oil bottles (*aburatsubo*) (Plate 54b), temple

vases (Plate 54*a*), and trumpet-shaped beaker vases, none of which were found in kilns E, A, or D.

I found other shapes from the *monohara*. A very large part of the production of the kilns must have been of bowls; apart from pieces similar to those mentioned above, I found bowls with glazed feet and decoration on the exterior of the foot only, bowls with the window pattern not with net but with formal waves (this pattern on bowls with glazed feet, too), and bowls with the six-character Chenghua mark either within the foot-ring or in the well of the bowls. Bowls with unglazed feet included some with wavy radial bands and others with ribbed bodies. One bowl had a pattern of oak leaves. Small bowls included the flared moulded white bowls on relatively high feet (Plates 19*b* and 54*c*), some with underglaze blue circumferential lines on the exterior, and *guinome* with rice-sheaf or with willow, as found at Kodaru and Danbagiri.

Both celadon and *temmoku* bowls usually had blue and white pine tree decoration to the interior. I found celadon *kōro* and large bottles, and a shell-shaped *kōro* formerly with a lid, which strongly resembled the pair of celadon *kōro* of this shape in the Residenz Museum in Munich and the pair formerly at Drayton House, all of which bore blue and red overglaze enamel colours; it is difficult to see these as contemporary.

Small dishes were usually of a simple landscape, either within a border, which was sometimes incised, or without a border. Flower patterns, again sometimes within a border were quite common, one style apparently distinctive to Tengudani, possibly from Tengudani A. Another piece had a bunch of flowers resembling pieces from Kodaru. The half-chrysanthemum floating in waves as found at Kama no tsuji (see Plate 51*f*) was also found. A few pieces were plain white; among these was a very small figure of a seated priest.

Among bottles not mentioned by the excavators, I found long-necked *aburatsubo* (Plate 54*b*), and a double gourd bottle of unusual shape (Plate 54*e*). Temple vases had either bamboo or pine tree decoration.

There were many dragon and phoenix bowls and the related small dishes, all of better quality than is usually found, somewhat similar to those at Chōkichidani. I found a small cylindrical *kōro*, and some round-bodied temple jars. Most interesting of all were sherds of jars. Two of these were plain white and of the low rounded profile of typical *densei*

pieces of this period (see also fig. 82). Another plain white piece was larger, thicker, and with a robust foot; the wall flared outwards in an almost straight profile and the shoulder (not present) would have been relatively high, perhaps 25 cm. The fourth sherd was similar to the last though more curved and with a more complex foot, but it was decorated with a bold plant growing from rocks over a well-drawn *karakusa* pattern all in underglaze blue (Plate 54*f*). I also found the lid of a jar, with knob, decorated only with circumferential lines in underglaze blue.

Kiln report 24.

TENJINYAMA

The site, now mostly built over, lies close to the shrine on the same small hill as Hiekoba but on the east slope. There is a memorial stone to Soden, who is sometimes said to have founded the kiln.

As at Hiekoba, the kiln may have started in the middle of period one. Typical small dishes are found, though few bowls; these have the feet glazed, and one had an incised floral scroll pattern. Landscape dishes and bowls, sometimes within borders, may be quite large. Another large dish with a small foot was plain white. Some bowls are fluted, and the flattened edge of medium-sized dishes, as at Hiekoba, is quite common. I found one *aburatsubo,* but no other bottles, one *temmoku* bowl and two pieces of moulded celadon dishes, one with a fine floral pattern.

One bowl of straight flaring profile was decorated with bamboo leaves over circumferential lines, a technique found at Hyakken and Tenjinmori.

This is a kiln that is usually cited as an export kiln, probably incorrectly; certainly I found no export-type sherds there, and there are none in the Kyushu Ceramic Museum.

Trial trenches dug in 1990 produced some typical phase two material; these included shallow bowls with narrow feet, one with a rolled-over lip like those of Yamagoya but with the celadon on the exterior, and another with a *bekkō-de* ('tortoiseshell') pattern. One bowl had a lowered central area, giving it a double-curved cross-section. Deep bowls included typical dragon and phoenix, celadon, and others. Small dishes and bowls were similar to those of Tenjinmori. One sherd depicted in the report was of a dish with the flattened rim ('Hiekoba type', see fig. 94).

Kiln report 17.

YAMAGOYA

An attempt was made in 1987 to investigate the site of Yamagoya, which lies between the railway and the bypass, close to the shrine by Kami Arita station. Part of the site is covered with a private house, and another part has been destroyed by the removal of soil. A later kiln, almost on the site, adds to the confusion. Several products of this apparently small kiln are distinctive, and the inventiveness of the products surpasses that of Hyakken—indeed, some of the characteristic products of Yamagoya are often misattributed to Hyakken. Naturally, however, the range of products is more limited, as Yamagoya was in operation for a much shorter period than was Hyakken. It may, too, have been a smaller kiln.

Most characteristic are some of the *temmoku* dishes; one type are conical bowls of flattened profile on a relatively high foot and with a strongly waved rim (Plate 56a). Reserved against the *temmoku* is a small panel, usually square but sometimes round, containing an abstract pattern in underglaze blue. There is an example of this type in the Ashmolean Museum (Plate 12a). In some sherds the *temmoku* has fired to a yellow ochre colour; as I have never seen a *densei* piece of this colour, this may be due to misfiring. This *temmoku* type is a variety of the so-called Suisaka style, found at Hyakken, though pieces of this shape and type have not been found at Hyakken. Other early Arita *suisaka* pieces found at Yamagoya but usually attributed to Hyakken include the small dishes with standing egrets in reserve (see Plate 24a) and those with flying *chidori* in reserve; both of these may have slight touches of underglaze blue. Another strange *temmoku* type, moulded as a leaf, has a matt brown glaze decorated with spots of blue glaze as if in imitation of a bunch of grapes (Plate 56e).

Some of the celadon, again, is distinctive. One type of small celadon dish has a flattened *temmoku* rim decorated with the blue spots of glaze cited above, evenly spaced out around the perimeter (Plate 56d). Small dishes with incised lines were similar to those found at Yamabeta, as were curved dishes with a flattened brown rim; those of Yamagoya, however, have underglaze blue decoration on the outside. This reversal of the norm is also seen on the most distinctive of the Yamagoya celadons; these are wide dishes, on a small foot, of very flattened profile but with a rolled-over edge. Inside is celadon, outside white with a scrolling flower pattern in underglaze blue on the rolled-over rim. Sometimes there are some small shells

luted to the exterior as rudimentary handles (Plates 12b and 56b). This celadon sometimes misfires to an olive green colour.

Other celadon shapes included *kōro*, very small dishes with moulded patterns of leaves or of gourd vines, tripod dishes with unglazed interiors, and medium-sized dishes with the narrow flattened rim of the same shape as those found at Hiekoba, though those of Hiekoba are not in celadon. Apparently unique are celadon dishes with small reserves of flowers, or stars, or plant patterns which are painted in underglaze blue and in underglaze red; this triple combination has, so far, been found at no other early Arita kiln-site.

Blue and white sherds were mostly of small dishes. Some landscape scenes were extremely simplified, and some flower patterns so simple as to appear to be stencilled. Other flower patterns on small dishes were more strongly painted (Plate 56c); these fall into the periods late one and two. Many of the later small dishes had shaped or moulded edges, while some white pieces were moulded with an all-over pattern. Painted patterns included the net pattern, the fisherman pattern (see Plate 55f) of Kusunokidani and Gezuyabu, and the radial wavy bands; one piece had a rabbit. Some of these small dishes had a brown edge. Diamond-shaped small dishes, with a blue and white diamond-shaped panel of decoration on the inside, were clearly shaped after throwing, as they had round feet. No moulded footed dishes were found at Yamagoya.

Bowls were uncommon, but net, willow, and landscape patterns were found. More unusual were sherds of small jars, perhaps 15 cm. tall, decorated with flowers or landscape. A lid for one of these gave a neck diameter of about 6 cm.

Yamagoya is perhaps the most distinctive kiln of the early periods. The range of products and the innovative techniques of the kiln are outstanding.

Kiln report 28.

Nangawara

HIGUCHI

Higuchi kiln-site lies at the southern end of the Nangawara valley, close to Mukorodani (a late export kiln) on the one side and the Genzaemon kiln on the other (Genzaemon was an early stoneware kiln of somewhat aberrant type). When I visited the kiln in 1970, only sherds of the early period and of the eighteenth and nineteenth centuries were to be

found. By 1973 a road had been cut through the area and I was able to find a wider range of sherds, including celadon and *kraak*-type export wares.

In 1984 the site was investigated, while some preliminary investigations of two waste heaps had been made in 1982. The later waste heap contained export wares very similar to those of the Kakiemon kiln, which lies about half a kilometre to the north, and to those of neighbouring Mukorodani.

Sherds of the early period, presumably from kiln one, included wide bowls with dragon and phoenix and rising fish, bowls, and small dishes. I found mostly small dishes, many with landscapes, though one had a striking group of flowers and grasses (Plate 55c) and another a distinctive melon plant (Plate 55d). I found one bottle of ordinary Arita type, a celadon dish with the unglazed circle in the foot and a medium-sized dish with underglaze blue circumferential wash lines. The only stoneware I found was a series of somewhat underfired *temmoku* bowls.

I was given a sherd of a matt-surface iron-glazed tea-whisk-shaped bottle with a *ruri* neck (Plate 55e and see Plate 30b), probably originally some 30 cm. tall, that I was told was from this site. These had been reported at the site by Yamashita in 1967.

Kiln reports 7 and 10.

KOMONONARI

The site is in Nangawara, south of the bypass, on the eastern side of the valley, across the valley from Tenjinmori. As at Tenjinmori, with which kiln it has much in common, the stoneware resembles that of the western Arita group (Mukae no hara group). In all probability, like Tenjinmori, this was a stoneware kiln that turned to the making of porcelain somewhat late, towards the end of period one, for no very early sherds have been found at the site. The site was excavated in 1987, but no details are known yet of the two kilns that are thought to have succeeded each other on the site.

The stoneware I found was robust and mostly plain; dishes, bowls, and small bowls, stacked with *taidome*. Only a few pieces of *e-Karatsu* were found.

Porcelain included pieces from periods one and two. Small dishes had simple landscapes or flowers, the borders were sometimes moulded. Bowls had the feet glazed. I found one white *guinome*. Period two dishes had cartouche borders or were sketchily decorated in the Tenjinmori manner. One sherd of a vertical-sided bowl was found. Seggars were used.

TENJINMORI

The site of the Tenjinmori kilns is on the western side of the Nangawara valley, about two hundred metres south of the bypass. It is across the valley from Komononari. When I visited the site first in 1970, some part of it was being bulldozed in preparation for building.

Tenjinmori is important for its second period porcelain; it is a prolific source of finely and boldly decorated small dishes (Plate 57). In this it belongs firmly in the Hyakken group, though its origins lie in stoneware kilns of western Arita (Mukae no hara group). It seems that stoneware production ceased here relatively late, in favour of porcelain, as at neighbouring Komononari.

The site was surveyed in 1974 when five kilns were excavated; four others were found but not excavated. Kilns one, two, and six were stoneware kilns; none of these was excavated. Kiln eight, excavated, made stoneware only; four chambers were found. Kiln nine was not investigated. Kilns three, four, five, and seven all made stoneware and porcelain, and it is conjectured by the excavators that there may have been a period after the first production of porcelain at the site that only stoneware was made. In other words, porcelain production may have ceased for a period when other kilns were continuing to make porcelain. I can find no evidence to support this proposal.

Of the kilns excavated, kiln three probably had twenty-seven chambers; the angle of slope was 15° and the chambers were 2.5–3 m. wide and 2–3 m. deep. Remarkably, there seems to have been a workshop adjacent to the kiln; usually they were further away. The kiln seems to have been repaired, often extensively, rather frequently. At kiln four, eight chambers were found, though there had presumably originally been more. The slope was slightly less than the 15° of kiln three. The chambers were 2.3–2.6 m. wide and 2.2–2.6 m. deep. Kiln five was badly damaged and only partial remains of eight chambers were found. At kiln seven, fourteen chambers were found, and there had probably been at least five more. The lower chambers (1–9) were smaller (width 2.2 m., depth 1.6 m.) and built on a steeper slope than were the upper chambers (width 2.6 m., depth 1.6 m.). The excavators were convinced that this was original, and that there had not been two phases of construction.

The stoneware I found was mostly plain Karatsu; I found no *e-Karatsu*, though I did find *hakeme* pieces

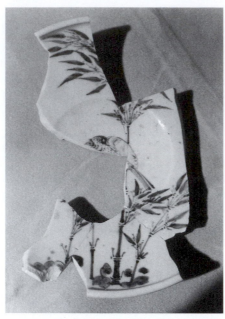

FIGURE 95. Dish with bird on branch, Tenjinmori kiln, period two

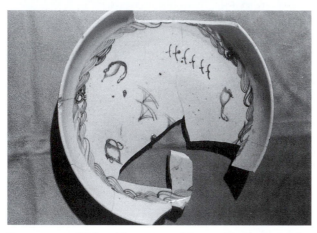

FIGURE 97. Dish with geese and boats, Tenjinmori kiln, period two

of Takeo-Karatsu type. Most pieces were dishes, bowls, and pouring bowls, though one of the *hakeme* pieces was a large jar. Both *taidome* and *suname* methods of kiln-stacking were used.

Some of the early porcelain, plain white except for circumferential lines in underglaze blue, was stacked with *taidome*; more commonly *tochin* were used. Bowls had the foot glazed, and some bore decoration resembling that of bowls from Iwayakawachi and Tengudani E and A kilns; others were almost plain.

Far more common were dishes from period two. These greatly resemble those from Hyakken, though it could be that just as Hyakken had a greater variety of bowls, so Tenjinmori had a wider range of

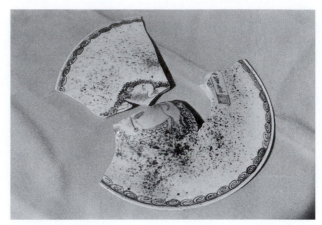

FIGURE 96. Fukizumi dishes with boy on buffalo, Tenjinmori kiln, period two

small dishes. Many of these are very beautiful (figs. 95–7). Naturalistic designs included butterflies (Plate 57d) and pine trees that resemble those on bottles from Tengudani E (see Plate 31b). In many of the decorations there is a tendency for the patterns to become formalized, and flower patterns, for instance, tend to become mere pattern (Plate 57a). This often turns into geometrical patterning, a most attractive feature of this kiln. A fan pattern was not uncommon (see fig. 87), while many pieces had formalized chrysanthemum (Plate 57c). Some dishes had a cartouche border, others more simple borders and yet others no border. The flattened small rim (as at Hiekoba) was quite common. Bowls were rounded, conical (as at Hyakken), or vertical-sided. The latter were often faceted. One *ruri* (blue ground) bowl was found. Larger bowls, perhaps 20 cm. diameter, were petalled, with radial lines, or ribbed horizontally on the exterior, when the interior decoration was a sparse floral scroll on the walls. A few ribbed bowls had a flat profile with a sharply upturned rim. Among other shapes I found were *kōro* and ribbed, tea-whisk-shaped bottles (see Plate 30a). These were found in quantity during the excavations of 1974, though I found few. The ribbed bottles, as at Hyakken, bore the *fuku* or *takara* character between the double ribs; one of the sherds I found was more akin to those found at Komizo, where the painting is of flowers or landscape and may ignore the ribs (see Plate 58c and d). Also found were large, ribbed white bowls.

I found little celadon, and only one *temmoku* piece. This, however, was remarkable, being in underglaze blue on a reserved *temmoku* ground, very similar to the so-called Suisaka-style pieces found at the Hyakken kiln-site. The decoration seems to be of birds.

Among the most remarkable of the large number of sherds from Tenjinmori in the Kyushu Ceramic Museum is a series of medium-sized landscape dishes that bear the inscription *ho hitsu-e*, meaning 'Chinese-style picture'. This may be a comment on the relationship of *shoki*-Imari and *ko-sometsuke* that we discussed in Chapter 6. Sherds dated 1624 (see fig. 104) and 1639 (see figs. 105–6) have been found at the site.

Kiln report 21.

South-West Arita

HARAAKE

The kiln-sites lie in woods about 300 m. west of the Nangawara valley, and about the same distance south-west of Tenjinmori. Excavations in 1974 and 1975 revealed the remains of six kilns. Of these, kilns A and B have been excavated, kiln D crosses and has partly destroyed kiln C, while kilns E and F are unexcavated, though their positions are known.

Kilns A and B and the sites of E and F have been damaged by the building of a road. All the kilns seem to have made stoneware, some of it in early Karatsu style, of utilitarian type, shapes including the pouring bowls (*katakuchi*) that are also found at Tenjinmori. Otherwise the shapes are confined to small and medium-sized bowls and dishes. Many are decorated in *e*-Karatsu style and some are dark glazed. Small dishes were stacked with the use of *taidome*. The stoneware body is coarse, often containing small pebbles, and the technique of making crude, so that the turned unglazed foot is frequently off-centre.

A quantity of porcelain bowls has also been found at Haraake. Both A and B kilns contained sherds of porcelain as well as of stoneware. These bowls are decorated with half-chrysanthemum designs (kiln A) or scroll-work (kiln B), those of kiln B looking the more sophisticated. Kiln A probably pre-dates kiln B. The porcelain is of the same shape as some of the stoneware, and the excavators commented in their report on the continuity of technique between the stoneware and the porcelain. In Arita Ceramic Museum is a sherd from Haraake of a stack of stoneware dishes topped by a porcelain one, just as was found at Mukae no hara (see fig. 48). There is little doubt that there was a period, presumably of short duration, when these kilns made porcelain and stoneware in the same chambers at the same firing. Thermoluminescence tests quoted in the report give a reading for the kilns A and B of 1610 ±50 years.

Kiln A stood on a slope of 16.5°. It was 45 m. long and had seventeen chambers not including the end-chamber or the firing chamber. The average width of the chambers was 2.59 m. and the average depth 2.47 m. Traces of a workshop were found close to the kiln as was the path alongside the kiln, and post holes that suggest the kiln was protected by a roof of some sort.

Kiln B stood on a slope of 13.5°; there were twenty-one chambers with an average width of 2.26 m. and average depth of 2.25 m. The upper five chambers were unusually heavily glazed, and the excavators suggest that the extreme length of the kiln (for that period) necessitated an abnormally strong firing of the upper chambers.

Kiln D crosses over kiln C. Of the latter, only seven chambers were found each of approximately 2.7 × 2.7 m. Apparently uniquely for Hizen, some of these chambers were decreased in size during repair. Kiln D had at least seventeen chambers. A thermoluminescence test is quoted for kilns C and D of 1600 ±50 years.

The excavators comment on the source of porcelain clay: apparently a high strontium content makes it unlikely that the source was Izumiyama. They suggest the source to have been Ryumon. This clay has, however, a high arsenic content, and this may have had some bearing on the short duration of the production of porcelain at these kilns.

Kiln report 5.

IPPONMATSU

The kiln-site lies in the south-west part of Arita, almost at the end of a small valley lying parallel to and between the main road to Hasami and the Nangawara valley. Across the road lies Zenmondani kiln-site; it is indeed possible that these two kilns should appear under one name. Just to the north-west lies Toshaku Mukae no hara (not to be confused with the West Arita kiln of the same name).

The kiln slopes up in a south-south-west direction. Excavations in 1989 found evidence of one kiln of at least eight chambers. An approximate measurement of the least damaged chamber found (chamber 7) was 2.80 m. long by 3.35 m. wide.

Products found were mostly small dishes of 10–12 cm. diameter, of phase two, but of unusual patterns. Many of these had compartmented borders, in four, five, or more divisions, with otherwise fairly typical phase two floral, patterned, or landscape central

decoration. Some without borders had geese and reeds, birds or flowers, while one pattern, possibly unrecorded elsewhere, had flowering plants in a tripod basin. Among the few other shapes found were a small bowl, a bottle with concealed foot, and a (stoneware) mortar.

ZENMONDANI

The site lies close to and just north-east of Ipponmatsu. It may belong under the same name.

Trenches dug in 1989 revealed the presence of a single kiln, sloping up to the north-east, of at least five chambers; the best preserved chamber (chamber 4) measured approx. 2.85 m. long by 2.60 m. wide. Products were of phase two, typical food bowls and small dishes with borders, mostly of geometric patterns; also some larger bowls, all about 20 cm. diameter, conical with an almost *fuyō-de* pattern, and deep and flat bowls (as at Toshaku Mukae no hara) and one fluted bowl of chrysanthemum shape.

TOSHAKU MUKAE NO HARA

Not to be confused with the West Arita kiln of the same name.

The kiln lies south-west of Arita, north-west of Ipponmatsu, on the west side of the road.

Excavations in 1990 revealed the presence of two kilns, probably successive, the earlier one (kiln 1) being a phase two kiln. Products were fairly typical of the period, mostly of Hyakken/Tenjinmori type. A bottle such as those found at Tengudani E had the concealed foot and there were sherds of a deep bowl of unusual type.

North-West Arita

HIROSE

The Hirose site lies north-west of Arita, beyond Yamabeta. The site is on the bend of the road, by a graveyard. No structure has been found, and the area has been much worked over by collectors, following the discovery in the early 1960s of quantities of copper-red decorated sherds of *aburatsubo*.

When I collected there in 1971, there was little to be found. Yamashita[3] reported that there had been much blue and white, mostly of periods one to two; small plates, bowls, *aburatsubo*, and bottles with flared mouths (as at Tengudani and elsewhere).

Celadon was also found, including small plates and incense-stick holders.

Copper-red decorated *aburatsubo* were the most important finds (Plate 9a); usually these were decorated with a simple plant motif, though some have horizontal bands. Clearly some were fired standing directly on the floor of the kiln, on a scatter of coarse grit which still adheres to the feet of wasters, but would have been ground off pieces for sale. Other pieces have been found adhering to *tochin*. They have been much faked.

The red colour is dark and muddy, almost certainly due to the fact that it was painted onto the unfired body (as was the cobalt-blue). The copper is contaminated by the chemicals in the body, causing this poor colour. In China, copper seems to have been applied over a glaze and then glazed overall again. Other kilns made copper-red (e.g. Sarugawa, Yamagoya) but no other seems to have specialized in it. The production period was not all that long, mostly in periods one to two.

Kiln report 18.

KAKE NO TANI

Kake no tani is the most northern of all the porcelain kiln-sites within the area of Arita town, that is, not including the Kotoge and Otani kilns of Kuromuta. It lies close to Yagenji and Kamenotani, to the north-east of the road from Yamabeta to Hirose.

It therefore belongs to the north-western group of Arita kilns. The kiln was excavated in 1970.

The total length of the kiln was 54.4 m., and there were seventeen chambers. No obvious firing chamber was found. The height of the roof of the kiln was deduced as 1.5–1.6 m., which is somewhat taller than would normally be expected at the time, and the flue holes between the chambers were relatively high. No angle of slope was quoted, but the kiln must have been steep, probably about 20°. The lower chambers were smaller in size than were the upper.

Most remarkably, the output of this kiln was totally restricted to small dishes, all of the same size (diameter approx. 14–15 cm.) and all decorated in blue and white; 97 per cent of these have similar decoration of grasses within a crude scroll-work border (Plate 55a). I also found dishes with the phoenix border and the *hi* character (sun) (Plate 55b), and dishes with a radial spiral decoration, similar in both cases to pieces from the neighbouring Yagenji.

Kiln report 27.

KOMIZO

There are supposed to have been at least three kilns at Komizo, which lies north of the railway and of the western part of Arita, almost opposite the northern end of the Nangawara valley; it is thus about 0.6 km. west of Maruo kiln-site. Of the three kilns, Middle Komizo is supposed to have made stoneware only, while Lower and Upper Komizo made stoneware and porcelain. Recent excavations of Upper Komizo (1986) and of Middle and Lower Komizo kilns (1988) have to some extent confirmed this, in that Middle Komizo seems to have made a small quantity of porcelain among a stoneware production, while Upper and Lower Komizo were clearly important and distinctive porcelain kilns.

The area has been much disturbed. Of Middle Komizo five trial trenches revealed the presence of ten chambers, probably all there had been, on a slope of about 20°. The total length of the kiln was about 22 m. Lower Komizo was easier of access and the remains of seven chambers were found, again on a steep slope. The lower end of the kiln was inaccessible and it was not possible to determine its original length. The upper two chambers, 1 and 2, were 2.6 m. wide by 2.54 m. long, and 2.5 m. wide by 2.3 m. long respectively. The lower chambers may well have been a little wider than these, but this could not be ascertained with any certainty. A preliminary excavation of Upper Komizo showed the kiln to lie south to north; parts of one chamber were investigated, and a small part of the *monohara*.

The stoneware is either undecorated or *e*-Karatsu, rather simple and often of a markedly reddish clay.

Very few period one pieces of porcelain were found in either of my two visits to the sites, but of these, some were stacked by the *suname* method of kiln-stacking. Remarkably, one of these is a stack of two small dishes topped with a ribbed bowl. Komizo may be, as may be Tenjinmori, one of the kilns that changed from the making of stoneware to the making of porcelain relatively late.

Much of the porcelain must·come from Lower or Upper Komizo; most is of Hyakken type, vertical-sided bowls, some ribbed, and standard rounded bowls; small dishes bear decoration remarkably similar to those of Tenjinmori (Plate 58*f*), while there are bottles of the normal Tengudani type. Of the second period also, there are *kōro*, waisted vases with lug handles ('temple vases') and the double ribbed, tea-whisk-shaped bottles that resemble those

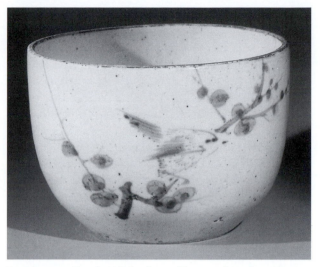

FIGURE 98. Bowl with bush-warbler, attributed to Komizo kiln, period two, dia. 12.8 cm. Metropolitan Museum of Art, Harry G. C. Packard Collection of Asian Art, gift of Harry G. C. Packard and Purchase, Fletcher, Rogers, Harris Brisbane Dick, and Louis V. Bell Funds, Joseph Pulitzer Bequest and Annenberg Fund Inc., 1975 (1975.268.488)

of Hyakken and Tenjinmori in shape. At Komizo these bottles are often larger and of more rounded profile, while the decoration is usually not of *kanji* but of scrolling foliage between the ribs or of landscape that ignores the ribs (Plates 58*c* and *d*), running all over the body of the bottle. The famous bottle at Hakone of this shape must surely be from Komizo (Plate 7).

Upper Komizo also has a type of large bowl that has been reported from no other kiln. This is a flared bowl with scratched petalled exterior covered in a thin celadon glaze. Under this glaze are some small motifs painted in underglaze blue, and there is usually a stamped decoration of chrysanthemums in the interior (Plate 58*e*). In all probability the bowl in the Metropolitan Museum, New York, of this type is from Komizo kiln (Plate 15). Unique also to Upper Komizo may be a blue and white *chawan* decorated with a small bird in a plum tree, in which the decoration continues over the rim. There is a similar bowl to this also in the Metropolitan (fig. 98).

The excavators found much period two blue and white, including well-painted dishes and a lidded jar associated with Lower Komizo and much stoneware associated with Middle Komizo. In Kyushu Ceramic Museum there is the sherd of a small square dish with a square foot and its associated shaped *hama*. There is also a bottle marked *Tsu-ire* (vinegar).

Kiln reports 13 and 15.

MARUO

The kiln-site lies to the west of the road leading from Arita to Hirose, at the south-western corner of a large development of warehouses and wholesale porcelain merchants' premises. It is just down the road from, and on the opposite side of the road to the factory of Tatebayashi Genemon. The kiln is famous for its celadon in fifteenth-century Chinese style (Plate 14), and for its bold use of underglaze blue decoration. The kiln may well have been the source of some of the porcelains called *ko*-Kutani (ch. 7).

No details of kiln structures are known, and little of the site is accessible.

Most of the sherds of celadon that I found at the site were of medium- and large-sized dishes (Plate 59*b*). The majority of these had been fired on the ring-stand that seems to have been used for celadon only (see fig. 39). Diameters of these dishes ranged up to about 40 cm. Most were decorated with incised floral patterns on the interior, and the rims were often moulded with patterns such as bamboo; sometimes these patterns surrounded the well at the base of the interior wall. A sherd of one such piece had a high foot and may well have been tazza-shaped. These dishes can be compared with those from Fudōyama kiln of Ureshino and from Mitsunomata kiln at Hasami. Smaller dishes had fluted or petalled edges, while small bowls had white interiors.

There was a little late period one blue and white; mostly the blue and white was from periods two and three. Styles typical of other kilns occurred in the simple small dishes painted with landscape or floral designs, usually within a border. The cross-hatched and dotted background to some areas of some pictorial designs that used to be called Blue Kutani was found here (Plates 19*d* and 59*a*). Larger pieces were often boldly designed, with finely drawn leaves or strong bamboo (Plates 59*e* and *f*). Borders were sometimes double and often included formal patterns such as the cash pattern, or a sort of imitation of wood grain. Some of these large dishes bore a strong resemblance to some of the *ko*-Kutani wares. On these, the glaze on the back was thin and smeared, often showing the fingerprints of the glazer (Plate 42*c*). Circumferential lines around the foot and an abbreviated decoration on the back confirm that these dishes from Maruo played their part in the *ko*-Kutani story (see ch. 7).

Blue-glazed pieces, *ruri*, are of several types, both very rare; one has a reserved decoration in white

(Plate 59*d*), the other has overpainting in underglaze blue, blue on blue (Plate 59*c*), in a bold style, on large bowls.

Kiln report 10.

YAGENJI

The site is in extreme north-western Arita, very close to Kake no tani kiln-site. No kiln structure is known, but the *monohara* was excavated in 1970, when the owner of the site was building a pond.

Almost certainly there were two kilns here, very close together. Yagenji seems to have been a fairly early kiln, late first period, while the later kiln on the site, called Obo, was late Edo into Meiji. In all probability this was not as clear at the time of the excavation as it was to become later. The report may, therefore, be somewhat misleading; many of the sherds reportedly from Yagenji may have been from Obo. Certainly the long-necked bottles, the small *kabin* shrine bottles, and the oil bottles (*aburatsubo*), some of which bore enamels, cannot have been contemporary with the small dishes and bowls from Yagenji.

Most of the small early dishes are of a diameter of about 12.2 cm. Over 40 per cent of the sherds found in 1970 had a border of two or three flying phoenix and the *hi* character (sun) in the middle (see Plate 55*b*); these are related to the wider dragon and phoenix bowls with the rising fish pattern in the centre of the interior that are also found at this kiln (and at so many other kilns over such a long period; see figs. 17 and 18). Other patterns included willow, grasses, and landscape. The few larger dishes were usually decorated with water-plants. Bowls were more varied; net patterns, net and plant patterns, plum blossom, and formal patterns all occur. The decoration on bottles was either zonal or not. All the painting on wares of the kiln, and indeed, of this group is of a coarse and vigorous style; one is tempted to use the word provincial.

The only piece that I found that does not conform to the above list was a celadon bowl with a blue and white interior motif.

Kiln report 27.

YAMABETA

The kiln-sites lie in north-western Arita, north of the road to Hirose on a small hill which is now scrub and small fields.

The Yamabeta kiln complex is famous for the large flared shallow dishes with boldly painted blue and white decoration that are among the most sought after of the *shoki*-Imari porcelains (Plates 3 and 4). Up to 48 cm. in diameter and yet on a very small foot, these dishes are a triumph of potting within the limitations imposed by the lack of sophisticated kiln furniture. Frequently the painting on these dishes is of a very high standard; it may also be so slight and so bold as to be a remarkable contrast.

The kiln has also achieved fame for a second range of products; these are two types of undecorated wares that are thought to have been made for the reception of overglaze enamels. Two main types have been found, neither in close association with any one kiln. Both types are large dishes which have a wider foot-ring than have other products of the kilns. Of the two, the earlier type, found near to though not necessarily made at kiln 4, is plain, often with a double curved profile (Plate 36*b*). The size and shape of the foot-ring, the thin smeared glaze, and the profile all conform to those on some pieces of porcelain now called *ao*-Kutani, green Kutani. The other somewhat more sophisticated and therefore probably later type of dish has underglaze blue decoration around a foot-ring that is wider in proportion to the overall diameter than was that of the white type, wide enough to necessitate the use of spurs for the support of the well, an unparalleled innovation for kilns of this early date. The underglaze blue may be confined to circumferential rings within and without the foot-ring (Plate 42*d*), or there may also be an abbreviated plant pattern or scroll pattern, markedly similar to those found on some examples of porcelain formerly classified as *ko*-Kutani (Plate 37*d*). Thus it is clear that some *ko*-Kutani dishes must have been made at Yamabeta. The date of production of this Arita *ko*-Kutani is a matter of speculation (see ch. 7).

The history of the Yamabeta kiln complex is not easy to determine; excavations in the years after 1972, one of which (1973) I was privileged to attend, have demonstrated that at least seven kilns have existed on the site. The excavations of these kilns has not always given unequivocal answers to questions of priority or sequence, for the area has been much worked over by sherd collectors and no *monohara* is certainly that of the kiln-site by which it lies. The kilns were given arbitrary numbers by the excavators, which we shall use here; these numbers bear no relation to age or anything else. Kilns 1 and 2 are very close together, and kiln 1 may in fact be a rebuild of kiln 2. Of kiln 3 there are hardly any remains, nor are the sherds nearby necessarily associated with the site. Kiln 4 stands by itself, a large and early kiln. The site of kiln 5 is not known. Kilns 6 and 7 cross each other so that 6 is over the top of 7, and kiln 9 may be a rebuild of kiln 8. The kilns furthest apart from each other are 80 m. or so apart.

The earliest kiln is generally agreed to be kiln 4, excavated in 1973. In its final stages, this kiln had sixteen chambers, was about 50 m. long, and stood on a slope of 23°. That it was repaired during its time of production is proved by the finding of sherds of porcelain under the floor of chamber 16, and yet this had originally been a kiln making stoneware only, some of which was stacked by the supposedly early *taidome* (balls of clay) method (see fig. 36). It is thought that the kiln must have begun to make porcelain towards the end of its time-span. The finding of the white porcelain for enamelling in a *monohara* near to kiln 4 suggests that only the very base of that *monohara* is that of kiln 4. The remains of kilns 6 and 7 are so intermingled that it is very difficult to differentiate between them. Probably kiln 7 is earlier than kiln 6. The main production of these kilns was porcelain, mostly blue and white. In the lower part of the kiln remains of large dishes (i.e. of diameter of over 30 cm.) were found. Bottles of the standard Arita early shape, with no foot, were found here, but nowhere else at Yamabeta. Also found were dishes with fan decoration, and bowls painted with the *kanji* characters *fukujū* (good luck) and *kotobuki* (congratulations).

Of kilns 8 and 9 little remains. Kiln 9 seems to overlie 8, and indeed may merely be a major rebuild of 8. Production was of porcelain only, including bowls with the net and window pattern (as at e.g. Tengudani E and B) with the *fuku* character instead of plant decoration.

Kilns 1 and 2 lie parallel to each other at the north-east extremity of the site. Kiln 1 may be a rebuild of kiln 2. Of kiln 2, eight chambers remain; the kiln is now 22 m. long and the angle of slope is 13°. In chamber 5 enough of the wall of the kiln was left to demonstrate that the extreme height of the interior of the upper edge of the chamber was 70 cm. This is the most important evidence there is for the height of the roof of the chambers of any seventeenth-century Arita kiln. Kiln 1 has fourteen chambers remaining and the site is now 40 m. long. Only the upper part remains in reasonable condition.

In chamber 14 some large and medium-sized dishes were found with *hama*; it is not certain that they were fired there for although the report says they were on their *hama*, the photograph in the report shows otherwise. In chamber 13 there were similar pieces, rather underfired, while chambers 12 and 11 had only small bowls, many of the bowls in chamber 11 having the same decoration of bamboo leaves.

The large dishes seem to come from kilns 6 and 7, and from kilns 1 and 2. The white body for enamelling was not found in association with any kiln. The excavators consider that the great reorganization of the Arita kilns in 1637 caused the outer kilns such as Yamabeta to be closed. They are therefore forced to the conclusion that this white-bodied, wide-footed, spur-marked porcelain was made before 1637. This would radically alter the dating of a great deal of Arita and other porcelain. It would imply that enamelling began in Arita considerably before the mid-1630s, before it began in Kyoto. This seems unacceptably early, and it is more likely to have been in the 1640s. There may have been a later kiln at Yamabeta, a revival, possibly in the 1650s into the 1670s. Nor should one conclude that all *ko*-Kutani was made in Arita simply because we have good evidence that most of it was.

The stoneware I found at Yamabeta included *e*-Karatsu, plain Karatsu, and a mortar (*suribachi*). I found seggars. The *e*-Karatsu included large dishes, stacked with *taidome* and bowls, the plain pieces were bowls and dishes, some with flattened rims, all stacked with *taidome*, and a pouring bowl.

Small porcelain dishes were almost all perfunctorily decorated with an underglaze blue landscape, sometimes within a double ring border. Bowls were usually ribbed, with the *fukujū* character repeated four times between wider spaced ribs. These bowls all had the foot glazed; a bowl with net pattern had an unglazed foot.

The diameter of the larger dishes varied considerably, running between about 30 cm. and approximately 45 cm. Most such dishes bore landscape patterns, the style varying from a crude, rather primitive style (Plate 60b) to the crisp and angular style found at Maruo, Chōkichidani, and Nakashirakawa. Other patterns of large dishes included plum trees in *fukizumi* (blown-blue) (Plate 60c), grape vines (Plate 60a), plants, radiating lines, or a scatter of circular *mon*. An unusual technique, also found at Maruo, was of *ruri* (blue ground) with a white reserve of

lines (the sherd was too small for further identification of the pattern). Borders were usually of a primitive *karakusa* scroll, sometimes interspersed with half-chrysanthemums, double borders with a wave pattern within another border, more formal borders of cartouches interspersed with a formal pattern akin to *kraak* patterns, lambrequin borders and cash pattern borders (Plate 60e). Some pieces had no border and some had a brown-glazed edge. In profile such dishes were curved, or with an edge that sloped up at a sharp angle before being flattened at the rim. The foot-ring of such dishes was on average some 7 cm. in external diameter.

Celadon dishes usually had a diameter of about 20–3 cm. with the same type of foot-ring as the blue and white pieces. I found no signs of celadon ring-stands. Some celadon dishes were plain, more commonly there was an incised pattern of interlocking diamond patterns within a plain border, others were shaped as a melon and leaf. The colour of the celadon was usually very bluish.

I found three pieces of the *ko*-Kutani-style ware. One was of a large dish, probably of about 35 cm. in diameter, and with a foot-ring of about 21 cm. diameter. The interior (such as the sherd showed) was plain, while the foot had three concentric rings in underglaze blue around the exterior of the foot, and one inside the foot-ring on the base of the dish (Plate 42d). The second was of a bowl of about 30 cm. diameter. No foot-ring was preserved. Two concentric rings were visible at the base of the wall of the interior, but no pattern was preserved. On the exterior was a boldly drawn plum tree (Plate 37d). The third piece was of a plain white small dish with a foot-ring of about 15 cm. diameter. The foot was triangular in section, though not actually sharp (Plate 36b).

All three pieces have analogues in current descriptions of *ko*-Kutani wares. It is now more or less accepted that many of the *ko*-Kutani pieces with underglaze blue could have been made in the *shoki*-Imari period. For a further discussion of this point, see Chapter 7.

A few enamelled sherds have been found at Yamabeta; these included examples of both *ko*-Kutani (Plate 39b and c) and *ao*-Kutani. Enamelled sherds are rare at the sites of *noborigama* (see ch. 3). Further Kutani-type enamelled sherds similar to those of Yamabeta were found during the excavation of the old post office site, on the site of part of the old Akae-machi in 1988.

It is worth noting that alongside the enamelled sherds found at Yamabeta was found the sherd of a large blue and white bowl with very strongly marked angular radiating ribs. A similar piece is in the Kyushu Ceramic Museum, presented by Imaizumi Motosuke (Plate 13d). The painting on both the piece and the sherd is superb, more resembling that on sherds from Chōkichidani than from anywhere else; it seems out of place at this kiln where strength of painting was emphasized over delicacy.

Kiln report 20.

West Arita

BENZAITEN

Benzaiten kiln-site in West Arita has only recently been recognized as an early porcelain site. It lies some 350 m. west of the Hirose kiln complex, just south of the Hirose river. Most of the production of the kiln was of Karatsu stoneware, very similar to that of Haraake, Mukae no hara, Tenjinmori, and Komizo. Only the *suname* method of stacking was used (see fig. 36), and this was used for porcelain dishes as well as for stoneware, as at Yamabeta, Tenjinmori, and Komizo. The body of the *suname*-stacked porcelain pieces is poor, greyish, and possibly underfired. Underglaze blue pieces include bowls and small dishes and at least one vertical-sided bowl.

This must have been an early porcelain kiln, falling into the Mukae no hara and Haraake group.

KŌTAKE

The kiln-site has not been excavated. It lies in West Arita, north of a bend in the Hirose river, about 300 m. north-east of the Hirose kiln complex.

No stoneware has been found at the site. Blue and white shapes include bowls a little larger than the ordinary curved bowls, which also occur, stem-cups, small bottles, very small plates (diameter approx. 8 cm.), and small dishes. Patterns on the small dishes include the fisherman pattern of Kusunokidani and Gezuyabu (see Plate 55f), flowers, landscape, and phoenix, and *hi* character (see Plate 55b). Some have borders. Bowls have net or landscape patterns, while larger bowls have a landscape on the exterior and a perfunctory flower spray in the middle of the well.

Apart from blue and white, which is on the greyish body typical of most West Arita kilns, there is a white-bodied type with moulded decoration on the border of dishes.

MUKAE NO HARA

The kiln-site lies in southern West Arita, close to the river and the railway line where they both turn north, to the north of Seiroku no tsuji. Of the two kilns on the site, one was excavated in 1971. This stood on a slope of 20°, was 26.4 m. long and had thirteen chambers and a firing chamber. The floors of the individual chambers sloped slightly, on average at an angle of 4°. The largest chamber, no. 9, was 2.32 m. wide by 1.94 m. deep.

The report of the excavators, published in 1977, is somewhat perfunctory and the excavation, being an early one for Arita kilns, was clearly relatively inexact. The excavators reported the finding of small dishes and bowls in both stoneware and porcelain, and a few larger dishes. The porcelain was decorated in underglaze blue, sometimes on a moulded shape, with flowers and grasses or with chrysanthemum or half-chrysanthemum. A few pieces bore the *kanji* characters *fukujū* (good luck).

Two types of *tochin* were most common, though there were a few larger examples, and there were reportedly some seggars of early type. The stoneware dishes were stacked by the *suname* method.

I visited the site shortly after the excavation and found a wider variety of sherds, in the *monohara*, than was reported by the excavators, but no kiln furniture other than *tochin*. As well as finding pieces similar to those described in the report, the small dishes and rounded bowls, I found porcelain stacked with *suname*, dishes with moulded fluted edges, bowls with vertical sides of the Hyakken type, and stoneware made by the *tataki* (hand beating) method.

Most important was a sherd of four small stoneware dishes topped by a porcelain one (see fig. 48); these, stacked with *suname*, had fused together in the firing, giving irrefutable proof of the firing of stoneware and porcelain at the same time. This demonstration of the concurrent manufacture of stoneware and porcelain has only been found elsewhere at Haraake kiln. In all probability this marks the first ventures into porcelain production of the Arita kilns. It is therefore to Mukae no hara, Haraake, and Seiroku no tsuji that we should look for the origins of porcelain in the Karatsu kilns.

It is difficult to reconcile this suggestion of a very early date with the finding of porcelain bowls with

vertical sides of the second period; presumably we are seeing the beginnings and the end of the life-span of the kiln.

Kiln reports 16 and 17.

SEIROKU NO TSUJI

The three sites stand each side of the road and railway that leads from Arita to Imari, two to the south-west, one to the north-east, in western Arita. Preliminary investigations were made in 1987 of the latter site (called Seiroku no tsuji No. 1) and of the more northerly of the other two sites (called Seiroku no tsuji Taishidō yoko gama). An excavation was made at the more southerly site, Seiroku no tsuji No. 2.

The No. 1 kiln has been damaged by the building of the railway, but remains of two chambers suggest that this was a large kiln, for the chambers seem to have been approximately 3 m. wide by 2 m. long. The waste heaps, too, are very large and have been much worked over by sherd-hunters. Sherds from this site include both stoneware and porcelain, both in styles markedly similar to those of Mukae no hara and of Haraake, and it may well be that Seiroku no tsuji was an early Karatsu kiln that began to make porcelain in the earliest period. Among the stoneware there are plain and e-Karatsu pieces, and also half-plain, half-temmoku, as also found at Hata no hara kiln in Hasami. All the stonewares are dishes and bowls, some quite large, or spouted bowls. The porcelain is very grey in body and in glaze, and sometimes the same glaze is found on the stoneware body. I found dishes, bowls, and small cups. The foot of each bowl is glazed, and the decoration of a primitive landscape or floral pattern. Of the very few whiter-bodied pieces, one bowl had the large scroll pattern as found at Tengudani (see Plate 53b). The investigators in 1987 did not find such a wide range of porcelain at this site.

The sherds are somewhat at variance with the known size of the kiln. The sherds are clearly early; the structure of the kiln, by its dimensions, suggests a later date if the progression of kiln size towards bigger chambers is strictly accurate. I accept Seiroku no tsuji No. 1 as an early kiln and suggest that this may be an exception to the chamber-size progression rule that throws doubt upon the validity of the rule.

Seiroku no tsuji Taishidō yoko gama, on the south-west of the railway, was less susceptible to investigation, but trial trenches dug in the monohara have revealed sherds of both stoneware and porcelain. In 1970 I found only stoneware. The porcelain found in 1987 consisted of bowls and small dishes with primitive floral designs and a ribbed vertical-sided bowl which suggests a later date.

Of No. 2 kiln more was found, revealing a kiln of some eighteen chambers and of a length of some 39 m. The best-preserved of the chambers was approximately 2.8 m. wide by 2.7 m. deep. The angle of slope was about 15°. Most of the production was of stoneware, with a few examples of blue and white porcelain, small bowls and dishes with sparse decoration. I am not entirely convinced by Ohashi's suggestion that this kiln is later than Mukae no hara and Haraake.

Kiln reports 13 and 22.

North-East Arita

GEZUYABU

An early kiln, close by and with similar production to the early period of Kusunokidani, north of the Fukuoka road. The exact site is unknown, as it is probably under some houses, and hence the size of the kiln is not known. In all probability it was a small-scale production of short duration in the early period, and into the second period.

Most of the products of the kiln were small dishes very similar to those of Kusunokidani, including the small dishes with the fisherman in the large hat (Plate 55f), and modelled ribbed pieces. One decoration, of half-chrysanthemums floating in water, has affinities to sherds from Hyakken and from Kama no tsuji (see Plate 51f). One piece of carved celadon, similar to a piece from Hiekoba, was also found; this had not been fired on a celadon ring-stand.

KUSUNOKIDANI

Kusunokidani lies north of the road from Arita to Fukuoka about 300 m. north-west of Izumiyama, on the south slope of the hill called Esan. The area is partly farmed, with some scrub, and there is a house built over the former monohara. The location of the kiln itself, and hence its size, is unknown. When the ko-Imari Research Committee visited the site in 1958, sherds were fairly plentiful, but there was not much to be found in 1970. Products are markedly similar to those of the neighbouring Gezuyabu, which lies about 100 m. to the east.

Most of the sherds I found were of small dishes of periods one and two. Decoration on these suggests an evolutionary progression between the phases into

the Tianqi style that is confirmed elsewhere. Some of the patterns found here were thought to be characteristic to this site and to Gezuyabu, but have now also been found at Yamagoya and Kōtake kilns. One of these, found on small dishes, is of a standing fisherman wearing a wide-brimmed hat (Plate 55f); another is a modelled pattern of overlapping petals. Some dishes have Chinese-style borders, others have the dragon and phoenix pattern. Many are close to phase two patterns.

Some small white-bodied dishes have been found, and a small trefoil leaf-shaped plate with a shaped foot. Ikeda Chu-ichi showed me a sherd he had found at Kusunokidani in 1978 of a small dish with a petalled wall, the centre with a copper-red ring enclosed by cobalt-blue rings.

Trial trenches dug in 1986 suggest the former presence of two kilns. Most of the sherds were of phases one to two, similar to those I found, but there were also found some pieces of phase three, with wide foot-rings and decoration resembling pieces from Chōkichidani and Kakiemon.

Much recent attention (1993–4) has been paid to Kusunokidani, which appears to have produced other interesting wares. Many pieces with moulded interior and low-shaped foot have been found (Plate 61b) and also some shaped pieces that were clearly intended for enamelling, some apparently in the ko-Kutani style and palette (Plate 43d). Other pieces have moulded rims known from densei pieces of blue and white, in a style related to the strong painting found at Chōkichidani. Sherds dated 1648 (see figs. 114–5) and 1653 (see figs. 116–17) have been found at the site, and a ko-Kutani-style dish dated 1653 (Plate 43c) has been plausibly attributed to the site on account of such sherds as that in Plate 43e.

Kiln reports 14 and 15.

Itanokawachi

DANBAGIRI

In Itanokawachi, downhill from Hyakken and close to Kama no tsuji, Danbagiri kiln was investigated in 1983. No kiln structure was found. The kiln seems to have specialized in very small pieces, dishes, cups, and guinome and in minute cups of a diameter of 40–50 mm. Larger pieces on the site may well be intrusions from neighbouring kilns, as the site has been so overworked by sherd-hunters. An important product of the kiln was of shaped, that is, not round dishes with luted-on ribbon feet, as also found at Sarugawa (see Plate 24). There were appropriately

shaped hama for these pieces. Of the six such pieces I found, only one had underglaze blue. Another was of nigoshide-style white porcelain with a complex moulded inner-wall pattern of flowering plants and with the kuchi-beni brown edge. This is remarkably similar to products of the Kakiemon kiln. Other shapes found include stem-cups, rounded bowls, and flat dishes.

The excavators found fragments of cockerel-shaped water-droppers; one of these was fused to the lid of a seggar, and another bore traces of overglaze red enamel. They also report the finding of bottles and jars.

Kiln report 11.

HYAKKEN

The site of Hyakken kiln, deep in the Itanokawachi valley, south-east of Arita and south-west of Yamanouchi-cho now seems a long way from central Arita. By the old road, however, running over the hills from near the Kodaru kiln-site, it was only about two and a half kilometres. The site is on the south or south-east slope of a wooded hill. The Hyakken kiln-site is so famous for its beautiful products that it has been repeatedly dug over for sherds and the surface is much disturbed. So famous is it, that when potsherds are sold commercially (an infamous practice) they are usually ascribed to Hyakken—or were so until the discovery of Chōkichidani in the mid-1970s.

The site was surveyed in 1984, when three trial trenches were dug. A report was published in 1985. The large size of the site suggested that there had been several kilns in the area; excavation revealed a chamber of one of these, on a slope of 14°. This chamber was 3.6 m. wide and 1.6 m. deep; the firing platform was 0.32 m. deep. Within this chamber were blue and white small dishes, blue and white miniature dishes, white porcelain cups, white miniature bowls, stoneware dishes, seggars, hama, and tochin. This list of the contents of one chamber is remarkable; Hyakken was not a very early kiln, and yet here was a Karatsu dish along with second period blue and white, tochin, and seggars. It cannot possibly be concluded that these represent waste from a single firing; they cannot all have come from the firing of that chamber, but must have been deposited there later. This is a practice that we have met before.

The two trenches dug into the monohara, to the south of the excavated kiln chamber, down the hill, were productive of a very general range of the products of the kiln. The excavators concluded that the

time of activity of the kiln covered the period from just before 1630 to about 1650; they commented on the presence of white jars and bottles, suggesting that these might have been destined for enamelling. They drew comparisons with finds from the closely neighbouring Danbagiri and Kama no tsuji kilns and from Tenjinmori in Nangawara. As we can see, there are also affinities to be seen with sherds from Kusunokidani, Komizo, and Kotoge kilns.

Several remarks of the investigators deserve attention. The ash-glazed Karatsu dish showed the scars of the placement of another dish upon it in the *suname* method of kiln-stacking; this method of stacking, the investigators assert, was abolished in 1637 when the Arita kilns were reorganized. This is more than contentious. They comment on a tea-whisk-shaped bottle, of a type also found at Tenjinmori (see Plate 30a), which they say was popular before 1630, and thus they date the origin of the kiln to before 1630. The scheme followed here would place these bottles a little after 1630, not before. They also comment on celadon and on *temmoku* bowls with blue and white decoration to the interiors (see Plate 53f), that they date to the period 1630–50, whereas our scheme here, comparing these to similar examples from Tengudani (and elsewhere) would place these before 1630. In fact these bowls may mark a link from period one to period two. At Tengudani they seem advanced, especially in colour; here they seem primitive. The characteristic vertical-sided bowls of the Hyakken group kilns are more sophisticated in shape, in decoration, and in the skill with which they are made (Plate 63a–e).

This is borne out by the collection of sherds in the Ashmolean Museum. There are a few small dishes of the early period. These are mostly underfired and the body looks almost buff-coloured. All save one are blue and white, and that one is very grey and is plain. Patterns are trees and flowers, though one is a very primitive landscape, similar to pieces found at Tengudani and Gezuyabu. Among them are small dishes with plum-tree decoration in *fukizumi* (blown-blue). Karatsu stoneware middle-sized dishes with glazed feet, small bowls with *suname* stacking scars and unglazed feet, and small bowls are all undecorated, and there is also *hakeme* and 'oribe' decorated Takeo-Karatsu stoneware. Thus it is possible to suggest that there was a relatively small kiln here in period one, possibly towards the end of the period, or in early phase two, making stoneware of basically Takeo-Karatsu styles and porcelain, though not necessarily concurrently.

Probably also from this early period are the celadon and the *temmoku* bowls referred to in the report, with blue and white chrysanthemum decoration to the interior (as found at Tengudani) (see Plate 53f) and small ribbed white cups, of coarse greyish colour and with sand adhering to the unglazed feet also found at Danbagiri and at Komonotsuji. There are also small cups with blue and white rice-sheaf decoration (see Plate 54d). Ordinary food bowls of the first period have bamboo, chrysanthemum, or pine-tree decoration, or a wide scroll-work band around the upper half. All such bowls have the foot glazed. There are a few larger pieces of this early period, wide plates and Tengudani-type bottles. The wide plates are decorated with floral motifs or with 'precious objects'; one has a net border. One of the bottles has blue horizontal bands.

It is in period two that Hyakken becomes so important. The range of shapes, techniques, and decoration, the very inventiveness of this kiln seems outstanding (fig. 99). Small dishes with flattened, fluted, petalled, or vertical edges may or may not have borders, and are decorated in landscape (Plate 64c), floral or geometric patterns (Plate 64b); some of these patterns have a markedly Chinese flavour, others not at all. Food bowls, too, are similar in breadth of decoration, some zonal, some all over, and the shapes are equally varied. Most important of all the small pieces are the vertically-sided bowls so characteristic of this kiln (Plate 63a–e), and almost a definitive shape of the group that I have called the Hyakken group. As with dishes, some of these were reshaped after throwing so that they may be faceted. They are decorated, again, in a wide variety of ways, and are among the most satisfying of all small *shoki*-Imari wares; curiously, perhaps, they are remarkably uncommon as *densei* pieces. The sherd of the bowl with 'The Three Friends' dated 1642 (see figs. 109–11) is probably from Hyakken.

Jars and bottles of this period, some large, are also present, as are large dishes and wide, deep bowls. One of the shapes of bottle is the so-called tea-whisk shape, which has doubled vertical ribs (shaped after throwing) on a slightly tapering body, flattened shoulders, and an out-turned lip on a short neck (Plate 30a). Between the double ribs are painted in underglaze blue rows of the *kanji* characters *fuku* (good luck) or *takara* (treasure). This type of bottle, with the same decoration, has been found at Tenjinmori. At Komizo the same shape occurs, but it is usually larger and the *kanji* may be replaced by a painted pattern (see Plate 7).

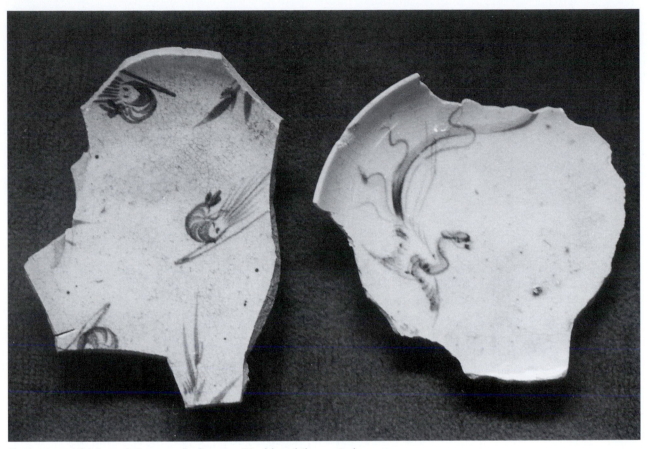

FIGURE 99. Dishes, shrimps and phoenix, Hyakken kiln, period two

Sherds of porcelain in shapes usable in the tea ceremony, such as *mizusashi*, have reportedly been found at Hyakken. Neither the investigators of 1984 nor I in 1970 found such pieces.

Other pieces reported from Hyakken include jars with lug handles, wide bowls with petalled, out-turned edge (as at Sarugawa) (Plate 62e), large dishes in celadon decorated in blue and white with feathers (Plate 62d), celadon dishes with raised, moulded decoration in the white (Plate 62c), and squared celadon dishes with reserved decoration of storks. I have seen a small dish reportedly from Hyakken with the date Shōhō 3, 12th month (1647).

Kiln report 7.

KAMA NO TSUJI (Not to be confused with the later Nangawara Kama no tsuji)

The site of Kama no tsuji in Itanokawachi, very close to Danbagiri and to Hyakken, was investigated in 1983. Only the *monohara* was found, so the size of

the kiln is not known. The excavators reported blue and white dishes of several sizes, bottles, bowls, *kōro*, and *guinome*. They found several types of stoneware, including a *mizusashi*. They also report *ruri*, copper-red, iron glaze, and celadon, none of which I found.

Many of the small plates are moulded into lozenge or *mokko* shapes or petalled; the foot is turned (and therefore circular) and not moulded (see Plate 18); some have the *janome* ('snake-eye') base that may be a little later than the other. One such dish has a complex moulded pattern that gives the effect of *bianco sopra bianco* (Plate 51e). Patterns are of period two, related to those of Hyakken, Tenjinmori, and Danbagiri; half-chrysanthemum in waves (Plate 51f), wheel-shaped *mon*, herons, the 'jade rabbit' in *fukizumi*, and birds in *fukizumi*, treble gingko leaves, landscapes, and plant patterns predominate. Some of these are superb essays in Tenjinmori styles (see Plate 57). White pieces are not uncommon and include shaped and moulded pieces. All the moulded pieces have the round thrown foot. Rounded *guinome*

with blue and white *mon* occur. Some small dishes have an out-turned rim, some have a brown edge. The excavators report the presence of pieces with the Ta Ming mark. Cups with vertical sides, like those at Hyakken occur (see Plate 63); one of these has a raised moulded design of waves.

An apparently unique piece was a tall ribbed jar in dark celadon. Other celadons included stem-cups with underglaze blue under the celadon, and shaped small and medium-sized dishes.

Kiln furniture includes *hama*, *tochin*, and seggars; many of the seggars are marked either by scratching or with stamps, presumably by the owners. Some of these marks resemble others found at Tenjinmori and at Chōkichidani.

No pieces with unglazed feet were found at Kama no tsuji, nor any tea-whisk-shaped bottles of Hyakken type. The excavators conclude that this kiln began in the 1630s and continued into the 1650s.

Kiln report 11.

TSUTSUE

The site is in Itanokawachi, about 2 km. north of Danbagiri. Some sherds from the site greatly resemble those from Danbagiri; these include the small ribbed *guinome* and small dishes. An exceptional sherd is of a leaf-shaped dish in celadon, with an iron-brown rim. However there are also phoenix and *hi* character dishes, which do not occur at Danbagiri, as well as later pieces which suggest that the kiln lasted well into the nineteenth century. It seems likely that Tsutsue was a continuation of Danbagiri on a new site, beginning in about 1650.

Uchida Kuromuta

KOTOGE

The site lies a long way north-east of Arita, being one of the Uchida group of kilns, along the road to Kuromuta and not far from Taitani kiln-site. Basically a stoneware kiln making *e*-Karatsu *mishima*, *hakeme*, and plain stoneware, it also made porcelain of the type found at Hyakken, and is included here among the Hyakken group. The exact location of the kiln or kilns is not known.

The porcelain sherds that I found there were all of small dishes and bowls. All of these were similar to those of Hyakken except for some vertical-sided bowls that were glazed all over with celadon (Plate 61*f*). I also found a hatched pattern on a bowl, in

underglaze iron-brown (Plate 61*e*). Copper-red has been found at the site; a sherd from the kiln, found by Sato Shinzo was given to the Ashmolean by his son Sato Masahiko (Plate 61*e*).

One bowl misfired in a seggar demonstrates very clearly the use of seggars (see fig. 37).

The nearest kiln to Kotoge to make porcelain is the very dissimilar Taitani.

TAITANI

Taitani lies some distance north-east of Arita in the Uchida group on the road to Kuromuta. The site is now a terraced grove of orange trees (actually, *mikan*), and the terrace walls are partly composed of sherds. Basically this was a Takeo-Karatsu stoneware kiln, making large *mishima*, *hakeme*, and 'oribe'-Karatsu bowls (see figs. 46 and 47); but as at Umino and Niwage there was also made a particular type of blue and white porcelain. This is characteristically greyish in body and glaze and is almost entirely confined to bowls and dishes crudely decorated in underglaze blue with dragon and phoenix on the exterior (see figs. 17 and 18) (bowls) or in the border (dishes) and with either the rising fish or the *hi* character (sun) in the well (see Plate 55*b*). I found a sherd of one bowl of larger size with a similar style of decoration, but with a plant motif.

Ureshino

FUDŌYAMA

As the Fudōyama kilns made porcelain markedly similar to several types of Arita porcelain, over a considerable period, it seems necessary to include the kiln-sites in this list, even though the kilns may not have been productive actually during the *shoki*-Imari period. The sites of the five Fudōyama kilns lie at the top of a valley some four kilometres west of Ureshino town, itself lying south-east of Arita. During the Edo period, Ureshino was not in the Nabeshima fief.

Kiln three was excavated in 1978, and the report was published in 1979. The kiln was 60 m. long, composed of seventeen chambers lying on a slope of 10°. The width of the chambers varied from 3.25 to 5 m., the depth from 2.75 to 4 m. Kiln furniture was confined to *tochin*, *hama* of truncated cone type, and cup-shaped *chatsu* stands for celadon. *Hama* over 12 cm. in diameter were of stoneware, smaller ones of porcelain. There were no seggars.

The products of Fudōyama were mostly imitative of Arita and of the nearby Mitsunomata kiln of Hasami; they were mostly poor imitations of a variety of export and domestic styles. Of most interest to us here are the celadons, many of which resemble those of Maruo (Plate 61d), and may well have been intended for the same markets; others seem to have been more inventive, including high-footed tripod bowls.

In chamber L of kiln three, the roof had clearly fallen in onto the stacked pots, still in the position in which they had been fired. This is an important piece of evidence to be used when considering whether or not pots found in kiln chambers of ruined kilns had actually been fired in those chambers. In chamber L some of the *tochin* (see fig. 35) and the bowls between and upon them were still in position.

The excavation report quoted a magnetic dating of 1680 ±30 years for kiln three (the excavated kiln) and 1700 ±30 years for kiln one. If this is not later than expected, it still suggests that Fudōyama, apart from participating in the export of celadon dishes, was a supplier of porcelain in late *shoki*-Imari style to the domestic markets of Japan some considerable time after the end of the *shoki*-Imari period in Arita.

Kiln report 4.

UMINO AND NIWAGE

The nomenclature of the Umino kilns is far from clear; different names are used by different authorities, and those used locally differ yet again. The kilns lie south of Takeo in the Ureshino–Hasami–Takeo triangle. The major production of all these kilns was of the large Takeo-Karatsu stonewares that are contemporary with much Arita porcelain, and some of which were exported to Thailand. *Mishima, hakeme* (see fig. 46), 'oribe'-Karatsu (see fig. 47) and dark green and blue glazes are the standard decorative techniques used on these usually large pieces. Seggars are not found at the kiln-sites, and the dishes were separated by balls of clay (*taidome*).

Porcelain of a particular type is found at two or possibly three of the sites in this area. It is all so much the same as to be indistinguishable not only from one kiln to another, but also from the products of the Taitani kiln at Uchida, a considerable distance to the north-east. Nearly all pieces are dishes and bowls, probably consistently underfired, decorated in underglaze blue with the dragon and phoenix on the exterior (bowls) or in the border (dishes), and

with the rising fish (see figs. 17 and 18) or the *hi* character (sun) in the centre (see Plate 55b).

Hasami

HATA NO HARA

The kiln Hata no hara is included in this chapter on account of the similarity of some of its products to those of the early Arita kilns of the Mukae no hara group, and because of the claims to priority made on its behalf.

The kiln-site lies in the valley north-west of Hasami town, which is itself some 10 km. south of Arita. Hasami is in Nagasaki-ken, not in Saga-ken as is Arita. Nearby to the kiln are two other Hasami kiln-sites, Furusaraya and Yamanita.

The kiln as excavated in 1981 revealed twenty-four chambers, and the total length was 55.4 m.; there is a possibility that two chambers at the base had been destroyed, and that originally it had had twenty-six chambers. The kiln curved slightly, running from east to west up the hill. The lower part stood at an inclination of 13°, the upper part at 9°. The average size of the chambers was 2.2 m. long and 2.4 m. wide; the estimated height of the chambers was 1.3 m.

Kiln furniture comprised *tochin* and *hama*, some of which were not round, and some lidded seggars. Stacking of small dishes, sometimes on *tochin*, sometimes on a scatter of sand on the floor, by the *taidome* method was the norm. Bowls stood individually on *tochin*. The excavators have made interesting estimates of the amounts fired in each chamber; an average of 1,330 small dishes and 30 bowls. This suggests a total of 30,000 dishes and 700 bowls from each firing of the kiln. I am not aware of other estimates with which to compare this figure.

The main product of Hata no hara kiln was the small wheel-thrown stoneware dishes, ash glazed, that I have referred to as the lowest common denominator of the Karatsu wares. Other stoneware products included mortars (*suribachi*), a few jars, bowls, and some iron-glazed bowls. The excavators also found some porcelain; mostly this consisted of small moulded plates with a small central flower or insect motif painted in underglaze blue, though some were plain white. There were also a few white food bowls and some small celadon plates. The production was estimated as 98.15 per cent stoneware, 1.81 per cent porcelain.

When I visited the kiln in 1970, I found only stoneware of the simplest type; I remarked upon the similarity of this to the products of Mukae no hara, pointing out the geographical proximity of Hata no hara to the south-west Karatsu/western Arita group of kilns, with which it should probably be classed.

Although the kiln is undoubtedly early, and disproves my (1975) conjectured dating of the commencement of porcelain production in Hasami to the eighteenth century (as do also new finds at Mitsunomata and other Hasami kilns), I cannot agree with the excavators' claim that porcelain was made here before it was made in Arita. I would draw comparisons with the porcelain of Mukae no hara, Seiroku no tsuji, and Haraake, but would not claim priority. Curiously, in view of the excavators' claim, the thermoluminescence dates for Hata no hara, as given in the excavation report, do not support their claim, being 1670 ±20, whereas for Haraake they were given as 1610 ±50 (A and B) and 1600 ±50 (C and D).

Notes

1. See Soame Jenyns, *Japanese Porcelain* (London, 1965), pls. 8, 9.
2. See Mikami Tsugio, *New Light on Early and Eighteenth-Century Imari Wares: A Report on the Excavations at Tengudani Kiln-Site* (Tokyo, 1972), pl. 2.
3. Yamashita Sakurō, 'Imari no nazo o sagaru', *Nihon bijutsu kōgei*, I/424 (1974), 42–9, and II/425 (1975), 42–52.

PART V

Contemporary Documentation

11

JAPANESE DOCUMENTATION

THE traditional stories relating the finding of porcelain stone and the building of the first kiln in Arita usually centre on a Korean, one Ri Sampei, or Shirakawa Sambei who is said to have found the mountain of porcelain stone at Izumiyama and built a kiln at Tengudani, which was the first kiln to make porcelain in Japan. It is worth while examining the documentation of this. This evidence, and that of much of the speculation about various phases of the history of porcelain production in Arita both at this time and later, has mostly involved the use of four sets of documents:[1]

1. the Arita Sarayama Sōgyō Shirabe, a compilation of earlier documents from the Saga fief office, published by Kume in 1873
2. the Oyakata Nikki, the official diaries of the Taku family
3. the Sakaida (Kakiemon) family documents
4. the Kanagae family documents.

The Arita Sarayama Sōgyō Shirabe suffers from the grave defect that the compiler nowhere gives his sources. One is therefore always in some doubt as to the age (or authenticity) of the document listed. Many of the documents are themselves not contemporary to the events they describe, but were written much later. Inevitably there is much confusion. Nowhere in this compilation is the origin of Arita porcelain discussed, so we shall not use it here.

The Oyakata Nikki are the official diaries kept by the Taku family, who held jurisdiction over the Arita area for the Nabeshima Daimyō. These only began in 1682 and are therefore of interest to us here only for the fact that they sometimes corroborate the later documents of the Kanagae family, which we will discuss below.

The Kakiemon family documents are all too late to be relevant to this discussion.

Many of the Kanagae family documents are still in the possession of the family. As we have seen, some of the later ones can be corroborated by evidence in the Oyakata Nikki. It seems reasonable, then, not to distrust the most important Kanagae document that falls within our period. This is the famous letter signed Sambei, and probably datable to 1653. It is here quoted in full, no. (5).

Quoted, summaried or reprinted here are six documents relevant to the subjects of this book. The first four are orders from either Nabeshima Katsushige, the Daimyō of Hizen, or from his delegated servants. The fifth is the much mis-quoted letter from Sambei (Ri Sambei). The final document is a list of all the ceramics mentioned in the inventory taken at Sumpu on the death of the Shogun Tokugawa Ieyasu, in 1616.

(1) 439

Summary of a letter written by Nabeshima Katsushige

Taken from: *Saga-ken shiryō shūsei* (Saga prefecture collected documents), vol. ix, *Taku-ke Monjō* (Taku family documents).

This letter is included as it suggests that Arita was a rural area in 1607, a hunting preserve, and not a nascent industrial town.

Letter from Nabeshima Katsushige to his 'Librarian'* warning that the laws prohibiting the hunting of deer and wild boar in Arita and Yamashiro, areas designated as (official) hunting grounds, must be strictly obeyed.

Dated 15th day 9th month Keicho 14 (1607) but the calligraphy of the date is different from that of the rest of the document.

* *Tosho-dono*, literally 'Mr Librarian', but probably referring to the person in charge of receiving, dispatching, and filing documents. Probably quite important. This letter is in effect instructing the librarian to issue an order in this area.

(2) 353

Letter from Nabeshima Katsushige

In *Saga-ken shiryō shūsei, Ko-monjō-hen* (compilation of old documents), vol. ix, *Taku Monjō*; in Saga prefectural library.

This letter is not dated; Nakamura Tadashi has kindly informed me that it cannot be before Kanei 12 (1635). Presumably this was a preliminary warning before the ban of 1637 (see no. 3).

item As I was advised by Uchi-no Kami sama that both potters be given permission [to work], I have issued passes [accordingly]. As is stated therin, the large number of potters is causing damage to the mountains and I should like this point emphasized to them. Could you also make clear to them the [contents of the] general regulations that have been in force heretofore.
[followed by four items unrelated to ceramics]
9th day, 6th month, [to] Taku Mimasaka-dono Morooka Hikozaemon-jo
[from] Shinano-no-kami, Katsushige [monogram]

(3)

Laws pertaining to Sarayama; Kanei 14 (1637)

The order of Nabeshima Katsushige that kilns should be closed in 1637 exists today in more than one version; two are reprinted here:

In accordance with an order from [Lord Katsushige] issued to Taku no Mimasaka-no-kami-sama on the 19th day of the 3rd month, according to which the potters in the fief were causing damage to [Mt.] Tateyama, a total of some 800 men and women except those of Korean stock were expelled. The 'mountain bailiff' at that time was Kyuzaemon [?]-yama Kyudaiyu.

The beginnings of Arita Sarayama go back to the time of Lord Naoshige's return from Korea. Thinking that they would be an asset to Japan, he brought back with him six or seven skilled potters of leading status and established them at the above mentioned [Mt.] Tateyama. There he had them make pottery. Later he moved them to [Mt.] Fujinokawashimayama in Arita and had them make pottery there. The Koreans multiplied in number and the Japanese learned from them, applying themselves to the potters' craft. They spread and set themselves up in workshops all over Arita, Imari, and roundabout, and in search of firewood devastated the mountains. Yamamoto Shinemon, who had previously been put in charge of the area surrounding the above mountains, went before Lord [Katsushige] and told him of the situation. Accordingly Lord [Katsushige] instructed Taku Mimasaka that except for those of Korean stock all Japanese engaged in pottery should be expelled. He also instructed Shinemon that as he was a resident in Arita he should check on all those going into the mountains, and that if there were any Japanese with good reason for being there he should report

them to Mimasaka who would then give them a letter of permission. All others were to be expelled. Such were Lord Katsushige's orders. The expelled totalled 826, 532 men and 294 women from a total of 11 workshops, 4 in Imari and 7 in Arita. After this the pottery industry grew and prospered so that it became the most important business in the fief.

Other version of the above

On the matter of the dish-makers [*sara-ya*] of Arita; when Lord Naoshige returned from Korea he brought back with him to this country six or seven leaders of those who were skilled at pottery. He settled these men at Konryuzan [?], where they fired their pots. Thereafter, at the Lord's behest, they moved to Kawachiyama at Naito in Imari. These Koreans had many descendents and the Japanese, observing and learning how they worked, made [their own] wares [in imitation]. As a result, potters were established scattered through the districts of Imari and Arita, and the hills were denuded of trees. Thus an inspector was instituted for these hills. [The Lord consented to the appointment of Jin'yuemon] and an order was handed to Lord Mimasaka on the 15th day of the 3rd month on Kanei 14 [1637], that apart from those of Korean lineage, the Japanese who were firing pots should be expelled. An order was given that since Jin'yuemon had gone to Arita, he should conduct a thorough investigation and record those among the Japanese who had a case, report them in the presence of the Lord, and they were to be allowed to stay on the basis of a certificate [signed by] Lord Mimasaka; the rest were strictly to be expelled. On the 15th day of the intercalary third month of Kanei 14,826 men and women were expelled. Of these 532 were men and 294 women. The list of expulsions is now in my possession. Lord Mimasaka is aware of this. On the occasion of the expulsion of the Japanese, dish-makers from 4 places in Imari and 7 places in Arita, altogether 11 places, on the judgement and examination of Jin'yuemon alone, were expelled with the Lord's consent. Thus they were confined in their firing of pots [to an area] from where the dish-makers lived at Kuromuta and Iwayakawachi to Jonen Kiyama, Kamishirakawa, altogether 13 hills. At that time, during the intendances of Mitsuno Kyuzaemon and Kagiyama Marutayu, the Lord had derived tax of barely 2 kan, 100 me per year. Thereafter, Morooka Hikoyuemon memorialized the Lord, and among the Japanese whom Jin'yuemon had expelled, a few were pardoned and joined the Koreans and the Lord's tax from the firing of pots increased.

(4)

Copy of an order issued by Yasunori-no-in-sama (Nabeshima Katsushige) concerning the business of ceramics as practised among Koreans, stipend-holders and others

From *Hiyo kyū shoroku* (Old records from Hiyo) from the Koshiro family documents, Kyushu Cultural History Dept.

Another order, concerning Koreans and their descendants

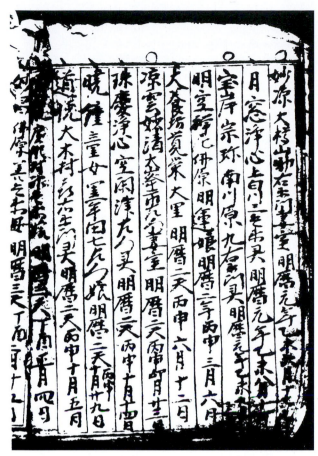

FIGURE 100. Extract from the records of Ryusenji Temple (near Arita), recording the death of Ri Sampei (from Cleveland, 1970): 'Gesso Joshin Sampei Kamishirakawa [became a] spirit on the 11th day of the 8th month of Meireki, the year being *kinoto-hitsuji* [12 September 1655].'

item Established Koreans and their legitimate heirs who have lived [? in the same place] for many years are hereby granted permission to continue with their ceramics as before.

item Even among Koreans, those who have come from other fiefs and do not have their own house in this fief are to be expelled.

item Such people as stipend-holders and their retainers, towns people and travellers may continue their dealings in ceramics as before. However those who are resident in this fief and claim to be engaged in agriculture [illegible]

29th day, 3rd month, Kanei 14 [1637]
[to] Taku Mimasaka-dono

(5)

Document concerning the emigration from Korea of Kanagae Sambei of Sarayama

From *Hiyo kyū shoroku* (Old records from Hiyo) from a film in the Kyushu University Cultural History Department; No. 4.

The famous letter of 'Ri Sambei':

item Having crossed over from Korea, I spent several years in the service of Nagato-no-kami-sama. Thirty-eight years ago in the year of hinoe-tatsu [3rd calendar sign/year of the dragon] I moved here to Sarayama in Arita, having been granted [land?]. The eighteen people who moved with me from Taku are my apprentices and they brought [their possessions] in carts. They consist of eight Korean apprentices of Noda Juemon-dono's, Kinoshita Garakunosuke-dono, his wife Sei and two apprentices, three Koreans in the service of Higashi-no-hara Kiyomoto and three people from the Takunoto workshop. They all came here bringing their possessions in carts.

item My servants consist of four Koreans I took from the service of Takagi Gonbei-dono, three Korean employees of Senpu Heiemon-dono's two sons of a farmer in Arita and Sukesaku of Arita-machi. I take full responsibility for these ten and the one hundred and twenty servants I have who have gathered from various parts to work under me.

20th day, 4th month, year of the serpent [thought to be Joo 2, 1653].
Arita Saraya Sanbei-no-jo [seal]

It will instantly be seen that nowhere in this document is any reference made to porcelain or even pottery, to clay or Izumiyama, to Tengudani or Shirakawa. No claim is made to the finding of clay or to the starting of a kiln, let alone of an industry. Nor does the Japanese word for apprentice assure us that these were apprentice potters.

The discovery by Ikeda Chūichi of the record of the death on 20 September in the first year of Meireki [1655] of 'Kamishirakawa Sambei' in the Temple register of Ryusenji in West Arita (fig. 100)[2] in no way proves the legend of Sambei's so-called discoveries to be true. This merely proves that there was a Sambei living in Shirakawa before 1655. This may or may not be the author of the letter quoted above, and while it is pardonable to assume that it is so, it seems absurd to believe the legends wholesale simply because we know that Sambei actually lived. That is really all we do know.

(6) 653

Inventory of objects and utensils in the possession [of Tokugawa Ieyasu] at Sumpu
Taken, 17th day, 4th month, Genwa 2 (1616)

Vol. ii of two vols.; in 1923 in possession of Marquis Tokugawa Yoshichika, taken from Tokyo Imperial University, Faculty of Literature, History Department (ed.), *Dainihon shiryō*, ser. 12, vol. 24 (Tokyo, 1923).

Table of contents

730

Inventory of utensils used when entertaining

733

10	Large Kuan (celadon) dish	9	one broken one broken and repaired
11	Korai (celadon) fish salad dish	7	one broken and repaired
12	Korai (celadon) rimmed dish	10	three broken and repaired
13	Tenryuji (celadon) rimmed dish	5	
14	Celadon rimmed dish	13	
15	Flat celadon dish	4	
16	Eggshell white rimmed dish	43	six broken and repaired
17	Blue and white tea bowl	1,000	in ten boxes

734

1	Small b&w tea bowl	700	in seven boxes
2	Small b&w dish	200	in two boxes
3	B&w fish salad dish, crab design	100	in one box
4	Small b&w dish	100	in one box
5	B&w fish salad dish, grass design	500	in five boxes
6	B&w fish salad dish, tortoiseshell design	120	in one box
7	B&w jar with lid	4	in one box
8	B&w tea bowl	107	in one box
9	Small b&w dish	40	
10	Flat b&w dish	47	in one box
11	B&w fish salad dish, grass design	35	
12	B&w *sashimi* dish	5	in one box
13	Large flat b&w dish	7	
14	Large b&w tea bowl	23	
15	Large b&w tea bowl, *fuyō* design	18	in one box
16	B&w *tokuri* (bottle)	1	
17	B&w tea bowl	26	in one box

735

1	Small b&w helmet shaped dish	20	in one box
2	B&w *tokuri*	1	in one box
3	Small b&w tea bowl	75	in one box
4	Small b&w tea bowl, *fuyō* design	12	
5	B&w dish, large and small	8	
6	B&w bowl	2	
7	Tenryuji (celadon) bowl, large and small	7	
12	B&w jar	2	with lids; in one box
13	B&w jar	2	with lids
14	B&w *aburatsubo* (oil jar)	13	in one box

736

1	B&w *tokuri*	4	
2	B&w jar	1	
3	Large b&w jar	2	

737

Utensils listed above checked and received in good order
Genwa 4, 11th month, first day

Asahina Hoemon
Yamashita Shinano-no-kami-dono

739

[Note to say that in *Dainihon shiryo*, 16th day, 8th month, Keichō 16 (1612), there is the explanation of how Ieyasu had a new storehouse built in Sumpu and had his possessions stored there.]

756

Inventory of objects and utensils in the possession (of Tokugawa Ieyasu) at Sumpu
Vol. i of 2 vols.

Table of contents

763

Inventory of various utensils in the Sumpu collection

769

6	Tenryuji (celadon) vase	2
7	Tenryuji (celadon) sutra case	1

770

various objects of inferior quality

771

4	Tenryuji (celadon) tea bowl	2

781

list of jars

782

2	B&w jar	1
5	Tenryuji (celadon) jar	1
7	B&w food-box	1

786

8	Tenryuji water-dropper	1

787

incense utensils

789

6	Incense burner, Tenryuji (celadon)	4
9	Incense burner, celadon	1
15	Incense burner, b&w	3
Subheading;		
16	B&w container for burnt incense	1

797

Utensils for herbs and medicines

798

7	B&w tea bowl, containing medicine, with lids	5
9	Mortar for medicines, Tenryuji (celadon)	3
12	Small b&w dishes	26
13	B&w dishes	2
15	White *fuyō* . . .	3
16	Tenryuji (celadon) extinguisher	1
17	B&w sake cups	3

800

1	B&w *tokuri*, chipped	1
2	B&w *tokuri*, large and small	3

810

Utensils listed above checked and received in good order
Genwa 4, 11th month, first day

Hida Magosaburo
Ueda Chuzaburo
Ishiguro Ichijuro
Yamashita Shinano-no-kami-dono

810

Inventory of objects given to Hida Magusaburo and Kanematsu Tanzaburo

811

17	B&w incense box	1

812

Medicines, herbs and containers listed above checked and received in good order
Genwa 4, 11th month, first day

Hida Magusaburo
Kanematsu Tanzaburo
Yamashita Shinano-no-kami-dono

[For a discussion of this document, see Chapter 2.]

Notes

I am much indebted to Nakamura Tadashi, who provided me with transcriptions and copies, to Morioka Yoshiko and Hiroko Nishida. I am also indebted to Kodama Kōta who drew my attention to the Tokugawa inventory.

1. Trans. Rupert Faulkner.
2. See John Pope's Introduction to Richard Cleveland, *200 Years of Japanese Porcelain* (St Louis, 1970).

12

DUTCH DOCUMENTATION

WHEN Volker compiled his monumental and indispensable 'Porcelain and the Dutch East India Company',[1] from the archives of the Dutch East India Company called Factorij Japan (NFJ), now in the Rijksarchief, den Haag, he concentrated on the orders for porcelain, rarely consulting the actual bills of lading. His work therefore records what was ordered rather than what was actually delivered. As there are significant differences between the two, this is important. This led him to mistake the date of the first official purchase of Japanese porcelain by the Company as 1653, where it is in fact 1650, and to misinterpret the taste for colour of the first major order of 1659, where he claimed that only blue and white was wanted for Holland, whereas the demand for enamelled porcelain for Holland may have been crucial in the decision to ship porcelain from Japan in quantity. The blue and white was for Mocha.

The first large order for Japanese export porcelain, that of 1659 for Mocha, is quoted by Volker in full.[2] From our point of view, the more important order for coloured ware for Holland of the same year is lost; however the bills of lading for 1659 exist and those for Holland are printed below.[3] This order was the response by the Company to the case of samples sent to Holland in 1657 (see fig. 101); the bills of lading prove that many or all of the samples must have been enamelled. This means that the Com-pany had approved the coloured samples and sent in an order for their purchase.

As the Arita porcelain industry had to adapt to a new series of shapes and, probably more importantly, of sizes, as well as of new designs (*kraak* and 'transitional') this order was not filled in 1659. The second half of the order was shipped in 1660. The bills of lading for these cargoes also are printed below.

These documents are discussed in Chapter 9.

Bills of Lading

24 OCTOBER 1650[4]

| 145 | pieces for Tonkin | |
| 145 | *diverse porseleijne schotels pieringhs* various porcelain plates dishes | 0.0.57 |

16 AUGUST 1651[5]

| 176 | pieces for Tonkin | |
| 176 | *diverse sorteringen Japanse porceleijne schotels, pieringhs en flessen* various varieties Japanese porcelain plates, dishes and bottles | 0.0.5 |

31 OCTOBER 1652[6]

| 1265 | pieces for Taiwan | |
| 1265 | *groote en cleijne medicament potten* large and small medicinal pots | 0.0.3 |

10 NOVEMBER 1653[7]

2200	pieces for Batavia	
2200	*diverse porceleijne fleskens, potjens, zalfs en conserfs potten voor Batavia, volgens d'overgesonden monsters alhier gemaeckt* various porcelain (small) bottles, (small) pots, salve and preserve pots for Batavia, made here according to the samples sent	
1200	*cleijne fleskens, en potjens* (small) bottles, and (small) pots	0.0.4
1000	*zalfs en conserfs potten* salve and preserve pots	0.5.0

25 OCTOBER 1654[8]

| 3745 | pieces for the surgeon's shop in Batavia | |
| 3745 | *stux conserfpotten, cleijne fleskens ende potjens voor de chirurgijns winckel van batavia expres van hier gewordert* | |

FIGURE 101. Extract from the archives of the VOC, Factorij Japan 781, Folio 1. Invoice of the ship Ulisses, Nagasaki, 12 October 1657: '1 crate with assorted samples of porcelain for Holland (of which duplicates are retained here), marked No. 2, costing as per specification, 25 guilders, 5 maas, 3 conderijn.'

pieces preserve pots, small bottles and (small) pots for the surgeon's shop in batavia expressly ordered here

305	*stux salfs en conserfs potten*	0.0.8
	pieces salve and preserve pots	
1640	*stux diversche sorteringe,*	
	cleijne fleskens ende potjens	0.0.2
	pieces various varieties, small bottles and pots	
1800	*stux cleijne fleskens van driederhande sorteringe conform de modellen desen jare pr 'tCalff van batavia becomen, gemaeckt*	0.0.06
	pieces small bottles of three varieties made according to the models received from batavia this year on the Calff	

31 OCTOBER 1655[9]

3209	*stux zoo salf ende consert potjens, mitsgares cleijne porceleijne fleskens te weten*	
	pieces both salve and preserve pots, as well as small porcelain bottles namely	
502	*ps dito potten eerste soort*	
	pieces ditto pots first first variety	
480	*p dito potten tweede soort*	
	pieces ditto pots second variety	
504	*p dito potten derde soort*	
1509	*p salf ende consers potten*	0.0.8
	pieces salve and preserve pots	
1700	*p cleijne porceleijne fleskens*	0.0.2
	pieces small porcelain bottles	

22 OCTOBER 1656[10]

2003 pieces for the surgeon's shop on Taiwan

2003	*stx porceleijne groote en cleijne zalf ende conserf potten mitsgaders cleijne fleskens . . . voor de chirurgijns winckel in taijouan*	
	pieces porcelain large and small salve and preserve pots as well as small bottles . . . for the surgeon's shop on taiwan	
683	*stux grove dito*	0.0.8
	pieces coarse ditto	
230	*stux wat cleijnder*	0.0.5
	pieces a bit smaller	

| 1090 | *ps noch cleijnder* | 0.0.2 |
| | pieces even smaller | |

12 OCTOBER 1657[11]

samples for Holland

| 1 | *cas met diverse monsters van porceleijn voort vaderland waer van uijt ijder zoorteringe eenige hier tot naerrichtinge zijn verbleven* | 29.5.3 |
| | case with various samples of porcelain for the fatherland of which from each variety some have been kept for reference | |

25 OCTOBER 1657[12]

3040 pieces for the surgeon's shop in Batavia

3040	*stux medicament en zalfpotten . . . voor de chirurgijns winckel op Batavia*	
	pieces medicine and salve pots . . . for the surgeon's shop in Batavia	
1720	*stux ordinarij potten*	0.0.8
	pieces ordinary pots	
1320	*stux cleene ditos*	0.0.5
	pieces small dittos	

16 OCTOBER 1658[13]

457 pieces for Bengal

| 457 | *stux Japans porceleijn in een cas* | 27.4.5 |
| | pieces Japanese porcelain in a case | |

23 OCTOBER 1658[14]

4800 pieces for Batavia

| 4800 | *stux medicament potten en flesjens van diverse soorte voorde Chirurgijns winckel op Batavia* | 281.2.0 |
| | pieces medicine pots and (small) bottles of various sorts for the surgeon's shop in Batavia | |

5748 pieces for Batavia and Holland, 5548 were sent on the Holland (17 Jan. 1660), so 200 pieces must have remained in Batavia

15 OCTOBER 1659[15]

600	*wit-kantige thee copiens* white faceted (small) teacups	0.0.15
400	*ditos root en groen* dittos red and green	0.0.15
200	*groote ditos met rode schilderij* large dittos with red painting	0.0.2
200	*thee copiens met silver gebloemt* (small) teacups with silver flowers	0.0.25
100	*grote coppen met silver en rode randen* large cups with silver and red borders	0.0.4
42	*blaauwe ditos buijten vergult* *binnen wit* blue dittos outside gilded inside white	0.1.5
54	*dubbelde rode overdekte copiens* double red lidded (small) cups	0.0.7
100	*thee copiens met blaau geschildert* (small) teacups painted with blue	0.0.2
——		——
1696	cups	0.0.24
100	*groote blaauw geschilderde commen* large blue painted bowls	0.1.5
100	*cleijne ditos* small dittos	0.0.9
60	*rode en groene ditos* red and green dittos	0.0.5
100	*witte commen* white bowls	0.0.35
100	*ditos met vergulde bloemen* dittos with gilded flowers	0.0.9
——		——
604	bowls	0.0.89
100	*witte pierings met silvere bloemen* white dishes with silver flowers	0.1.3
100	*kantige ditos binnen blaauw* angular dittos inside blue	0.2.0
130	*ditos blaauw geschildert* dittos blue painted	0.1.0
120	*dito pierings als voren geschildert* ditto dishes painted likewise	0.0.9
340	*ditos geheel wit* dittos wholly white	0.0.9
200	*rood met silver gebloemde thee pierings* red with silver flowered tea dishes	0.0.6
300	*wit en blaauwe ditos* white and blue dittos	0.0.6
100	*diepe boter pierings* deep butter dishes	0.0.5
100	*slechte rood en groen* poor quality red and green	0.0.2
90	*blaauwe root en vergult* blue red and gilded	0.0.6
100	*cleijne bladt pierings* small leaf dishes	0.0.13
160	*witte pierings* white dishes	0.0.9
140	*witte diepe booter pierings* white deep butter dishes	0.0.5
400	*ditos met gedraaijde canten* dittos with turned sides	0.0.5

100	*viercante ditos binnen blaauw* square dittos inside blue	0.0.85
100	*pierings binnen root en vergult* dishes inside red and gilded	0.1.0
100	*pieringstiens blaau en zilver cantigh* dishes blue and silver angular	0.1.55
100	*ditos ruijts gewijs heel blaauw* dittos lozenge shaped wholly/very blue	0.1.55
50	*licht blaauw geschilderde ditos* light blue painted dittos	0.1.55
60	*bladt pierings binnen blaauw* leaf dishes inside blue	0.0.8
60	*wit blaauwe vierkante pierings* white blue square dishes	0.0.8
——		——
2950	dishes	0.0.99
300	*schotels drijlingen* plates thirds	0.4.0
50	*roodt en groene fleskens* red and green bottles	0.0.5
100	*diversche poppen* various dolls	0.0.5
5	*siouubacken met rode schilderij* *jūbako* with red painting	0.8.0
3	*craanvogels* cranes	0.7.5
10	*zoutvaten* salts	0.3.0
10	*inktkokers* inkpots	0.5.0
10	*sackij ketelgens* sake kettles	0.8.0
——		——
198	various shapes	

4 NOVEMBER 1659[16]

108	'new porcelains', part of the previous shipment of 5748 pieces	
24	*pintgens kannetgens* *pintgens* jugs	0.5.0
30	*mostert potgens* mustard pots	0.2.5
30	*zoutvaten* salt containers	0.2.5
10	*intkokers* inkpots	0.4.0
14	*wijn kannetgens* wine jugs	0.5.0
——		——
108	various shapes	

24 OCTOBER 1659[17]

230	pieces for the table of the governor	
50	*stux fijne schotels drielingen* pieces fine plates thirds	0.4.0
30	*stux dito quarten* pieces ditto quarts	0.3.5

80	plates	0.3.81
100	*platte pierings* flat dishes	0.1.0
50	*stux cleene ditos* pieces small dittos	0.0.5
——		——
150	dishes	0.0.83

25 OCTOBER 1659[18]

508	pieces for Taiwan	
182	*stux olij fleskens houdende 1 once yder* pieces (small) oil bottles containing 1 ounce each	0.0.16
30	*stux salffpotten houdende 1½ lbs* pieces salve pots containing 1½ lbs	0.0.8
76	*stux houdende yder 1 lbs* pieces containing each 1 lbs	0.0.7
76	*stux houdende ider ½ lbs* pieces containing each ½ lbs	0.0.4
68	*stux ditos houdende ¼ lbs* pieces dittos containing ¼ lbs	0.0.4
76	*stux ditos cleijne houdende 2 oncen yder* pieces dittos small containing 2 ounces each	0.0.2
——		——
326	salve pots	0.0.46

30 OCTOBER 1659[19]

1048	pieces for Bengal	
250	*stux tafelpieringtiens* pieces (small) table dishes	
	50 *stux blaauwe met vergulde* pieces blue with gilded flowers	0.1.2
	50 *stux witte ditos met zilvere* pieces white dittos with silver flowers	0.1.1
	150 *stux met blaau loffwerk beschildert* pieces with blue leafwork painted	0.1.0
590	*stux diversche cleijne pieringtiens* pieces various (small) dishes	
	100 *stux ronde met rode bloemen* pieces round with red flowers	0.0.8
	100 *ditos grover binnen met root loffwerk* pieces coarser inside with red leafwork	0.0.4
	100 *ditos ronde en blad wijse blaau geschildert* dittos round and leaf shaped blue painted	0.0.8
	30 *stux ronde donker blaau en vergult* pieces round dark blue and gilded	0.1.0

50	*stux vierkante pieringties* pieces four-sided (small) dishes	0.0.83
40	*stux schulps gewijse* pieces shell shaped	0.0.83
50	*ronde met blaau loffwerk* round with blue leafwork	0.1.2
50	*ditos binnen weijnich vergult* dittos inside a little gilded	0.1.2
50	*stux cleene blad pieringtiens* pieces small leaf dishes	0.0.2
20	*stux diepe boter pieringties* pieces deep (small) butter dishes	0.0.7
——		——
840	dishes	0.0.78
200	*stux diversche witte en vergulde thee copiens* pieces various white and gilded (small) teacups	0.0.28
4	*stux vierkante intkokers* pieces four-sided inkpots	0.5.0
2	*sousvaten* sauce boats	0.3.0
2	*mostertpotten* mustard pots	0.3.0
——		
208	various shapes	

30 OCTOBER 1659[20]

870	pieces for Coromandel	
50	*stux witte tafelpierings* pieces white table dishes	0.0.8
70	*stux ditos met blomwerk blaau beschildert* pieces dittos with flowerwork blue painted	0.1.0
150	*stux witte cleijne ronde pieringtiens* pieces white small round dishes	0.0.45
50	*stux dito binnen vergult met root loffwerk* pieces ditto inside gilded with red leafwork	0.0.96
50	*stux wit met blaauwe randen* pieces white with blue borders	0.0.7
70	*stux dito pieringtiens met blompotten beschildert* pieces ditto (small) dishes painted with flowerpots	0.0.7
20	*stux ditos kantige met vergult rooswerk gestreept* pieces dittos angular with gilded rosework striped	0.1.5
100	*stux blaauwe kantige en vergulde thepieringties* pieces blue angular and gilded (small) tea dishes	0.1.2
40	*stux ronde pieringties binnen rood en groen* pieces round (small) dishes inside red and green	0.0.9

600	dishes	0.0.83
240	*stux blaauw geschilderde theecopies* pieces blue painted small teacups	0.0.13
10	*stux schotels drijelingen* pieces plates thirds	0.4.0
10	*stux commen blaauw beschildert* pieces bowls blue painted	0.1.3
10	*stux cleijnder commen* pieces smaller bowls	0.1.0
270	various shapes	

30 OCTOBER 1659[21]

21567	pieces for Mocha	
3240	*stux copiens met blaauwe bloemen* pieces (small) cups with blue flowers	
1920	*stux* pieces	0.0.2
1320	*stux* pieces	0.0.18
3600	*stux copiens* pieces (small) cups	0.0.2
4320	*stux witte ditos* pieces white dittos	0.0.13
3105	*stux cauwa copiens met voetgens* pieces (small) cups with feet	0.0.3
2970	*stux dito copiens* pieces ditto (small) cups	0.0.3
2835	*stux ditos buijten geheel blaauw* pieces dittos outside wholly blue	0.0.7
20070	cups	0.0.28
345	*stux groote commen* pieces large bowls	0.1.6
520	*stux kleijnder commen* pieces smaller bowls	0.1.2
570	*stux noch cleijnder ditos* pieces even smaller dittos	0.0.7
1435	bowls	0.1.0
25	*stux porceleijne flessen met blaau loffwerk* pieces porcelain bottles with blue leafwork	0.5.0
37	*stux dito vlessen met rood en groene verff beschildert* pieces ditto bottles painted with red and green paint	0.6.0
62	bottles	0.5.6

30 OCTOBER 1659[22]

560	pieces for Surat	
10	*schotels drijlingen* plates thirds	0.4.0

40	*stux schoteltiens binnen meest rood beschildert* pieces (small) plates inside mostly red painted	0.0.88
40	*stux binnen wit met heel blaauwe randen* pieces inside white with wholly blue borders	0.0.75
90	plates	0.1.17
50	*stux blaauwe tafelpierings* pieces blue table dishes	0.1.0
50	*stux witte ditos* pieces white dittos	0.0.8
50	*stux cleijnder witte pieringtiens* pieces smaller white (small) dishes	0.0.45
50	*stux cleijnder witte ditos binnen met silvere rosen* pieces smaller white dittos inside with silver roses	0.0.96
50	*stux te weten 30 witte en 20 met roodt beschilderde thepierings* pieces namely 30 white and 20 with red painted tea dishes	0.0.6
30	*stux viercante pieringtiens binnen vergult* pieces four-sided (small) dishes inside gilded	0.0.8
280	dishes	0.0.72
10	*stux grote commen blaauw beschildert* pieces large bowls blue painted	0.1.3
10	*stux cleijnder commen* pieces smaller bowls	0.1.0
20	bowls	0.1.15
20	*stux fijne coppen zijnde buijten met goud gebloemt* pieces fine cups being outside flowered with gold	0.0.75
50	*stux kleijnder copiens wit en vergult* pieces smaller (small) cups white and gilded	0.0.6
100	*stux witte cantige theecopiens* pieces white angular (small) teacups	0.0.25
170	cups	0.0.41

4 NOVEMBER 1659[23]

3271	pieces for the surgeon's shop in Batavia	
276	*medicament potten No 1* medicine pots No 1	0.0.8
720	*stux dito weijnich cleender No 2* pieces ditto a bit smaller No 2	0.0.8
275	*stux dito na t monster No 3* pieces ditto after the model No 3	0.0.8
210	*stux potten na t monster No 4* pieces pots after the model No 4	0.0.7

640	*stux potten No 5*	0.0.5
	pieces pots No 5	
———		———
2121	pots	0.0.7
1150	*stux witte fleskens No 6*	0.0.2
	pieces white (small) bottles No 6	

15 OCTOBER 1660[24]

11530	pieces for Holland	
200	*stux boter pieringjens*	
	blaau geschildert	0.0.8
	pieces (small) butter dishes	
	blue painted	
80	*stux met rood en blaauwe schilderij*	0.0.7
	pieces with red and blue painting	
40	*stux ditos waijers wijs met*	
	blaau en gout	0.1.0
	pieces dittos fan shaped	
	with blue and gold	
80	*stux met rood en silver geschildert*	0.0.6
	pieces painted with red and silver	
100	*stux ditos blaau geschildert*	0.0.85
	pieces dittos blue painted	
340	*stux ditos met roo en groene randen*	0.0.55
	pieces dittos with red and	
	green borders	
60	*stux boter pierings met blaau en*	
	gout	0.0.9
	pieces butter dishes	
	with blue and gold	
300	*stux met blau swart en silver*	
	geschildert	0.0.8
	pieces painted with blue black	
	and silver	
80	*stux ditos binnen root en silver*	0.0.55
	pieces dittos red and silver inside	
60	*stux ditos met blaau en silver*	0.0.6
	pieces dittos with blue and silver	
40	*stux root en groen geschildert*	0.0.6
	pieces painted with red and green	
90	*stux geriffelde ditos met gout*	0.1.2
	pieces ribbed dittos with gold	
100	*stux blad pierings met*	
	silvere bloemen	0.0.6
	pieces leaf dishes with silver flowers	
120	*stux blad pierings root en blaau*	
	geschildert	0.0.3
	pieces leaf dishes red	
	and blue painted	
40	*stux viercante ditos root en groen*	0.0.5
	pieces four-sided dittos red and green	
120	*stux ruijts gewijse met rode schilderij*	0.0.5
	pieces lozenge shaped	
	with red painting	
100	*stux blad ditos met root*	
	blau en gout	0.0.8
	pieces leaf dittos	
	with red blue and gold	

200	*stux witt en met silver*	0.0.45
	pieces white and with silver	
140	*stux halve pierings met root*	
	silver en gout geschildert	0.1.0
	pieces half dishes painted with	
	red silver and gold	
200	*stux pieringtjes met blaau blomwerk*	0.0.33
	pieces (small) dishes with blue	
	flowerwork	
240	*stux rond en viercante*	0.0.8
	round and four-sided	
70	*stux ditos met blaaue randen*	0.1.0
	pieces dittos with blue borders	
430	*stux ditos blaau geschildert*	0.0.7
	pieces dittos blue painted	
40	*stux ditos met groen en silver*	0.0.55
	dishes with green and silver	
50	*stux pierings met gout en silver*	
	geschildert	0.1.3
	pieces dishes painted	
	with gold and silver	
100	*stux ditos blaau geschildert*	0.0.8
	pieces dittos blue painted	
30	*stux achtcantige ditos*	0.1.8
	octagonal dittos	
85	*stux ditos met blaauwe schilderij*	0.1.0
	pieces dittos with blue painting	
100	*stux pierings groen en roodt*	
	geschildert	0.0.8
	pieces dishes green and red painted	
330	*stux witte ditos*	0.0.8
	pieces white dittos	
320	*stux witte pierings*	0.0.75
	pieces white dishes	
200	*stux pierings blaau geschildert*	0.0.8
	pieces dishes blue painted	
300	*stux boter pierings*	0.0.7
	pieces butter dishes	
120	*grote pierings rood en silver*	0.0.9
	large dishes red and silver	
100	*stux blaau geschilderde ditos*	0.0.5
	pieces blue painted dittos	
50	*stux viercante thepierings*	0.0.5
	pieces four-sided tea dishes	
100	*stux ditos met groene*	
	wijngaart bladen	0.1.1
	pieces dittos with	
	green vine leaves	
30	*stux achtcantige pierings*	0.1.2
	pieces octagonal dishes	
100	*stux blaauwe theepierings*	0.0.55
	pieces blue tea dishes	
100	*stux ditos met japanse letters*	0.0.8
	pieces dittos with Japanese letters	
60	*stux viercante ditos*	0.1.0
	pieces four-sided dittos	
170	*stux ronde ditos*	0.1.0
	pieces round dittos	
———		———
5615	dishes	0.0.74

80	*stux root en groene halve commen* pieces red and green half bowls	0.0.6
60	*stux commen met swart en silver geschildert* pieces bowls painted with black and silver	0.0.9
40	*stux commen met swart en silvere bloemen* pices bowls with black and silver flowers	0.0.9
60	*stux grote commen* pieces large bowls	0.1.0
14	*stux blaau schoon geschilderde commen* pieces blue finely painted bowls	0.4.0
254	bowls	0.0.1
200	*stux met silver geschilderde thecopies* pieces with silver painted (small) teacups	0.0.3
150	*stux coppen met groen en goude blommen* pieces cups with green and gold flowers	0.0.45
100	*stux copies buijten met silver geschildert* pieces (small) cups silver painted on the outside	0.1.0
200	*stux coppen met roo en silvre bloemen* pieces cups with red and silver flowers	0.0.45
50	*stux met root en silver* cups with red and silver	0.0.7
800	*stux witte theecopiens* pieces white (small) teacups	0.0.07
30	*stux copiens met d'exels* pieces (small) cups with lids	0.0.4
1200	*stux witte theecopiens* pieces white (small) teacups	0.0.07
500	*stux ditos blaau geschildert* pieces dittos blue painted	0.0.1
480	*stux ditos met blaau blomwerk* pieces dittos with blue flowerwork	0.0.4
500	*stux thecopiens blaau geschildert* pieces (small) teacups blue painted	0.0.2
400	*stux ditos wat cleender* pieces dittos a bit smaller	0.0.23
100	*stux blaauwe theecopies* pieces blue (small) teacups	0.0.23
4710	cups	0.0.20
55	*stux ronde flesjens* pieces round (small) bottles	0.1.2
45	*stux blaau geschilderde flesjes* pieces blue painted (small) bottles	0.0.5
55	*stux blaau geschilderde flesjens* pieces blue painted (small) bottles	0.0.5
155	bottles	0.0.75

25	*intkokers* inkpots	0.1.2
75	*intkokers* inkpots	0.1.2
120	*intkokers* inkpots	0.3.25
220	inkpots	0.2.32
3	*stux sijn 2 osjes en een wierookpotjen* pieces being 2 (small) oxes and a (small) incense pot	0.0.5
5	*stux wierook potten* pieces incense pots	0.6.4
13	*stux sioebacken* pieces *jūbako*	0.8.0
70	*stux boter dosen* pieces butter boxes	0.0.5
100	*stux croesjens* pieces (small) mugs	0.0.4
80	*stux stene popiens* pieces stone (small) dolls	0.0.4
100	*stux blaau geschilderde boter dosen* pieces blue painted butter boxes	0.0.5
20	*stux dito (blaau geschilderde) fruijtschalen* pieces ditto (blue finely painted) fruit plates	0.2.5
25	*stux wijn cannetgens* pieces wine jugs	0.3.5
416	various shapes	

15 OCTOBER 1660[25]

902	pieces for Batavia, as samples	
882	*schotels soo halve drijlingen als quarten* plates both half thirds as quarts	0.4.67
20	*lampeth schotels* wash basins	2.3.0
3429	pieces for the surgeon's shop in Batavia	
468	*stux potten* pieces pots	0.1.8
510	*stux ditos* pieces dittos	0.0.9
630	*stux* pieces	0.0.25
1608	pots	
590	*stux fleskens* pieces (small) bottles	0.0.25
1200	*stux ditos* pieces dittos	0.0.1
1790	bottles	
15	*stux witte beckens* pieces white basins	0.3.8

16	*stux blaau geschilderde ditos*	0.7.0
———		
31	basins	

24 OCTOBER 1660[26]

57173	pieces for Surat and Mocha	
12840	*stux copiens sonder voetiens* pieces (small) cups without (small) feet	0.0.19
12000	*stux dito copiens* pieces ditto (small) cups	0.0.19
5400	*stux ditos* pieces dittos	0.0.12
2025	*stux copiens met voetjens* pieces (small) cups with (small) feet	0.0.25
2025	*stux ditos mede gesorteert als voren* pieces dittos also sorted as before	0.0.25
2160	*stux copiens met voeten* pieces (small) cups with feet	0.0.5
2760	*stux heel blaauwe copiens* pieces very/wholly blue (small) cups	0.0.5
1560	*stux blaau geschilderde copiens* pieces blue painted (small) cups	0.0.3
9000	*stux achtcantige ditos*	0.0.09
———		———
49770	cups	0.0.2
1600	*stux grote commen* pieces large bowls	0.1.0
1600	*stux middelbare ditos* pieces middle-size dittos	0.0.8
2100	*stux cleender ditos* pieces smaller dittos	0.0.5
———		———
5300	bowls	0.0.74
60	*stux flessen* pieces bottles	0.5.0
20	*stux ditos* pieces dittos	0.5.0
———		———
80	bottles	0.5.0
191	*stux grote schotels* pieces large plates	0.8.0
282	*stux middelbare ditos* pieces middle-size dittos	0.6.0
224	*cleender ditos* smaller dittos	0.4.0
126	*stux* pieces	0.3.3

200	*stux ditos* pieces dittos	0.2.0
———		———
1023	plates	0.4.82
1000	*stux blaau geschilderde tafelborden* pieces blue painted table plates	0.0.4

Notes

Transcriptions and translations by Menno Fitski.

1. T. Volker, 'Porcelain and the Dutch East India Company as Recorded in the *Dagh-Registers* of Batavia Castle, those of Hirado and Deshima and Other Contemporary Papers, 1602–1682', *Mededelingen van het Rijksmuseum voor Volkenkunde*, Leiden, 11 (1954).
2. Ibid. 129–31.
3. Actually the bills of lading exist from 1650 up until 1663, but those after 1660 are not relevant to us here. These were first used by Nishida Hiroko in her unpublished doctoral dissertation for the University of Oxford 'Japanese Export Porcelain during the Sev-enteenth and Eighteenth Century' (1974), and I am grateful to Dr Nishida for drawing these to my attention.
4. NFJ 774, fo. 7. Prices are average prices per piece for assorted lots, or the actual price per piece otherwise.
5. NFJ 775, fo. 37.
6. NFJ 776, fo. 16.
7. NFJ 777, fo. 35.
8. NFJ 778, fo. 33.
9. NFJ 779, fo. 4.
10. NFJ 780, fo. 64.
11. NFJ 781, fo. 1.
12. NFJ 781, fo. 9.
13. NFJ 782, fo. 9.
14. NFJ 782, fo. 14.
15. NFJ 783, fos. 2, 3.
16. NFJ 783, fo. 11.
17. NFJ 783, fo. 4.
18. NFJ 783, fo. 6.
19. NFJ 783, fo. 7.
20. NFJ 783, fo. 8.
21. NFJ 783, fo. 9.
22. NFJ 783, fo. 10.
23. NFJ 783, fo. 11.
24. NFJ 784, fos. 2, 3.
25. NFJ 784, fos. 3, 4.
26. NFJ 784, fo. 9.

APPENDIX 1

Dated Pieces, Sherds, and Boxes

Included here is a selection of material relevant to the dating of *shoki*-Imari.

Dated sherds are not common at kiln-sites, and the finding of them at a particular site is not always truthfully reported. When a particular kiln is 'news' as was Hyakken and then Chōkichidani, then sherds tended to be attributed to those kilns to enhance their importance; I have tried to illustrate only sherds of which the provenance is secure. I am grateful to the Arita Museum, the Kyushu Ceramic Museum, the Arita Rekishi Minzoku Shiryōkan, and a private collector for allowing me to take photographs.

1. Plate 18*a* and *b* illustrate a dish from a box of twelve formerly owned by Yamashita Sakurō, which is dated 1639. The box is illustrated by Yamashita in *Tōsetsu* 175 (1967) 9, plate 16 A and B.

2. Figure 102 illustrates a small dish, diameter 15 cm., of Hyakken or Danbagiri type, period two, from a box dated 1639 (fig. 103). Illustrated by Igaki Haruo in *Tōsetsu* 292 (1977), 7, plate 1.

3. Figure 104 illustrates a sherd, dated 1624, from Tenjinmori kiln.

4. Figures 105–6 illustrate a sherd from Tenjinmori, dated 1639.

5. Figures 107–8 illustrate a sherd of a bottle, kiln-site uncertain, dated 1643.

6. Figures 109–11 illustrate a sherd of a bowl variously reported to be from Hyakken or from Hiekoba, the former the more likely, dated 1642.

7. Figures 112–13 illustrate a sherd from Hyakken, dated 1647.

8. Figures 114–15 illustrate a sherd of a bowl from Kusunokidani, dated 1648.

9. Figures 116–17 illustrate a sherd from Kusunokidani, dated 1653.

10. Plate 45*b* and *c* illustrates a square dish dated 1653.

11. Plates 43*c* and *d* illustrate a plate, attributed to Kusunokidani, dated 1653.

12. Figures 118–19 illustrate a sherd from Chōkichidani, dated 1660.

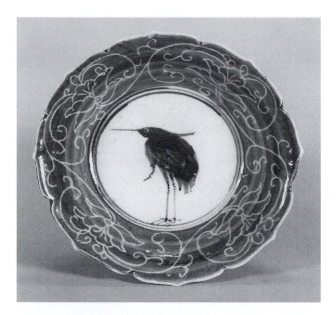

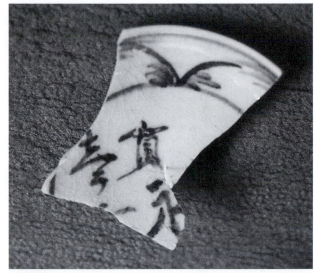

FIGURE 104. Sherd from Tenjinmori, dated 1624

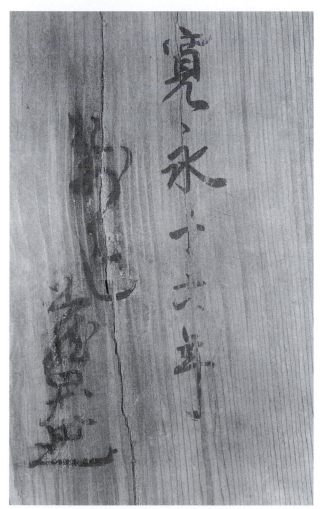

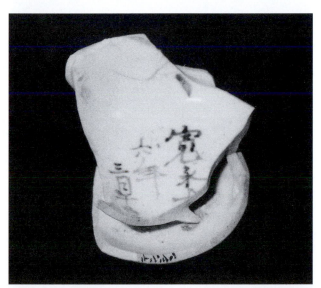

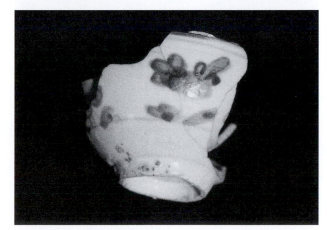

FIGURE 102–3. Dish from box, dated 1639, and box (detail)

FIGURE 105–6. Sherd from Tenjinmori, dated 1639

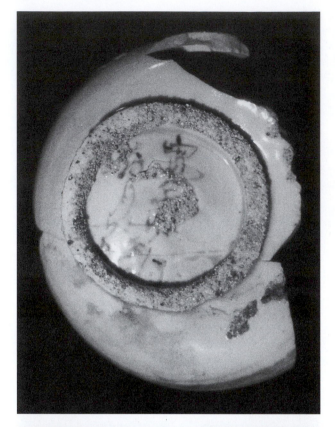

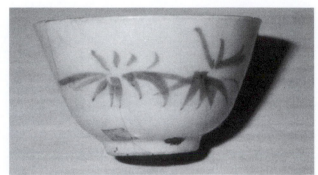

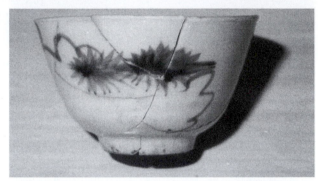

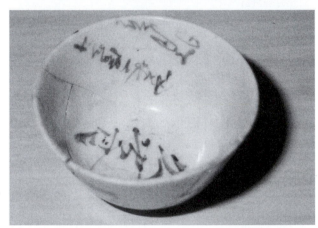

FIGURE 107–8. Sherd, dated 1643

FIGURE 109–11. Sherd from Hyakken or Hiekoba, dated 1642

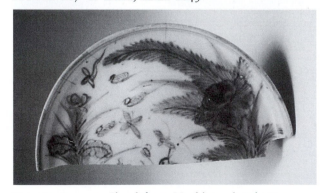

FIGURE 112–13. Sherd from Hyakken, dated 1647

FIGURE 114–15. Sherd from Kusunokidani, dated 1648

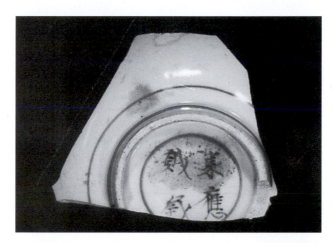

FIGURE 116–17. Sherd from Kusunokidani, dated 1653

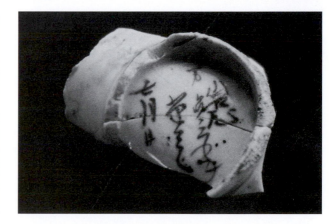

FIGURE 118–19. Sherd from Chōkichidani, dated 1660

APPENDIX 2

Chemical Content of Arita Porcelain as Analysed by Atomic Absorption Spectrometer

kiln	Si	Al	Ca	Mg	Fe	Ti	Na	Mn	K
Tenjinmori	74.8	18.89	0.25	0.10	0.98	0.07	0.89	0.017	3.98
	77.0	17.50	0.18	0.07	0.88	0.09	0.72	0.012	3.58
	74.4	19.28	0.29	0.11	1.00	0.07	0.76	0.013	4.09
	75.2	17.90	0.23	0.08	0.75	0.07	1.27	0.014	4.53
	71.7	20.48	0.25	0.12	0.83	0.07	1.68	0.017	4.90
	78.5	15.51	0.40	0.10	0.18	0.09	0.85	0.025	3.68
	76.6	17.30	0.29	0.09	0.18	0.07	1.01	0.014	3.84
	75.3	19.08	0.28	0.11	0.88	0.09	0.44	0.017	3.82
	75.5	17.09	0.29	0.07	0.84	0.07	1.34	0.027	4.78
	74.7	18.09	0.24	0.08	0.76	0.09	1.39	0.017	4.64
	77.8	17.15	0.16	0.12	0.93	0.10	0.61	0.008	3.15
	75.7	17.09	0.31	0.08	0.84	0.07	1.31	0.042	4.55
mean (of twelve)	75.7	17.80	0.26	0.09	0.88	0.079	1.03	0.019	4.16
standard deviation	1.66	1.31	0.06	0.02	0.09	0.011	0.35	0.009	0.52
Yamabeta (mean)	71.2	21.07	0.18	0.30	1.49	0.09	1.17	0.024	4.47
standard deviation	1.45	1.10	0.04	0.03	0.14	0.01	0.51	0.009	0.016
Komononari (mean)	75.9	18.48	0.27	0.11	0.97	0.04	0.65	0.01	3.62
standard deviation	2.19	1.81	0.04	0.03	0.23	0.01	0.12	0.002	0.34
Komizo (mean)	74.3	19.13	0.27	0.13	1.06	0.09	0.91	0.013	4.09
standard deviation	3.06	2.44	0.03	0.05	0.28	0.06	0.25	0.002	0.93
Maruo (mean)	73.2	20.24	0.22	0.21	1.26	0.12	0.90	0.016	3.85
standard deviation	1.1	0.74	0.03	0.04	0.09	0.03	0.26	0.003	0.32
Tengudani (mean)	78.4	15.3	0.20	0.13	0.82	0.04	0.92	0.007	4.20
standard deviation	1.7	1.36	0.07	0.07	0.20	0.02	0.22	0.001	0.42
Hyakken (mean)	73.9	19.17	0.12	0.3	0.92	0.07	0.70	0.008	4.18
standard deviation	2.79	2.25	0.03	0.03	0.09	0.02	0.16	0.008	0.47

Adapted from Mark Pollard, '[Technical studies of Tianqi porcelain] Description of method and discussion of results', *Trade Ceramic Studies*, 3 (1983), 155–6.

BIBLIOGRAPHY

Books in Western Languages

Ayers, John, *The Baur Collection, Geneva; Japanese Ceramics* (Geneva, 1982).

—— Impey, Oliver, and Mallet, J. V. G., *Porcelain for Palaces: The Fashion for Japan, 1650–1750* (London, 1990).

Baart, Jan, *et al.*, *Opgraving in Amsterdam, 20 jaar stadskernonderzoek* (Amsterdam, 1977).

Becker, Johanna, *Karatsu Ware: A Tradition of Diversity* (Tokyo, 1986).

Boxer, C. R., *The Great Ship from Amacon* (Lisbon, 1960).

Bureau of Cultural Properties, Ministry of Culture and Information, *Relics Salvaged from the Seabed off Sinan* (Seoul, 1985).

Cleveland, Richard, *200 Years of Japanese Porcelain* (St Louis, 1970).

Cort, Louise, *Shigaraki: Potters' Valley* (Tokyo, 1979).

de Flines, E. W. van Orsay, *Gids voor de Keramische Verzameling* [of the *Koninklijk Bataviaasch Genootschap van Kunsten en Wetenschappen*] (Batavia [Jakarta], 1949).

Faulkner, Rupert, '*Seto and Mino*: An Archaeological Survey of the Japanese Mediaeval Glaze Ware Tradition and its Early Modern Transformation', unpub. doctoral diss. (Oxford University, 1987).

—— and Impey, Oliver, *Shino and Oribe Kiln-Sites* (London, 1981).

Ford, Barbara, and Impey, Oliver, *Japanese Art from the Gerry Collection in the Metropolitan Museum of Art* (New York, 1989).

Gompertz, G. St G. M., *Korean Pottery and Porcelain of the Yi Period* (London, 1986).

Hinton, Mark, and Impey, Oliver, *Kakiemon Porcelain from the English Country House* (Oxford, 1989).

Howe, J. Allen, *A Handbook to the Collection of Kaolin, China-Clay and China-Stone in the Museum of Practical Geology, Jermyn Street, London SW* (London, 1914).

Impey, Oliver, and Fairley, Malcolm (eds.), *Treasures of Imperial Japan. The Nasser D. Khalili Collection of Japanese Art*, i: *Selected Essays* (London, 1995).

Jahn, Gisele, and Petersen-Brandhorst, Anette, *Erde und Feuer; traditionelle japanische Keramik der Gegenwart* (Munich, 1984).

Japan Society, *The Burghley Porcelains* (New York, 1986).

[Jenyns, Soame] The Oriental Ceramic Society, catalogue of, *A Loan Exhibition of Japanese Porcelain* (London, 1956).

—— *Japanese Porcelain* (London, 1965).

Nishida Hiroko, 'Japanese Export Porcelain during the 17th and 18th Century', unpub. doctoral thesis (Oxford University, 1974).

[Philadelphia] *Official Catalogue of the Japanese Section and Descriptive Notes on the Industry and Agriculture of Japan* (Philadelphia, 1876).

Pijl-Ketel, C. L. van der (ed.), *The Ceramic Load of the 'Witte Leeuw' (1613)* (Amsterdam, 1982).

Reichel, Friedrich, *Early Japanese Porcelain* (Leipzig, 1980; London, 1981).

Rinaldi, Maura, *Kraak Porcelain: A Moment in the History of Trade* (London, 1989).

Tichane, Robert, *Ching-te-Chen: Views of a Porcelain City* (New York, 1983).

Books in Japanese

Akamatsu, T. (ed.), *Hōrin shōshō 'Kakumei-ki'* (Tokyo, 1959), 4 vols.

Arita Board of Education, *Akaemachi: Saga-ken, nishi-Matsuura-gun Arita-chō, 1604 banchi no chōsa* (Arita, 1990).

Goto Museum, *Edo no yakimono* (Tokyo, 1984).

Idemitsu Museum of Arts, *Inter-Influence of Ceramic Art in East and West* (Tokyo, 1984).

Imaizumi Motosuke, *Iro-Nabeshima to Matsugatani* (Tokyo, 1969).

—— *Genshoku Nihon no meitō* (Tokyo, 1970).

—— *Ko-Imari to ko-Kutani* (Tokyo, 1974).

Kawahara Masahiko, *Ko-sometsuke* (Tokyo, 1978).

Koishiwara Town Board of Education, *Nakano kami no haru koyōseki* (Fukuoka, 1990).

Kyushu Ceramic Museum, *Kokunai shutsudo no Hizen tōji* (Arita, 1985).

—— *The Shibata Collection* (Arita, 1990 (vol. i), 1991 (vol. ii), 1993 (vol. iii)).

Mikami Tsugio, *New Light on Early and Eighteenth-Century Imari Wares: A Report on the Excavations at Tengudani Kiln-Site* (Tokyo, 1972).

The Editorial Committee for essays in honour of Prof. Dr Tsugio Mikami on his 77th birthday, *Mikami Tsugio hakushi kiju kinen ronbunshū* (Tokyo, 1985), iii, *tōji-hen*.

Mino Koto Kenkyūkai [Narasaki Shōichi], *Mino no koto* (Tokyo, 1976).

Miyazaki Yoshio, *Hasami kotōji monyō-shū* (Hasami, 1983).

Mizumachi, W., 'Shoki-Imari', *Tōji taikei*, 22 [Old series] (Tokyo, 1960).

Nagatake Takeshi (ed.), *Ko-Imari* (Saga, 1959).

—— *Hizen tōji no keifu* (Tokyo, 1975).

—— *Kakiemon* (Arita, 1969).

—— and Hayashiya Seizō (eds.), *Sekai tōji zenshū*, 8 (Tokyo, 1978).

Nakajima, K., *Hizen tōji shikō* (Arita, 1936).

Narasaki Shōichi (ed.), *Mino no koto* (Kyoto, 1976).

Nishida Hiroko, 'Ko-Imari', *Nihon tōji zenshū*, 23 (Tokyo, 1976).
—— 'Kutani', *Tōji taikei*, 22 [New series] (Tokyo, 1978).
—— *One Hundred Tea Bowls from the Nezu Collection* (Tokyo, 1985).
—— 'ko-Kutani', *Tōji taikei*, 22 (Tokyo, 1990).
Noda Toshio, *Ko-Imari saihakken* (Tokyo, 1990).
Ogi Ichirō, *Imari no hensen: seisaku nendai no meikaku na kibutsu o otte* (Tokyo, 1988).
—— *Shoki-Imari kara ko-Kutani yōshiki: Imari zenki no hensen o miru* (Tokyo, 1990).
—— *Imari* (Tokyo, 1993).
Ohashi Kōji and Shimazaki Susumu (eds.), *Exhibition of Imari and ko-Kutani Ware* (Arita, 1987).
Ohashi Kōji, 'Hizen tōji', *Kōkogaku raiburarii*, 55 (Tokyo, 1989).
Saitō Kikutarō, 'Ko-sometsuke, Shonzui', *Tōji taikei*, 44 (Tokyo, 1972).
Shimazaki Susumu, 'Kutani ware', *Nihon tōji zenshū*, 26 (Tokyo, 1976).
Shintani Masahiko, *Aigan shoki-Imari* (Tokyo, 1987).
Suzuta Yukio, 'Imari seiji', *Ko-Imari shiriizu* II (Sakai, 1991).
Tokyo National Museum, *Nihon shutsudo no Chūgoku tōji* (Tokyo, 1975).
Yabe Yoshiake and Ogi Ichirō, *Imari hyakushu* (Tokyo, 1993).
Yamashita Sakurō, *Ko-Imari to ko-Kutani* (Tokyo, 1965).
—— *Ko-Imari no sometsuke sara* (Tokyo, 1976).
—— *Shoki no Imari* (Tokyo, 1972).

Series of Books in Japanese, Some with English Summaries

Nihon yakimono shūsei (early 1980s).
Nihon tōji zenshū (late 1970s).
Sekai tōji zenshū (late 1970s).
Tōji taikei (1970s).

Articles in European Languages

Avitabile, Gunhild, 'Gottfried Wagener, 1831–1892, in Impey and Fairley, *Treasures of Imperial Japan* (London, 1995).
Baart, Jan (ed.), *Opgravingen in Amsterdam* (Amsterdam, 1977).
Carswell, John, 'China and Islam in the Maldive Islands', *Transactions of the Oriental Ceramic Society*, 41 (1976–7), 119–98, pl. 60F.
Frasche, Dean, 'Pottery from Takeo City Area, Kyushu, Discovered in Southeast Asia', *International Symposium on Japanese Ceramics* (Seattle, 1972), 166–71.
Impey, Oliver, 'A Tentative Classification of the Arita Kilns', *International Symposium on Japanese Ceramics* (Seattle, 1972), 85–90.
—— 'The Ceramic Wares of Hasami', *Oriental Art*, 17/4 (1975), 329–32.
—— 'The Earliest Japanese Porcelain: Styles and Techniques', in Percival David Foundation Colloquy on Art and Archaeology in Asia, 8, *Decorative Techniques and Styles in Asian Ceramics* (London, 1979), 126–48.
—— 'Japanese Tea Wares in Porcelain and their Relation to China', in Symposium on Tea Ceramics, the Deutsches Keramikmuseum, Dusseldorf, *Keramos*, 85 (1979), 91–108.
—— 'Ceramics of the Edo Period', *Apollo*, 115 (Jan. 1982), 26–33.
—— 'Shoki-Imari and Tianqi: Arita and Jingdezhen in Competition for the Japanese Market in Porcelain in the Second Quarter of the Seventeenth Century', *Mededelingenblad nederlandse vereniging van vrienden van de ceramiek*, 116 (1984), 15–29.
—— 'Celadon Porcelain from Arita', *Mededelingenblad nederlandse vereniging van vrienden van de ceramiek*, 130/1 (1988), 29–42.
—— 'The Beginnings of the Export Trade in Japanese Porcelain', *Hyakunenan tōji ronshū*, 3 (1989), 1–17.
—— 'Japanese Export Porcelain Figures in the Light of Recent Excavations in Arita', *Oriental Art*, 36/2 (1990), 66–76.
—— and Tregear, Mary, 'Provenance Studies of Tianqi Porcelain', *Trade Ceramic Studies*, 3 (1983), 102–18.
Jenyns, Soame, 'The Wares of the Transitional Period between the Ming and Ching 1620–1683', *Archives of the Chinese Art Society of America*, 9 (1955), 20–42.
—— 'The Chinese ko-sometsuke and shonsui wares', *Transactions of the Oriental Ceramic Society*, 34 (1962/3), 13–50.
Narasaki Shōichi, 'Recent Studies on Ancient and Mediaeval Ceramics of Japan', in *International Symposium on Japanese Ceramics* (1972), 31–5.
Pollard, Mark, '[Technical Studies of Tianqi Porcelain.] Description of Method and Discussion of Results', *Trade Ceramic Studies*, 3 (1983), 145–58.
Satow, E., 'The Korean Potters in Satsuma', *Transactions of the Asiatic Society of Japan*, 6, pt. II (1878), 193–203.
Volker, T., 'Porcelain and the Dutch East India Company as Recorded in the *Dagh-Registers* of Batavia Castle, those of Hirado and Deshima and Other Contemporary Papers, 1602–1682', *Mededelingen van het Rijksmuseum voor Volkenkunde, Leiden*, 11 (1954).
Wood, Nigel, 'Technical Studies of Tianqi Porcelain', *Trade Ceramic Studies*, 3 (1983), 119–44.

Articles in Japanese Language

Igaki Haruo, 'Ko-Kutani no nazo', *Tōsetsu*, 241/4 (1973), 35–8.
Igaki Haruo, 'Ko-Imari no nendai kōshō yushutsu jiki o chūshin ni shite', *Tōsetsu*, 292/7 (1977), 15–36.
Imaizumi Motosuke, 'Arita sarayama no konjaku to hakkutsu hahen no shinhakken', *Tōsetsu*, 225/12 (1971), 36–41.
Kamei Meitoku, 'Trade Ceramics of the 14th and 15th Centuries Particularly about Chinese Ceramics Excavated from Japan', *Trade Ceramic Studies*, 1 (1981), 1–8.
Mizumachi Wasaburō, 'Ko-Imari', *Tōji taikei*, 22 (Tokyo, 1960).
Narasaki Shōichi, 'Three-Colour Glazed Ware and Green-Glazed Ware', *Nihon tōji zenshū*, 5 (Tokyo, 1977).
Ohashi Kōji, 'Kagoshima-ken Fukiage no hama saishū no tōji-hen', in Editorial Committee for essays in honour of

Prof. Dr Tsugio Mikami, *Mikami Tsugio hakushi kiju kinen ronbunshū* (Tokyo, 1985).

Ohashi Kōji, 'Hizen koyō no hensen—shōsei shitsu kibo yori mita', *Saga Kenritsu Kyūshū Tōji Bunkakan kenkyū kiyō*, 1 (1986), 61–89.

—— 'Hizen jiki no akebono', *Hyakunenan tōji ronshū*, 1 (1988), 1–16.

—— 'Overglaze Enamel Porcelain Wares of Hizen during the First Half of the Edo Period', *Tōyō tōji*, 20–1 (1990–3), 5–31.

Suzuki, H., and Watanabe, S., 'Sherds of the Early Edo Period Unearthed at the Site of the Memorial Hall of His Imperial Highness in the Hongo Campus of Tokyo University', *Tōsetsu*, 432 (1989), 15–25.

Tatebayashi Genemon, 'Arita Maruo-gama no tenryiū-ji seiji', *Tōsetsu*, 279 (1976), 53–6.

Tezuka Nobuo, 'Ko-Imari no kama to kama zairyō ni tsuite', *Tōsetsu*, 263 (1975), 34–40.

Tokyo Imperial University, Faculty of Letters, History Department (ed.), 'Inventory of Objects and Utensils in the Collection [of Tokugawa Ieyasu] at Sumpu, taken 17th day, 4th month, Genna 2 [1616]', *Dainihon shiryō*, ser. 12, vol. 24 (Tokyo, 1923).

Yabe Yoshiaki, 'Shoki-Imari sometsuke-Chukoku aobana faishōhyō' in Nagatake Takeshi and Hayashiya Seizo (eds.), *Sekai tōji zenshū*, 8 (Tokyo, 1978), 182, 183.

Yamamoto Nobuo, 'Dating of Northern Song Dynasty Trade Ceramics—Mainly Excavated from Daizaifu', *Trade Ceramics Studies*, 8 (1988), 49–87.

Yamashita Sakurō, 'Shoki-Imari aka-e no kaimei', *Tōsetsu*, 175 (1967) I/10: 42–7, and II/11: 38–46.

—— 'Shoki-Imari no mizusashi', *Tōsetsu*, 217 (1971), 42–7.

—— 'Arita koyō shutsudo no ko-Kutani sochi to ai-Kutani no shinchiken', *Tōsetsu*, 261 (1974), 12: 21–30.

—— 'Imari no nazo o sagaru', *Nihon bijutsu kōgei*, I/424 (1974), 42–9, and II/425 (1974), 42–52.

Yoshida Naojirō and Fukunaga Jirō, 'Mineralogical Studies of Izumiyama Pottery Stone', *Journal of the Ceramic Association of Japan*, 70/2 (1962), 36–41.

Kiln-Site Reports

(1) *Arita-chō Sarugawa koyōseki dai 1 bu; hakkutsu chōsa gaihō*, Saga-ken kyōiku-chō shakai kyōiku-ka bunkashitsu, Saga-ken kyōiku iinkai (Saga, 1970).
The Sarugawa Kiln-Site in Arita, pt. 1: Summary of the Excavation Findings, Saga Prefecture Society for Art and Education, Saga Prefecture Board of Education (Saga, 1970).

(2) *Arita-chō Sarugawa koyōseki dai 2 bu; hakkutsu chōsa zuroku*, Saga-ken kyōiku-chō shakai kyōiku-ka bunkashitsu, Saga-ken kyōiku iinkai (Saga, 1971).
The Sarugawa Kiln-Site in Arita, pt. 2: Pictorial Record of the Excavation Findings, Saga Prefecture Society for Art and Education, Saga Prefecture Board of Education (Saga, 1971).

(3) *Chōkichidani yōseki*, Arita kyōiku iinkai (Arita, 1981).
The Chōkichidani Kiln-Site, Arita Board of Education (Arita, 1981).

(4) *Fudōyama yōseki; Ureshino-machi bunkazai chōsa hōkokusho dai 1 shū*, Saga-ken Ureshino-machi bunkakyōkai (Saga, 1979).
Fudōyama Kiln-Site: Report of the Investigation of Cultural Properties in Ureshino, Ureshino Cultural Association (Saga, 1979).

(5) *Haraake koyōseki*, Saga-ken Nishi Arita-chō kyōiku iinkai (Saga, 1981).
Haraake Group of Kiln-Sites, West Arita Board of Education (Saga, 1981).

(6) *Hata no hara yōseki; Hasami-chō bunkazai chōsa hōkokusho dai 3 shū*, Nagasaki-ken, Hasami-chō kyōiku iinkai (Hasami, 1988).
Hata no hara Kiln-Site: Report of the Investigation of Cultural Properties in Hasami, Hasami Board of Education (Hasami, 1988).

(7) *Hyakken-gama, Higuchi-gama; Hizen chiku koyōseki chōsa hōkokusho, dai 2 shū*, Saga-ken kenritsu Kyushu tōji bunkakan shiryō kankōkai (Arita, 1985).
The Hyakken and Higuchi Kilns: Investigation Report of Kiln-Sites in the Hizen Region, vol. ii, Kyushu Ceramic Museum, Department of Publication of Materials (Arita, 1985).

(8) *Ipponmatsu-gama, Zenmondani-gama, Nakashirakawa-gama, Tatara ni-gō kama; chōnai koyō sekigun shōsai bunpu chōsa hōkokusho, dai 3 shū*, Arita-chō kyōiku iinkai (Arita 1990).
Ipponmatsu, Zenmondani, Nakashirakawa, Tatara No. 2: Report of the Investigation of the Precise Location of the Inner Town Group of Kiln-Sites, vol. iii, Arita Board of Education (Arita, 1990).

(9) *Kama no tani yōseki*, Arita-chō kyōiku iinkai (Arita, 1994).
Kama no tani Kiln-Site, Arita Board of Education (Arita, 1994).

(10) *Kama no tani-gama, Tatara no moto-gama, Maruo-gama, Higuchi-gama; chōnai koyō sekigun shōsai bunpu chōsa hōkokusho, dai 2 shū*, Arita-chō kyōiku iinkai (Arita, 1989).
Kama no tani, Tatara no moto, Maruo, Higuchi: Report of the Investigation of the Precise Location of the Inner Town Kiln-Sites, vol. ii, Arita Board of Education (Arita, 1989).

(11) *Kama no tsuji, Danbagiri, Chōkichidani; Hizen chiku koyōseki chōsa hōkokusho*, Saga kenritsu Kyushu tōji bunkakan shiryo kankōkai (Arita, 1984).
Kama no tsuji, Danbagiri, Chōkichidani: Investigation Report of Kiln-Sites in the Hizen Region, Kyushu Ceramic Museum, Department of Publication of Materials (Arita, 1984).

(12) *Kodaru ni-gō yōseki*, Saga-ken Arita-chō kyōiku iinkai (Arita, 1986).
Kodaru No. 2 Kiln-Site, Arita Board of Education, Saga Prefecture (Arita, 1986).

(13) *Komizo naka-gama, Komizo shimo-gama, Seiroku no tsuji ichi-gō kama, Seiroku no tsuji Taishidō yoko-gama; chōnai koyō sekigun shōsai bunpu chōsa hōkokusho, dai 1 shū*, Arita-chō kyōiku iinkai (Arita, 1988).
Middle Komizo, Lower Komizo, Seiroku no tsuji No. 1, Seiroku no tsuji Taishidō yoko: Report of the Investigation of the Precise Location of the Inner

Town Kiln-Sites, vol. i, Arita Board of Education (Arita, 1988).

(14) *Kusunokidani-gama, Tenjinmachi-gama, Hokaoyama-gama; chōnai koyō sekigun shōsai bunpu chōsa hōkokusho, dai 5 shū*, Arita-chō kyōiku iinkai (Arita, 1992).
Kusunokidani, Tenjinmachi, Hokaoyama: Report of the Investigation of the Precise Location of the Inner Town Group of Kiln-Sites, vol. v, Arita Board of Education (Arita, 1992).

(15) *Kusunokidani-gama, Komizo ue-gama; Hizen chiku koyōseki chōsa hōkokusho, dai 4 shū*, Saga kenritsu Kyushu tōji bunkakan (Arita, 1987).
The Kusunokidani Kiln and the Upper Komizo Kiln: Investigation Report of Kiln-Sites in the Hizen Region, vol. iv, Kyushu Ceramic Museum (Arita, 1987).

(16) *Mukae no hara koyōseki; Nishi Matsuura-gun Nishi Arita-chō kyokusen shozai*, Nishi Matsuura-gun Nishi Arita-chō oki (henshū), Nishi Arita-chō kyōiku iinkai (Saga, 1977).
The Mukae no hara Kiln-Site in West Arita in the West Matsuura District, edited by the West Arita, West Matsuura District, West Arita Board of Education (Saga, 1977).

(17) *Mukae no hara-gama, Tenjinyama-gama, Mukurodani-gama, Kuromuta, chōnai koyō sekigun shōsai bunpu chōsa hōkokusho dai 4 shū*, Arita-chō kyōiku iinkai (Arita, 1991).
Mukae no hara, Tenjinyama, Mukurodani, Kuromuta: Report of the Investigation of the Precise Location of the Inner Town Group of Kiln-Sites, vol. iv, Arita Board of Education (Arita, 1991).

(18) *Nangawara Kama no tsuji-gama, Hirose Mukae-gama; Hizen chiku koyōseki chōsa hōkokusho, dai 3 shū*, Saga kenritsu Kyushu tōji bunkakan shiryō kankōkai (Arita, 1986).
Nangawara Kama no tsuji Kiln and Mukae Kiln in Hirose: Investigation Report of Kiln-Sites in the Hizen Region, vol. iii, Kyushu Ceramic Museum, Department of Publication of Materials (Arita, 1986).

(19) *Saga-ken Arita-chō Tani yōseki no hakkutsu chōsa*, Arita-chō kyōiku iinkai (Arita, 1992).
Excavation Report of the Tani Kiln-Site in Arita, Saga Prefecture, Arita Board of Education (Arita, 1992).

(20) *Saga-ken Arita-chō Yamabeta koyō shigun no chōsa (ikōhen ibutsuhen)*, Arita-chō kyōiku iinkai (Arita, 1980, 1986).
Investigation of the Yamabeta Group of Kiln-Sites (The Sites, The Remains), Arita Board of Education (Arita, 1980, 1986).

(21) *Saga-ken Arita-chō Tenjinmori koyō shigun chōsa gaihō*, Arita-chō kyōiku iinkai (Arita, 1975).
Summary of the Investigation of the Tenjinmori Group of Kiln-Sites in Arita, Saga Prefecture, Arita Board of Education (Arita, 1975).

(22) *Seiroku no tsuji ni-gō yōseki*, Artia-chō kyōiku iinkai (Arita, 1988).
The Seiroku no tsuji No. 2 Kiln-Site, Arita Board of Education (Arita, 1988).

(23) *Shimoshirakawa-gama, Toshikidani ichi-gō gama;*
Hizen chiku koyōseki chōsa hōkokusho, dai 5 shū, Saga kenritsu Kyushu tōji bunkakan (Arita, 1988).
The Shimoshirakawa Kiln and the Toshikidani No. 1 Kiln: Investigation Report of Kiln-Sites in the Hizen Region, vol. v, Kyushu Ceramic Museum (Arita, 1988).

(24) Mikami Tsugio, *New Light on Early and Eighteenth Century Imari Wares: A Report on the Excavations at Tengudani Kiln-Site* (Tokyo, 1972).

(25) *Ureshino-machi Yoshida ichi-gō yōseki; Hizen chiku koyōseki chōsa hōkokusho dai 7 shū*, Saga kenritsu Kyushu tōji bunkakan (Arita, 1990).
The Yoshida No. 1 Kiln-Site in Ureshino: Investigation Report of Kiln-Sites in the Hizen Region, vol. vii, Kyushu Ceramic Museum (Arita, 1990).

(26) *Ureshino-machi Yoshida ni-gō yōseki; Hizen chiku koyōseki chōsa hōkokusho, dai 6 shū*, Saga kenritsu Kyushu tōji bunkakan (Arita, 1989).
The Yoshida No. 2 Kiln-Site in Ureshino: Investigation Report of Kiln-Sites in the Hizen Region, vol. vi, Kyushu Ceramic Museum (Arita, 1989).

(27) *Yagenji koyōshi monohara narabi ni Kake no tani koyō ni tsuite; hakkutsu chōsa hōkoku*, Saga-ken bunkakan (Saga, 1970).
The Rubbish-Dump of the Yagenji Kiln-Site and the Kakanotani Kiln-Site: Investigation Report of the Excavation, Saga Prefectural Museum (Saga, 1970).

(28) *Yamagoya iseki*, Arita-chō kyōiku iinkai (Arita, 1987).
The Yamagoya Kiln-Site, Arita Board of Education (Arita, 1987).

Excavation reports

'Hakata I', *Fukuoka-shi maizō bunkazai chōsa hōkokusho*, 66, Fukuoka-shi kyōiku iinkai (Fukuoka, 1981).

'Itoshima-gun Maebaru-chō shozai Hatae iseki no chōsa', *Imajuku baipasu kankei maizō bunkazai chōsa hōkoku*, 6, Fukuoka-shi kyōiku iinkai (Fukuoka, 1982).

'Miyako iseki: Rokkakugawa kasen kaishū kōji ni tomonau maizō bunkazai hakkutsu chōsa hōkokusho', *Takeo-shi bunkazai chōsa hōkokusho*, 15, Takeo-shi kyōiku iinkai (Takeo, 1986).

'Miyako iseki II: Nōgyō kiban seibi jigyō ni tomonau hakkutsu chōsa hōkokusho', *Takeo-shi bunkazai chōsa hōkokusho*, 19, Takeo-shi kyōiku iinkai (Takeo, 1989).

'Mode iseki: Rokkakugawa kasen kaishū kōji ni tomonau maizō bunkazai hakkutsu chōsa hōkokusho', *Takeo-shi bunkazai chōsa hōkokusho*, 15, Takeo-shi kyōiku iinkai (Takeo, 1986).

'Mode iseki: Rokkakugawa kasen kaishū kōji ni tomonau maizō bunkazai hakkutsu chōsa hōkokusho 2', Takeo-shi kyōiku iinkai (Takeo, 1983).

Nagasaki-shi kōhōka, 'Yomigaeru', *Shimin gurafu Nagasaki*, 30, Nagasaki-shi kōhōka (Nagasaki, 1991).

Nara joshi daigaku maizō bunkazai hakkutsu chōsa-kai (ed.), *Nara joshi daigaku kōnai iseki hakkutsu chōsa gaihō*, II, Nara joshi daigaku (Nara, 1984).

Nara joshi daigaku maizō bunkazai hakkutsu chōsa-kai (ed.), *Nara joshi daigaku kōnai iseki hakkutsu chōsa gaihō*, IV, Nara joshi daigaku (Nara, 1989).

Nihon kōkogaku kyōkai (ed.), *Nihon kōkogaku nenpō 35:*

1982 nendo-han, Nihon kōkogaku kyōkai (Tokyo, 1985).

Sakai-shi kyōiku iinkai (ed.), *Sakai-shi bunkazai chōsa hōkoku*, 15, Sakai-shi kyōiku iinkai (Sakai, 1983).

Shiba Rikyū teien chōsa-dan (ed.), *Shiba Rikyū teien: Hamamatsu-chō eki kōkashiki hokōsha-dō kasetsu kōji ni tomonau hakkutsu chōsa hōkoku*, Shiba Rikyū teien chōsa-dan (Tokyo, 1988).

'Tokyo daigaku hongō kōnai no iseki: Rigaku-bu 7-gōkan chiten', *Tokyo daigaku iseki chōsa-shitsu hakkutsu chōsa hōkokusho*, 1, Tokyo daigaku rigaku-bu iseki chōsa-shitsu (Tokyo, 1989).

Toritsu hitotsubashi kōkōnai iseki chōsa-dan (ed.), *Edo: Toritsu hitotsubashi kōkō chiten hakkutsu chōsa hōkoku*, Toritsu hitotsubashi kōkōnai iseki chōsa-dan (Tokyo, 1985).

Manuscripts

Tanner, Culpepper, 'An Inventory of the Goods in Burghley House Belonging to the Right Honble John Earl of Exeter and Ann Countesse of Exeter taken August 21th 1688', Burghley House.

Archives of the Dutch East India Company, Factorij Japan, nos. 285–8, 290, 774–6, 781–3.

GLOSSARY

aburatsubo	oil bottle
Akae-machi	the enamellers' quarter of Arita
ao-Kutani	'green Kutani'
bekkō-de	tortoise shell pattern
bianco sopra bianco	white decoration on a white background
cha-ire	tea jar
chatsu	ring-shaped firing support for celadon
chawan	tea bowl
chidori	'wave-birds', usually translated as plovers
chōnin	townsman, the merchant class
daimyō	feudal lord
densei	'handed-down', used here frequently to mean an intact piece of porcelain
e-Karatsu	painted Karatsu stoneware
factorij	Dutch trading station
fukizumi	'blown-blue', decoration of scattered blue pigment particles
fuku	(good) fortune
fukujū	good luck
fusuma	sliding door-screens, often painted
fuyō-de	'flower-painting', used to describe the Wanli *kraak* design with radially divided border
grog	powdered fired clay used for streng-thening unfired clay
guinome	a large sake cup
hakeme	slip-decoration on a pot
hama	a flat kiln stand
hera	a wooden tool used by Karatsu and Arita potters in throwing
hi	the character for sun
Hizen	old name for the area of Saga-*ken* and Nagasaki-*ken*
Imari	the port through which porcelain was shipped and hence that porcelain
janome	'snake-eye', base of a pot with a flat unglazed area within the foot-ring
jūbako	a tiered box
kabin	flower-vase; bottle for a shrine
kaiseki	the formal meal that may accompany a tea ceremony
kaki	persimmon
kame	wide-necked jar
kanji	Chinese characters used in Japan
karakusa	scrolling pattern
karamono itokiri	'Chinese cutting', a method of detaching a thrown pot from the wheel
katakuchi	a lipped or pouring bowl
kenjō-Imari	'presentation' Imari
kinrande	Chinese porcelain decorated with gold painting over red enamel, usually Ming dynasty
kinuta	fine-quality celadon from Zhejiang
ko-sometsuke	Chinese export blue and white porcelain of c.1625–50
kōgō	incense box
Korai	Korea
Korai-*chawan*	Korean tea bowl
kosode	'small-sleeve', type of kimono
kotobuki	congratulations
kraak (porselein)	'carrack' porcelain, misnomer for Wanli export porcelain
kuchi-beni	painting around the lip of a vessel, hence brown-rim
mikan	a type of orange
mishima	stamped decoration on a pot

mizusashi	water-jar used in the tea ceremony
mokko	a shape, squared oval with indented corners
momme	peach
mon	crest
monohara	rubbish dump beside a kiln
mushikui	'worm-eaten', the fritting on the rim of a Chinese ceramic due to difference in shrinkage between body and glaze
Nankin-*sometsuke*	old name for *ko-sometsuke*
nigoshide	the white ('milky-white') clay body used for the finest of small pieces at the Kakiemon and rarely elsewhere
nishiki-de	'brocade painting', usually used for overglaze enamelling
noborigama	a stepped, chambered kiln
ōgama	brick- (or clay-) built kiln with central supporting pillars, firing box and side entrance
otona	neighbourhood supervisor
poppegoet	Dutch word, 'doll-wares', either figure-models or ceramic wares for dolls' houses
punch'ong	a style of painting in underglaze iron used in Korea in the sixteenth century and later
ruri	blue background to porcelain decoration
ryokan	Japanese inn
sansui	landscape, scenery
sashimi	raw fish, thinly sliced
seggar	a pot in which another pot is placed to be fired
shōji	sliding door-screens, usually translucent, sometimes with glass
soba	buckwheat noodles
sobachoko	cup for the sauce eaten with buckwheat noodles
sometsuke	blue and white porcelain
suisaka	name given to a style of decoration that has underglaze iron ground, or iron-brown glaze, with white reserves and sometimes with underglaze blue
suname	method of stacking pots in the kiln with a scatter of sand
suribachi	grinding-mortar
taidome	method of stacking pots in the kiln using balls of clay
takara	good luck, or treasure
tataki	the method of building of a clay body by beating-up from scraps of clay
tatara-built	not thrown on the wheel
temmoku	from Tianmu shan, Chinese temple complex, hence iron-glaze
tochin	dumbell-shaped stand for raising pots off the kiln floor during firing
tokuri	bottle
tsuba	sword-guard
tsubo	narrow-necked jar
tsugi	cryptomenia tree, Japanese cypress
yamachawan	coarse mass-produced glazed bowl of Heian and later periods
yingqing	Chinese thin-bodied, bluish-white glazed porcelain
yōhen	iridescent spots in a glaze

PHOTOGRAPHIC CREDITS AND LICENCES

Colour plates

Ashmolean Museum 9*a*, *b*, 10*a*, 12*a*, 13*a*, 16*e*, *f*, 17*d–f*, 18*a*, *b*, 19*f*, 23*c*, *e*, *f*, 25*b*, 28*d*, *e*, 29*a*, 30*a*, 31*c*, 36*b*, 37*c*, 41*b*, 42*b*, *c*, 45, 46*c*, 48*a*, 51, 52*a–e*, 53*a*, *f*, 54, 55, 56*a–c*, 57, 58*a*, *e*, *f*, 59*a*, 60, 61*a*, *d–f*, 62*d–f*, 63*f*, 64

Jackson and Mary Burke Collection 32*b*

Menno Fitski 50*f*, 58*b*, 61*c*

Idemitsu Museum 30*b*, 37*c*, 38*b*, *c*, 42*a*, 43*c*, 44*b*

Ishikawa Prefectural Museum 36*a*, 37*a*, *b*, 38*a*, *b*, 39*a*, 41*a*, *c*, 43*a*

Kakiemon family 2*a*

Kōhashi Ichirō 40*d*, 41*d*, 42*b*, *d*, 44*c*, 62*b*

Kyushu Ceramic Museum 4*a*, 8*b*, 13*b*, 22*a*, 24*b*, 25*a*, 29*b*, 34*b*, 40*c*, 46*a*, *b*, 49

Matsuoka Museum 40*a*

Metropolitan Museum 15, 17*a*

M.O.A. 7

Brian Morgan 23*d*

Museum het Princessehof 6

Saga Press News 1

Suntory Museum 5

Taeda Mikihiro 62*a*, *b*

Museum Yamato Bunkakan 3

Black and white figures

Ashmolean 5, 17, 18, 36, 37, 39, 40, 45–56, 99, 120

Jan Baart 80

Burghley House 79

Louise Cort 7

Fukuoka City Board of Education 72, 73

Fukuoka Prefecture Board of Education 62, 63

Idemitsu Museum 43

Mayuyama Junkichi 83–6, 102, 103

Metropolitan Museum 81, 98

Mikami Tsugio 2

Nara Womens' College 65–70

Okayama City Board of Education 73–8

Okayama Prefecture Board of Education 71, 72

Sakai City Board of Education 64

Takeo City Board of Education 57–9

INDEX

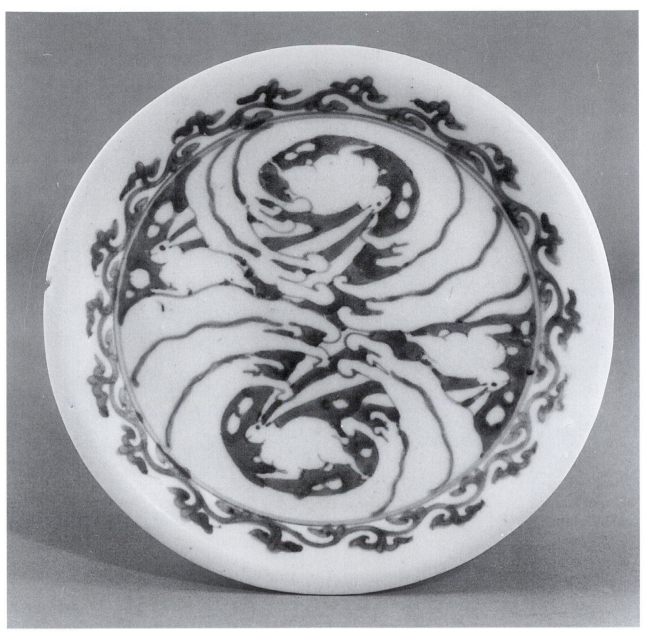

FIGURE 120. Dish with reversible design of hares under the moon, period two, dia. 20.6 cm. Ashmolean Museum, 1992.69. Respectfully dedicated to all those who like to begin a book from the back...